THE COLOR OF STONE

THE COLOR OF STONE

Sculpting the Black Female Subject in Nineteenth-Century America

Charmaine A. Nelson

University of Minnesota Press / Minneapolis London

Material from the Hiram Powers and Powers Family Papers, 1827–1953, and from the Preston Family Papers, 1836–1927, appears courtesy of the Archives of American Art, Smithsonian Institution.

Letters from Anne Whitney are from the Anne Whitney Papers in the Wellesley College Archives; courtesy of Wellesley College Archives.

Letters from Lydia Maria Child to Sarah Shaw are from Shaw Family Correspondence, Manuscripts and Archives Division, The New York Public Library, Astor, Lenox and Tilden Foundations. Used with permission.

Published by the University of Minnesota Press
111 Third Avenue South, Suite 290
Minneapolis, MN 55401-2520
http://www.upress.umn.edu

Library of Congress Cataloging-in-Publication Data

Nelson, Charmaine A.
 The color of stone : sculpting the black female subject in nineteenth-century America / Charmaine A. Nelson.
 p. cm.
 Includes bibliographical references and index.
 ISBN: 978-0-8166-4650-0 (hc : alk. paper)
 ISBN: 978-0-8166-4651-7 (pb : alk. paper)
 ISBN-10: 0-8166-4650-3 (hc : alk. paper)
 ISBN-10: 0-8166-4651-1 (pb : alk. paper)
 1. Women, Black, in art. 2. Figure sculpture, American—19th century. 3. Marble sculpture, American—19th century. 4. Sculpture, Neoclassical—United States. 5. Race in art. I. Title.
NB1936.N45 2007
730.973'09034—dc22 2007001735

Printed in the United States of America on acid-free paper

The University of Minnesota is an equal-opportunity educator and employer.

12 11 10 09 08 07 10 9 8 7 6 5 4 3 2 1

To my mentors:

Joan Acland
Janice Helland
Don Andrus

Contents

Illustrations

Introduction
Toward a Black Feminist Art History

Cleopatra's White?

What do Africa, Cleopatra, and a slave have in common? While this may seem like the first line to a bad joke, it attempts to demonstrate what are at first glance the not so obvious links between the recurring subjects of the chapters that follow. Perhaps, more directly, I should ask, what is the connection between those subjects named above and the narratives that helped to construct the black female subject within nineteenth-century western visual art traditions? If your guess is that the subjects in question were all black, it is indeed too obvious to be fully correct. The fault lies in the word *were,* which essentializes the subject's racial identification, creating an already always state, an a priori identity or subjectivity. In actuality, the link I shall be exploring is not that these subjects *were* all black but rather how these female subjects *became* black within nineteenth-century art generally and neoclassical sculpture specifically, and for what social, political, cultural, and psychic ends. *Become/became* here is not just a matter of color or complexion, but one of identity, location, social and political positioning, and power.

Cleopatra has a central role within this exploration, specifically the neoclassical sculptures by contemporaries William Wetmore Story (*Cleopatra,* 1862) and Mary Edmonia Lewis (*Death of Cleopatra,* 1875). I was initially drawn to Cleopatra by her potential Africanness, an identification stemming from her rulership of an ancient Egyptian kingdom on the African continent. Having grown up in a home where the histories of transatlantic slavery and western imperialism were related from a young age, it seemed natural that I equated Africa with blackness. To be confronted in my youth by successive images of pale, decidedly white Cleopatras in popular culture and "high" art alike was disruptive to my early ideal of a black queen. How, I asked myself, could Elizabeth

Taylor be recruited by Hollywood to play Cleopatra? My early suspicion of the western desire to visualize a white Egyptian body predated my knowledge of Cleopatra's unknown maternal genealogy and alternative histories of ancient African and European cross-colonization but nevertheless led to an overall suspicion of race and racial representation as a visual category that had more to do with privilege, desire, and power than with history, accuracy, or "authenticity"—vision and representation were and are suspect. But there has also been a competing discourse that represented a black Cleopatra.

My attraction to Cleopatra as a subject of art historical inquiry stemmed from my desire to recuperate the black Cleopatras visualized through nineteenth-century abolitionist discourse as well as to tackle the seemingly aesthetic impenetrability of neoclassical sculpture. Partly attributable to the distance that separates us from the time of their production and also due to the generally unfashionable nature of neoclassical sculpture today (especially in comparison to the dominance of modern), my ability to read Cleopatra's supposedly black nineteenth-century sculptural bodies was constantly thwarted by what I saw as the lack of specificity of undifferentiated white marble surfaces that registered neither the color of flesh nor the intimacy of the sculptor's hand. It seemed to me that Cleopatra's race, as that of other black female subjects, had been rendered illegible by nineteenth-century neoclassical sculptural traditions. Observing the white marble fields of Cleopatra's neoclassical bodies, I wondered, where, if anywhere, was her blackness visible and what meanings could be attributed to such racial flexibility?

The idea of *becoming* captures the process of the body's materializations, its very corporeality and identifications. Identity then indicates not just a physical phenomenon—the body—but also the social, cultural, and psychic meanings that are attributed through the identification, experience, and visual scrutiny of the physical. Attribution or naming in any society is controlled by those with the power to create and assign the names. Identity often comes down to the meanings that are attached to bodies when they are rendered as objects of vision. And vision in the west, an exclusive domain, has been a dominant way of keeping bodies and people, according to race, sex, gender, sexuality, class, and other markers of difference, in their "proper" social place.[1] Vision and the visual are western tools of social ordering. Identity is unstable and unfixed. The process of identification is the site of struggle and contestation, and as with any struggle it is fair to ask: What is at stake? Who are the players? And what stands to be lost or gained when shifts in the field of identifications occur? At stake were the definitions and practice of race in nineteenth-century colonial discourse. The players were the artists, patrons, critics, cultural tourists, abolitionists, and social reformers. To be lost or gained were status, privilege, reputation, wealth, dignity, self-possession, and power.

Neoclassical Sculpture: Narration and Viewership

Identification is an inherently willful attempt at the control, unification, and regulation of that which is inherently fragmentary, fluid, and ceaseless in its movement.

Rather than a vision of the body that sees an a priori identity that is the subject of representation, representation, as I regard it, is the very ground where identities are fabricated and made possible, the place where identity occurs and the subject *becomes*. The idea of *becoming* is linked throughout this project to the idea of narratives or narration. In the nineteenth century the act of narration was central to the most basic creative considerations and intentions of artists and to the viewing practices of audiences of neoclassical sculpture. While I shall explore below the reasons for my focus on sculpture, for now I will explain nineteenth-century sculpture's specific debt to the processes of narration. Since sculptors, unlike painters, often represent single subjects because of practical, material, and compositional considerations, they regularly erase extensive details of their subject's context, environment, and condition. Instead of multiple subjects and elaborate settings, sculptors have to rely extensively on composition, pose, ornament, and props—abridged contextual markers—to direct their audiences in the reading of their sculptures. A fitting example is the biblical subject of Hagar. Traditionally in western paintings and other two-dimensional art forms, Hagar was often one of many subjects represented, including Abraham, Sarah, Ishmael, and angels. In contrast, nineteenth-century American sculptor Edmonia Lewis represented only the Egyptian bondswoman in her *Hagar* (1875) and relied on the definitive placement of an overturned water vessel to trigger the audience's knowledge of specific moments within the biblical narrative, a narrative that facilitates the desired moral and socially appropriate reading of the sculpture.

Whereas the term *becoming* indicates the body's or subject's process of materialization, narration indexes the socially, historically, geographically, and politically specific context that a body was allowed to inhabit and ultimately the body's raison d'être within nineteenth-century visual culture. Narration indicates the stories that artists and audiences told themselves to facilitate the process of viewership, achieve a suitably moral interpretation, and legitimize visual representations as "high" art. But if a body's social status, as revealed by its physical assumption of space, is understood to correspond with that body's identification, then narration is also indicative of the very subjectivity of the body itself. Therefore, as in the case of Hiram Powers's *Greek Slave* (first version, c. 1843), the white female subject could be read as a chaste slave, despite her nudity, because the narrative of her ravishment at the hands of vile Turkish colonizers racialized and gendered her in ways that supported the idea of a coerced and vulnerable nudity. But simultaneously, the very whiteness of the female slave itself, at this heightened colonial moment, became the narrative cue that triggered the audience's racialized reading of idealized female subjectivity at risk. The narrative context was the mechanism of racialization that helped to create an idealized white female subjectivity.

Whereas our now canonical modern art traditions have been broadly associated with the idea of "art for art's sake," sculptural neoclassicism and "premodern" nineteenth-century western forms of "high" art generally were often deployed toward the ultimate goal of an intelligible moral message. The examination of nineteenth-century opinions of art critics, patrons, and exhibition-goers reveals a complex discursive

literary practice that enveloped the sculptural subjects within suitable moral narratives, which facilitated the appropriate visual consumption of the artwork, directed the reading of a particular identity, and supported an equally appropriate sensorial response in the viewer's body. *Appropriate* refers to the ideals of subjectivity that governed nineteenth-century bourgeois social interaction and conduct, differentiating bodies by producing visual signs of gender, sex, class, and race. Within the nineteenth-century hegemonic viewing practices, people's social status, particularly their class, and their very identity were often ascertained from their corporeal and visceral reaction or response to an artwork. There is no one gaze, no singular universal way of seeing. The process of vision, of viewing, is classed, raced, and sexed, and the way one sees and what one sees are both products of that person's identification and location and a part of what confirms and reinstates both. Viewers do not merely see what *is*. Rather, vision must be addressed not as a process of objective reading but as a process through which identifications are imagined and assigned. For example, below I refer to the crying white women who lamented the horrible fate of the shackled white marble maiden represented in Hiram Powers's *Greek Slave*. These women's sorrowful mediation on the fettered nude sculpture and the tears they shed for this inanimate object's "predicament" indexed their bourgeois femininity as much as their whiteness, their floor-length dresses, parasols, or bonnets. The practices of nineteenth-century art viewership were often public performances that powerfully and deliberately inscribed class, gender, and race.

An even more explicit reminder of the inequities and complexities of viewership is that a nineteenth-century person's ability to access original works of art, specifically within the rituals of European cultural tourism, was absolutely determined by financial means, which intersected not just with one's class but also with one's racial and sex position. As the discussion on the hegemonic practices of cultural tourism in chapter 2 will reveal, practices of art viewing and narration were invested in staking a claim to cultural capital, declaring one's right to viewership by publicly displaying an ability to read and narrate art, and also teaching others not just what to see but how to see it. The claim to cultural capital was activated largely by proximity, a physical proximity to the site or object of scrutiny that was deemed to be significant and valuable, a source of knowledge, an aesthetic achievement, and a source of sensorial pleasure.

In considering the idea and function of narration, I wish to interrogate the representational limits and possibilities of the black female subject. If a black female subject could support the narrative of an ancient African queen in the nineteenth century, what were the conditions attached to the racing of such a body, to the type of blackness that was representable and represented? Examining these narratives that were deemed suitable to support the deployment of the black female subject is the process of questioning the conditions and contexts of black female identity and subjectivity and the very racing of the body itself. In my search I have found that it is often the artworks that were deemed transgressive—ridiculed by their audience, such as John Gibson's *Tinted Venus* (c. 1851–56), rejected by their patrons, such as Hiram Powers's *America* (1848–50), or destroyed by their creators, such as Anne Whitney's *Africa* (c.

1863–64)—that reveal most clearly not only the inextricability of the process of narration and production but also how particular modes of sentimental narration were governed by the bourgeois limits of subjectivity, which were always both racial and sexual. The response to transgressive artworks also reveals the entrenched practices of the social and cultural policing of identity, and by examining who the actors were, one can come to understand what was at stake and for whom. Ambiguity, too, is critical. Artworks that supported multiple and often contradictory narrations and readings indicate the instability of identification and the subjective nature of viewership despite hegemonic representational traditions, which were resistant to heterogeneity and non-dialectical identification. This exploration excavates the nineteenth-century colonial representational limits and possibilities of the black female subject.

I am working constantly on two levels, that of the "author-function" and the "subject-function."[2] The Foucauldian notion of the author-function suggests a means for understanding the articulation of discourse as opposed to the examination of themes or concepts. By author, I mean not merely the artist as an individual person who constructs the specific art object but also the historical, social, and cultural context that surrounds, shapes, and informs the artist as the producing subject. If this idea is applied to the subject, the subject-function allows for an understanding of the role of the subject and how his or her social identification as dictated by race, sex, sexuality, gender, class, and so forth, mediates and informs his or her representation within the visual field. As such, I recognize both the author and the subject as discursive products.

I proceed from the position that identity is embedded in representation. The visual processes of the representation of the body are acts of differentiation that delineate the surface and boundaries of the body. As Stuart Hall has noted:

> Identification is, then, a process of articulation, a suturing, an over-determination not a subsumption. There is always "too much" or "too little"—an over-determination or a lack, but never a proper fit, a totality. . . . It requires what is left outside, its constitutive outside, to consolidate the process.[3]

This differencing is relational and performed through acts of inclusion and exclusion, which create hegemonic identifications with dialectical relationships. Judith Butler guides me in her questioning, "What is excluded from the body for the body's boundary to form? And how does that exclusion haunt that boundary as an internal ghost of sorts? To what extent is the body surface the dissimulated effect of loss?"[4] My project is the location of these absences and ghosts, what Stuart Hall has called "what is left outside" and what Griselda Pollock has called "traces of incomplete repression."[5] I am searching for the remnants of what has been disavowed and what has been strenuously avowed. It is the excavation of these sites of rupture or slippage, caused by these ceaseless movements and negotiations, wherein conflations cannot sustain themselves but reveal their discursivity and the structures of their materialization.[6] By examining the visual piecing together, if you will, of the black female subject, we can come

to understand what she could and could not be to and for nineteenth-century artists and audiences.

Unmasking Methodology: Subjectivity and Disciplinarity

Throughout the process of writing this book, I became increasingly sensitive to and concerned about the continuing disciplinary demands for "objective" scholarly engagement with or disengagement from one's topic and methodological approach. At an event organized by the Institute for Research in Arts, Humanities and the Environment at the University of Manchester, Dr. Erik Swyngedouw articulated the connection between the academic ideal of the objective scholar and the lack of passionate scholarly engagement beyond the walls of the university, particularly in Britain.[7] With the advent of critical theories and the questioning of disciplinary boundaries and discursivity, the ideal of the "objective" and disinterested scholar is increasingly (and thankfully) the domain of the hegemonic structure of traditional phallocentric canonical academic practice. As Griselda Pollock has argued of art history, "The canon is fundamentally a mode for the worship of the artist, which is in turn a form of masculine narcissism."[8] Quite simply, scholars applying critical theory have increasingly integrated the process of self-reflexivity into their work in ways that do not just deconstruct disciplinarity and canonicity but also situate themselves as authors and practitioners and render their methodological apparatus and desires transparent. As Pollock has explained, "There are, however, productive and transgressive ways to re-read the canon . . . ways to question our own texts for the desires they inscribe, for the investments which feign through telling the stories of our own ideal egos."[9]

The problem is that when scholars who are actively and consciously self-reflexive are set against those who do not name themselves, their methodology, or their product, the latter are often accepted as the "norm" of the discipline, the specificity and exclusivity of their desires masked as the paradigm of the discourse in which they operate instead of being revealed as the very fabric of discursivity. The marginalization or, as Griselda Pollock has stated, "ghettoisation" of self-reflexive,[10] critical scholars today parallels the constraints and regulatory processes imposed on nineteenth-century black authors participating in the colonial discourse of the slave narrative. The censorship of their utterances was both external (from the white abolitionists who sanctioned their texts and the "liberal" whites who consumed them) and internal (from the colonial self-regulation that often becomes a part of the racially marginalized subject's self-identification). Just as black fugitive slaves felt compelled to apologize for their racial identifications and the horrific experiences their identifications engendered, contemporary critical scholars—feminists, postcolonialists, queer theorists—often feel compelled to offer similar explanations for their desires that do not conform to the disciplinary traditions of phallocentrism, Eurocentrism, and heterosexism. Paul Gilroy, too, has noted such disciplinary exclusion, particularly citing the banishment of race and representation from the traditional disciplinary concerns of "orthodox histories of western

aesthetic judgement, taste, and cultural value."[11] Intimately aware of the identificatory difficulties of authorship and disciplinary intervention, Griselda Pollock offered just such an apology in the preface of *Differencing the Canon* (1999):

> I ask indulgence of the reader for the ways in which a personal narrative informs and even might be said to intrude upon its apparently historical materials. . . . I have used this book to find my own autobiography as much as I have lent some of my story to the texts I discovered in the archive. The trick is to hold the two in creative covenant.[12]

Pollock's apology does not, of course, interfere with her critical awareness of the practice of disavowal and repression inherent within traditions of western disciplinarity, but rather is born of it. Has it not been the refusal to state and claim a specific white, male, heterosexual desire that has resulted in the exclusivity of western canonical traditions that have functioned through the abjection of the female, the black, and the homosexual body? This academic purging of self-identification and subjectivity is part of the canonical regulation that preserves the exclusivity of disciplinary boundaries for the chosen few. It is what makes possible the relegation of a (black) feminist intervention into art history to the margins while the canon of "great white male masters" constructed by "great white male art historians" remains unmoved at the discipline's center. In the writing of this text, I am striving, as Pollock advocates, to form a creative covenant in which I acknowledge and embrace the ways in which my own subjectivity informs my desire for and approach to the historical documents and visual objects that I choose to examine. It is this transparency that will inevitably reveal the strings on the puppet of art history's biased canon. And yet, I am not suggesting that an unbiased canon, in the sense of a desireless canon, is possible, but rather that the inclusivity of art history is rendered more possible through the revelation of individual and group desires that have become normalized as universal.

The profound contribution of bodies of study such as postcolonial theory, queer theory, and feminism to art history and other disciplines is that those formerly marginal topics of inquiry have become areas worthy of our contemplation. They are scrutinized, questioned, and examined not just for their seeming alterity but also diametrically to reveal the process of their "othering" as that which was formerly beyond recognition and unworthy of scholarly contemplation. This means that I, as a black feminist scholar, am interested in an artist such as Edmonia Lewis, black, Native American, and female in the nineteenth century, for many reasons: because she made art, because she made good art, because she achieved a professional status and international fame at a time when every obstacle was stacked against her, because, because, because . . . I choose to be. Edmonia Lewis's place in art history is no more in need of defending than Hiram Powers's or William Wetmore Story's. And likewise, her race, sex, gender, sexuality, and class are no more in need of discussion and analysis than are those of Powers and Story as white men of significant privilege.

Contextualizing the Black Female Subject

This project charts the process of recuperating the nineteenth-century social and cultural languages and discourses of race and racial signification to understand the identifications of the black female body and the role of the visual arts in the constitution of those identifications. I am examining art as colonial discourse and as a field in which identities are formed and deployed. To discuss the black female subject within the nineteenth century, one must confront the prolific nature of transatlantic slavery and the colonial logic on which it was constituted and through which it flourished. The confrontation with slavery necessitates an understanding of its geographical parameters, constituting networks of European, American (North, South, and Central), Caribbean, and African colonies intersecting through their shared access to and use of the Atlantic as the "middle passage," where bodies became commodities, relatable to and exchangeable for natural products such as sugar, tobacco, and cotton. Although much has been written about the economic, social, and political contexts of this triangular traffic, much less attention has been paid to the role of the visual arts and culture. And yet every facet of the practices and processes of transatlantic slavery—capture, torture, labor, punishment, transit, commodification, and so forth—was witnessed and represented by visual artists, professionals and amateurs alike. As members of the colonial societies they sought to represent, their stakes in their representations were often high, informed by their own political, social, and geographical locations, their identities, and their stake in slavery.

It is with this knowledge of the centrality of the Atlantic as the common ground of slavery and the black diaspora it produced that Gilroy has argued:

> I want to develop the suggestion that cultural historians could take the Atlantic as one single, complex unit of analysis in their discussions of the modern world and use it to produce an explicitly transnational and intercultural perspective.[13]

This is Gilroy's Black Atlantic, and it enters my text in several important ways. First, it is the geographical space of commodification that mapped the transition of Africans to slaves, making black bodies accessible subjects of representation within particular narratives to dominantly white artists. But for my purposes, the Atlantic also points up the significant international character of nineteenth-century neoclassicism, which, focused in Rome at midcentury, was characterized by a diversity of Americans and Europeans, the American presence fed continuously by a marine access made possible by steamship crossings of the Atlantic. Within this triangular configuration, which literally mapped the black diaspora, I have examined blackness within the multinational cultural and political context of the Black Atlantic, addressing pluralities and antagonisms of identification and competing meanings generated within production and viewership complicated by conflicts of divergent racial, gender, class, and national interests. Gilroy's Black Atlantic is a complex transformative concept that makes possible an

awareness of how transatlantic crossings shifted the social, legal, and political status of black bodies, activating new symbolic meanings that translated into aesthetic possibilities and limitations. I have also discussed the transformative capacity of transatlantic travel within the context of cultural tourism and the productive bodies of the artists, particularly Edmonia Lewis, for whom a racial identification as black and Native repeatedly foreclosed certain nineteenth-century Eurocentric associations among travel, tourism, and liberation.

Also of great significance to any discussion of the black body within nineteenth-century western culture is the role of the human sciences as an influential power or knowledge nexus that legitimized ideals of white supremacy. The human sciences produced race within hierarchical visual systems, which secured the white male body as paradigmatic, always at its apex. Nineteenth-century representations of the black female body reveal embedded strategies of dehumanization that facilitated and justified the technologies of oppression, which violently controlled the black body within the institution of slavery and colonialism generally. Although I am attempting to theorize the racialization of the body within visual culture, this cannot be divorced from the material, aesthetic, narrative, and historical limits of black female subjectivity generally. My exploration of a postcolonial psychoanalysis, below, is to me as much a worthwhile exercise in and of itself as it is an introduction to the more explicitly art historical inquiries that it informs in the chapters that follow.

Theorizing Race

Aimé Césaire discussed the inherent paradox of colonialism that necessitated an initial violent degradation of the body of the colonized but turned back on the body of the colonizer:

> That colonial activity, colonial enterprise, colonial conquest, which is based on contempt for the native and justified by that contempt, inevitably tends to change him who undertakes it; that the colonizer, who in order to ease his conscience gets into the habit of seeing the other man as *an animal,* accustoms himself to treating him like an animal, and tends objectively to transform *himself* into an animal.[14]

The violent and perpetual restatement of the self as the white body through the degradation, violation, and oppression of another body is evident throughout the historical texts that document nineteenth-century western visual art practice. This initial degradation can be viewed, in the same way that Judith Butler has defined the materiality of sex, as a forcible production.[15] As Butler acknowledges Foucault's explanation of sex as a "regulatory ideal," the same logic can be applied to an understanding of race and color. Race–color is a regulatory ideal whose materialization is compelled and occurs within highly regulated practices.[16] Blackness and whiteness do not preexist this often violent regulatory apparatus; they are products of it.

We must begin from a position that acknowledges the inseparability of sex and gender from race and color identifications. To understand the body as a form in motion is to attempt to recuperate moments of historical, geographical, and social specificity. The period of study, the mid-nineteenth century, is a period of vivid transition and instability for the black (female) body as it maps the shifts from western slave economies to the abolition of transatlantic slavery, which is also the shift from the enslaved to the free black subject. But the end of slavery did not constitute the end of colonialism or the end of the ideologies of racial oppression that had informed and justified slavery to begin with. The words of Alexis de Tocqueville's *Democracy in America* alert us to the symbolic significance of blackness as supposedly visible biological marks of racial inferiority that operated separately from the actual social status of the enslaved body: "The Negro transmits the eternal mark of ignominy [slavery] to all his descendants; and although the law may abolish slavery, God alone can obliterate the traces of its existence."[17]

By naming God as the one means to abolish the racial inferiority of the black body, Tocqueville used religion to justify a biological essentialism that located blackness as the very source of an inherent racial inferiority that freedom could not override. Significantly, he made no distinction between free or enslaved blacks. To be free for a black was to be free of the "eternal mark" and thus not black at all. Tocqueville illuminated the extent to which the state of being black for many, in the nineteenth century, was the same as being a slave. And as Kirk Savage has argued, "The Negro as slave functioned more readily and more evenly as a sign of lack—lack of power, lack of decorum, lack of self-restraint, lack of humanity."[18] Potential "liberation" was then a matter of divine intervention, which signaled the whitening of the black body through its very obliteration. By focusing on specific subjects or themes of visual culture, I am seeking to recuperate these historical signs of blackness, that which the human sciences deemed biological, to examine the processes of signification that resulted in the black body and, perhaps most important, to understand what the identification of blackness meant, socially, culturally, psychically. Coupled with this is the crucial question of how the black female subject was *allowed* to be made visible, an interrogation of the possibilities and impossibilities of identification at a specific historical moment. But to accomplish this, I wish to go back even further to the issue of the very materialization of race itself.

Starting from Lacan's idea of sex as a symbolic position, Judith Butler has argued that "sex," or biological sex, "is that which marks the body prior to its mark, staging in advance which symbolic position will mark it, and it is this latter 'mark' which appears to postdate the body, retroactively attributing a sexual position to a body."[19] If race can be understood as a product of the symbolic order, then signs that are taken as biological marks of race, such as hair texture, skin color, and nose width, have served to activate the subsequent colonial meanings of race within the symbolic order. These two types of marks, the biological and the symbolic, are not of necessity predetermined in their definitions or correlations. Hence, female biological sex does not essentially signify

sexual lack within the symbolic order, rather only within a symbolic that functions phallocentrically. Nor does blackness essentially signify racial inferiority, rather only within a colonial symbolic. These later symbolic markings are representations that have become naturalized through forcible political, cultural, psychic, and social constraints: they are deployed and they are policed. To fully understand the naturalization process of blackness as an abject symbolic position, one must examine its performativity.

If race is "assumed" as sex is "assumed," then the biological mark is not enough to confirm a subject's position; rather, race is and must be constantly performed by bodies, which are largely constrained within the regulatory practices of colonialism. In order for blackness to become a consistent mark of inferiority, certain signifying practices had to be set in place to mandate that the representation of the black body always be in dialectical opposition to the white. In terms of real people, we are talking about hindrances or prohibitions (legislated and not) to social mobility, political agency, public vocality, economic enfranchisement, and educational opportunity. We are talking about limitations on where one can live and with whom, if one can participate economically and legally in one's own community, whether one has control of one's body, sexuality, and marital status, and has access to education, employment, voting rights, pay equity, and government services. Within the scope of the visual arts we are talking about aesthetic and material structures, rules of composition, conditions of sexual propriety, hierarchies of genre, style, and media, popularity of themes, ideas of artistic intention, and procedures of exhibition, viewing, and consumption.

The trick of the symbolic is that the regulatory apparatus that *precede* the symbolic marking come to be seen as a later condition or application of an essential racial marking (if they are seen at all). This process is what Judith Butler refers to as "the kind of 'prior' authority that is, in fact, produced as the effect of citation itself."[20] The naturalization of the symbolic order is what produces hegemony. According to Butler, the hegemony of heterosexuality depends not on the refusal of homosexuality but on the identification of abject homosexuality.[21] Similarly, the hegemony of whiteness is founded on the active representation of an abject blackness. But it is important to remember that a symbolic mark may have force and meaning within more than one ideological frame. Hence, the symbolic mark of blackness carries significant racial meaning but also sexual meaning and class meaning. As shall be demonstrated throughout this text, the blackness or blackening of a female body in visual art triggered a myriad of sexual and class repercussions that should also alert us to the complex intersectionality of various markers of identity.

Making Space in Art History: Black Feminisms and the Postcolonial

I am indebted to the various publications that have preceded me,[22] laying a foundation for postcolonial interventions in art history.[23] However, this project departs in significant ways from its predecessors in its exploration of race and racial signification as inextricable from sex and gender signification. In the growing and influential body

of literature on the representation of the black in western culture, the most obvious omission has been the overwhelming lack of attention to the ways in which a shift in sexual or gendered identity impacts the representation of the racialized body. For the most part these texts have pursued histories of *the black subject* with a disregard for the critical importance that sex, gender, and sexuality play in the construction of racial identity. Still others have written histories of the black male subject that presume a theoretical and methodological breadth and depth that could unproblematically account for the specificity of the black female subject. The uniqueness of visual cultural production as opposed to other forms of culture or other forms of representation has also often been overlooked or remained untheorized or undertheorized. Many of these publications do not consider the identity of the artist and the impact of his or her identity, racial and otherwise, on representation and representational processes. White and black, male and female artists have been written about in ways that do not account for the extent to which class, gender, sex, and race mediate vast discrepancies in access to visual culture and art education, which in turn determine aesthetic, material, and social practices.

But while the patriarchal and colonial machinations of the symbolic may appear rather inflexible, I am particularly concerned with the ways in which bodies can resist the identifications assigned to them and the social positions with which those identifications correspond or can take on entirely unexpected or unintended meanings. For example, how did Edmonia Lewis, a black–Native female, whose difference surpassed that of her white female colleagues, subvert her marginalized race and sex identifications in order to practice sculpture professionally in the nineteenth century? As I shall discuss below, although Lewis did become a successful internationally recognized professional sculptor, her blackness–Nativeness and femaleness were often used by her white contemporaries as a motivation to not *see* her as such. As Judith Butler has noted, the regimes that regulate the body function largely through prohibitions and the "pain of guilt," which, when ignored, produce repercussions that reinforce (often violently) the identifications that have been transgressed.[24]

In taking up a sex- and race-specific subject for this inquiry, I have narrowed its scope in the hope that, in doing so, I have allowed myself to focus more thoroughly on the racial and sexual specificities of visual–cultural representation. My attention to the nexus of race and sex in *any-body* can be broadly linked to the theoretical category of black feminisms. Unlike many traditional white feminisms or some postcolonial theory, black feminisms have shared at their core a fundamental belief in the inextricability of race–color and sex–gender in the black female body and all other human subjects. Jean Walton has convincingly argued against this absence in the white feminist practice of psychoanalysis:

So far, white-authored psychoanalytic attempts to make an argument for a specifically "feminine" or "female" subject-position have only succeeded by their persistent refusal to ask questions about the historically determined whiteness of the models

they employ. Feminism as an institution has thus reenacted the way in which psy-
choanalysis as an institution defensively armored itself against charges of ethnocen-
trism. . . . Having acknowledged this, I would like to suggest that the project now is
investigating, in very specific and detailed ways, local constructions of racialized iden-
tification and desire, especially in those areas where the discourses of psychoanalysis
and feminism intersect and enrich each other. The objective of such a project would
not be to establish a more comprehensive ontology of femininity, or of female or les-
bian sexuality but, rather, to interrogate the ways in which the feminist ontologies
hitherto constructed are implicated in a vexed genealogy of racialized discourse.[25]

Therefore, although conscious of the important contributions of white feminisms to
the critical analysis and theorization of the body in visual culture, I am critical of the
desire to hierarchize sex–gender concerns above racial–color concerns and also of the
practice of not naming the race–color identity of the female body (be it artist or sub-
ject), an erasure that deploys the white female body as a universal female category and
ultimately replicates the hegemony of colonialism.

Representation and the Body: Vision, the Gaze, and Identity

Before we can understand how the black female body has been represented at this par-
ticular moment in western visual culture, we must gain an understanding of the terms
themselves—*body* and *representation.* I have sought to hold the intersections between
these terms in perpetual tension in regard to what they mean for the subjects of
representation, the production of art objects, and the audience who consumes them.
Psychoanalysis is particularly useful to the study of identity, because it allows for the
bidirectional impact of the intangible on the tangible, the unconscious on the con-
scious, the invisible on the visible. Psychoanalysis provides for the consideration of
the body as both a material and a psychic phenomenon: the self is constituted through
a constant and complex negotiation that also results in Other bodies. It also recog-
nizes the body as an unstable entity whose identifications must be maintained through
constant social and psychic reinforcement and performance, which provide the feeling
of stability, sameness, and security to an unstable, changing, and insecure form. The
materiality of the body is not stable but adaptive to competing and simultaneous dis-
cursive, physical, and psychic requirements.

 The significance of a psychoanalytical conceptualization of the body for the visual
arts is its fundamental basis in vision, which can be easily applied to cultural processes
of art production, artist and subject identification, and viewership. As I shall discuss
in detail below, two critical psychoanalytical theories of identity, from Freud and Lacan,
are fundamentally dependent on the power of vision to activate the formation of bod-
ily identity. Psychoanalysis describes the body's materialization as a function of the gaze,
its projection of an image that is taken as the body of the self, which is inseparable
from its visual scrutiny and differentiation of Other bodies. The limits and content

of the self are determined only through the visual process, which differentiates Other bodies. Difference is the measure of separation between self and Other, but it is always based on the assumed normality of the self. Although differentiation within psychoanalysis has traditionally indicated the process of signifying sexual difference, it is precisely the privileging of sexuality and the disavowal of race that provide the opportunity to harness and redirect this theory back on itself in order to examine its colonial logic and to question the universalizing assumption of the white body alongside that of the male. As Griselda Pollock has argued:

> But, if difference is not just to be a replication of phallocentric ideologies of *the* difference—based on a reified heterosexual opposition Man versus Woman—it must acknowledge the divisions within the collectivity of women that produce real, antagonistic conflicts shaped by modernity's imperialist and racist face.[26]

Foucault posited the gaze as a mechanism of power that is eventually interiorized, with individuals ultimately exercising surveillance over and against themselves, self-policing their hegemonic identifications.[27] This Foucauldian notion of the gaze and its power drives to the heart of colonialism, revealing the regulation of identity that is both social and psychic. It locates the process of normalization wherein bodies take up assigned identifications and, through their performance, work to entrench them as "natural." This is the process through which the symbolic meanings assigned to biological markings are accorded an essential status in the Lacanian symbolic. We must then understand race and the racing of the body as a process of signification confirmed within the symbolic and the limits of race and racial signification as indexes of power, knowledge, desire, and anxiety.

The field of visual culture is dependent on the proper function of the gaze within the processes of representation, exhibition, and consumption. Further, the process of representation is not limited to the material or aesthetic level in the cultural creation of an art object or the physical performance of the self, but also occurs in the physical confrontation between the body of the viewer and the object of visual consumption in the moments of reading, interpretation, and narration. This point shall become abundantly clear when I discuss some nineteenth-century female neoclassical sculptors and the limits and possibilities of their sex, gender, and race identifications in chapter 1. Although they were active, successful, independent professionals (or perhaps *because* they were) working within the international Roman art colony, other male artists and patrons refused to *see* them as such. The gaze is implicated not just in the body of the artist but in the body of the viewer and in the subjects of art as well. The cultural term of representation for art making is not merely a means of reproducing in visual language a body that is already always locked into a particular network of identifications. Rather, representation is a visual process that must be confronted as a part of the body's materialization, a cultural field wherein the process of differentiation takes place, signification occurs, and symbolic identifications are assigned and maintained.

The Usefulness of Psychoanalysis

As I mentioned above, psychoanalysis has provided two significant theories for the understanding of the materialization of the body and its specific identifications. For Freud and Lacan both, the primary concern of bodily identification was sexual, and the organizing principle of sexual difference was the phallus. The exclusivity of such male-centered theory is unavoidable. However, the usefulness of psychoanalysis to feminism stems from this very sexual exclusion. As Pollock has argued:

> Even though Freudian psychoanalysis ultimately privileges the place of the Father, seeing all cultural stories as modelled on masculine Oedipal anxieties, and, as here, making the Father/Hero central to his analysis of art history, it theoretically offers a way to expose the desires and fantasies which have so far made it inconceivable to imagine women in the canon.[28]

Although Lacan repeatedly denied the phallus as either an imaginary effect or the penis itself, the phallus, as a privileged signifier, is secured only through its symbolization of the penis, which it is not. Thus, as Butler has stated, "The phallus *symbolizes* the penis; and insofar as it symbolizes the penis, retains the penis as that which it symbolizes; it *is* not the penis."[29] The phallus is the term through which the disavowal of the female body and the representation of its sexual lack become possible. But it is also the term through which fetishization occurs, since the usefulness of the fetish is precisely its ability to "replace" the phallic absence of female sexual lack and placate the troubled male psyche, which has witnessed the disordered female body, the female "wound"/vagina, as the sign of female castration. The phallus is not the male genital organ but an ambivalent and transferable symbolic term in the relations of sexual power.[30] If, as the phallocentrism of the Freudian Oedipal moment implies, the threat of the "castrated" female body is that it indicates the potential for the same in the male, then a postcolonial rereading of Freud's idealized body poses blackness as the inevitable threat of the racialized Other body. But if, as Pollock contends, it is the very nature of the sex–gender exclusion embedded in psychoanalytical thought that holds the possibility for liberating rereadings, should not a similar potential exist in terms of its embedded race–color exclusions? Jean Walton has argued:

> Psychoanalysis has, in other words, been from its inception an explicit and obvious terrain for exploring and critiquing sexual and gendered difference. It has been both a tool for and obstacle to political intervention in gender and sexual oppression. In contrast, until the work of Frantz Fanon in the 1950's, and, more recently, of other theorists in the last decade, psychoanalysis was not seriously considered a likely arena for the exploration and critique of racialized constructions of subjectivity.[31]

Thus, in the same way that Pollock exposes the route for seeing women in the canon, I might add to that the potential for the black producer/subject.

Lacan used the mirror stage to conceptualize the transition of the body from the imaginary to the symbolic, in which the body takes on a discrete identity that individuates it from the maternal body.[32] Within the Oedipus complex and the mirror stage, the activating force is always traumatic, a trauma triggered by the fear of lack, the result of which is the disavowal of the female body. In both cases we are dealing with a drive toward the completion of a fictive "whole" body that has been organized through a phallic logic. In both cases the body's materialization is a process of imaginary and affected loss and psychic and material manipulation and projection toward an ever illusive completion. As Parveen Adams has argued, "The urge to 'wholeness,' far from demonstrating the lack of a lack, demonstrates the defence against a lack."[33] The body emerges through the movements between selective exclusions and inclusions, avowals and disavowals. The body is the product of fetishization.

The Freudian response to the confrontation of sexual difference, located as female genital lack, is anxiety. The phallocentrism of Freudian psychoanalysis cannot permit the possibility of a sexual difference from the male body that is not constituted as sexual lack. According to Charles Bernheimer, "The traumatic perception that the fetishist disavows is not what Freud calls 'the unwelcome fact' *[die unliebsame Tatsache]* of women's castration, but the unwelcome fact of sexual difference."[34] Castration is not, as Freud would have it, the "natural" state of female sexual lack but, rather, the fetish that seeks to disavow female sexual difference and displace it as Other. The fetish marks the site of psychic struggle, which, manifested on the body of the Other, is a recognition of the failure of the imagined singularity and integrity of the body that produced/projected it. It is a declaration of authority through singularity that rests on the confrontation with and disavowal of plurality and heterogeneity. In this sense the fetishization of the Other body is always the narcissistic representation of the "self" and the impossible desire for wholeness.

The process of identification is itself a process of differentiation wherein the selfness and otherness of bodies are constituted and object relations can be established. Since the reference point for the image of the Other body is the image of the body of the self, the process of bodily materialization is inherently narcissistic. But the ability to project an image of the body and have it be confirmed, outside of oneself, bespeaks a social mobility, authority, and power that have historically been relatable to specific sex, class, and race positions. So to Judith Butler's observation of the body's constitution through a specifically male narcissism, I would add that this narcissism has also had a class specificity that is bourgeois and a racial specificity that is white.[35] To acknowledge the inherent phallocentrism and colonialism of bodily identification is to recognize that not all bodies, not all people, have the same opportunity or power to generate and register the self as the point from which differentiation begins. To understand this is to understand that the marginalization of a subject disrupts the subject's ability to think its body outside the organizing structure that effected the marginalization in the first place. Hegemonic systems produce a marginalization that in turn effectively disrupts one's ability to counteract the system.

Lacan's mirror stage likewise explains the process of identity formation as the experience of anxiety and loss in which "idealized totality" is attained through a disavowal of the material body, a disavowal that compels the assumption of the phallus. As Judith Butler has explained:

> If to be in pieces is to be without control, then the body before the mirror is without the phallus, symbolically castrated; and by gaining specularized control through the ego constituted in the mirror, that body "assumes" or "comes to have" the phallus.[36]

These theories of Freud and Lacan sought to explain the body's process of becoming as both material and psychic and to demonstrate the instability of identification and individuation. But they are as much maps of the materialization of the body as they are demonstrations of control that seek the sexual ideal of the social body. A postcolonial confrontation with the psychoanalytic conceptualization of the body also reveals the colonial assumption of specific race–color identity, which privileges whiteness as it disavows and fetishizes blackness. The ambivalent and transferable character of the phallus is also evident in the symbolic category of whiteness. The prolific idea of the fixity and transparency of racial identifications is a result of the process of the body's materialization within a colonial discursive and psychic framework that insists on the materialization of racialized bodies with definitive and distinct signs of racial identification. Just as the phallus has been the organizing principle of sexual difference, whiteness and its signs have been the organizing principle of racial difference. In both cases, the difference of the Other body (the perception of sexual or racial lack) must be disavowed, and disavowal leads to fetishization and the search for an illusory totality. Fetishization is not simply something that is done to the body; it is a process that participates in the very materialization of the body. It is not merely a regulation of the body. It is, as Parveen Adams has noted, the *regulation of difference*.[37]

The primacy of vision is imbedded within the Oedipus complex and the mirror stage. The anxiety that elicits disavowal is activated by the accessibility and physical proximity that allow for visual scrutiny of the body, whether it be of the self or an Other body. It is the male subject's viewing of the female's genitalia that produces the anxiety around castration. Proximity and visual access activate danger and produce the need for regulatory control of the threatening body. The colonial term *miscegenation*, discussed at length in chapter 5, locates the threat of the black body through a proximity to and sexual contact with the white body and the possibility of reproduction, signified in the colonial terms for interracial offspring—*mulatto, quadroon, octoroon,* and so forth—which acutely and obsessively registered white anxiety at the prospect of interracial contact. This anxiety surrounding white–black sexual relations was evident in the western human science theories of polygenism, which disavowed the possibility of the racially hybrid body by defining the black body as a separate species that would be fundamentally, in a biological sense, incapable of procreation with the white race. As Judith Butler has demonstrated, the body is not merely a material manifestation

that is witnessed through a specific psychic orientation. Rather, it is a manifestation of psychic and material tensions that are inseparable from language.

Black feminist and postcolonial readings of Freudian and Lacanian psychoanalysis allow us to think critically about the processes and spaces wherein the body *becomes*, where it is individuated and identified with its symbolic positions: sex, gender, class, race, color, and so on. Race is *of* the body but not essential to it. Race is assigned to the body when biological marks are given symbolic meaning within language through the process of differentiation from other marks. The black female body is a complex site where the symbolic marks of blackness and femaleness have resulted in multiple and simultaneous marginalizations. Psychoanalysis is helpful in understanding the body as an imaginary formation whose position within the symbolic order is dependent on its submission to language that marks the body with signs of sex, gender, and race, among other things. Furthermore, it is useful precisely because of its phallocentrism and colonialism, *because* it is itself an anxious site of the production of sexual and racial difference.

The racial fetishization of the black female body is the fear-based process that actively regulates the race–color difference of the black body. But the simultaneity of the blackness and femaleness in the black female body occasions types of fetishization that do not necessarily align themselves easily with the fetishization of the white female or the black male body. Fetishization, proceeding from the desire for a bodily integrity that is synonymous with a phallic presence, acts on the body and exists both in the process and completion of its materialization. Since the moment of fetishization remembers the anxiety of loss or fear of difference, it is possible to trace the path of regulation back to the source of anxiety and the site of disavowal and to reclaim, in some measure, the historically and socially specific structure that occasioned the regulation of the body in the first instance.

It is my goal to examine how the convergence of femaleness and blackness determined and was determined by forms of fetishization that are specific to the representation of the black female body in visual culture. Within the visual arts, to speak of fetishization implicates psychic, material, and social processes that can address both the aesthetic regulation of the body in representation and the prohibitions placed on the bodies of artists, subjects, viewers, and patrons. The process and limits of fetishization reflect the perceptions and anxieties of the bodies who can assume the positions of authority, the authority being secured through the power of the gaze and the ability to represent, and thereby regulate the difference that fetishization most fears. It is fetishization and the anxieties that trigger it that determine the sexualization and racialization of a body.

Aesthetics and Material Specificity: Representing Blackness

The historical representation of blackness as a racial type must be examined within the context of two overarching and interconnected concerns: (1) the broader historical

western preoccupation with color symbolism and (2) the signification of whiteness as the paradigmatic racial position. The manifestation of neoclassical sculpture's very specific and limited material and aesthetic parameters has profound implications for nineteenth-century ideals of race and racial preference. Neoclassicism's fealty to white marble replicated in the visual arts the broader colonial desire to regulate and control the bodies of black subjects by symbolically aligning blackness with social, moral, and spiritual contamination. But for this to be achieved, whiteness had to be defined as a noncolor, the symbolic paradigm, which in its purity had to be protected from the possible incursion of color. This fear of color, according to David Batchelor, is nothing less than a chromophobia, which has inflicted many elements of western society for centuries:

> It is, I believe, no exaggeration to say that, in the West, since Antiquity, Color has been systematically marginalized, reviled, diminished and degraded. Generations of philosophers, artists, art historians and cultural theorists of one stripe or another have kept this prejudice alive, warm, fed and groomed. As with all prejudices, its manifest form, its loathing, masks a fear: a fear of contamination and corruption by something that is unknown or appears unknowable. This loathing of Color, this fear of corruption through Color, needs a name: chromophobia.[38]

An exploration of the manners in which blackness was signified and the black body was represented, materially and aesthetically, is particularly important to this project. Blackness is not today, and was not in the nineteenth century, a unitary category. Its meanings, identifications, and legibility shifted, were produced, represented, aligned, and harnessed in various, often competing and contradictory, ways depending on the variables of location, politics, culture, and power. Again, what may at first appear an obvious racial category, blackness, was actually a complex network of aesthetic, social, and psychic significations. Various methods of representing blackness and black female bodies, their distinctiveness, interconnectedness, deployment, and consumption shall be explored throughout in detail. The ways of representing blackness were as various as the reasons for which blackness was represented. In thinking through the representation of blackness I have had to grapple with the distinct modes of material signification that were specific to particular styles of art. While some artists such as Charles Cordier, practicing polychromy, employed different-colored media to convey the specificity of skin color (for example, the blackness of black skin), others such as William Wetmore Story and the expatriate American neoclassicists registered race at the level of physiognomy and anatomy, doggedly representing black women in white marble. While some artists surrounded their black female subjects with generally inauthentic, exotic, African props or, adhering to ideals of racial essentialism, deployed an even more illusory black countenance or expressiveness, others concentrated on the representation of the black body. But even when these choices were made, the process of signification was not simple. A major question of concern still remained: How black

should a body be? Again, I speak of race not solely as color, since the level of blackness, the proximity of a body to a so-called full-blooded Negro type, directly and profoundly implicated the possibilities and impossibilities of a body within colonial societies. These modes of signification shall be explored in detail as they intersect with the subject and themes that were used to narrate black female subjectivity. And in each case any retrieval of the original racial signification of the represented body will necessitate a historical analysis of textual and visual evidence.

Why Sculpture?

Why focus on sculpture? As the discussion of the specific artistic practices of the Roman expatriate colony will attest, nineteenth-century neoclassical sculpture was an expensive and many times monumental tradition that often intersected with overtly political rituals of commemoration within the public sphere. It is in part the public nature of sculpture as "high" art that resulted in its investment in the bourgeois ordering of the body, which was both patriarchal and colonial. Sculpture constitutes, perhaps more than other forms of visual art, a racialized aesthetic and material practice. Within the colonial discourses of eighteenth- and nineteenth-century science, sculpture was intimately connected to the production of race as a biological category of human difference. Kirk Savage has charted the significance of sculpture in the scientific racialization of the body.

> Sculpture helped effect this transformation of the human body and was in turn transformed by it. Sculpture's relation to the human body had always been more direct and intimate than painting's: the sculptor's main task was not to create illusions on flat surface but to reproduce three-dimensional bodies in real space. Sculptors could even create exact molds of the human face and body in plaster, which gave their art a unique scientific and documentary power that lasted even after the advent of photography.[39]

As a powerful representational tool of the human sciences, sculpture has been deeply invested in the racial differencing of bodies. The material and aesthetic processes of sculpture and their investment in the notion of the ideal body were inherently well suited to the colonial practices of the human sciences, providing concrete representational validation of stereotypes of racial difference.[40] This point is evidenced in the very collections of "bodies" that many human scientists have personally amassed or accessed through private patrons or institutions. By *bodies,* I mean not just the aesthetically and ethnographically sculpted representations of the body mediated by a racialized gaze activated by distance but also the life and death masks produced from direct impressions of the biological body as well as the preservation of human remains, particularly skulls.

The specific focus on nineteenth-century neoclassicism reveals a color bias at the level of medium that underpinned an ideal racialized body. The nineteenth-century's

stylistic dependence on classical sculpture, broadly termed neoclassicism, located the privileging of the white body as the aesthetic paradigm of beauty. Quite simply, the term *classical* is not neutral. It does not refer merely to examples of Greek and Roman antiquities. Rather, *classical* is a colonial term that privileged a white racial corporeal ideal; as Savage has noted, "Broadly speaking, classical sculpture still served as the benchmark of the sculptural and thereby defined what was not sculpture—most fundamentally, the body of the 'Negro,' the black antithesis of classical whiteness."[41]

However, the inclusion of the black subject in the exclusive canon of western sculpture was not, in itself, enough to erase the racial marginalization of the black body. While Kirk Savage has argued that "simply to represent black slaves in sculpture was in a sense to emancipate them,"[42] I would counter that the specificities of aesthetic and material practice, as well as the artistic choices of theme and subject, the evocation of imaginary contexts, the manipulation of composition, pose, and expression, in short the narration of the black body, allowed artists to continue to represent black people as racially Other within the canonical field of neoclassical sculpture. Not just the field of sculpture but the practice of western art in general was colonial; a shift in the race of the subject did not constitute a change in the underlying ideology.

The signification of race in nineteenth-century sculpture was further complexified by exhibition practices. Many of the works discussed were displayed at international exhibitions that simultaneously exhibited agricultural produce, industrial and scientific objects, popular cultural items, "high" art, and human beings as paradigmatic of the natural, economic, intellectual, popular, cultural, and physical products of particular regions, nations, empires, and races. The history of the nineteenth-century racialization of the black body in sculpture parallels the objectification of human beings as exhibitable "scientific" objects, which legitimized the colonial signification of race within western human sciences. Within this colonial western cultural space, the status of the black body was that of object/property, the same status held within systems of transatlantic slavery. However, the objectification of black bodies that resulted in traditions of live exhibition worked to secure the rejection of black bodies from ideal subject positions within high art, which was governed by aesthetic paradigms of whiteness. If the nineteenth-century aesthetic paradigm of beauty was that of the white body, the question becomes, how or in what forms were black female bodies allowed to enter the field of sculpture?

The issue of producing or reproducing black bodies is a particularly compelling one for the visual arts, in which representations take on a materiality that seeks to replicate the appearance and, in the case of sculpture, the volume and corporeality of the living subject within communal space. There is the very real consideration of sculptural possession by whites as a psychic and social stand-in and reiteration of the real-life possession of slaves. In the nineteenth century, during which the western notion of "high" and "low" art forms was particularly entrenched, sculpture emerged for many as the most revered form of art, often praised above painting as the most truthful aesthetic expression. Traditional painting is an intrinsically two-dimensional art form that

can deploy a three-dimensional space only through perspectival technology, whereas sculpture can assume a three-dimensional form and volume within the viewers' space. Sculpture is distinguished from painting in medium and form, sculptors having historically deployed various media (e.g., marble, bronze, gilt, polychrome, stone, wood, wax) that have, as we shall see, distinct and historically specific ideological meanings and aesthetic limits.

Sculpture that is three-dimensional provides a viewing experience that differs significantly from that of two-dimensional works of art. Sculpture in-the-round elicits a different sensorial experience between the viewing body and the art object, for the audience is allowed to become a part, if only in an imaginary sense, of the produced or implied contextual environment of the sculpture. The narration that supports and legitimizes the subject can also encompass and position the viewer as an actor in the subject's world. The importance of this point shall become clear in the discussion of Hiram Powers's *Greek Slave* and Erastus Dow Palmer's *White Captive* in chapter 4. The viewer can become a part of the sculptural context; and the sculpture, a part of the viewer's space. My discussion of Hiram Powers's *Greek Slave* (c. 1843) locates the profound significance of a sculpture's real and imaginary contexts to the audience's interpretation of a work of art. This interaction between sculpture and viewer, especially when the sculpture represents a human form, is life-sized, and utilizes materials to elicit a hyperrealistic impression (e.g., polychrome, chryselephantine sculpture), can even activate a level of fantasy that contributes to the viewer's reading of a real human body. The legibility of the sculpture is often determined by the proximity of the viewing experience (the space between the viewer and the sculpture), which is aided by the ability of the viewer to circulate around and through the sculptural object.

Space and the Art Object

Henri Lefebvre has cautioned us against any uncritical use of the term *space*. I use the term mainly with regard to the physical context into which an art object is inserted or consumed or both. In terms of the colonial context of production, an understanding of the space into which these art objects were deployed and how they functioned within the cultural world of the nineteenth century became critically important. According to David Chaney:

> Space in abstract is infinite, it needs to be broken up or structured in some way to become meaningful. Space is therefore defined by the form of its organisation—the categories of organisation are necessarily human interventions that underlie formal distinctions.[43]

How does a space inform an art object, and how does an art object inform a space? How does a space position, order, or organize the consumption of an art object, and how does the art object order, organize, or discipline the space? B. Werlen has stated, "Space

is neither an object frame nor an a priori, but a frame of reference for actions."[44] In this light, could one not argue also for the conception of space as a frame of reference for objects, a frame of reference that not only helps to produce meaning but also is itself infused with meanings by the objects it holds? Space is unfixed, malleable, and shifting. Space can be infused with all manner of political and ideological meaning. For my purposes, I will question the function, symbolization, and performance of blackness within art objects in particular spaces of cultural consumption. Of specific importance will be the space of the artist's studio as a site of cultural exchange within the bourgeois traditions of the grand tour discussed in chapter 2 and the space of Rome itself as a site of memory and replication for the international expatriate cultural colony discussed in chapter 1. In particular I will touch on the differences in cultural consumption and viewership that existed in democratized touring public exhibitions of single objects such as Hiram Powers's *Greek Slave* (chapter 4), the private or semi-private viewing of works such as William Story's *Cleopatra* (chapter 6) in Roman studios, and the grand, official spaces of international exhibitions where Edmonia Lewis displayed her *Death of Cleopatra* (chapter 7).

In terms of the reading of the artworks, I of course acknowledge my separation from the original historical moments of production, but in our endeavor to understand and to reclaim (to whatever extent possible) that initial moment of production, it is important to recognize that artworks are produced and inserted into a space of expectation.[45] That is, art enters the world and is consumed within a structure that predates it, a structure within which the potential audience is educated in how to consume and view the art object "properly," how to read and narrate the work, and how to extract its meanings. The idea of knowledgeable and educated viewing is particularly acute within nineteenth-century art, in which the classical canon and its constant references to mythology, Christianity, and literature were widely understood by the art-viewing elite, the practice of cultural tourism was deeply entrenched, celebrated, and supported by an extensive literary discourse, and narratives of viewing that encoded a moral intention were often preproduced and marketed to potential viewers by astute artists.

Race and Power

A discussion of modes of representation and of the significations of these modes is at the heart of this inquiry. In the Foucauldian sense I am examining the intersection of visual discourse and colonial discourse, or rather visual discourse as colonial discourse, in terms of its "modes of existence."[46] As I have already discussed, the production of race in nineteenth-century sculpture was both *on* and *outside* the body. But it was this combination of race *on* the body and race *outside* the body that combined to evoke what is perhaps the most critical facet of colonial stereotypes: the ideal of race *within* the body. Race *within* the body points to the colonial ideal of racial differences as being manifest in intrinsic ways that affected all aspects of human behavior and social

formation and were largely thought to be beyond transcendence. Moral, intellectual, and psychological capacities inhabited this internalized racial makeup within the body.

Here it seems appropriate to restate Foucault's view that knowledge and power imply each other, and furthermore that knowledge is activated by the power to turn bodies into *objects of knowledge*.[47] If colonialism is the power structure in question, I refer to the statement of Aimé Césaire, which, predating Foucault, concluded plainly that "colonization = 'thing-ification.'"[48] These very similar theoretical explanations of power and knowledge seem particularly appropriate for the practice of visual artists that culminates in the production of the material object/thing. The artistic process, then, can be described as the production of knowledge by an artist, this type of knowledge manifesting in the physical form of a concrete, material presence, which for nineteenth-century neoclassicists was most often a body.

Butler's concept of the ritualized repetition of norms as a mechanism for the construction of an ideal is useful for an understanding of how race–color is *practiced* into being. The ideal is produced through the normative nature that is acquired through historical depth, the accumulation of layers of meaning over time, which eventually lose their sense of being *produced,* because the origin and originating logic is lost and sometimes irrecoverable. This performativity, as Butler names it, is precisely the reiterative power of discourse to produce the phenomenon that it regulates and constrains. Performativity, though, is also identifiable by its ability to conceal the conventions of which it is a repetition.[49] Butler warns us, however, that performativity is not free but operational within constraints:

> Rather, constraint calls to be rethought as the very condition for performativity. Performativity is neither free play nor theatrical self-representation; nor can it be simply equated with performance. Moreover, constraint is not necessarily that which sets a limit to performativity; constraint is, rather, that which impels and sustains performativity.[50]

I shall apply this notion of performativity not only to the Foucauldian author-function but to the subject-function as well.

Homi K. Bhabha also acknowledges, like Butler (in her concept of performativity), the importance of the act of repetition in colonial power. He has described the ambivalence of western colonial authority as a significant function of discriminatory power structures. According to Bhabha:

> It is the force of ambivalence that gives the colonial stereotype its currency: ensures its repeatability in changing historical and discursive conjunctures; informs its strategies of individuation and marginalization; produces that effect of probabilistic truth and predictability which, for the stereotype, must always be in *excess* of what can be empirically proved or logically construed.[51]

Theory is useful to an analysis of race, not as intellectual play, but as a tool by which the powerful colonial category can be understood and dismantled. As I have tried to

demonstrate by drawing dominantly from discourse analysis and psychoanalysis, the theorization of race has benefited from multiple approaches and considerations that can tackle it as a category that impacts all spheres of human existence and experience: the material, the social, the psychic. I have not relied solely on one theoretical body of thought to inform this project, because one would not do. Rather, I have tried to draw from several useful methodological practices that together can address the complexity of racial identification and experience and their specific implications for visual art while also necessitating the acknowledgment of the generative power of culture. As Michael D. Harris has argued, "Racial discourses, though they are discourses of power, ultimately rely on the visual in the sense that the visible body must be used by those in power to represent nonvisual realities that differentiate insiders from outsiders."[52] I am naming visual culture as a form of colonial discourse that has actively produced and deployed ideals of race, racialized bodies, and racial stereotypes. Neoclassical sculpture represents a particularly elite and influential form of visual culture at this historical juncture. And as will be discussed, it is precisely colonialism that was being articulated and even celebrated within many of the sculptures under examination.

PART I
ARTISTS, ENVIRONS, AESTHETICS

1. Dismembering the Flock
Difference and the "Lady-Artists"

Why Rome?

By the mid-nineteenth century, the Roman colony of which William Wetmore Story, Mary Edmonia Lewis, and many other talented sculptors were to become a part was dominantly Anglo-American and attracted throngs of cultural practitioners and cultural tourists. For the neoclassicists, Rome provided a concentrated access to the examples of Greek and Roman antiques from which their own sculptural forms were inspired, as well as revered collections of art from various historical periods and national origins. For sculptors and painters alike, the accepted process of artistic education entailed the common practice of honing one's skills by copying these revered original works. Although Florence was more convenient to the quarries at Carrara and Seravezza, Rome provided a plentiful, if less immediate and more expensive, access to the sculptors' material of choice.[1] Rome also offered cheap and skilled manual labor; established European sculptors, who acted as mentors and instructors;[2] a ready artistic, cultural, and intellectual community; and access to patronage through the rituals of cultural tourism. Rome was often the final and most popular destination of the cycle of European travel during the mid- to late nineteenth century. American tourists generally sailed to England, often docking at Liverpool, and visited London before moving on to the Continent, where trips to Germany, Switzerland, and France often culminated in Italy. Florence, Milan, Venice, and Naples were other popular Italian destinations.[3]

Story and Lewis became neoclassical sculptors at a time when cultural consensus dictated a period of study in Italy.[4] Although a significant number of sculptors had established themselves in Florence early in the century, Rome was the more common destination, in part for its more cosmopolitan community, which featured artists, writers, socialites, nobility, musicians, and celebrities. Romare Bearden and Harry Henderson have described the Roman colony thus:

Figure 1. Portrait of William Wetmore Story, c. 1870. Photograph. Charles Scribner's Sons Art Reference Department records, c. 1865–1957, Archives of American Art, Smithsonian Institution, Washington, D.C.

Figure 2. Henry Rocher, portrait of Edmonia Lewis, c. 1870. Photograph (albumen silver print on paper). National Portrait Gallery, Smithsonian Institution, Washington, D.C.

Rome was the center of a fashionable international society that included many wealthy Europeans, English nobility, famous writers like the Brownings, and artists. Prominent American writers such as Nathaniel Hawthorne, Henry Wadsworth Longfellow, and Harriet Beecher Stowe, as well as artists like Randolph Rogers and Thomas Buchanan Read, made prolonged visits. "Entertaining" titled socialites, celebrities, cardinals, artists, and writers and climbing the status ladder preoccupied nearly everyone in the palazzi and villas of the international set. These status-seekers and their visiting friends were the artists' main patrons.[5]

Writing in 1884 from Rome, Eugene L. Didier described the guests at a "literary and artistic reception" at the Virginia artist Mr. Ezekiel's studio as a diverse international set that included poets, musicians, priests, and professors from Britain, Italy, Greece, France, Spain, and America.[6] In 1858, Nathaniel Hawthorne observed the absence of Romans among the revelers of a winter carnival, noting, "The balconies along the Corso were entirely taken by English and Americans, or other foreigners."[7] Yet earlier, the American tourist Samuel Young Jr. described his experience of dining in Rome: "I am surrounded by them every day at dinner, most of the Americans having the opposite end of the table. I wish to see and hear the *foreigners* at this time."[8] Thus, the Rome of many of these expatriate Americans seemed conspicuously free of Romans.

Being a Woman (Sculptor) in Rome

For artists, Rome was an obvious choice. For sculptors even more so. The popularity of Rome for artists was confirmed by Hawthorne's rather cynical observation: "Though the artists care little about one another's works, yet they keep each other warm by the presence of so many of them."[9] But what of that category of cultural producers that Henry Wreford dubbed "lady-artists"?[10] The mythic nature of Rome as a haven for white female artists was initiated in the nineteenth century by Madame de Staël's novel *Corinne, or Italy* (1807) and confirmed in Elizabeth Barrett Browning's *Aurora Leigh* (1857). Writing to Wayman Crow in August 1852 with an awareness of her impending departure for Rome, Harriet Hosmer captured its romantic viability for artists:

You have already enjoyed what is before me, your heart and mind have been filled with beauty and a sense of infinity by the glories of nature and art, but I feel that I am on the eve of a new life, that the earth will look larger, the sky brighter, and the world in general more grand. . . . I take it there is inspiration in the very atmosphere of Italy, and that there, one intuitively becomes artistic in thought.[11]

While these fictional texts offered the possibility of an imaginary identification of a white woman artist beyond the phallic signification of male artists and the possibility of alternative significations of the female/feminine body, no such imaginary possibility of the black–Native female artist predated Edmonia Lewis. Nancy Proctor has described the Roman experience for American women sculptors as

less as a "flight" from a sexist United States to an Italian feminist commune, than a sacrifice of the security, support and acceptance that these emerging women sculptors enjoyed within their circle of friends at home, for the harsh realities of a competitive professional ambience in Rome.[12]

Proctor's pioneering work has brought many important aspects of this colony's work to light. Nonetheless, her account neglects the overwhelming evidence of the possibilities that Rome provided, albeit to a limited extent, for alternative significations of the white female body that ruptured and displaced normative ideals of bourgeois gender, sex, and sexuality. The energetic pursuit of professional recognition, unchaperoned social mobility, rigorous physical activity, independent maintenance of living environment, financial independence, and the overwhelming rejection of heterosexual marriage and open lesbianism that these women lived were simply not possible to the same degree in mid-nineteenth-century America.

For the white female sculptors, Rome offered a reprieve from the more rigid practice of bourgeois ideals of sex and gender within American culture, which placed hindrances on female physical activity, social mobility, and vision in ways that effectively prohibited the professional pursuit of the cultural knowledge necessary to produce the most exalted and canonized forms of art. It was in recognition of the relative social freedom of the Roman colony that Harriet Hosmer wrote, "I wouldn't live anywhere else but in Rome, if you would give me the Gates of Paradise and all of the Apostles thrown in. I can learn more and do more here, in one year, than I could in America in ten."[13]

However, for Lewis, as for other people of color, the experience of travel was marked by sharp racial marginalization. While for many bourgeois whites, travel was a means to reinforce or elevate social and cultural status, for blacks, enslaved or free, it often symbolized a search for racial equality and demarcated rapid and dramatic shifts in identification. Whereas many nineteenth-century black American travelers to Europe experienced what the fugitive slave William Wells Brown described in *The Travels of William Wells Brown* (1855) as a liberation from the oppressive American identifications of blackness, Lewis's experience, which transitioned rapidly from traveler to resident, may not have afforded a sustained sense of such liberation.[14] For Lewis, while Rome could also have represented an opportunity to transcend the social, material, and psychic limitations of her racial–color identity in America, the exceedingly small, exclusive, and competitive white bourgeois and aristocratic expatriate community in Rome and the whiteness and maleness of her chosen profession served also to exacerbate Lewis's racial identifications and visibility because of the lack of alternative communities and the compounding nature of class, race, and the barriers of culture and language.

Writing just a few short months after Lewis had departed by steamship for the Continent, the white female social reformer and abolitionist Lydia Maria Child—often cited as a friend, mentor, and patron to Edmonia Lewis—surmised the racial difficulties that lay ahead for Lewis in Rome: "I hope the artists in general will be able to

divest themselves of American prejudice as to give Edmonia a fair chance to make for herself such a position as she may prove herself entitled to."[15] Rome would have had no measurable Native American communities at the time, and the few blacks present would have been mainly slaves or employees serving white households. Additionally, many members of the Roman colony were affluent white Americans who imagined blackness through the colonial logic of their own slaveholding and racially segregated country.

Although it does not appear that Story and Lewis were friends, they were surely aware of each other, since they moved within some of the same social circles within the small Roman colony, Story, of course, more freely than Lewis because of his identity as a white male from an affluent family. Edmonia Lewis sailed for Europe in August 1865 and arrived in Rome early in 1866. This seems to be substantiated by the writer Henry Wreford, who, writing from Rome in March 1866, reported that Lewis had made considerable progress with her sculpture, given that she had been in the city for only two months.[16] Apparently, Lewis first visited London, Paris, and Florence before settling in Rome in the winter of 1865–66.[17] Lewis's passport application from the month she set sail is a revealing document that offers glimpses into her life. The ambitious sculptor, bound for Rome, listed her date and place of birth as 4 July 1844 in Greenbush, New York, making her a mere twenty-one years of age at the time of her voyage.[18] The application, completed by Jonathan Amory, a notary public for the County of Suffolk, had space for an extensive physiognomical and physical description. Lewis's responses record a petite woman whose racial identification was visually read as black within the context of nineteenth-century America and Europe (Figure 3):

> Residence, Boston; Age, 20; Stature, 4 feet; Forehead, High; Eyes, Black; Nose, Small; Mouth, Medium; Chin, Small; Hair, Black; Complexion, Black; Face, Oval.[19]

We can add to this, however cautiously, one of the firsthand descriptions of Lewis's appearance that many a white patron or critic attempted. From Lewis's supporter and patron Laura Curtis Bullard:

> Edmonia Lewis is below the medium height, her complexion and features betray her African origin; her hair is more of the Indian type, black, straight and abundant. She wears a red cap in her studio which is very picturesque and effective; her face is a bright, intelligent and expressive one. Her manners are childlike, simple, and most winning and pleasing. She has the proud spirit of her Indian ancestors, and . . . more of the African in her personal appearance, she has more of the Indian in her character.[20]

Story's knowledge of Lewis was confirmed in his acknowledgment of Miss Cushman and her "little satellites."[21] Whereas Story's label conjures the image of a network of insignificant objects connected to and circulating about a central focal point, these little satellites were in actuality individual professional American women sculptors,

259

21933. Recd. Aug...

Residence,	Boston
Age,	20
Stature,	4 feet
Forehead,	High
Eyes,	Black
Nose,	Small
Mouth,	Medium
Chin,	Small
Hair,	Black
Complexion,	Black
Face,	Oval

Passport — to be sent to George F. Baker New York —

I, M. Edmonia Lewis of Boston in the State of Mass do solemnly swear that I am a Native and Loyal Citizen of the United States of America, and about to travel abroad, That I was born in Amherst, New York on or about the 4th day of July 1844

M. Edmonia Lewis

I, M. P. Kennard of Boston in the State of Mass. do solemnly swear that M. Edmonia Lewis now present, is personally known to me, and that to the best of my knowledge and belief the foregoing Declaration, made and signed by him in my presence, is true.

M. P. Kennard

Commonwealth of Massachusetts.

SUFFOLK, SS.
BOSTON.

On this Twenty first day of August A. D. Eighteen Hundred and Sixty five personally appeared before me, JONATHAN AMORY, a Notary Public for the County of Suffolk, duly appointed and sworn, M. P. Kennard and M. Edmonia Lewis and severally solemnly swore to the truth of the foregoing Declarations, by them subscribed, according to the best of their knowledge and belief.

In Testimony Whereof, I have hereunto set my hand, and affixed my Seal of Office, the day and year above written.

Jonathan Amory
Notary Public

I, M. Edmonia Lewis do solemnly swear that I will support, protect, and defend the Constitution and Government of the United States against all enemies, whether domestic or foreign; and that I will bear true faith, allegiance, and loyalty to the same, any ordinance, resolution, or law of any State convention or legislature to the contrary notwithstanding; and, further, that I do this with a full determination, pledge, and purpose, without any mental reservation or evasion whatsoever; and, further, that I will well and faithfully perform all the duties which may be required of me by law: So help me God.

M. Edmonia Lewis

Sworn to and subscribed before me, this Twenty first day of August A. D. one thousand eight hundred and sixty five

Jonathan Amory
Justice of the Peace
Not. publ.

Figure 3. Passport application for Edmonia Lewis, 21 August 1865. National Archives and Records Administration, National Archives, United States.

some loosely associated with the internationally renowned American actress Charlotte Cushman (1816–76) (Figure 4), who provided, by example, a model of a successful, independent, professional woman. Cushman had adopted the role of mentor to many of the younger women, chaperoning them on the long sea voyage to Rome, encouraging them to pursue their art professionally often in the face of familial discouragement and patriarchal social barriers, assisting them in obtaining studio space and instruction, securing patronage, and even boarding them in her large apartments at 38 Via Gregoriana.[22]

The condescending label of the "white, marmorean flock" was affixed to the group by the novelist Henry James, Story's biographer, who described the women's relationships as a "strange sisterhood."[23] The members of the flock were considered to be Sarah Clampitt Fisher Ames (1817–1901), Margaret Foley (1827–77), Florence Freeman (1836–76), Harriet "Hattie" Goodhue Hosmer (1830–1908), Lavinia "Vinnie" Ream Hoxie (1847–1914), Louisa Lander (1826–1923), Mary Edmonia Lewis (exact life span unknown: 1843–45 to after 1911), Blanche Nevin (1838–1925), Emma Stebbins (1815–82), and Anne Whitney (1821–1915) (Figure 5). Nancy Proctor also names Elisabeth Ney.[24] Meanwhile Henry Wreford in Rome, referring, it would appear, to the same general group of "lady-artists in Rome," described them as a constellation of twelve stars and mentioned the following: Mrs. Freeman of England, Miss Freeman (a relative of the aforementioned) of America, Miss Foley, Miss Hosmer, Miss Edmonia Lewis, Miss Jane Morgan, Miss Stebbins, Mrs. Cholmelay, Miss Lloyd, Miss Latilla (the English niece of Mrs. Freeman), the Misses Williams, Miss Farrell of England, and Miss Kabalyne of Russia.[25]

Henry James's labels indexed the limits of the female sculptor in the nineteenth century, his use of quotation marks around the term *lady sculptors* indicating their sex–gender difference as the source of his discomfort and objection to their presence in the colony and public visibility as professional artists.[26] Yet, sexuality was certainly implicated here too, since several of the women were involved in open lesbian relationships.[27] The threat of professional and successful female artists was twofold: first, it challenged the traditional patriarchal expectation of an unquestioned female desire for marriage, domesticity, and motherhood; and second, it offered the possibility of professional and intimate relationships that required neither male authority nor male sexuality. In his nineteenth-century novel *The Marble Faun,* based on his experience of the Roman colony and its artists, the American Nathaniel Hawthorne revealed the obstacles to a male narcissism in his dialogue between the lovesick sculptor Kenyon and the practical Miriam in their conversation about the painter Hilda:

"It is a mistaken idea which men generally entertain, that Nature has made women especially prone to throw their whole being into what is technically called Love. We have, to say the least, no more necessity for it than yourselves;—only, we have nothing else to do with our hearts. When women have other objects in life, they are not apt to fall in love. I can think of many women, distinguished in art, literature and science—and multitudes whose hearts and minds find good employment, in less

Figure 4. Portrait of Charlotte Cushman (seated) and Emma Stebbins, c. 1859. Photograph. Harvard Theatre Collection, Houghton Library, Harvard University, Cambridge, Massachusetts.

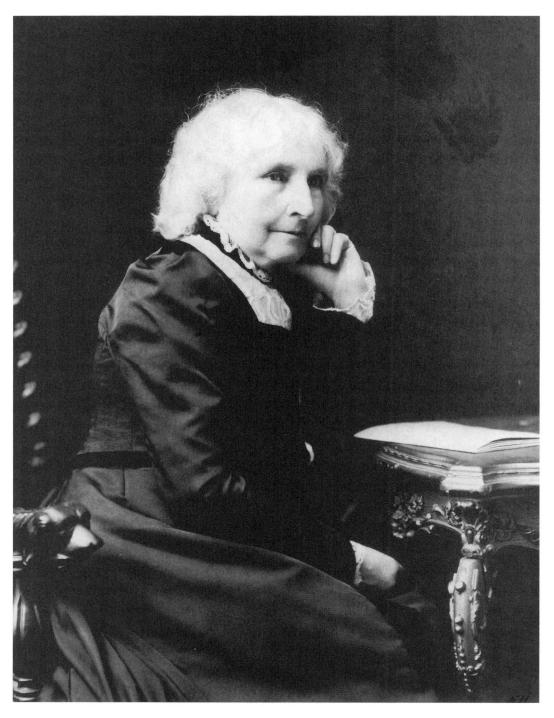

Figure 5. Portrait of Anne Whitney (no date). Photograph. Reproduced from the Collections of the Library of Congress, Washington, D.C.

ostentatious ways—who lead high, lonely lives, and are conscious of no sacrifice, so far as your sex is concerned."

"And Hilda will be one of these!" said Kenyon sadly.—"The thought makes me shiver for myself—and—and for her too!"[28]

In the final analysis, the only way for Kenyon to win his distant and art-devoted Hilda and thereby fulfill his desire to become the singular object of her attention and devotion is through her failure as an artist. As Miriam adds, "Perhaps she may sprain the delicate wrist which you have sculptured to such perfection. In that case you may hope! These Old Masters to whom she has vowed herself, and whom her slender hand and woman's heart serve so faithfully, are your only rivals."[29]

As Griselda Pollock argued in *Differencing the Canon,* "Structurally, the discourse of phallocentric art history relied upon the category of a negated femininity in order to secure the supremacy of masculinity within the sphere of creativity."[30] Contrary to the group identity that Story's and James's naming implied, the easy assumption of facile comradery and unconditional friendships among these women sculptors and their female patrons and supporters was more likely problematic, which I will demonstrate. Although Lewis was very much like her female contemporaries in her professional ambitions and cultural desires, she was also unquestionably and remarkably different from them in her racial identifications and subjectivity, which had profound and far-reaching implications for her artistic production.

These cross-racial, cross-cultural, and cross-class relationships, with all of their complex intersections, demand further scrutiny. Although patrons and mentors such as Lydia Maria Child and a fellow artist such as Anne Whitney may have expressed pain and regret about doing so, they diminished, belittled, or chastised Lewis, often relying on commonly held black or Native stereotypes, in letters written directly to the sculptor or to other acquaintances or family.[31] In particular Lydia Maria Child spent much ink writing about Edmonia Lewis—her ambitions, actions, movements, decisions, characteristics, and sculptures—in letters to her circle of mainly white, bourgeois, abolitionist friends. But much of what she wrote demands careful exploration to unravel how complex relationships were constituted and maintained across definite racial identities and social lines; her words also have much to reveal to us about the patronage, production, and criticism practices of neoclassical sculpture and the networks (financial, social, and cultural) that sustained the sculptors.

Nineteenth-century sisterhood had its limits, some of which were decidedly racial. Significantly, the uncomplicated and romanticized idea of an artistic and cultural sisterhood that transcended difference is something perpetuated by twentieth-century white feminist art historians. I am guided by Pollock's call for a "demystifying analysis" grounded in her desire to question what she has termed "the mythologies of the woman artists Western feminism has been fabricating."[32] These mythologies have been decidedly colonial in their capacity to refuse any discussion of the significance of race–color in the lives of women. Thus, it has largely been white feminisms' refusal to discuss

the intersectionality of race–color with sex–gender and its implications for class, sexuality, and other areas of identity that has led to the entrenchment of a universalized category of Woman and a discursive practice that has perpetuated the silence around coloniality. What is necessary here is a demystifying consideration of the impact of the nineteenth-century complex of race, gender, sex, sexuality, and class differences that mediated the relationships of these women artists, their membership in the colony, and their success as sculptors.

In her Ph.D. dissertation, "American Women Sculptors in Rome in the Mid-Nineteenth-Century: Feminist and Psychoanalytic Readings of a Displaced Canon," an important feminist intervention within art history, Nancy Proctor has noted the power of naming in Henry James's deployment of the term *white, marmorean flock* as a disavowal of the professionalism, productivity, and success of these American women sculptors through the label that erased the women's independence and individuality as artists, instead imposing the idea of a group identity and mentality and a shared historical/temporal experience.[33] As Proctor has written:

> Stone birds can't fly. Rather, they are "dropped" by history, however "good-naturedly," and presumably fall heavily from their dizzying heights. The impossibility of a "marmorean flock" flying to settle anywhere indexes the impossibility, for James and the art historical discourse he represents, of a woman being a sculptor.[34]

Proctor has aptly noted that Hawthorne's description predates James's in the use of bird imagery and marble symbolism to describe and delimit the productive body of the female artist in Rome. In *The Marble Faun,* Hawthorne described the female painter Hilda as birdlike and had her suitor, the male sculptor Kenyon, represent her hand in marble. Hilda's artistic ability is questionable. Unlike her male counterpart, Kenyon, she is only a painter, not a sculptor, the most revered form of art at the time, and she is only a copyist of "great masters," not a creator of original objects. Kenyon's representation of Hilda's hand, which he "stole" (representing it without her knowledge), is small, white, frozen, inactive, and objectified, betraying his desire to arrest her artistic activity and indexing the incompatibility of female professional activity and the state of nineteenth-century heterosexual marriage.

The term *white,* amplified by the term *marmorean,* which, as I will demonstrate further below, within the nineteenth-century neoclassical canon carried the implication of whiteness as a privileged racial signifier, also foreclosed the possibility of racial diversity among these women, summarily eclipsing Lewis's presence as a productive and professional member of the Roman colony at this time. This disavowal of the possibility of a black–Native female artist—Edmonia Lewis—is the same anxious erasure, containment, and regulation—fetishization—of the black (female) body evident in the neoclassical sculpture of the same period. However, the specific deployment of marble to signify living, breathing women also served to mortify their active bodies, as the

use of the bird allegory served to minimize their cultural contributions by evoking ineptitude, frailty, and whimsy, qualities certainly in opposition to the focus, determination, and physical stamina that professional cultural engagement in this art form entailed. The words of sculptor Kenyon about the object of his affection, the painter Hilda, in Hawthorne's *Marble Faun* make this point: "Hilda does not dwell in our mortal atmosphere; and, gentle and soft as she appears, it will be as difficult to win her heart, as to entice down a white bird from its sunny freedom in the sky."[35]

Racing the Artist: Edmonia Lewis in Rome

A postcolonial and black feminist awareness of the specificity of race and the racialization of the body as significant to a person's identification and subjectivity within the Lacanian symbolic prohibits one from an unwitting replication of the racial disavowals of a phallocentric psychoanalysis, which has privileged sexual difference above all other forms of bodily identifications. An endemic problem of white feminist analysis is that it has historically tended to assert the primacy of gender and sex as the inaugural identifications of the body, an assumption that implies the possibility of a body that exists outside a racialized position in the symbolic while instituting a hierarchy of identification. Whereas sex–gender is indexed as a contested signification, the privilege of whiteness within a colonial theorization of the body (in psychoanalysis or other domains) is so secure that it is not "visible" to many white feminists as something that needs to be named and similarly contested as a site of marginalization and privilege. The very silence that leaves the race of the body unnamed is the process through which the privilege of whiteness is secured.

Whiteness, through white feminisms, becomes an invisible signification, much the same as the symbolic deployment of whiteness in neoclassicism. Normalized and unquestioned, it undermines the possibility of a subject position that is not primarily and exclusively governed by gender and sex. It is this privileging of whiteness that refutes the possibility of blackness as anything but an absence, negativity, or deficiency of the normative position of the white body. This inability to think outside the dominant logic of the white body reveals the regulatory power of the symbolic, wherein alternative identifications are disavowed or literally rendered invisible, unable to be seen or recognized within the hegemony of symbolic signification. The remedy to this theoretical and pragmatic blind spot is an analysis capable of examining *any-body's* race—Hiram Powers's (Figure 6), William Wetmore Story's, and Harriet Hosmer's whiteness—in much the same way as we have become accustomed to expecting an examination of Edmonia Lewis's blackness-Nativeness.

The impossibility of the white *female* sculptor for Harriet Hosmer, Emma Stebbins, Anne Whitney, and others was multiplied for Lewis by the impossibility of the *black-Native* and female sculptor. Some contemporary writers noted this point. One such author wrote of Lewis in the *New National Era:*

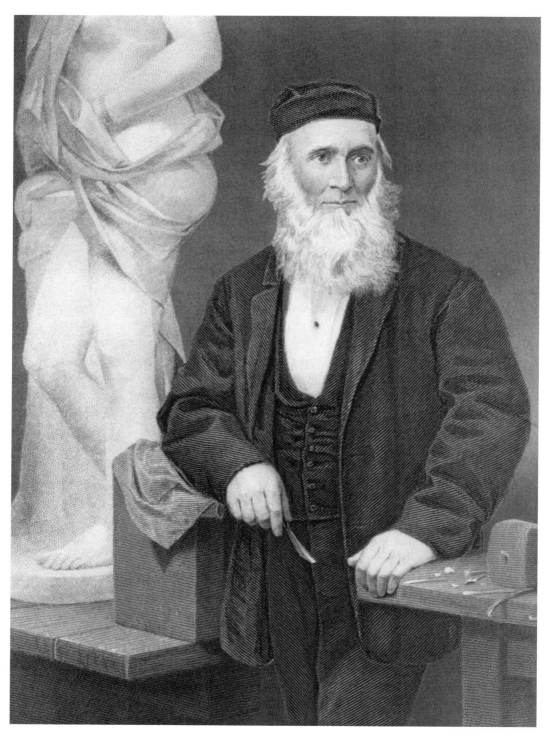

Figure 6. Alonzo Chappel, portrait of Hiram Powers, c. 1874. Engraving. Reproduced from the Collections of the Library of Congress, Washington, D.C.

The world has advanced in the route of progress; but it has not yet reached that point to which we hope a few more centuries will bring it—when a woman can enter upon any vocation, whether literary, artistic, mercantile, or mechanical, with the same freedom as a man, and find no greater obstacles in the way of her success than her brother has to encounter. . . . In her struggle to reach the goal of independence, she finds herself heavily-weighted by her sex, and if, in addition to that burden, she has to bear also, like Edmonia Lewis, the prejudices felt against color and race, she needs a vast amount of enthusiasm and courage to venture into the field at all.[36]

Although, fighting against the art historical desire to unify these women, Proctor, when she insists that the "flock" had no common class, race, or nationality, merely reinforces the nineteenth-century invisibility of Lewis's black–Native body when she fails to note Lewis's obvious racial difference from all of the other women artists, her sharp displacement and marginalization from the normative category of the white artist, and, connectedly, her class difference.[37] For these women sculptors, and even more so for Lewis, we can read an actual symbolic failure in the inability of languages and discourses of nineteenth-century western culture to represent the productive body of a female artist and the inability of other subjects in the space to "see" them as such. Again vision in this sense not only signals a physical bodily act but also implicates the identity, location, desire, and power of the viewer.

Lewis was recognized as one of the flock, but in comparison with her white female contemporaries, the invisibility, visibility, or hypervisibility of her black–Native body within the Roman colony further complexified her experiences as a female sculptor, since her racial identity challenged the "regime of race" as it transgressed the entrenched western ideal of the white artist.[38] Significantly, Lewis's early experience with racism and racist violence at Oberlin College would have made her acutely conscious of the barriers and potential hazards of relationships with so-called liberal whites. In the town known for its liberal attitudes, Lewis attended the racially integrated and coeducational Oberlin College with approximately thirty other black students. In the winter of 1862, accused of poisoning two fellow female classmates, Lewis was savagely stripped and beaten by a white mob and left for dead. Although exonerated with the help of the black lawyer John Mercer Langston, she was later accused of stealing art supplies and effectively barred from graduating.[39]

Lewis was, from a very early stage in her career, keenly aware of the "false praise" she received, generated by sympathy for what many whites saw as her racial inferiority.[40] On inviting Lydia Maria Child to her room to see some of her works, the twenty-year-old sculptor reputedly proclaimed, "I don't want you to go to praise me. Some praise me because I am a colored girl, and I don't want that kind of praise. I had rather you would point out my defects, for that will teach me something."[41] It would appear that as far as Child was concerned, Lewis got her wish (for the most part) in spades. In a letter to a friend, Child recounted being rebuked by another acquaintance for her "critical mood" as concerned her comments about one of Lewis's sculptures. Her response

to the friend, who, according to Child, thought the work praiseworthy because Lewis was a "colored girl," revealed Child's determination to avoid bestowing undeserved praise solely on the basis of race.

> "I should praise a really *good* work all the more gladly because it was done by a col-ored artist; but to my mind, *Art* is sacred, as well as *Philanthropy;* and I do not think it either wise or kind to encourage a girl, merely because she is colored, to spoil good marble by making it into poor statues."[42]

The sculptor Anne Whitney seems to have held a similar opinion about the dangers of Lewis's race for her art and patronage. Writing to her sister Sarah in the winter of 1869, Whitney painted the image of Lewis as a stubborn, strong-willed, yet overly sensitive character:

> She made last year a statue life-sized which she called *Hagar*—had I thought it pos-sible to counsel her I should have been thankful to save her from the peril—color—indulgence and it must be said the dreadful ignorance of a large class of buying have led her on—but there is a limit somewhere to such things and now it seems she has involved poor ——. But this is also marked Private. Poor creation—what will she do if this work gives out.[43]

Clearly Whitney surmised Lewis's limited success to be the product of her racial iden-tification and her ability to win the patronage of "friends of the black race," rather than the product of her talent, dedication, and perseverance.

Although from the point of their initial meeting, Child is often unproblemati-cally cited as one of Lewis's greatest supporters, by her own testimony, Child from the very outset doubted the younger woman's abilities and withheld strategic support or, as some might argue, even placed barriers in her path. In a letter to Sarah Blake Sturgis Shaw (and her husband, Francis George), she related:

> With regard to Edmonia Lewis, I partly agree with you, and partly I do not. I do not think she has any genius, but I think she has a good deal of imitative talent, which, combined with her indomitable perseverance, I have hoped might make her some-thing above mediocrity, if she took *time* enough. But she does *not* take time. . . . I think it is a pity that she has undertaken to be a sculptor; and when she first told me of her design, I tried hard to dissuade her from it.[44]

And more harshly still:

> I agree with you that, looked at in the light of *Art,* nothing she has produced is worth a second glance; but I am more disposed than *you* seem to be to give her time for a fair trial. If she will only take time![45]

To her credit, Child wrote of having modified her opinion of Lewis after seeing her bust of *Voltaire*.[46]

Unlike Child's view, Anne Whitney's opinions about Lewis's talents seemed to improve drastically over time. In a letter to her sister she related:

> I went this ——— to Edmonia Lewis' studio when I think I have not been since the 1st year at least to look about and I must confess I was not only surprised but greatly pleased at the progress she has made. . . . She is working in her own way up and certainly her performances are much more creditable.[47]

Meanwhile, Child's doubts and the constant grudging and belittling opinions of Lewis's abilities persisted throughout their relationship. Child's underestimation of Lewis's talents smacks of Hawthorne's own gender biases, embedded within his character of Hilda, the artist who likewise had no genius of her own. From the first, Child developed the habit of severely underestimating Lewis, her talent, and her ability to develop as an artist, not as a copyist, but as a professional and a creator of original works. At times Child's disapproval was expressed not through what she did or said but through what she withheld. Early in their relationship after Lewis had sculpted the martyred Bostonian Robert Gould Shaw (the son of Francis and Sarah Shaw), Child related her encounter with Lewis in her home:

> I bought one of the busts of Robert; and, wishing to make it look more military, I sawed off a large portion of the long, awkward-looking chest, and set the head on the pedestal again, in a way that made it look much more erect and alert. When she saw it, she did not seem displeased, but said, "Why didn't you tell me of that, before I finished it? How much you improved it!"[48]

"Before I finished it" indicates that Child had accessed the work in progress in Lewis's Boston studio at 89 Studio Building, Tremont Street; Mrs. Chapman was also present.[49] Clearly Child had a knowledge of art, specifically sculpture and issues of composition, that she chose not to relate to Lewis. But this exchange also contradicts Whitney's assessment and shows Lewis as an artist who wanted to learn and who was open to criticism.

Lewis and Child, each in her own way, were keenly aware of the extent to which dominantly white bourgeois audiences wished to frame Lewis's success through the benevolence of their abolitionist philanthropy and, concomitantly, to define her not as a sculptor but as a "colored sculptor" (deleting or downplaying her Native heritage unless otherwise useful) and exploit her successes. One key example of this attitude was the conflicting accounts of which white abolitionist, if any, facilitated Lewis's introduction to the Boston sculptor Edward Brackett—an event that purportedly marked the start of Lewis's "formal" training in sculpture.[50] The desire of whites to be seen as conspicuous supporters of Lewis was, however, something that Child felt Lewis fully

exploited, whether for financial support or for press. After completing one of her *Hagar* sculptures in Rome, which she would later exhibit in Chicago in 1870,[51] Child told others that Lewis had sent her a photograph of the work and added, "with a request that I write my opinions of it." Disliking the work, she declined "in the kindest manner" she could, instead cautioning Lewis "not to be in such a hurry to do large works."[52] Child wrote of Lewis, "She literally takes *no* thought about money, and because she has been very generously aided, she draws upon the *friends of her race,* as if their sympathy was an inexhaustible Bank entirely at her disposal" (italics mine).[53] However, this type of blatant self-promotion was certainly normal and something of which Lewis's contemporaries were also taking full advantage. As one author put it, "Few sculptors have risen among us who have not found liberal and appreciative patronage, while several whose ability is somewhat questionable are luxuriating in Rome and Florence at the expense of undiscriminating patrons."[54]

Arguably, both women may have overestimated the desire of abolitionists and philanthropists to support Lewis's budding career. In an early letter from Rome dated 3 May 1868 to a patron named Mrs. Maria Weston Chapman, Lewis beseeched the woman to send word of the state of her ideal work *Forever Free,* which she had previously shipped back to America. On this rare occasion we have Lewis in her own words expressing her dire need of assistance and detailing the vacuum of support: "It seems almost I was going to say impossible that not one of my many kind friends have not writen *[sic]* to me some word about the group Forever free. Will you be so kind as to let me know what has become of it?"[55] Even though Lewis's race–color made her the recipient of some philanthropic, often abolitionist, assistance throughout her career, such support seemed spotty or unreliable at times; her race–color also implicated a class position that excluded her from complete and legitimate membership in the colony.

Navigating Class in the Colony

The class immobilization of black subjects was expressed in popular nineteenth-century prints that disparaged "polite" society's tastes, fashions, and affairs of honor by representing blacks engaged in the rituals of white bourgeois culture.[56] Prints such as Edward William Clay's *Philadelphia Fashions* (1837) (Figure 7) and *Life in Philadelphia, How You Like de Waltz, Mr. Lorenzo?* (1829) presented black bodies to point up the pretensions involved in the corporeal masquerade of white bourgeois culture. But they also secured whiteness as the means to the right to aspire to an elite class status through the slippage created by their black subjects, whose language, mannerisms, and postures mimicked, but could never completely duplicate, white "refinement."

Class obstacles to Lewis's artistic status were obvious. On the simplest level, marble was not a cheap material to acquire; housing, studio, and other living expenses needed to be paid for; the artisans that were a necessity to any effective sculptor's studio (although rumored at this time to be conspicuously absent from Lewis's) needed to be paid; and the freight costs of shipping finished pieces across the Atlantic to American

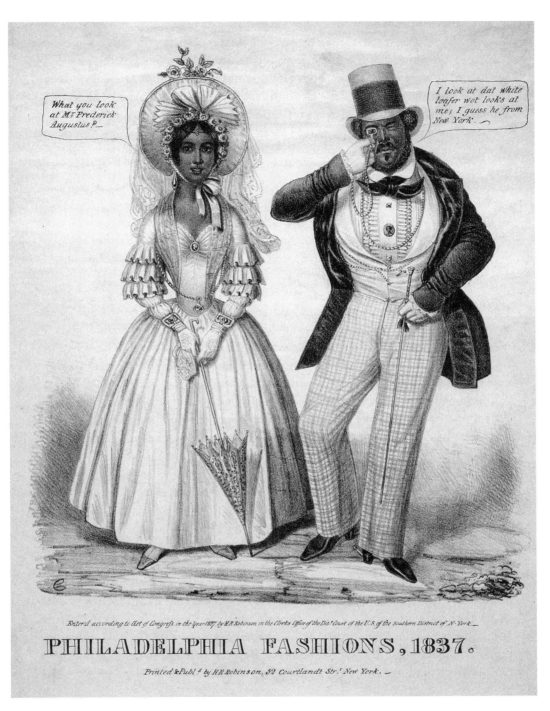

Figure 7. E. W. Clay, *Philadelphia Fashions,* 1837. Lithograph published by H. R. Robinson, New York. The Library Company of Philadelphia, Philadelphia, Pennsylvania.

patrons were considerable. Lydia Maria Child recounted having advised Lewis to be more financially prudent, warning her against the expense of marble sculptural production.[57] It appears that Lewis, orphaned in childhood, with the only unquestionably close remaining family a brother, who remained in the United States, seemed by this point in her career to have been almost completely without familial economic resources. Whitney mentioned Lewis's brother as "having helped her a great deal" but related also that she thought Lewis's expenditures were large.[58]

Child's comments in a letter of 1868 about Lewis, by then in Rome, are compelling in what they reveal about the sculptor's class identity:

> I have no doubt Edmonia was very poor at the time she wrote. She would take music lessons, and hire horses, while her money lasted, and then be surprised and distressed to find herself without funds. It is absolutely necessary for her to do *something* for a living, and devote only a *portion* of her time to perfecting herself as a sculptor; which it will take years of patient labor for her to do. I have always told her that, from the outset.[59]

Perhaps most interestingly, Child's mention of music lessons and hiring horses seems to indicate Lewis's determination to equip herself with the cultural education and outward symbols befitting her newfound profession and the social circles that it implied. Riding horses and playing musical instruments were certainly the types of pastimes that Lewis's wealthy white contemporaries would have been raised on.

Although Lewis was established in the colony and selling her works regularly by the early 1870s,[60] her early years in Rome appear to have been hard ones financially. A letter written by Anne Whitney went into significant detail about Lewis's business affairs:

> Poor Edmonia. I don't know how she will come out on top of her bitter quarrel with Encole. Comes the story Mr. Pick—— told us (2 evenings since) of another Ch—mley an Eng. (Catholic) banker—and whom his wife she has always looked upon as her best friends—it seems she is under indebtedness to Ch—— which she cannot meet and he has threatened to confiscate the contents of her studio.[61]

Even Child conceded that Lewis's "hurry to get up to a conspicuous place" was not a product of "self-conceit" but one "of the necessity of making things to sell, in order to pay for her daily bread."[62] The concerns that Lewis expresses in a letter to a patron, Mrs. Chapman from Rome, reveal an awareness of her finances but also, and important, her knowledge of the gossipy nature of the educated and upper-class social circles on which her career would depend. Referring to her work *Forever Free,* she wrote:

> I am in great need of money what little money I had I put all in that work with my heart and I truly hope that the work of two long years has not been lost. dear Mrs. Chapman I been thinking that it may be that you have meat with some who think

that it will ruin me to help me—but you may tell them that in giving a little some-thing towards that group—that will not only aid me but will show their good feeling for one who has given all for poor humanity.[63]

It is very likely that at least one of the "some" to whom Lewis referred was Lydia Maria Child, who documented having visited Lewis's Boston studio with Chapman while Lewis was sculpting Shaw's bust.[64] Lewis's letter is also revelatory on a number of other significant levels: first, it demonstrates her command of social graces in attempting to win over Mrs. Chapman, not only as a potential donor and patron herself, but also as an ally in the recruitment of others; and second, Lewis shrewdly and perhaps justifiably cast herself also in the role of humanitarian toiling selflessly for social justice. But Lewis's class, race, and cultural identifications combined in a nexus to deny her privileged access to the innermost social spheres and intricate normative practices of nineteenth-century "high" art and cultured society. Thus, although patrons like Child openly lamented Lewis's social indiscretions in their letters, such indiscretions were to Child "very excusable in one so inexperienced and so entirely unacquainted with the customs of society."[65] Lewis's cultural exclusion also extended to many critical aspects of art education to which her white colleagues, male and female, had a less impeded access.

The centrality of representations of the human form to neoclassical sculpture necessitated the knowledge of the human body usually garnered through the study of anatomy. As one contemporaneous author put it, "Few medical men are so capable of pronouncing upon certain points and shades of anatomical precision so surely as a deeply accomplished sculptor."[66] While white male sculptors openly accessed anatomi-cal training through medical and arts institutions, nineteenth-century academic insti-tutions often excluded female students because of the pervasive belief that the female sex did not possess the intellectual or moral fortitude to study from the nude or the cadaver. The harsh moralizing comments of sculptor Thomas Crawford about his con-temporary Harriet Hosmer demonstrate how the mid-nineteenth-century bourgeois identifications of sex and gender, foreclosing any legitimate female knowledge of the body, effectively worked to disqualify women from productive visual–cultural engage-ment. According to Crawford:

> Miss Hosmer's want of modesty is enough to disgust a dog. She has had casts for the *entire* model made and exhibited them in a shocking indecent manner to all the young artists who called upon her. This is going it rather strong.[67] (italics mine)

Such exclusions were only heightened when female artists represented the male body.[68] Male judges, administering a national competition for the commission of a memorial sculpture of the Northern senator and ardent abolitionist Charles Sumner, stripped Anne Whitney of her first-place award when they discovered the anonymous entrant to be a woman. Their main concern was to avoid the indelicate associations of a woman knowledgeable of the male body, particularly the modeling of a man's legs.[69]

But whereas white female sculptors like Harriet Hosmer and Anne Whitney were often able to use class privilege to circumvent sexist institutional exclusion by arranging professional private tutoring from within the social sphere of their familial contacts, Lewis appears to have launched her career without comparable anatomical instruction.[70] It remains to be seen whether Lewis's lack of anatomical training was the result of difficulties in securing a tutor or a decision not to pursue such studies. Regardless, her institutional options would have been far fewer than those of her white male or female colleagues. This gap in her tutelage became visible in material shortcomings detected in her representations of human bodies. Child's description of fault with Lewis's *Freedmen's Group* isolates her inability to secure proper anatomical training as a problem that became visible in her early sculptures. Commenting on Elizabeth Peabody's published description of the piece in the *Christian Register*, which stated "every muscle is swelling with emotion," Child quipped, "Now the fact is, the figure *had* no muscles *to* swell. The limbs were like sausages."[71] It is within this context that Child appears to have repeatedly urged Lewis "not to be in such a hurry to do *large* works, depending on subscriptions to pay for the marble."[72] Child presumed that Lewis was offended by her unsolicited advice, since she did not hear from her for a period of time thereafter.[73]

After beginning to model in 1849, Harriet Hosmer, realizing her ignorance of human anatomy, sought instruction. Although no medical school in Boston would admit female students, through the influence of Mr. Wayman Crow, the father of her classmate Cornelia Crow, Hosmer received private instruction from Dr. J. N. McDowell, the head of the Missouri Medical College (now Washington University School of Medicine), in St. Louis.[74] Although denied access to the official lectures, Hosmer earned a diploma by studying privately with Professor McDowell, who revisited his daily lectures with her and allowed her to examine the specimens used in his lectures. Anne Whitney was also able to arrange for the private study of anatomy with a doctor at a hospital in Brooklyn, working mainly from the skeleton. Whitney also studied privately for two years during the Civil War, under the sculptor Dr. William Rimmer, a man known for his knowledge of human anatomy. During this time she was able to represent bone and muscle tissue.

Among the wealthier classes, economic freedom was also apparently taken as a sign of dedication to one's art and to moral as opposed to financial gain. Writing to his long-time friend James Russell Lowell in 1864, William Story condemned the majority of his fellow American artists, whom he characterized as participating in the "money-making trade" in order to "make their living."[75] Story's position exemplifies Pierre Bourdieu's definition of cultural capital, which "can only be acquired by means of a sort of withdrawal from economic necessity."[76] Story's ability to snub those artists who needed to sell to survive was of course a product of his not having to do so. Racialized class identifications were pivotal in obtaining and maintaining a sense of belonging within the elite Roman colony. By class identification I do not mean merely the state of material wealth or financial independence but, rather, the right to aspire to and work toward such a status. Many first- and second-generation American sculptors alike

came from a modest farming background (Powers, Ives, Clevenger, Brown, Brackett, MacDonald, Rinehart, Simmons) or a working-class background (Ball, Rimmer), yet the symbolic privilege of their maleness and whiteness facilitated their financial and sculptural achievements and their movement, membership, and acceptance within bourgeois and aristocratic society. What Child interpreted as Lewis's rush to work in marble must be read within the context of her need to support herself financially with the sale of her sculptures as opposed to what was often assumed to be the outcome of her bravado, arrogance, ignorance, or impatience. Within this context, Child's attempts at offering Lewis guidance, however well-intentioned, seem at times unnecessarily harsh.

> There is at present a *little* coolness between us. I want her to earn her *living* by moulding small decorations for architects, copying small statuettes, and reserving a third of her time, or more if she can, for the study of anatomy, of general literature, and careful working in clay on larger subjects, until she attains sufficient merit to have her works *ordered* without extra *efforts* being made in their behalf. But she does not like my advice. She insists upon making large groups, and depending on contributions to pay for the marble, and effect the sale.[77]

Being a Black–Native Woman (Sculptor) in Rome

While we must be wary of discussing Edmonia Lewis solely in terms of her race and the sensitivity of her sculptural themes to racial issues as uncritical and outside the traditional aesthetic, stylistic concerns of art history, we need also to question the historical validity or legitimacy of such traditional concerns in the discipline. Additionally, we must acknowledge the overarching investment of neoclassical sculpture throughout the nineteenth century in the racialization of the human body. The question is, then, not whether Lewis's racial identification should be considered when her art is analyzed, but why the racial identifications of her white contemporaries are regularly overlooked when their art is analyzed. Lewis's artistic status, her presence as a member of the Roman cultural colony, and her participation within the racial limits of nineteenth-century neoclassical practice must be assessed in light of the prolific and deliberate racial segregation of nineteenth-century European and American society. The white (bourgeois) fear of proximity to the black body meant that social contact between black and white populations was controlled through the material and symbolic regulation of the body in public and private space, partly through the enforcement of racial segregation and partly through the legislation of cross-racial relationships, which effectively prohibited or undermined the formation of intimate relationships based on an equality of social status and interaction.

Although Kirk Savage has stated that Lewis was "the only sculptor of identified African American descent working in this period,"[78] at least one other black sculptor from this period was visible within the expatriate cultural communities in Italy, an interracial man named Eugene Warburg. Warburg was a freeborn black born to a

German-Jewish father named Warburg and a Cuban "mulatto" mother named Marie Rose Blondeau (originally owned by Warburg) in New Orleans in 1825. Warburg had his early artistic training in that city with Phillippe Gabrielle before traveling to Europe in 1852, where he studied in France for four years. Although Lewis traveled to the American South with her black friend Adeline (Addie) T. Howard to teach freed slaves in Richmond, Virginia, it is highly unlikely that she would have met Warburg at that time, and there is no evidence that she went to New Orleans.[79] Warburg died in 1859, five or six years before Lewis was to reach Rome, and so it would appear that the two sculptors did not have an opportunity to meet, although Lewis certainly may have known of Warburg.[80] Another black artist who was an active contemporary of Lewis was Robert Scott Duncanson (1821?–72), claimed by both Canada and America, who became the first landscape painter of African descent to gain international acclaim. Duncanson made several trips to Europe between 1842 and 1871, with a visit to Italy in 1853–54.[81] Although Duncanson did not become a member of any Italian colony and his trip to Italy predated Lewis's own move by over a decade, the artists may have met during Lewis's initial stop in England and visit to London. A further potential connection between the two was the American actress Charlotte Cushman, who had apparently aided Duncanson during a European trip in 1853 and who would later help to welcome and establish Lewis in 1865.[82]

Nevertheless, it is hard to overstate the visual incongruity of the black–Native female body, let alone that identity in a sculptor, within the Roman colony. As the first black–Native sculptor of either sex to achieve international recognition within a western sculptural tradition, Lewis was a symbolic and social anomaly within a dominantly white bourgeois and aristocratic community, whose prior experience with black subjects would have overwhelmingly been limited to inequitable contact across class boundaries, contacts that were rife with racialized power imbalances. The comments of the nineteenth-century collector and museum benefactor William Hayes Ackland speak volumes about the kinds of abuse that the confluence of Lewis's racial and sexual identity provoked. Of meeting Lewis at an exhibition in Philadelphia, he wrote, "I was standing near a statue of Cleopatra by Edmonia Lewis, the negress sculptress who looked like a southern cook . . . as she dusted off her marble figure. I asked her what she thought of Mozier. 'Quite a competent sculptor and did some creditable work,' was her reply."[83] Ackland, even while seeing Lewis in the midst of her competent, active preparation of her own sculpture, still refused, like other whites, to read her as a sculptor. Instead, he relied on colonial stereotypes that evoked the white fantasy of the complacent house servant, the mammy. The profound disconnection that existed between Lewis's representation of her body and Ackland's misidentifications was not a facet of the illegibility of Lewis as a sculptor but, rather, a facet of Ackland's refusal to read and interpret the obvious signs because of his own desire to see an abject black femaleness that could sustain the privilege of his whiteness, that of cook or mammy or maid or some other equally comforting colonial stereotype. It was within this very process of vision that the othering of Lewis's racial and sexual body occurred.

Lewis's racial–color difference from the other members of the colony would on several occasions contribute to tokenizing and paternalistic celebration or to hostile suspicion of her abilities. For example, Lewis's fellow white female sculptor Anne Whitney has often been unproblematically cited as a helpful friend to the considerably younger sculptor.[84] However, Whitney's correspondence with her family and friends indicates conflict, deceit, and condescension in her relationship with Lewis. Describing Lewis in 1864, Whitney wrote:

> Lo! The poor Indian! Edmonia is very much of an aboriginal, grateful, vengeful, a little cunning, and not altogether scrupulous about the truth when dealing with those she doesn't love, open, kind, and liberal as day with those she does. I like her in spite of her faults, and will help her all I can. I wish she were a little less of an aborigine about the ordering of her wigwam.[85]

Shifting between pity for the poor Indian and contempt for the vengeful Indian, Whitney's contradictory descriptions were racial stereotypes and expressed a decided lack of sympathy and insight for Lewis's potential need to deploy strategies of performance and mimicry for the basic purpose of emotional, psychic, and material survival. The supportive facade that Whitney extended to Lewis's face daily in the colony was not the same as that revealed to her inner circle back in America. This is not to contest that Whitney was a reassuring presence in Lewis's life but to note the important point that her support had limits, informed by the normative nature of her own whiteness and colonial ideals of Natives as "primitives." What previous scholars have overlooked or erased is the complexity of nineteenth-century relationships across the limits of racial identifications. Although Anne Whitney's blatant deployment of racist colonial stereotypes to describe Lewis seems at odds with her liberal Unitarian upbringing and concerted opinions about women's equality and abolition, her inability to reconcile the two locates the extent to which Lewis's otherness was a product of a racial and sexual conflation that displaced her from categories of racial and sexual privilege, as well as a product of the difficulties liberal whites had in applying their racial philosophies to their actual interaction with black and Native people in their daily lives.

As I have demonstrated above, another of Lewis's cross-racial relationships worthy of closer scrutiny is that with Lydia Maria Child. Lydia Maria Child was a pivotal figure in Boston antislavery social reform and women's rights circles. Her many archived letters reveal a woman who was well read and opinionated about public affairs and the national and international news of the day, someone who held great regard for dear friends but also was not afraid to share her strong opinions. Child's *An Appeal in Favor of That Class of Americans Called Africans* was published in 1833, and she edited the slave narrative of Harriet Jacobs, entitled *Incidents in the Life of a Slave Girl*. In 1840 she became one of the first female members of the executive board of the American Antislavery Society and served for two years as the editor of the *National Anti-slavery Standard*. She also petitioned the Massachusetts government to repeal antimiscegenation

laws. Although Child's résumé seems at odds with the basest forms of racist exclusion that governed nineteenth-century American society, she was not immune.

Edmonia Lewis met Child, who became a strong if somewhat conditional supporter, in Boston after moving from Oberlin. Child's correspondence of the 1860s is replete with references to the much younger woman (many mentioned above) and details a rather tumultuous relationship. Child was also friends with Lewis's contemporaries, the sculptors Harriet Hosmer and Anne Whitney and the patrons Mrs. Chapman and the Shaws. The personal letters of the prominent social reformer Lydia Maria Child reveal her deep concerns for Lewis and similarly demonstrate the extent to which her support of Lewis was conditioned on Lewis's deference and obedience. In part, Child's constant badgering about Lewis's abuses of established social custom and decorum seems to be a product of her sincere doubts about the extent of Lewis's artistic talents:

> Of course, any attempt to force her, or any one else, above the level of their nature will prove unavailing; but assuredly all obstructions ought to be removed. Considering her antecedents, I think she has done wonderfully well, thus far; and I sympathize, as you do, in her energetic efforts to rise above depressing circumstances.[86]

Whether or not Child expressed all of her doubts about Lewis's talent *to* Lewis directly is unknown. But, as articulated above, she was quick to berate Lewis for any breach of social decorum. Her comment about Lewis's antecedents opens up her ideals of racial difference evidenced in other comments about the ways of Negroes and Indians. Child went further still, commenting specifically on what she thought were Lewis's racial shortcomings:

> And should it not be forgotten that Edmonia is younger than young,—brought up, as she was among Chippewas and negroes without education . . . how *can* she know anything of the delicate properties of refined life? I doubt whether we *can* treat our colored brethren *exactly* as we would if they were white, though it is desirable to do so. But we have kept their minds in a state of infancy, and children *must* be treated with more patience and forbearance than grown people. How can they learn to swim, if they don't dive into the water? They will sprawl about, at first, doubtless, but they will find the use of their limbs by dint of trying.[87]

Has liberal white benevolence ever found so perfect an expression? Much like Whitney, Child, writing to Sarah Shaw (of all people), relied on an abundance of racist stereotypes to excuse what she construed as Lewis's many character flaws. Essentializing the sculptor's black and Native racial traits, she refused the possibility of any civilization or social norms that are not white and western. Although Child could admit to white culpability in the oppression of blacks and Natives, she was unable to dislodge the colonial ideal of an unquestioned white racial and cultural superiority. She not only doubly infantilized Lewis "as younger than young," and the black and Native races in

general, but also primitivized them as peoples without education and beyond the Euro-centric ideals of western social graces and "polite" society. Indians and Negroes, like Lewis, were people who might (even given their best efforts) sink before they swim, but it was the role of good white people like Child and Shaw to encourage them nonetheless.

An acute example of the tumultuousness of the relationship between Child and Lewis—and Lewis's determination to proceed with her career in her own way and time—concerned Lewis's desire to sculpt a portrait bust of the white Civil War hero Colonel Robert Gould Shaw, who had died in battle while leading an all-black battalion. Thinking the task too advanced for the novice sculptor, Child openly discouraged Lewis and deliberately withheld personal documents (unbeknownst to Lewis at the time), including photographs that would have aided Lewis tremendously in sculpting the martyred Bostonian.[88] Specifically on this subject, Child wrote of Lewis to the Shaw family and had a considerable amount to say:

> She has given me a good deal of trouble, first and last; not that she *intended* to be troublesome. I did not want her to make a bust of Col. Shaw. I appreciated the feeling of gratitude and admiration which led her to *wish* to do it, and which prompted her to keep kissing the clay while she worked upon it; but I did not think it would be agreeable to you and Frank to have Robert's bust made by so inexperienced a hand; at least I knew *I* should feel reluctant under similar circumstances.[89]

And earlier:

> When she told me she was going to make a bust of Col. Shaw, I remonstrated against it. I had a feeling about him that made me reluctant to have any prentice-hands tried upon his likeness. I did not send her any suggestions, or any assistance of any kind, hoping she would give it up.[90]

By Child's own admission, her relationship with Lewis was strained after this incident. Nevertheless, Lewis persevered and, working from photographs, sculpted a successful portrait bust, which, sold in plaster copies along with her *John Brown* medallion (c. 1863–64), helped to finance her passage to Europe in 1865.[91] Lewis's success with the Shaw bust and the *John Brown* medallion, which she had shrewdly advertised in the *Liberator*,[92] should also alert us to her keen awareness of how to exploit the cultural tastes of the Boston abolitionist art market.[93]

However, before she sailed, Lewis became privy to Child's betrayal, which must have resonated deeply, given that she was about to become increasingly dependent on the patronage of other "liberal" whites in Child's social circles. As Child described in a letter to Sarah Shaw:

> Edmonia came to see me to say good bye, a few days before she went to Europe; and when she saw the book of photographs which you gave me, containing four likenesses

of Robert, taken at different times, I think she was a little piqued that I had not loaned them to her, while she was making the bust.[94]

Child did at least acknowledge Lewis's success with the work after the fact, however half-heartedly. In a letter to the Shaws, she disagreed with their earlier charge that the work bore no likeness to Robert Gould Shaw (despite the claim of the *Liberator*), instead responding that it was an accurate, however soulless, representation.[95] She elaborated, "After she had done it, it seemed to me to have many obvious defects, and yet, on the whole, it was better than I had expected. It does give the idea of a *gentleman,* I think, likeness or no likeness. I certainly should not be *ashamed* of a son who looked like it."[96] It is intriguing if not curious, given this ongoing and revealing exchange between Child and the Shaws, that they both ended up owning a portrait bust of Shaw sculpted by Lewis, the same work that Child had so contested.[97] How should we interpret the patronage of Lewis by Child and the Shaws, given their considerable documented misgivings about her character and talent? It is a possibility that they deemed the works worthy enough to purchase or felt compelled to own them because of the place of Robert in their lives. But equally plausible is the idea that they were compelled not by the works or by the subject but by their own civic station as liberal-minded white abolitionists who should be *seen,* publicly, to support Lewis's improbable cultural endeavor. The latter possibility is supported by the following published account of the Shaws' encounter with the work, referring to Robert Gould Shaw: "The family of this young hero heard of the bust which the colored girl was making as a labor of love, they came to see it and were delighted with the portrait which she had taken from a few poor photographs."[98] This conclusion is also borne out by Child's own published account, which, contradicting her personal correspondence, gave high and poetic praise to Lewis's Shaw bust: "I thought the likeness extremely good, and the refined face had a firm yet sad expression, as of one going consciously, though willingly to martyrdom, for the rescue of his country and the redemption of a race."[99]

The ongoing conflict between Lewis and Child was well documented in Child's personal letters. With a mixture of exasperation, regret, and superiority, Child described Lewis as "incapable of measuring her own powers" and, referencing a previous "sincere" letter to "poor Edmonia," defined her duty to "check her thoughtless course."[100] Describing Lewis's unconquerable perseverance, Child related her attempts to dissuade Lewis from working in marble for two to four years, feeling she was "in a hurry to play *wear* the laurels before she has *earned* them."[101] Instead she suggested that Lewis earn her living "patiently" by working at the less prestigious forms of stucco-molding for architects, wood carving, and clay sculpture and pursue marble sculpture only in her leisure time over the course of years.[102] Child even took jabs at Lewis's appearance: "Indeed, I never thought her *person* attractive in any way."[103]

For her part, Lewis seems to have been undaunted in her path as a professional neoclassical sculptor of original works in the face of Child's constant and often highly critical and openly pessimistic input, which may have been interpreted by Lewis as

anything from discouraging attacks and open criticism to maternal pleas for caution and mindfulness. What is clear is that Child registered shifts in their relationship—coldness, distance, lack of communication—at these moments when she felt compelled to share her "sincere" opinions with Lewis. In a letter to a friend, she wrote that Lewis had ignored her pleas to avoid marble work for a few years, relating that the sculptor "went on all the same, and thought my advice very unkind. . . . I pity her, from the bottom of my soul; but she will be perpetually getting into such difficulties, unless some friend is sincere enough to warn her."[104]

Beyond the opinions and counsel of Whitney and Child, respected members of the colony, such as the art critic James Jackson Jarves and the novelist Henry James, saw Lewis only through her race. Jarves, updating readers on the progress of American women sculptors, mentions Lewis only to dismiss her as "the only representative of the recently emancipated race" and cites her bust of Longfellow only as an example of general female artistic ineptitude.[105] James was no kinder. His dismissive mention of Lewis bears the marks of a decided racial hostility, scarcely veiled beneath bourgeois politeness. Although James had offered that a person's presence within the realm of art could be justified merely by what he called the "representational impulse,"[106] of Lewis he wrote, "One of the sisterhood, if I am not mistaken, was a negress, whose colour, picturesquely contrasting with that of her plastic material, was the pleading agent of her fame."[107] James's "if I am not mistaken" is, of course, a deliberate play at forgetfulness, because Lewis's black-Native female body as a professional sculptor in the space of the Roman colony was for James, as for other whites present, beyond memorable. Indicating his own conception of the primacy of the "representational impulse," James's reduction of Lewis from an active and successful *producer* of art to a fetishized aesthetic *object* of visual scrutiny, the mere color contrast of black against white, reveals the hegemonic status of whiteness as a symbolic requirement of the mid-nineteenth-century identification of the artist and the criteria of equitable belonging within the exclusive cultural community. In emphasizing Lewis's color, James's description also crucially restated the aesthetic dominance of whiteness within the neoclassical canon. It is significant that James, who had arrived in Italy only in 1869–70, several years after Lewis had already established herself in the colony and won international acclaim as a sculptor, was arrogant and comfortable enough in his class and race position as a member of the exclusive colony to criticize the then reputed artist so openly.

The Limits of Race and Sex

Besides being practicing sculptors involved in the neoclassical movement, the women sculptors in Rome did not necessarily share a particular instructor, patron, artistic philosophy, or communal working environment. Instead, they were independent artists whose desire for professionalism, along with shared gender, sex, and sexual identifications, provided a safety zone, support network, and community of thought for one another.

Lewis sailed for Europe in 1865 and had established her Roman studio by the winter of 1865–66. The extreme class and racial segregation of nineteenth-century ship travel imposed material and physical hardships on black travelers. Although I have encountered no direct accounts of Lewis's Atlantic crossings, nineteenth-century accounts of the experiences of other black travelers on ships chronicle the normality of acute and dangerous segregation practices and explicit mistreatment, which often led to illness and hardships beyond the normal disruptions of early passenger ship travel, such as the bouts of seasickness and physical discomfort from the motion of the vessels reported by many white cultural tourists. The ship passage of Nancy Prince, a free black New Englander, serves as an example of such imposed hardship. Forbidden to stay in a cabin, she traveled between the Americas and Europe on the deck of a ship, where she became ill.

Similarly, when Charles Lenox Remond, a free black abolitionist from Salem, Massachusetts, traveled to London in 1840 on the *Columbus* as a representative of the World Anti-slavery Conference, blacks were segregated on the open decks or in the steerage section of the ship. Although Charles's companion, the white abolitionist William Adams, had offered to share a cabin with him, the captain's insistence and Adams's protest resulted in both men sharing a space at the bottom of the gangway on the open deck. Years later Charles's sister Caroline Putnam suffered "indignities" during her crossing onboard a Cunard vessel. The experience of travel for free blacks in the nineteenth century was, like the transport of black "cargo" in slavery, structured by the immobilization and deprivation of the black body. The threat of proximity and cross-racial interaction was contained through the invisibility and immobilization of the black body. Already, a ship is a floating space with immediate borders, the breaching of which can trigger death. But within this imposed territory, the black subject experienced yet another level of containment within certain approved and often dangerous places onboard the ship. The enforced racial immobility of the black subject corresponded to his or her immobility within the geographical boundaries of America. As such Lewis's experiences traveling between America and Europe probably served to sustain or prolong her American racial identifications or to remind her of them (depending on her destination). As Cheryl Fish has argued in the case of Nancy Prince, mobility was the means to knowledge, of self and other bodies, and the means to access protection of the body through either flight or the accessibility of other material resources.[108]

For black people the process and practices of nineteenth-century travel were threatening to the status and integrity of the body. Shifting geographical boundaries and colonial legal discourses meant the difference between slavery and liberation, incarceration and freedom. En route from Jamaica to America, Nancy Prince, detained onboard a disabled and unfit vessel with other black passengers while the whites were put ashore at Key West, witnessed the arrival of a cargo of black slaves bound for Texas. Her narration of the incident, which dramatically juxtaposed her free black body and the bodies of slaves, located the similarities of colonial strategies of containment deployed

against blacks, "free" or enslaved. The law that kept Prince and other blacks onboard was one designed to prevent their enslavement by southern slaveholders but also to inhibit their potentially transgressive contact with and influence on the black slaves. But in insisting on the containment of the free black body while not the policing of the white criminal one, it also performed and entrenched the very risk that it claimed to guard against. Nancy Prince's "freedom," like that of her fellow black passengers, was not absolute but all too easily rescinded on the basis of the differences in state legislation and the whim of white authority.[109]

Lewis was initially welcomed by Charlotte Cushman and Harriet Hosmer to the Roman colony early in 1866, Hosmer helping Lewis to secure studio space.[110] However, Child disputed the extent to which Cushman was watching over the new arrival. In a letter dated 10 July 1868, she wrote:

> The account given to you by a lady from Rome was a relief to my mind; though I presume it was only *partially* true. I don't believe that Charlotte Cushman has taken Edmonia "under her *protection*"; for if she had, she never would have allowed her to run in debt for marble, on the mere *supposition* that Mr. Garrison's friends would raise money to pay for it.[111]

The aspiring young sculptor would have arrived furnished with letters of introduction,[112] which may have come from her Boston patron Anne Quincy Waterson, the aforementioned Mrs. Chapman or Mrs. Stevenson, abolitionist Lydia Maria Child, or founder of the American Anti-slavery Society, William Lloyd Garrison, among others. In a letter to Lydia Maria Child in the spring of 1866, Lewis related Hosmer's warm welcome and added, "Miss Hosmer has since called on me and we often meet."[113] Lewis's determination not to waste a moment was documented in an early report from Henry Wreford, who visited her Roman studio in March 1866, a mere two months after she had reached the city:

> Another bust, of Mr. Dionysius Lewis, of New York, is nearly completed as a commission. The first ideal work of our young artist is a freed woman falling on her knees, and with clasped hands and uplifted eyes thanking God for the blessings of liberty. . . . Two other groups, the design of which is taken from Longfellow's Minchacha, are nearly modelled. They represent first Hiawatha coming to the wigwam of his love, and laying down a deer at her feet, in token of an offer of marriage, and secondly, Hiawatha leading away his chosen bride.[114]

However warm her initial reception, there is also evidence that Lewis had early encountered racism in Europe. In correspondence from November 1865, Lydia Maria Child referenced a letter from Lewis, who was "much excited" about an "unpleasant misunderstanding."[115] Before departing from Boston, Lewis had made the acquaintance of James and Annie Fields through Garrison and Child. Annie had provided Lewis with

a letter of introduction to her sister Miss Adams, who was living in Florence, and urged Lewis to call on her immediately once she arrived. After landing in England, Lewis eventually made her way to Florence, where she took Mrs. Fields's advice. However, instead of receiving the warm welcome Annie had implied, Lewis was summarily rebuffed by Miss Adams, who returned her letter and refused her admittance to her home without explanation.[116] Lewis instantly deduced that racism was at the heart of her rejection. Child's description of the incident clearly indicated both the significance of Lewis's race in the infraction and the commonplace occurrence of such racist incidents. Knowledgeable of the "American prejudice" that Lewis would have to navigate, Child explicitly cited Lewis's race as the cause of the incident: "But that is not to be wondered at, considering the trying position in which she is placed by her complexion."[117] Luckily her short stay in Florence was not an utter disappointment for Lewis, who was aided by Mr. George P. Marsh, the first U.S. minister to Italy. Marsh sent "his man" to accompany Lewis to the Fieldses' and later to see Thomas Ball, another American sculptor, and his wife. Mrs. Ball provided Lewis with a letter that helped her to gain lodgings, and Thomas made her some tools. Lewis also visited with another expatriate American sculptor, Hiram Powers, who also gave her some things.[118]

By 1867 Lewis was apparently living in rooms in the Via Gregoriana, close to Anne Whitney.[119] However, the isolation followed by the eventual "expulsion" of Louisa Lander from the Roman colony, for what was seen as a sexual indiscretion, appears to demonstrate the political and social limits of the female colonists' power or perhaps, in demonstrating differences in identifications with nineteenth-century bourgeois female sexuality, represents an instance in which the support network of the women sculptors failed or refused to actualize. Louisa Lander fell into social disfavor when her moral character was brought into question after rumors surfaced that she had "lived on uncommonly good terms" with a man in Rome and "exposed herself as a model" to a "number of respectable people."[120] Although in Rome, as a woman Lander still found her behavior subject to a particularly intense form of social scrutiny that did not befall male members of the colony. Her supposed moral lapses were a breach of the acceptable limits of bourgeois female heterosexuality.

Although the artistic representation of the human figure required models, the revelation of the body of the model was contingent on and implied a particular and displaced class and racial identification. Likewise, social control of female sexual activity was secured by the hegemony of heterosexual marriage. Although supposedly respectable people had participated in and visually witnessed or encouraged Lander's modeling, the transgression was registered in Lander's body as the object of vision, not in the viewing bodies of the men and women who instigated Lander's downfall. Nancy Proctor has effectively noted that while nineteenth-century male artists' works were judged on their aesthetic or moral merit, female artists' personal identifications and moral character were a critical factor in their success as artists and in the acceptance and popularity of their works.

The importance of this character–career connection for female artists is revealed

in the value of Lander's bust of Hawthorne, which, significantly *in the wake of* her public humiliation and disgrace, was dismissed as "bad" art.[121] Hawthorne commented, "The bust, my friends tell me, is not worth sixpence; but she did her best with it."[122] Lander's official renunciation was carried out through a mock trial and investigation supposedly led by William Story. Refusing to take an oath before an American minister, Louisa was shunned by members of the colony, including Hawthorne, who ignored her correspondence and refused to admit her when she called at his residence and subsequently refused all communication. Hawthorne's urging that Lander fully refute all charges and "throw her life open to the world" in order to be properly received by society and his desire to preserve the "sanctity of his domestic circle" point up the extent to which Lander was viewed as a contaminated body that threatened, through her sexual vice, to infect "innocents," mainly women and children.[123]

Hawthorne's rejection of Lander was further indexed by his refusal to deal with her directly regarding payment he owed for the portrait bust. He "should greatly regret to remain in her debt," however, so instead, "for reasons unnecessary to mention," he recruited a friend named Fields to contact James Clinton Hooker, an American banker at Rome, to complete the transaction. Hawthorne's wife and editor of his *Passages,* Sophia, went so far as to obliterate any mention of Lander from her husband's journals. Interestingly, knowing Hawthorne had sat for the portrait by Lander and aware of the scandal, John Rogers, Louisa's cousin, questioned whether Hawthorne was going to accept the sculpture. Hawthorne described his interaction with Lander when he wrote of "sitting for my bust in one of the suite of rooms formerly occupied by Canova." Her reputation destroyed and her career suffocated, Lander continued to produce sculpture largely at her own expense, relocating back to America in 1860.[124]

While Lander's case demonstrates the sexual limits of the female network, Lewis's experiences demonstrate the racial limits. The discourses of nineteenth-century abolitionism and proto-feminism were intimately intertwined, with the slave body representing an example of white feminists' assertion of white female personhood and white women's rights to political and public agency. The example of the slave's marginalization within slavery was used as a metaphor for white women within patriarchy. Sánchez-Eppler has noted that, since both discourses sought to disrupt the hegemonic correspondence between personhood and white male corporeality, "the slave, so explicitly an object to be sold, provides feminism as well as abolition with its most graphic example of the extent to which the human body may designate identity."[125] Although many of these female artists shared political views that championed both women's equality and racial equality, their words and deeds often revealed an ambivalence in the social occurrences of cross-racial interaction.

Racist comments and actions from white abolitionists or those merely supportive of abolition were not isolated incidents. As Whitney's documented descriptions and accounts of Lewis demonstrate, liberal whites were not free of racism but rather, like the proslavery whites they abhorred, deeply conflicted about the colonial logic through which they imagined and represented the racial difference of black and other nonwhite

bodies. This conflict resulted in the ambivalence of white abolitionists working against slavery yet perpetuating colonial ideals of racial difference within their actual daily interactions with black people. The American Thomas Ball, sculptor of a design for *Lincoln Memorial* (c. 1866) (Figure 8), commented that his original black male model "was not good enough to compensate for the unpleasantness of being obliged to conduct him through our apartments."[126] In a similar vein, one can examine the example of Henry Kirke Brown, the sculptor of *Lincoln and the Emancipated Slave* (c. 1866), who had devoted many years of his career trying to commemorate the intrinsic role of black slaves in the economic life of America in a national monument, with his design for the House pediment of the U.S. Capitol in Washington modeled in 1855 and his later design for the pediment of the new State House in Columbia, South Carolina, modeled in 1860–61. Neither design was ever realized. The decision to overlook Brown's pediment model was made by the Northerner Montgomery Meigs (then working under the secretary of war and slave owner Jefferson Davis), who, depending on Southern support, feared that the representation of black subjects could be construed as antislavery.[127]

Despite his cultural goals, Brown referred to the black male model for his Lincoln group in a letter to his wife as "that thriving nigger," whom he did not expect to "show his miserable muzzle here again."[128] In the first quotation above, Ball's comments again point up the actualization of white fear at the proximity to the supposed racial Other. In the second, Brown's use of the term *nigger* in the context of a communication with his wife locates the viability of such racist language even within the gendered prescriptions of bourgeois communication with "ladies." Abolitionist politics and sentiment were not always motivated by a genuine love of blacks or a genuine belief in their equality with whites.

Countering Hostilities or Strategies for Survival

All of the women sculptors, regardless of race, had also to contend with the often open hostility of the white male artistic community. Many male artists reacted against the presence and success of the female sculptors, which threatened the traditional notion of sculpture as a male art form that necessitated physical strength and endurance coded as masculine. This misleading notion was belied in the accepted sculptural practice of employing highly skilled Italian artisans who prepared large clay maquettes *(modello)* that were eventually transferred into plaster, releasing sculptors from the bulk of arduous physical labor and allowing them to focus on the conception of small clay maquettes *(bozetto)*. After witnessing the various phases of sculptural process in Story's studio, Nathaniel Hawthorne would later write, "It is not quite pleasant to think that the sculptor does not really do the whole labour of his statues, but that they are all but finished to his hand by merely mechanical people."[129] Further exposure to the process of transferring from plaster to marble prompted him to note, "These persons, who do what is considered the mechanical part of the business, are often themselves sculptors, and of higher reputation than those who employ them."[130]

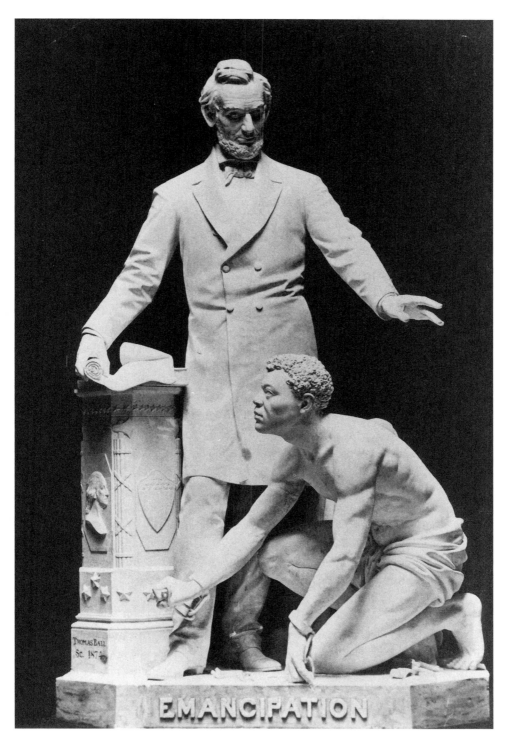

Figure 8. Thomas Ball, *Lincoln Memorial,* c. 1866. Plaster model for New York and Philadelphia monument to Abraham Lincoln. Reproduced from the Collections of the Library of Congress, Washington, D.C.

The hostility of male members of the Roman colony, which frequently registered as amazement and amusement, was often a response to the way women sculptors' bodies performed the transgressive rejection of the symbolic signs of bourgeois femininity, refuting the notion of any natural alignment between femininity and the biological position of female sex within the mid-nineteenth century. But their hostility was also a product of the hegemony of heterosexuality and often barely disguised condemnations of lesbianism, as James's label of "strange sisterhood" attests. Within this often openly hostile environment, the neoclassical predilection for the representation of biblical, mythological, and ancient heroines, women who had been historicized as rebels against male control or noble victims of abuse and violence may have resonated more powerfully with these female sculptors, who were themselves resisting cultural and social marginalization, since their physical presence as sculptors in the colony was often regarded as threatening and transgressive by their male contemporaries.

The writings and correspondence of the Roman colonists, cultural tourists, and Americans with links to the colony were peppered with descriptions, opinions, and judgments about the women sculptors, particularly their mannerisms, behavior, and dress.[131] The degree to which the descriptions were preoccupied with the visibility, mobility, and representation of the bodies of these female sculptors within the Roman colony highlights the ways in which the female sculptors' artistic and social practices transgressed the cult of bourgeois womanhood, which was, within the nineteenth century, dependent on the social performance of a femininity that was aligned with physical, emotional, and intellectual circumspection, inactivity, control, and containment largely within the domestic realm. Hawthorne's description of his encounter with Harriet Hosmer recalled his focus on her body as a catalog of her physical difference from nineteenth-century bourgeois ideals of femininity and femaleness. The impossibility of signifying a woman artist within the phallic symbolic led repeatedly to productive women being reduced to objects of visual scrutiny.

Proctor has termed this conflation of the body of the female artist with her work the "Pygmalion effect," the disavowal of the possibility of the woman artist through the fetishization of the female-producing body.[132] As much as any of her sculptures, Harriet Hosmer herself, like the other female sculptors in Rome, became in many respects a sculpture in her own studio. Hawthorne wrote of her:

> She has a small, brisk, wide-awake figure, not ungraceful; frank, simple, straightforward, and downright. She had on a robe . . . my attention being chiefly drawn to a sort of man's sack of purple or plum-colored broadcloth, into the side pockets of which her hands were thrust as she came forward to greet us. She withdrew one hand, however, and presented it cordially to my wife (whom she already knew) and to myself, without waiting for an introduction. She had on a shirt-front, collar, and cravat like a man's, with a brooch of Etruscan gold, and on her head was a picturesque little cap of black velvet, and her face was as bright and merry, and as small of feature as a child's. It looked in one aspect youthful, and yet there was something worn in it too. There

never was anything so jaunty as her movement and action; she was very peculiar, but she seemed to be her actual self, and nothing affected or made up; so that, for my part, I gave her full leave to wear what may suit her best, and to behave as her inner woman prompts.[133]

Henry James's observation of Hosmer, like Hawthorne's, came in Rome and originated from a dinner he attended at the Storys'. Even more than Hawthorne, James's descriptions registered not just curiosity or ambivalence but a visceral disgust at what he read as Hosmer's transgression of gender and sex boundaries. Dismissing the possibility that her art was of merit, James's vision disordered Hosmer's body, for he concluded that the "extraordinary little person . . . looks like a remarkably ugly little grey-haired boy, adorned with a diamond necklace, but she seems both 'vivacious' and discreet and is better, I imagine, than her statues."[134]

However, collegial hostility could also descend into petty, malicious, and career-threatening accusations. Two years before Lewis's arrival in Rome, the English journal the *Queen* printed accusations of fraud brought by an anonymous male artist, claiming that Harriet Hosmer's *Zenobia* (1859) (Figure 9) had been executed by her Italian artisans.[135] Hosmer responded publicly to the accusation with an article titled "The Process of Sculpture," published in the *Atlantic Monthly* in December 1864, as well as with a poem detailing the gossipy and conspiratorial atmosphere among some male sculptors, titled "The Doleful Ditty of the Roman Caffe Greco" and published in the *New York Evening Post* in the summer of 1864. Much later, Story, who had become Hosmer's friend and who had, along with his wife, defended Hosmer against the accusations, also confirmed in a 19 December 1873 article in the *Athenaeum* his having personally watched Hosmer modeling *Zenobia*.[136]

In defense of such a potentially career-damaging accusation, Edmonia Lewis and Emma Stebbins resorted to the unorthodox and physically strenuous practice of doing their own carving, usurping many of the activities traditionally left to their hired artisans. On visiting Lewis's studio, Laura Curtis Bullard left a record of the sculptor's practices suggesting even more severe practices had been adopted:

Miss Lewis is one of the few sculptors whom no one charges with having assistance in her work. Every one admits that, whether good or bad, her marbles are all her own. So determined is she to avoid all occasion for detraction, that she even "puts up" her clay— a work purely mechanical, and one of great drudgery, which scarcely any *male* sculptor does for himself. It is a very hard and very fatiguing process, for it consist in the piling up masses of wet clay into a vague outline of a human figure, out of which the sculptor brings the model into form and beauty. If Miss Lewis were not very strong she could not do this, and it seems to us an unnecessary expenditure of her physical powers.[137]

The impossibility of a female sculptor in the nineteenth century resulted in a sex-specific need to ensure authorship through unorthodox, time-consuming, and arduous

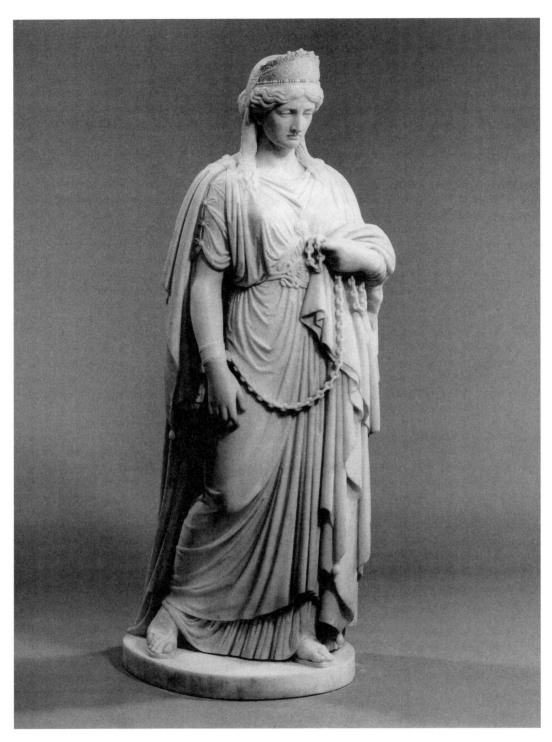

Figure 9. Harriet Hosmer, *Zenobia in Chains,* 1859. Marble. Height of 124.5 cm. Wadsworth Atheneum Museum of Art, Hartford, Connecticut. Gift of Mrs. Josephine M. J. (Arthur E.) Dodge.

artistic and physical practices. A similar and parallel pattern, prompted by racial impossibility, can be recuperated from the nineteenth-century literary genre of slave narratives, whose titles were often deliberately and emphatically completed with the appendage "written by Himself/Herself."[138] Emma Stebbins's lesbian partner Charlotte Cushman wrote anxiously in personal letters about Stebbins's "crucifixion," the result of her assumption of responsibilities that other sculptors appropriately left to paid help. Stebbins's distress, triggered by Hosmer's experience, resulted in what Cushman described as a morbid drive fueled by an extraordinary integrity and desire for self-preservation. Cushman's letters berate Harriet Hosmer for what she interpreted as her savvy exploitation of the libelous accusation. Cushman felt that Hattie (Hosmer) "never failed to ding into Emma's ears" talk of the libel, and while Stebbins had radically shifted her sculptural practice in light of the experience, in Cushman's estimation Hosmer continued, albeit legitimately, to let "the workmen advance her figure farther than any others"[139] (Figure 10).

Lewis, who would have known of Hosmer's travails from her time in the colony and even perhaps from Boston (by way of Lydia Maria Child and others), appears to

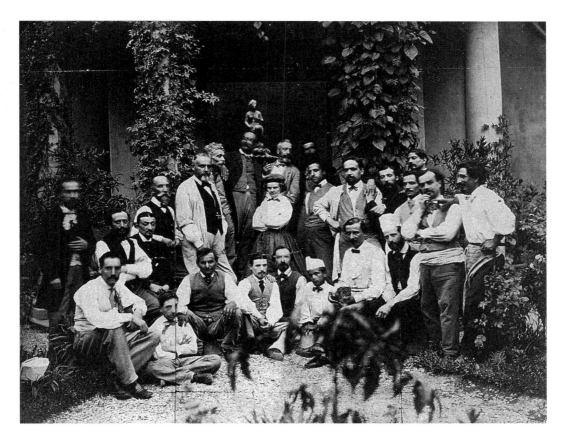

Figure 10. Harriet Hosmer with her Italian workmen, 1861. Photograph. The Schlesinger Library, Radcliffe Institute, Harvard University, Cambridge, Massachusetts.

have been similarly affected, and according to Charlotte Streifer Rubinstein, she "was even afraid to study with artists in the city because she feared accusations that others were doing her work."[140] Instead, Lewis practiced by sculpting copies of classical and Renaissance works such as *Young Octavian* and Michelangelo's *Moses,* which she sold to grand tourists.[141] These unorthodox practices not only exacted an emotional and physical price from Lewis and Stebbins, but they also directly affected the women's artistic output, the amount of time they could devote to the conceptualization of their art, and the inevitable quantity of their sculptural production.[142] More time spent on direct carving could only mean less time invested in creative and intellectual activity that resulted in the origination and conceptualization of new works, which eventually translated into a lowered output from the artist's studio and a lowered income.

Lewis's unorthodox cultural practices also extended from production to the area of patronage in how she secured "commissions" and gained access to sitters for portraits. Whereas many artists did not carve large works in marble without a specific commission from a particular patron, which assured at least the eventual recuperation of costs, Lewis more than once sent unsolicited, fully realized works from Rome to patrons in Boston, requesting assistance, retroactively, in raising funds for shipping and material expenses for which she had put herself in debt. In a letter of 1868, Child expressed her concerns about Lewis's developing habit of "consigning statues to people without any thought about the freight."[143] Child saw Lewis's actions as "an inexcusable liberty," which she blamed on her lack of social skills and flawed (read black and Native) upbringing.[144] Child recounted one such case in a letter recalling how Lewis had "*borrowed* money for the marble of her Freedmen's group, then sent it to Sam E. Sewall, without giving him any notice of her intention."[145] Sewall, forced to pay two hundred dollars in freight and duties to prevent the custom house from auctioning the piece, set up a subscription after a great deal of "uphill work" and donated the work to Rev. Grimes, "a colored clergyman."[146] Child wrote rather acerbically of sending a photo of the work to a Mrs. Minturn at Lewis's behest but refusing a subsequent request from Lewis for her to *"write it up"* (i.e., write a description of the sculpture).[147] Instead of Child, who "could not do it conscientiously, for it seemed to me a poor thing," Elizabeth Peabody wrote what Child described as a "flaming description" for the *Christian Register.*[148]

Although Lewis did garner significant moral and financial support from black patrons, with no comparably substantial black or Native middle class (compared with that of whites) from which to establish a reliable commission base, Lewis, like many of her white contemporaries, also relied on the white bourgeois abolitionist community for patronage. Although Lydia Maria Child chastised her, describing Lewis's practice as misguided, she saw her actions as a natural by-product of racial and class difference:

> My mind has been troubled somewhat by the letter I wrote to Edmonia, because you
> thought it must have been "very hard" for me to write it. The fact is, I should rather
> have given $50, than have done it. But I have observed that she has no calculation
> about money; what is *received* with facility is *expended* with facility. She is not to

blame for this deficiency. How could it be otherwise, when her childhood was spent with poor negroes, and her youth with wild Indians? People who live in "a jumpetty–scratch way" (as a slave described his "poor white neighbors") cannot possibly acquire habits of balancing income and outgo. If she found all her bills for freight and marble paid, without expostulation from any quarter, she would soon send me over *another* statue, in the same way.[149]

While Child expressed strong regret for her chastisement of Lewis, her reliance on dominant stereotypes of blacks and Natives did not allow her to contemplate the possibility that Lewis was not acting out of racial naïveté but with shrewd forethought and business acumen. Furthermore, what one may define as Lewis's ambition was interpreted as arrogance and ignorance. Child's letters featured details and gossip about Lewis's affairs, and while she at times defended her against others' slings, she often ended up merely replacing their insults with her own. To the Shaw family she wrote:

> You once wrote to me that you had no patience with her "over-whelming vanity." I do not think her injudicious proceedings are so much owing to that, as to her restless energy, which makes her feel competent to *any* undertaking, coupled with her want of education and experience, which makes her as unconscious as a baby of the difficulties that lie in her way. Whether she will ever be capable of original creations is doubtful; but she seems to me to have a good deal of talent, as well as perseverance, and I think she might make a *very* good copyist.[150]

Here, Lewis's character, actions, intelligence, and artistic capability are all questioned. Whereas Lewis's seemingly haphazard shipping of unsolicited finished pieces to Boston supporters was perceived as a product of her infantilized racial position, Lewis's practice also constituted a savvy exploitation of the philanthropy of the white Boston abolitionist community and preyed on their desire to support and promote Lewis as a product of their benevolence and a paradigm of black acculturation.[151]

Another example of Lewis's exclusion from traditional practices of neoclassical sculpture has been documented in her lack of access to potential sitters, many of whom were cultural tourists visiting or living in Rome. Whereas many of Lewis's white contemporaries, especially the males, gained relatively unimpeded access to potential patrons and sitters through their normal, everyday social interactions, Lewis's social sphere in Rome, although arguably more accepting of cross-racial relationships than any in America, would have been hampered by her racial identifications and the class position they implied. We must also consider how Lewis's unfamiliarity with the practices, decorum, and manners of "polite" society and her own life experiences and characteristics (as partly dictated by her racial identity) potentially impeded her ability to relate to white sitters (and they to her), even once they were attained.

The obstacles of Lewis's lack of access to particular contexts and therefore people were revealed in her pursuit of Henry Longfellow in the streets of Rome. Although

Lewis would eventually complete a portrait bust of the famous poet, who eventually sat for her at the bidding of his brother, initially Lewis resorted to tailing the American, catching glimpses of him in the city streets after she had spotted him at a hotel near her studio.[152] Securing a sitting with the likes of Longfellow was one thing, but ensuring that he was made to feel at ease and kept appropriately entertained during a sitting was another. What Lydia Maria Child described as Lewis's early problems with portraits may in part be attributable to a discomfort with the process of sittings, more so than any lack of artistic ability or focus. However, surely her completion of Longfellow's portrait bust, with the approval and praise of his family, demonstrates a level of considerable talent, especially given the bizarre initial circumstances of having to sculpt him on the run. In a letter of 8 April 1866 to Sarah Shaw, Child hypothesized that Lewis's *Voltaire* and *John Brown,* representations copied from extant busts, were far better than her *William Lloyd Garrison* or *John Wendall Phillips,* both representations taken from life and, according to Child, "horridly vulgarized."[153] That the best of the works were supposedly the ones that Lewis likely made in isolation, from inanimate objects, as opposed to those that necessitated delicate social interactions, with often rich and culturally elite white patrons, is compelling.

Writing in 1945, almost one hundred years after the height of nineteenth-century neoclassicism, the art historian Albert TenEyck Gardner doggedly retained the deliberately marginalizing label of "lady sculptors," describing Emma Stebbins as a spinster (despite the long-standing lesbian partnership she shared with Charlotte Cushman), implying Vinnie Ream Hoxie used her "saucy curls" on "susceptible senators" to extort national commissions, dismissing Harriet Hosmer's achievements and the artist herself as the female sculptor who demonstrated "the greatest talent for making friends with influential people," and aestheticizing Edmonia Lewis as the "exotic" body in contrast with the white marble.[154]

This unproblematic revision of Henry James's scornful masculinist and racist assessments should not surprise us, given art history's patriarchal and colonial legacies. Feminist art history has also been more recently guilty of the elision of race and class difference necessary for the mystification that rendered Lewis's unique and challenging position, as the only black–Native female artist in the Roman colony, practically invisible. Although many would argue that Lewis, Stebbins, Hosmer, Whitney, and the other female sculptors shared the experience of being women in nineteenth-century Rome, their significant differences across race, class, and sexuality, in many cases, must be understood and recognized as identifications that challenged their inclusion in the very category of Woman. Their differences from their male contemporaries and from one another should not diminish their work and accomplishments but rather allow us to understand and celebrate them, further equipping us with a better knowledge of the social, material, and psychic hurdles they all faced.

2. "Taste" and the Practices of Cultural Tourism
Vision, Proximity, and Commemoration

Writing Rome

Nineteenth-century neoclassical sculpture, its production, and the practices of viewing it were widely documented within guidebooks, tourist literature, travel diaries, novels, personal letters, and articles in popular journals. Many of these sources regularly emphasized the critical importance of Europe, Italy, and Rome within the western bourgeois rituals of cultural tourism.[1] Cultural tourism is a significant site of scholarly inquiry into the often exclusive identifications of tourists (those who travel in upper-class privilege) and travelers (those who travel purposefully or of necessity, often in discomfort), since, as a literary genre, it united the privileged practices of travel and authorship. Both nonfiction and fiction literary works helped to popularize and legitimize neoclassical sculpture and the cultural activities of the American and European tourists who flocked to Rome to engage the contemporary artists and see the revered antiques. As Francis Haskell and Nicholas Penny have argued, "For many centuries it was accepted by everyone with a claim to taste that the height of artistic creation had been reached in a limited number of antique sculptures."[2] Coupled with the dissemination of casts, engravings, and eventually photographs of canonized artworks, these literary representations of Rome produced the effects of memory in the reader or viewer, the "return" to an idealized home space conjured through the sensorial repetition of the sites and sights of Rome.

Black Travelers, White Tourists

The terms *traveler* and *tourist,* however, require further consideration with regard to their differences. This familiarity with a site unseen and the experience of extended

travel itself were the privilege of a class position that was not equally accessible to all. The most powerful example of the racial dualism of nineteenth-century ship travel is the simultaneity of luxury steamships full of white, leisured, elite travelers and inhumane slavers such as the *Brookes,* filled beyond any reasonable capacity with enslaved black "cargo," as *Stowage of the British Slave Ship "Brookes"* illustrates (Figure 11).[3] While for the most part white bourgeois tourists used their travel to reconcile, perform, and entrench class privilege, the narratives of black travelers, often fugitive slaves or servants, initiated what Malini Johar Schueller has termed a "disaffiliation with American citizenship" and an aspiration to racial equality, made possible by the potential for imagining a new and different meaning for their blackness.[4] Although not all black travelers were from America, Schueller's point is important in recognizing a general disaffiliation of black subjects from their colonial location and an embodiment within the diaspora and strategies for creating a home space or safe place and new identifications somewhere else. While whites were often tourists, blacks, even outside slavery, were more often travelers. Schueller has effectively argued that the practice of nineteenth-century authorship was itself racialized and gendered, in that the "gentleman amateur" convention of anonymous authorship was synonymous with white (male) authorship, whereas black authorship was simultaneously subjected to rigorous authentication by whites, often abolitionists.[5]

The nineteenth-century discursive practices of authorship were colonial and afforded white women greater opportunities to assume the authority of authorship and credibility than black or other racially marginalized subjects had. For instance, while I have yet to come across a black writer who adopted the white bourgeois practice of taking a pen name within nineteenth-century literature, white female authors such as Sara Jane Lippincott, who wrote under the name Grace Greenwood, often took on pseudonyms. The pen name, which sought to impose an objective distance between the author and his or her text, marked the development of a white bourgeois conception of authorship and its distinction of intellectual class "labor." This forced anonymity was something that was neither desirable nor possible for black authors, who were expected to authenticate their writing incessantly and wished to create and preserve an intimate connection between their words and their own racial identifications. As Cheryl Fish has noted, Nancy Prince, a free black New Englander, felt compelled not only to defend her desire to travel but also her authority to write. Similarly, Mary Seacole, the black heroine of the Crimean War, claimed her authority to write through her ability to heal and to serve white soldiers. As a result of the economic and educational disenfranchisement of blacks within slavery, the literary audiences for such black-authored narratives were also racialized, mainly consisting of Northern, abolitionist-minded whites and, to a lesser degree, free literate blacks. As Schueller has argued, "It is important to remember that northern white readers and abolitionist sponsors were prepared to accept only a certain type of blackness as 'authentic' from former slaves, a blackness dependent upon a black–white binary."[6]

A rare example of a black author's rejection of this white sanction can be found

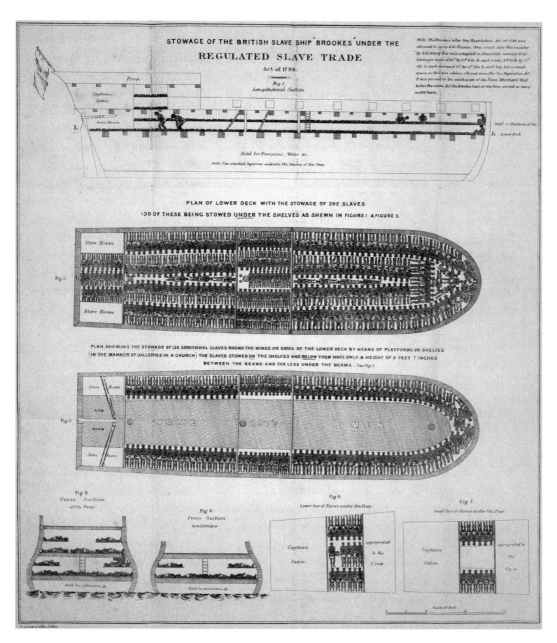

Figure 11. James Phillips, *Description of a Slave Ship,* Brookes of Liverpool, 1789. Plan and cross-section of slaver, copper engraving, 604 x 504 mm. Division of Rare Books and Manuscript Collections, Cornell University Library, Ithaca, New York.

in David Dorr's *A Colored Man round the World,* which was self-published with the authorial indicator "by a quadroon," an explicit racial identification, not with the traditional appendage "by Him-/Herself," a validation of authorship.[7] Since, according to a review in the *Cleveland Plain Dealer,* Dorr could "pass" not just as a white man but as an excellent white man, his self-identification was a bold and unnecessary and socially hazardous assertion of pride in a potentially otherwise invisible blackness. Dorr's self-identification exemplifies identity as negotiation in the way that Judith Butler discusses identity as contested, unstable, and ceaseless in motion. His proud and defiant naming of blackness also points up the extent to which the claiming of marginal significations can subvert discursive and symbolic processes by refusing to comply with the hegemonic ordering of the body and its traditional meanings within the symbolic. Inevitably, this resistance can result in the resignification of the body and the deployment of alternative identifications.

Writing within the white tradition of the leisured tourist, Dorr deploys multiple, complex, and seemingly contradictory self-identifications (colored, quadroon, slave, fugitive, black, southern gentleman, educated, American), shaking the easy nineteenth-century alignment with blackness and inferiority.[8] Dorr's simultaneous self-identification as slave and American challenged the prolific sentiment that one could not be both at the same time. Meanwhile, Dorr's refusal to use the term *master* in regard to his "owner," Cornelius Fellowes, and his criticism of white Americans' lack of class further distanced him from the traditional slave narratives of contemporary black authors. While attempting to understand how Dorr performed complex racial and class identities, Schueller theorizes Dorr's class privilege as *whiteface* (an inversion of the popular blackface practiced by white actors in minstrel shows), in inferring that Dorr's bourgeoisness was parody, but fails to question the naturalized relationship between the white body and class privilege—precisely what Dorr's self-identifications troubled.[9]

Because *blackface* names a deliberately stereotypical and offensive impersonation of the black body, the problem with Schueller's use of *whiteface* is that it does not name a masquerading or parodying of whiteness but simply identifies Dorr's "normal" behavior, mannerisms, language, and tastes as an educated black man. Dorr's narrative explicitly located his belief in the rights of blacks to cultural capital via his easy demonstration of a bourgeois position, which may indicate why his book was ignored by the "black" press (*Anti-slavery Bugle, Anti-slavery Standard*), which was used to celebrating slave narratives that focused on the disenfranchised black body and was intimately connected to white abolitionist constructions of blackness.

Like Dorr, Edmonia Lewis was a black, interracial traveler in the nineteenth century, moving between an America that did not uniformly identify her as a citizen or a human and an imperial European context equally colonial, if significantly demographically different, in the visibility of the black body, the nature of racism, and therefore the position of the black subject within society.[10] Like many of her white artist contemporaries, Lewis had a cultural motive for her travel to Europe. But unlike many white tourists with class privilege, Lewis did not travel specifically for the sake of adventure

or to perform her social position. Like many blacks, Lewis traveled with a cause, which was acutely attached to her "liberation" from marginalized racial identifications. In understanding the ways in which race, gender, and sex informed the black female's experience as traveler, Cheryl Fish offers a useful evaluation of the complexity of the unstable subject in engagement with an equally unstable and changing environment:

> To complicate the implications of the meaning created by the travelling subject, I have coined the term "mobile subjectivity," defined as a fluid and provisional episte-mology and subject position dependent upon the narrator's relationship to specific persons, ideologies, locations, and geographical space.[11]

This concept is, of course, equally applicable to the complexity and instability of experience and identity for the white subject within travel. But whereas for the white subject we are dealing with racial privilege intersecting with class and gender/sex/sexuality fluctuations, for the black we are examining degrees of racial marginalization, for within the colonial logic of race, even the most economically affluent or educated black subject suffered prejudices and indignities that displaced him or her from an elite class category and refused a sense of belonging to the position of the bourgeois.

Acquiring "Taste," or How to Be a Good Cultural Tourist

Racial identifications informed the possibilities of subjectivity and experience for travelers and tourists. The alignment of whiteness with class privilege facilitated the process of acculturation, which determined the knowing subject. But the nineteenth-century practices of viewership—looking at, reading, narrating, and moralizing about an artwork—were learned discursive practices that were not inherent to class positions but part of the process through which one aspired to and performed an elite class position.

Hiram Powers's description of his early, uninitiated experience of viewing art objects in Rome clearly reveals the differences in experiences of viewership and comprehension (seeing and reading objects) that arose between him and his experienced patron. Powers wrote:

> On my first opportunity . . . Mr. Preston (an early patron of Powers) of South Carolina accompanied me in my visit to the galleries. He was so thoroughly read up and instructed, that he knew beforehand everything that he was going to see, and just where it was. But he was so impatient to get back to his family, that he hurried me through like lightning; and forgot that I had none of *his* careful culture and readiness to receive impressions at a glance.[12]

Powers's observation reveals the extent to which the ability to read and appreciate art objects is learned and significantly the extent to which artistic value is socially constructed. The submission of the tourist to the ideal of Rome is evidenced when the

discordance of the experience of an Other place is eventually eclipsed by the idealized vision of Rome as a mystical haven/home and the focus of uncontested desire. This transition from confusion, anxiety, and dislike to heady splendor and romantic attraction is demonstrated in Hawthorne's *Passages,* wherein he begins with an acute dislike of Rome and eventually concludes with a decided passion for the city. The Rome of nineteenth-century cultural tourism was a fetishized site that disavowed the fragmentary, the unknown, the unknowable, the modern, the poor, discrete phenomena, producing instead the safe, unified, familiar, sanitized, remembered "Rome."

The role of memory was essential to the traveler's experience of the new sites in a palatable way that appeased the discomfort of a new, strange, and increasingly modern city that thwarted access to the ancient and mythical fantasy of Rome. By "memory" I mean not simply the visual or extrasensory calling up of past experience but the imagining of experience via visual and literary triggers, such as plaster casts of canonical ancient sculpture, engravings of the *campagna,* and travel narratives of other tourists. Such preparation for the never-before-seen often induced the feeling of familiarity via memory. As the white author Bayard Taylor noted of his inaugural travels in Europe, "Every place was familiar to me in memory, and they seem like friends I had long communed with in spirit and now met face to face."[13]

The first English-language guidebooks written about Italy were published in 1843 in London by John Murray and remained popular throughout the nineteenth century.[14] The importance and popularity of the Murray guides were demonstrated by Nathaniel Hawthorne, who used them to ascertain information about the Basilica of Santa Maria Maggiore, the Fountain of Egeria at the Temple of Bacchus, and the attribution of frescoes at the Vatican's *Stanze of Raphael* during his stay in Rome at midcentury, although he grudgingly described Murray as "a highly essential nuisance."[15] As Mary-Suzanne Schriber has stated, "Nineteenth-century Americans were voracious consumers of travel literature. Between 1800 and 1868 alone, some seven hundred books of travel were published."[16] Such guidebooks often noted the location of artists' studios, the visitation of which by the midcentury had become a crucial part of this ritualistic cultural process.[17] By the 1860s, a visit to William Wetmore Story's studio was recognized as an essential component of the cultural tourist's Roman itinerary, largely as a result of the stunning success of his *Cleopatra* (1862) (Figure 12), which had been frequently described and thoroughly praised within various genres of texts prior to its first public exhibition in 1862, in London.

The writing of nineteenth-century literature of cultural tourism was a discursive practice through which the authors asserted their right to social privilege through the textual demonstration of their cultural sophistication, which was largely a matter of their intellectual and sensorial response to a particular cultural site or object. Insofar as their responses demonstrated preference, these cultural tourists were articulating taste. According to Pierre Bourdieu, taste is the expression of preferences that are not natural but developed and acquired through familiarity and proximity, and it functions to articulate class positions.[18] Taste as a demonstration of the body is a mechanism of

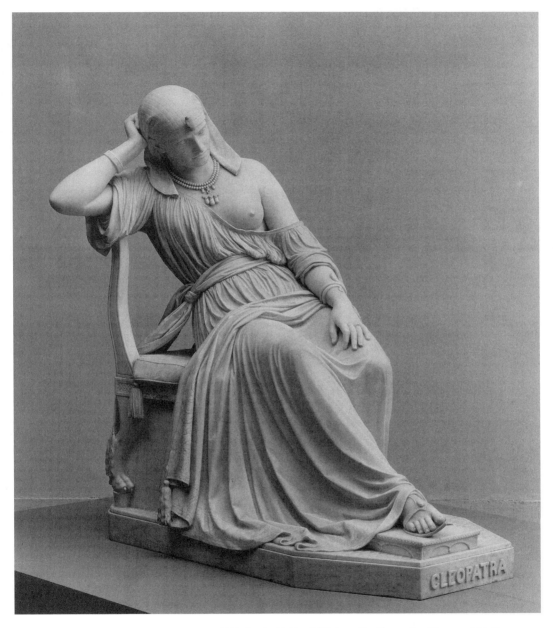

Figure 12. William Wetmore Story, *Cleopatra,* 1869. Marble. Height of 138.4 cm. The Metropolitan Museum of Art, New York. Gift of John Taylor Johnston, 1988 (88.5a–d).

distinction that works to differentiate self from Other by constituting a learned preference as the preordained, essential, and worthy desire of a particular group. It is the naturalization of preference and the alignment of preference with a specific racialized class position that sustained the hegemony of nineteenth-century viewing practices, which were based extensively on "correct" ways of interacting with, looking at, and narrating art. The extent to which the exclusive nineteenth-century practices of cultural tourism depended on a culturally knowledgeable and elite viewing body was articulated by Story, who related to Nathaniel Hawthorne "queer stories of American visitors" who had called at his studio. In one instance Story related how a visitor, after contemplating the early progress of his *Cleopatra,* had asked if he had baptized the sculpture yet, while another had commented on the expression on the face of *Hero,* captured in the torchlight search for the drowned Leander, "Is not the face a little sad?"[19] The implication was that the comments offered by these particular visitors were ill-informed, uneducated, and inappropriate, revealing their lack of knowledge of culture and the art of sculpture and their inability to engage properly with, interpret, and narrate his sculptures. It is in this vein that Bourdieu has described the visual consumption of art:

> Consumption is, in this case, a stage in a process of communication, that is, an act of deciphering, decoding, which presupposes practical or explicit mastery of a cipher or code. In a sense, one can say that the capacity to see (voir) is a function of the knowledge (savoir), or concepts, that is, the words, that are available to name visible things, and which are as it were, programmes for perception.[20]

The immense popularity of the variety of literature that engaged with cultural tourism by the mid-nineteenth century should alert us not only to the persistence of the cultural authorial voice but also to the confirmed audience for such literature and the repetitive, if not redundant and self-perpetuating, quality of this discursive practice. Writing from Rome on 3 February 1858, the American author Nathaniel Hawthorne, who would eventually publish two volumes of notes about his experiences in Italy and France, acknowledged the futility of participation within the seemingly saturated field of cultural tourism when he noted, "It would be idle for me to attempt any sketches of these famous sites and edifices—St. Peter's, for example—which have been described by thousands of people."[21] But the popularity of the literature of cultural tourism also demonstrates the potential demand for such texts as tools of cultural education and preparation as well as representational sites of memory, desire, and longing. Within this regime of knowledge the authors demonstrated their claim to cultural sophistication through the citation, or more often recitation, of sanctioned cultural knowledge, which confirmed their place within a particular class—as much about wealth and position as about color and race—as it distinguished them and their difference from other groups and cultural practices through their taste.

To See and to Touch

The source of these citations was vision, afforded by the viewer's physical proximity to the material object of scrutiny, which was authenticated by the literary texts they generated, which confirmed or proved their corporeal engagement with the objects.[22] Henry James's letter of 7 November 1869 to his "beloved sister" makes this point. James wrote from Rome, "*En attendant,* tell my brother not to cherish the fond illusion that in seeing the photos of M. Angelo's statues he has *même entrevu* the originals. Their beauty far surpasses my prior conception."[23] James's assertion is all the more significant given the prolific nineteenth-century claim to photography as an objective, authoritative, and scientific visual medium. This desire for visual and physical contact with objects through material proximity was also confirmed in Hawthorne's description of his visit to the Mamertine Prison, where the apostle Peter had been held; regarding an image of the saint's face that was visible in the wall, Hawthorne assured his readers, "We touched it with the tips of our fingers, as well as saw it with our eyes."[24] He again expressed a similar sentiment when he ascended into the copper ball at the peak of St. Peter's, where his presence was authenticated through proximity, or in this case the process of "putting our hands on" the ball's top and summit.[25]

Another requirement of the authentic viewing experience was the element of time. Hawthorne's interest in the viewer's ability to reach the "inner soul" of an art work was based on his assessment of proper temporal engagement with the art: "They look at these things for just a minute, and pass on, without any pang of remorse, such as I feel, for quitting them so soon and so willingly."[26] But however well the texts could relate the authors' experience of a specific Roman site or with a specific artwork, the complete sensorial experience of immediate visual engagement and material contact remained illusive and inaccessible to their readers. The text therefore served another purpose. It confirmed the authors' experience as privileged, highlighting their proximity to the work and the reader's literal distance, thus generating the desire for the reader to encounter or reencounter such pleasures for themselves—with their "own eyes."

But time enters the frame in yet other crucial ways. Pierre Bourdieu has demonstrated *cultural capital,* legitimate forms of taste and aesthetic disposition, as contingent on the control of time, which has been expressed in the accumulation of objects from the past as well as in the acquisition of the visual literacy to understand and narrate them.[27] Entrance into this elite cultural group, predicated on the primacy of vision, the authenticity of material contact, and the "mastery" of time, implicated race-, gender-, and class-specific viewing practices, which were largely a matter of economic opportunity, social mobility, and cultural and intellectual accessibility.

Especially for American cultural tourists, their knowledge of and participation in the discursive practices of cultural tourism helped to dispel the stain of American provinciality and the implications of cultural infancy, inferiority, and historical absence it occasioned. As William H. Gerdts has commented:

The Americans who went to Florence and Rome in the middle of the last century knew the works of these artists intimately. Many of these American "Grand Tourists" familiarized themselves with the European neoclassicists; they searched out the sculptors and their works with enthusiasm and sometimes even with a critical eye, although admittedly their criticism was untrained and often fulsome.[28]

Before even arriving in Italy, many American cultural tourists would have seen the productions of these Roman studios in various publications or within the circles of collectors and patrons. Edmonia Lewis, like so many of her peers, sent photographs of her works in progress back to journals, friends, patrons, and supporters in America with the desire of stimulating their assistance with promotion. In one such case, the *Freedmen's Record* reported that Lewis had sent a photograph of her first group (completed in Rome), representing a freedwoman and her child, to a Miss Stevenson. As desired, the journal related favorably, "The head of the woman is very strong in character and expression,—the brave daughter of toil; and the child is sweet and lovely in infantile unconsciousness," alerting its readers that any contributions would be transmitted to Lewis by a Mr. Waterston so that she might put her work in marble.[29]

Travelers' records of encounters with artists and the artworks in their studios in Rome functioned to disseminate information about artistic developments and specific information about artists' new works and their proposed narrative and symbolic intentions. But this textual tradition also helped to establish the tourists and authors as "knowing bodies" through their contemplation and analysis of artworks, which drew on a knowledge of both historical and contemporary artistic production and practice. For the artist whose studio doubled as showroom and for whom sales usually meant economic survival, inclusion in the practices of cultural tourism was a fundamental way of exposing oneself and one's art directly to potential patrons and benefactors or indirectly through the textual evidence that the cultural tourist produced.[30] Accordingly, Joy Kasson has commented:

> The overwhelming majority of American sculptors did not have independent means of income, and in order to survive, they had to find a common ground of taste and aspiration with those who had succeeded materially in the emerging commercial economy.[31]

Whereas public exhibitions were a means of securing fame, reputation, and even instant and international notoriety, the more private space of the artist's studio was an essential component to the economic viability of an artist and a crucial site of commemoration. Cultural tourists visiting artist studios did not just produce literary records of their journeys. The commission of sculptural portraits confirmed their direct contact with the artists through the process of sittings, which resulted in the material sculptural object that bore the memory of the sitter's body and the site and process of production. Thus, in the case of Nathaniel Hawthorne, we have inherited his 15 February 1858

textual account of "sitting for my bust in one of a suite of rooms formerly occupied by Canova," as well as the actual marble bust itself.[32] Although Hawthorne participated in the rituals of self-representation, the record of his Roman experiences, translated into the "fiction" of his novel *The Marble Faun* (1860), registered an ironic disdain for the popularity, commercialization, and vanity of the process. Describing the presence of portrait busts in the sculptor Kenyon's studio, Hawthorne wrote:

> Other faces there were, too, of men who (if the brevity of remembrance, after death, can be argued from their little value in life) should have been represented in snow rather than marble. Posterity will be puzzled what to do with busts like these, the concretions and petrifactions of a vain self-estimate; but will find, no doubt, that they serve to build into stone walls, or burn into quicklime, as well as if the marble had never been blocked into the guise of human heads.[33]

Quite simply, the artist's studio was designed for maximum commercial exploitation of the visitor. The cultural tourist encountered a visually accessible display of ideal plasters ready for transfer into marble with the confirmation of a commission. If they were lucky, they also witnessed the artist at work on clay maquettes in very early stages of conceptualization. This is where access became influence, since these grand tourists had the opportunity to influence artistic production directly through dialogue with the artist. As the American tourist Samuel Young recounted, "I went to-day to the studio of Gibson, the first English sculptor. . . . There were several statues and busts in progress, and numerous plaster models of perfected works."[34] Access to artists' studios provided a direct way of accumulating art, which, later installed in the patron's homes and private galleries, often with an excess that signified gluttony, became a material confirmation of their economic and cultural status and a reminder of their physical contact with the artists and the site of production. Art collecting, as the accumulation of material objects of nonfunctional or nonbiological necessity, celebrated economic desire by demonstrating the lack of economic need. The process of art collecting, as a form of privileged material and symbolic consumption, was a demonstration of leisure, economic potential, and power over time, which enabled the legitimization of bourgeois culture and taste.[35] But the class privilege that produced nineteenth-century culture and taste was also a racial privilege. Most of these grand tourists were white, as were the artists they flocked to see. Edmonia Lewis, the artist and cultural tourist, was an extraordinary rarity worthy of far greater critical contemplation than what she has been given—then and now.

3. "So Pure and Celestial a Light"
Sculpture, Marble, and Whiteness as a Privileged Racial Signifier

Aesthetic Primacy: Neoclassicism's White Marble

As expatriate artists, both William Wetmore Story and Edmonia Lewis created their *Cleopatra*s in Rome (see part III), the center of nineteenth-century western sculptural activity since the shift from Florence at midcentury. As Mary Hamer has described:

> Contemporary sculptors were drawn to Rome by the collections of antique sculpture for which the city was famous; since the beginning of the sixteenth century these statues had been the most prestigious objects in western art. Touchstones of "beauty" and "taste," the cultural capital of the west was most densely concentrated in these stone bodies and body fragments, most of them white.[1]

The whiteness of the marble medium was not of arbitrary significance but functioned to mediate the representation of the racialized body in ways that preserved a moral imperative essential to the ideals of nineteenth-century neoclassicism. Unlike other forms of sculpture or types of art, the medium of marble was inherent to the practice of nineteenth-century neoclassical sculpture. In understanding the profound and often overlooked implications of the primacy of marble, I am guided by Griselda Pollock's observation

> that different media, forming the basis for different practices of representation, service different psychic needs which determine for each element . . . a specific place and role in *an economy of representation* which is both an economy of desire and an economy of power.[2]

The exclusivity of marble was in part about the neoclassical desire to reclaim the ancient aesthetic forms and materials of the Greeks, but it also located the deliberate appropriation of ancient knowledge and culture, which had historically been sited as the root of western democracy and civilization—a point particularly relevant for a young America struggling to define a cohesive national cultural identity. The economic value of marble as expressed in the costs of the raw material, the labor of the skilled craftsmen to carve it, and the shipping of heavy finished pieces to patrons and exhibitions in America was significant. Lydia Maria Child's comments about Edmonia Lewis's progress as a sculptor revealed her knowledge of these costs and the permanency of marble sculptures as well as the mid-nineteenth-century cultural idealization of marble as the most desirable and symbolically privileged medium for sculpture. Referring to Lewis, Child wrote:

> Neither her mind or her hands are yet educated enough to work in *marble.* She should wait till her models are good enough to be *ordered* in marble. A mediocre *statue* is worse than a *painting* of the same degree of merit; for it is so conspicuous, and takes up so much room, that one knows not what to do with it.[3]

As Child's cautionary words imply, marble's symbolic value incorporated these material and commercial attributes yet superseded any mere economic value that could be assigned to the stone.

Nathaniel Hawthorne's description of witnessing the transfer of sculptures from plaster to marble at the Roman studio of the deceased sculptor Thomas Crawford captured the spiritual and moral implications of marble's symbolic value.

> It is rather sad to think that Crawford died before he could see his ideas in the marble, where they gleam with *so pure and celestial a light* as compared with the plaster. There is almost as much difference as between *flesh* and *spirit.*[4] (italics mine)

It was from firsthand experiences such as these that Hawthorne later created the "fictionalized" account of sculptors in Rome in his *Marble Faun,* a novel that also detailed the symbolic significance of marble, which he attributed to its material and significantly to what he saw as its color(less) qualities. Of sculptors Hawthorne wrote:

> His material or instrument . . . is a pure white undecaying substance. It insures immortality to whatever is wrought in it, and therefore makes it a religious obligation to commit no idea in its mighty guardianship, save such as may repay the marble for its faithful care, its incorruptible fidelity, by warming it with an ethereal life. Under this aspect, the marble assumes a sacred character; and no man should dare touch it unless he feels within himself a certain consecration and a priesthood, the only evidence of which, for the public eye, will be the high treatment of heroic subjects, or the delicate evolution of spiritual, through material beauty.[5]

Besides enacting the disavowal of the very female sculptors on which Hawthorne's novel depended (and about whom Hawthorne had written pages of notes from first-hand observation) by conspicuously deploying the pronoun *his* for the sculptor, Hawthorne used the terms *immortality, fidelity, sacred, consecration,* and *priesthood* to firmly align the artistic practice of sculpture making with religion and spiritualism, making the raison d'être of art the spiritual production of a moral, immortal, and beautiful object. Hawthorne's distinction between the spirit and the flesh points out the regulatory function of marble, which he saw as embodying the power to transform the biological human body (flesh) into a work of art with moral merit (spirit), or rather which he deemed capable of a sublimation of the flesh in order to achieve the celebration of the spirit. Morality, then, was the measure of "good" art, which was produced through the disavowal of the biological body, which was also the sexual and racial body. Marble was not incidental but critical to the process of representation, since it facilitated the fetishization of the body, representing it in a moral guise that could be visually understood as art. But returning to the words of Parveen Adams, fetishization is not merely a regulation of the body; it is the *regulation of difference.*[6]

Polychromy and the Threat of Color

Nineteenth-century neoclassical sculptors were certainly aware that their ancient predecessors had suffused their marble prototypes with colored pigments, although this knowledge was suppressed by Wincklemann and dismissed by other eighteenth-century scholars.[7] Therefore, neoclassical sculptors' very rigid and circumscribed use of marble, which was almost exclusively faithful to the medium's natural whiteness, was a conscious ideological choice rather than a casual, random happenstance.[8] Drawing from historical literary, artistic, and cultural sources alike, David Batchelor has elaborated on what he has termed the west's prolific chromophobia, making the link to the profound implications for the classical and neoclassical ideals in western sculpture:

> The virtuous whiteness of the West also conceals other less mystical terrors. These are more local and altogether more palpable; they are, mainly terrors of the flesh. Melville's great white whale is, conceivably, a monstrous corruption of the great western ideal of the classical body. This body, at least in its remodelled neo-classical version, was of course a pure, polished, unblemished, untouched and untouchable white.[9]

This classical or neoclassical body that Batchelor charts is distinguished not merely by its corporeal limits (size, frame, composition, pose, etc.) but also, and perhaps most significantly, by its color, or what neoclassicists imagined to be a lack of color. We must understand the symbolic and aesthetic value of whiteness for neoclassicists and their audiences in order to understand their rejection of art that they deemed to be corruptions of the neoclassical project.

An example of such corruption was detailed by Anne Brewster, who, writing from

Rome in December 1868, commented on the neoclassical restrictions on the pigmentation of marble in an article entitled "American Artists in Rome": "Painted statues are repulsive to the modern eye and taste. Gibson's tinted one in the Philadelphia Academy is a ghastly thing, and it seems impossible for us moderns to accept this practice of the ancients."[10] The ghastly thing to which Brewster referred is John Gibson's *Tinted Venus* (c. 1851–56) (Figure 13), which was exhibited at the International Exhibition at London (1862) and again at the Crystal Palace at Sydenham (1862) in a colored pavilion designed by the architect Owen Jones. Gibson's subtle tinting of his marble Venus, achieved through the combination of hot wax and paint, recalled the flesh color of the white body, enacting a sexualization in its palpable shift toward a "real" female body, which disturbed many viewers.[11] An anonymous critic writing in the *Art Journal* commented, "This attempt at *too palpable flesh* not only destroys the very essence of the sculptor's art, but violates the delicacy that attaches to pure material."[12] Similarly, after viewing Gibson's nude in the studio, the American tourist Samuel Young Jr. commented matter of factly, "Coloring has been used on and about the Venus, which is a *blemish*"[13] (italics mine). In his novel *The Marble Faun,* based largely on the diary notes that were later to become published as *Passages,* Hawthorne could not resist a comedic, if somewhat underhanded, swipe at Gibson by having his female painter Miriam comment boldly that Gibson's *Venus* had been stained with "tobacco-juice."[14]

Since the eighteenth century, the French Academy had viewed color as a seductive distraction, a mere simulation of the "real," which impeded the "beauty," "grace," "purity," and "nobility" of white neoclassical sculptural form.[15] Documenting the same ideology across various western cultural practices and disciplines, David Batchelor concurs, arguing:

> For Melville, the truth of Color is merely cosmetic; it contains "subtle deceits"; it is "not actually inherent in substances"; it is only "laid on from without." But if nature "paints like a harlot," it is not simply to seduce us, but to protect us in its seductions from "the charnel-house within." We have to wear tinted spectacles; otherwise, what we might see will make us blind.[16]

The issue was not only that of color but also that of illusion and integrity of material practice. The painter Thomas Cole complained, "Of late [1847]: painters are but an inferior grade of artists. This exaltation of sculpture above painting, which in this country has prevailed, is unjust, and has never been acknowledged in the past."[17] Hence, painting as the second-class status, in its use of color and perspectival systems that transformed flat canvas into three-dimensional space, was seen as untruthful in opposition to the supposed truth that could be represented in marble's tangible and voluminous whiteness. The elimination of color, except for whiteness, became a method for purging sensualism from the marble and assuring a morally sound object. It was a means of achieving a level of abstraction of form that denied the specificity of biological

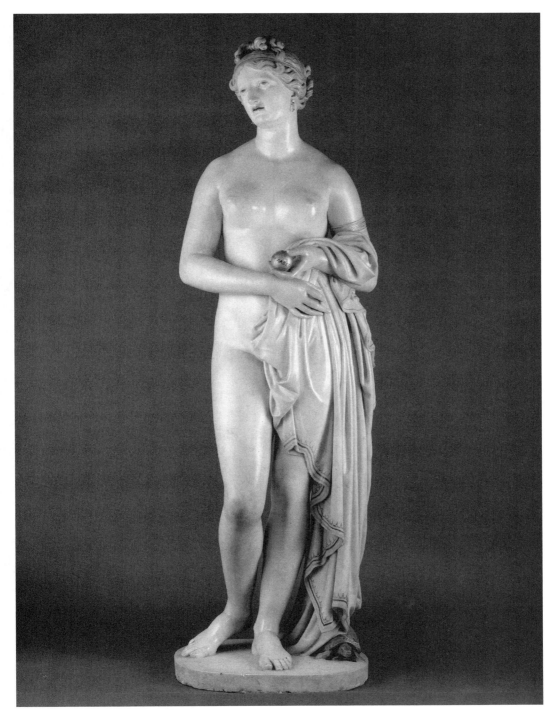

Figure 13. John Gibson, *Tinted Venus*, c. 1851–56. Polychromed marble. Height of 175 cm. Walker Art Gallery in National Museums, Liverpool.

detail and human sexuality. But it was also clearly and painfully about colonial ideals of race and racial privilege.

In his *Art-Hints, Architecture, Sculpture and Painting* (1855), the American art critic James Jackson Jarves wrote explicitly about the use of color in nude sculpture:

> Much doubt exists as to the propriety of rendering the nude figure . . . its chief claim is upon the intellect; add Color, however, and upon the universal principle of nature in its use, feeling is at once touched; it must of course be combined according to the law of harmony. A gilt or a bronze statue arouses no emotion beyond intellectual admiration; any artificial employment of color such as tinting marble, strikes the mind disagreeably as falsification of the material without any adequate motive. We look to sculpture for form alone; if it attempt more it becomes painful as a violation of its primary truth; indeed, I believe for sculpture itself, as confined to the human figure, that the intellectual pleasure diminishes in the degree that pure white is departed from as its material. Does any one find other pleasure in the artistic freaks of the classical ages, and the imitations of the Renaissance in the shape of blackamoors, draperies, and occasionally separate features, rendered by the natural colours of their stone-material, than in the ingenuity of these combinations?[18]

Because Jarves was one of the foremost critics of the period and the art form, his statement is worthy of careful dissection, especially for the explicit ways in which his rejection of color was tied to a rejection of the representation of blackness. First and again, whiteness was not accorded the value of a color but was situated as a universal category, a starting point that could be departed from, so much so that altering the uniform whiteness of marble was accorded the status of a violation of primary truth. To Jarves, the principal function of sculpture was form, and color (other than the uniform use of white marble, bronze, or gilt) interfered with the viewers' primary motivation, the intellectual consumption of the sculpture. Tinted sculpture provided a distraction that was emotive and sensorial, experienced at the level of feeling; in other words it registered in the viewer's body, not in the mind, which was equated with morality. Perfectly aware of the historical and contemporary practices in polychromy, which he labeled "artistic freaks," Jarves used the term *blackamoors* to register and marginalize at once the expanded possibilities for racial signification, here explicitly that of the black body and skin, which polychromy provided. What polychromy made possible, the representation of blackness at the level of skin color, was precisely what Jarves refused by dismissing the possibility of "pleasure" in the consumption of polychromy as a mere matter of material construction. In the end, his insistence on the whiteness of marble in sculptural practice is also a colonial insistence on the universality of the white body and skin as the aesthetic paradigm of beauty and morality in art. Polychromy was equated with everything the (neo)classical was not; therefore, if the (neo)classical body was white, the polychrome body was decidedly black, and if the (neo)classical was contained, controlled, pure, restrained, and noble, the polychromed was unruly, diseased, sensuous,

and immoral. Jarves's rejection of polychromy was nothing short of the rejection of the black body itself. The anxiety evident in this rejection has been detailed by Batchelor:

> Chromophobia manifests itself in the many and varied attempts to purge Color from culture, to devalue Color, to diminish its significance, to deny its complexity. More specifically; this purging of Color is usually accomplished in one of two ways. In the first, Color is made out to be the property of some "foreign" body—usually the feminine, the oriental, the primitive, the infantile, the vulgar, the queer of the pathological. In the second, Color is relegated to the realm of the superficial, the supplementary, the inessential of the cosmetic. In one, Color is regarded as alien and therefore dangerous; in the other, it is perceived merely as a secondary quality of experience, and thus unworthy of serious consideration. Color is dangerous, or it is trivial, or it is both. (It is typical of prejudices to conflate the sinister and the superficial.) Either way, Color is routinely excluded from the higher concerns of the Mind. It is other to the values of Western culture. Or perhaps culture is other to the higher values of Color. Or Color is the corruption of culture.[19]

Jarves's fervent dismissal of polychromy would most certainly have been predicated on his knowledge (if not firsthand, then surely through reviews and by word of mouth) of the work of the French sculptor Charles-Henri-Joseph Cordier. Perhaps the most celebrated and renowned contemporary practitioner of material polychromy, Cordier notably produced polychromed representations of black subjects under a French government commission at midcentury.[20] Combining porphyry, onyx, and bronze, works such as his *African in Algerian Costume, or African of the Sudan* (1857) (Figure 14) were intended for the new ethnographic gallery in the Musée d'histoire naturelle in Paris.[21] Unlike the supposedly strict aesthetic pursuits of neoclassical sculpture, the sculptures of artist–ethnographers functioned in the nineteenth century like the ethnographic photographs that were soon to replace them. They stood for objective representations of bodies that were consumed as scientific evidence of the racial difference and inferiority of Other cultures and peoples and thus supported Europe's colonization of other continents. Like an ethnographer's, Cordier's proximity to his human subjects served only to authenticate his "findings" in the field with his nineteenth-century audience. The task of Cordier, in traveling to France's North African colonies, was to capture racial types in amalgamated composites of the individuals he encountered—a point confirmed by the ethnic, racial, and cultural generalizations deployed in the seemingly interchangeable titles he attached to his sculptures.[22] This objective was fundamentally based on racial essentialism, which located colonialism's acceleration of racial hybridity, through miscegenation and cultural mixing, as a threat to so-called pure racial types, which artist–ethnographers such as Cordier needed to capture. Like his human scientist counterparts, the artist–ethnographer, perhaps more than the artist in pursuit of a supposedly purely aesthetic end, worked through a colonial process dependent on the white gaze as an "objective" tool of visual scrutiny. Cordier's ethno-aesthetic was antineoclassical

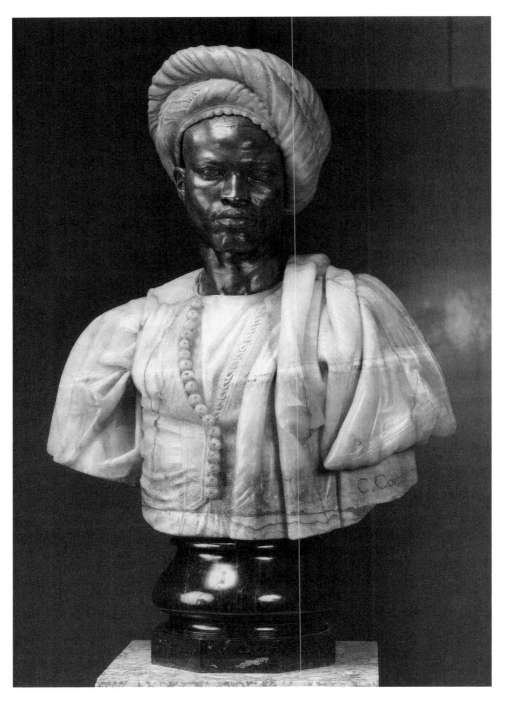

Figure 14. Charles-Henri-Joseph Cordier, *African in Algerian Costume, or African of the Sudan,* 1857. Bronze, onyx, porphyry. 76 x 66 x 36 cm. Musée d'Orsay, Paris, France. Scala/Art Resource, New York.

in its materiality, which, through the use of various colored stones, signified racial difference at the level of skin. However, Cordier's desire to represent "pure" racial types, as opposed to representing portraits of individuals he encountered, was similar to the dominance of ideal works in neoclassicism and their investment in racial differencing.

Color and the Racial Regulation of the Female Body

Hawthorne, Brewster, Young, Jarves, and others all acknowledged the moral imperative of marble for the aesthetic transformation and fetishization of the body into art. However, as Jarves's comments reflect, the significance of marble also rested in its influence on the bodies of viewers and sculptors, in other words, on how viewing sculptures made them feel.

On visiting the studio of an American sculptor in 1858, Hawthorne cleverly couched his comments about the man's "polish or refinement" in terms of the properties of the media in which he worked. "For one expects to find the polish, the close grain and white purity of marble, in the artist who works in the noble material; but, after all, he handles *clay,* and, judging by the specimens I have seen here, is apt to *be* clay—not of the finest—himself."[23] The aesthetic and moral judgments that these authors declared matters of "eye," "taste," "essence," and "purity" implicate the hegemonic nature of class formation and class-specific cultural practices, which determined material choices, representational strategies, and the parameters of visibility and identification for represented bodies.

The word *flesh,* deployed by both Hawthorne and the anonymous critic mentioned above, points out the aesthetic rejection or refusal of the human body as a biological and sexual phenomenon. Flesh was adopted as the antithesis of the aesthetic and spiritual transformation of the body by the artist. Flesh was a reminder of bodily functions and secretions, but it was also a reminder of physical desire and sexual contact and was understood as a dangerous trigger to the incitement of passion or desire in the viewing body. The more real the represented body in art, the more likely it was to evoke an inappropriate sexual, visceral response from a viewer. The practice of coloring marble, through its enunciation of flesh, threatened to expel the represented body from the realm of the ideal or allegorical. Race performed as complexion provoked this rupture.

Not surprisingly, within a patriarchal culture, opposition to color in sculpture often actualized around discussions of the female body. While visiting with Hawthorne in Florence in June 1858, Hiram Powers decried the use of color, also using Gibson as an example of the misuse of marble. According to Hawthorne:

> The best thing he [Powers] said against the use of colour in marble was to the effect that the whiteness removed the object represented into a sort of spiritual region, and so gave chaste permission to those nudities which would otherwise suggest immodesty. I have myself felt the truth of this in a certain sense of shame as I looked at Gibson's tinted Venus.[24]

The key words in Hawthorne's admission are *felt, immodesty,* and *shame,* for they explained his emotions or feelings in the face of the sculpture, emotions that he felt were sexually inappropriate. Hence, another crucial measure of the moral worth of art was not just what was represented but also what feelings (or indeed actions) the representation inspired in the viewer and whether such feelings/actions were deemed appropriate to the experience of "high" art. While visiting the Academy of Arts at Rome, Samuel Young Jr. admitted, "One or two of the marble female figures there, I like better than the Venus de Medici; and had I been alone, I should have kissed them. Couldn't help it!"[25] This rather playful, tongue-in-cheek statement recorded, nevertheless, a moment of "inappropriate" passion, wherein the beauty, sensuality, and "realism" of the female nudes inspired the fantasy of romantic/sexual contact between viewer and object. Young, however, makes us aware that he was cognizant of the impropriety of his feelings; his "had I been alone" alerts us to his knowledge of the cultural prohibition of such immoral desires. This movement toward sensual/sexual action as opposed to moral/ aesthetic contemplation was deemed one of the characteristics of "bad" art, "low" art, or pornography.

At issue was the ethics of art, with a struggle between the ideals of truth versus illusion and abstraction versus the "real," which indexed class divisions between so-called cultivated and uncultivated tastes. French critic Paul Mantz's biting criticism of Gibson's *Tinted Venus* (Figure 13) and *Pandora,* which he compared with mass-produced, neo-rococo figurines as examples of "le sentiment le plus bourgeois," locates the negotiation of class identifications within this aesthetic debate.[26] The whiteness of the marble so treasured by the aristocratic and bourgeois elite was seen not as another color with tangible aesthetic and symbolic properties but as a neutral or a noncolor, awarded the status of a privileged signifier. As Wolfgang Drost has commented:

> The eighteenth-century opposition between white marble sculpture, thought to represent a universal and philosophically purified reality, and polychrome sculpture, believed to be capable of reproducing material reality, remained essential to neo-classical doctrine throughout the 19th century.[27]

The nineteenth-century criticism of polychromy indexed neoclassicism's complex rejection of "colored" or even bronze sculpture, a rejection that embodied a resistance to "realism," which was indicative of class positions, as well as a statement against the aesthetic potential of the emerging technologies of photography. Although in the following Jarves is referring specifically to an invention by the American sculptor Joel T. Hart, a mechanical instrument that used a mathematical system to measure and transpose the subjects of representation, his opposition to Hart's invention also registers much of the anxiety around the mechanized representational process of photography.

> But he makes a fatal mistake to the dignity of his art in also reducing it to a system
> of external measurements, believing, as he undoubtedly does, that "beauty, expression,

and character" can all be reproduced in material through the agency of a machine. This is but another development in the common error of the age, by which mere science is made paramount to spirit, and all phenomena of the soul resolvable into her laws. . . . No machine can model an idea, or fill an hiatus of the imagination. When we succeed in measuring the soul, then, and not until then, we may be able to reduce sculpture to a mechanical art.[28]

Yet, beyond the cultural debates that disputed the role of technologies in aesthetics, neoclassicism's loyalty to white marble also undoubtedly registered the colonial "problem" of racial difference, which pointed up critical tensions around the persistence of American slavery and the "problem" of miscegenation and the interracial body.

Writing in 1861, Edward E. Hale provided an alternative viewpoint in his somewhat hesitant support of Gibson's controversial polychroming practices. Describing Gibson's tinting of marble as a process that achieved "a glow as from a warm sunset . . . making the marble seem warm instead of cold," Hale further explained the difference in sensorial experience in the face of the uncolored and the tinted marble:

> You have seen "Venus" in plaster: you see her now in marble, uncolored. The figure is exquisite, and you think you are satisfied; when a curtain is drawn, and you see her sister, alive and not dead, triumphant with her gold apple, instead of shivering in affected triumph; because she is ruddy and warm and not cold and blue.[29]

Interestingly, the term *ruddy* was often deployed in the nineteenth century to describe the complexion of interracial bodies, something that I will discuss in chapter 5. In Hale's observation, the ruddiness of the marble provided the representation of skin color and the illusion of life, which he saw as the triumph, not the shame, of the sculptural representation. Advancing his argument in support of the tinting of marble to achieve flesh tones, Hale argued:

> The real question, then, is this: If next week, in some new quarry at Seravezza or in Rutland, a vein of marble more flesh-like in color should be found than any used to-day, would not every artist gladly use it in his busts of living men and women? If not, why do we not work in black marble or green? We work in white, because that is the nearest approach we have to the color of the human flesh.[30]

The answer to Hale's question is not as straightforward as one might assume. Frankly, it was not at all obvious to neoclassical sculptors that a yellow- or pink-tinged marble would have been preferable to their preferred stark white medium. In overlooking contemporary sculptors' active employment of black and green marbles in representations of human subjects, Hale assumed that the use of white marble was a matter of material availability rather than ideological choice. While speaking in support of the possibilities of polychroming, Hale disavowed racial difference by defining human flesh, represented by white marble, solely as white flesh. White marble was not simplistically

deployed because of its closeness to white flesh. Rather, it was preferred precisely because it did not closely approximate white skin. Instead, it functioned as a supposedly universal abstraction of the biological reality of all white skin, which absented the possibility of racial difference, making the black subject more palatable to a dominantly white viewing audience. For if black bodies were cloaked in white marble, then the most obvious and arguably primary signifier of race, skin color/complexion, was obliterated and contained.

Just as the privileged signifier the phallus *is* not the penis and is therefore irrevocably bound to the penis, whiteness, the privileged signifier of race–color is not wholly interchangeable with white skin but is dependent on and bound to the racialization of whiteness. The whiteness of the marble as deployed within the nineteenth-century neoclassical canons did not directly represent white skin color but stood in for that which could not be signified, the *too palpable flesh* of Gibson's Venus. But inasmuch as it signified that which it displaced, flesh, it privileged the European race–color as the source of the signification and disavowed the possibility of Other race–color significations. What the white marble of nineteenth-century neoclassical sculpture really suppressed was the possibility of the representation of the black body, which registered racial–color difference at the level of the skin.

Distinguished from Gibson's practice of direct pigmentation, nineteenth-century neoclassical white marble sculptures were also colored with light. Three distinct practices, all dependent on light, were well documented in nineteenth-century texts and visual representations. And although they would appear to be no less visually titillating than direct pigmentation, their "purity" and cultural acceptability appear to have rested in the indirectness of their process. Albert TenEyck Gardner's *Yankee Stonecutters* (1945) recalled the common practice of moonlit strolls through the sculpture-laden ruins of Rome. One such excursion was recounted by Samuel Young Jr., who recorded, "A party is getting up with us to visit the Coliseum by moonlight."[31] Meanwhile the author Grace Greenwood (Sara Jane Lippincott) detailed what she described as the "rare pleasure" of a visit to the sculpture galleries of the Vatican by torchlight. Greenwood expressed amazement and pleasure at the ways in which the sculptures seemed to "spring up" around them. The shift that the torchlight performed was to animate the cold, still whiteness of the static sculptural objects. They seemed to Greenwood alive as she watched the play of deep shadows fall across them: "I almost looked to see the drapery heave on the breast of the sleeping Ariadne, to see her heavy eyelids lift under the glare of the torch."[32] What Greenwood records searching for were signs of the living body, breath and movement, but it is the play of the light on the marble surfaces of the still white stone that inspired this search. Along very similar lines, the sculptor Thomas Crawford, describing his torchlit visit to the Vatican, recalled

> pausing here and there amid the dark and silent shapes on either side, to throw the light of the torches upon some figure, and behold it start, as it were, into being. Pale marble assumes a fleshy tint; the rigid limbs seem to relax, the eyes move, the lips unclose.[33]

For Crawford as for Greenwood, the moment of anticipation of life was directly connected with the shift in a sculpture's color, the "fleshy tint" that was prompted by the warming effect of the light.

An even more dramatic example of the illusionistic interaction of light and white marble is the immensely popular neoclassical sculpture called *Ariadne on a Panther* (1804–14), by Johann Heinrich von Dannecker. The sculpture, which William Gerdts has described as "the most admired and revered Neoclassic statue in Europe, for visiting Americans,"[34] was housed in the private Bethmann Museum, in Frankfurt, and considered an essential stop within the travels of mid-nineteenth-century cultural tourists. What made this sculpture unique was its position directly in the path of a tinted pane of glass, which facilitated its transformation, via the illumination of sunlight, from cold white marble to the rosy-pink hue of living flesh. A similarly indirect illusion of white flesh was recalled by a viewer of Hiram Powers's *Greek Slave,* who described the "rosy tinge flushing the pure marble," an effect caused by the scarlet velvet drapery that framed the sculpture at the Great Exhibition of 1851.[35] Even though the technique of achieving the illusion of flesh was secondary and perhaps in its indirectness more innocent, Dannecker, like Gibson, had his share of detractors, principally for the same reasons.[36]

Racial Primacy: Neoclassicism's White Bodies

The strategic use of whiteness was paramount in the acceptability of the nude in art. Whiteness as a universal category, a noncolor, provided an abstraction that sublimated sensualism to a moral or intellectual ideal.[37] The use of light, as with Gibson's wax and paint method, created the illusion of the biological body largely through its ability to transform the pale coldness of stark white marble into the living warmth of human flesh. But the light also racialized the body in its ability to deploy the illusion of skin color, here, not just of any skin but of white skin. As the Freudian concept of the phallus masks the reality of sexual difference, so too did the symbolic privilege of neoclassical whiteness mask the possibility of racial difference. The illusion of flesh dislodged the strident whiteness of the marble and toppled its disavowal of racial difference, for in producing the effect of the white body/skin, the light, be it moon, torch, or sun, made possible the existence of an Other body/skin, that of the black body.

It is not insignificant that the majority of the marble bodies sculpted within the neoclassical style were female, many of them unclothed or semiclothed. The idea that the white female body represented the absolute paradigm of aesthetic beauty was widely accepted within the colonial discourses of nineteenth-century western art and science. According to Jarves:

> Female loveliness is the most fascinating type of humanity. In it we have the highest development of form and color as united in beauty. The lines of the perfect human form are the most beautiful in their graceful curvatures that Nature produces. So of

color. No hue of the animal or vegetable kingdom rivals the tints with which the charms of woman glow. . . . The Art that can make us feel the smoothness and elasticity of the female skin, its clear, translucent surface, not lustrous but tender from its delicate mingling of white and pale warm red, subdued by the nicest gradations of the purest and most pearly greys into sense-captivating loveliness, is scarcely of earthly mould.[38]

Jarves is referring not simply to female loveliness but, as his description of skin betrays, exclusively to *white* female loveliness, which within the context of nineteenth-century colonial discourse were one and the same. The translucent, delicate, clear flesh that he describes is no doubt the skin of the white female body, which the marble was used to represent. The marble's moral efficacy helped to mediate the representation of potentially transgressive—sexually and racially—female subjects and, specifically, their representation as the nude, a form that has traditionally required a raison d'être to establish its cultural legitimacy and secure its moral function. To most neoclassical sculptors at midcentury, as well as to their audiences, the whiteness of marble was an essential component of the aestheticization of the human body. The sculptures by nineteenth-century American artists reflect their hesitancy to embrace the nude figure as well as the relative conservatism of their American audience and patrons as compared with their European counterparts.

Even for the culturally knowledgeable American viewer, the nudity of bodies represented in marble was often rejected on moral grounds. When viewing the *Venus of the Capitol* at Rome, the American tourist Samuel Young Jr. noted with obvious sarcasm, "She is naked of course, like all good statues."[39] Similarly, on viewing the "poor nudity" of the sculpture *Eve Tempted* (c. 1842–43) (Figure 15), Hawthorne decried her "frightful volume of thighs and calves" and speculated, "I do not altogether see the necessity of ever sculpturing another nakedness. Man is no longer a naked animal; his clothes are as natural to him as his skin, and sculptors have no more right to undress him than to flay him."[40] As was his pattern, Hawthorne's opinion on nudity found its way into the mouth of one of his novel's characters when the painter Miriam launched into a tirade against nudity in *The Marble Faun*. As a prelude to the unveiling of the sculpture of Kenyon's *Cleopatra,* she complained:

> "Not a nude figure, I hope! Every young sculptor seems to think that he must give the world some specimen of indecorous womanhood, and call it Eve, Venus, a Nymph, or any name that may apologize for a lack of decent clothing. I am wary even more than I am ashamed of seeing such things. Now-a-days, people are as good as born in their clothes, and there is practically not a nude human being in existence. An artist, therefore,—as you must candidly confess,—cannot sculpture nudity with a pure heart, if only because he is compelled to steal guilty glances at hired models."[41]

Miriam's discomfort was as much about the process of viewing the nude as it was about the process of creating the nude—the contact, visual and physical, between the body

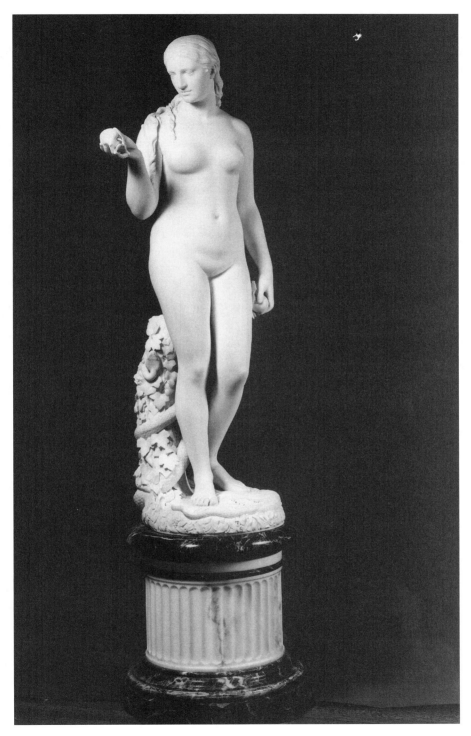

Figure 15. Hiram Powers, *Eve Tempted,* c. 1842–43, carved 1873–77. Marble. 174.9 x 75.8 x 52 cm. Smithsonian American Art Museum, Washington, D.C. Museum purchase in memory of Ralph Cross Johnson.

of the artist and the unclothed body of the artist's model. It is in this light that William Gerdts has noted "the pure, virginal white marble itself," which provided "an abstraction of form that made nudity acceptable."[42] White marble helped to remove the sculptural body from the real space of the viewer and facilitated the transformation of the human body into the nude or what Jarves referred to as a form "wrapt in beauty's mould."[43] It is not of incidental significance that many of the most popular subjects of nineteenth-century neoclassical sculpture were women made infamous by supposedly demonic power activated by sexual and gender transgressions: Cleopatra, Salome, Medea, Delilah, Judith, Clytemnestra, and Cassandra. The symbolic function of marble became paramount. As Joy Kasson has stated:

> By its ability to transform hot-blooded humanity into cool and approachable marble, the classical tradition gave nineteenth-century artists and viewers a way to explore— but at the same time contain—their fascination with alluring and sometimes disturbing subjects.[44]

And yet, even more disturbing than a white female nude to a white viewing audience was a black one.

PART II
FROM SLAVERY TO FREEDOM

4. White Slaves and Black Masters
Appropriation and Disavowal in Hiram Powers's *Greek Slave*

The *Greek Slave*

As I have argued above, the deployment of white marble within nineteenth-century neoclassical sculptural practice actively disavowed racial difference, specifically blackness, through proscriptions at the level of media and material practice that successfully obstructed the possibility of racing the body in the dimension of skin color/complexion. What I detailed in the previous chapter was a material and aesthetic displacement. However, the black female body was also displaced at the level of theme or subject through a further disavowal of the immediacy of the contemporary sociopolitical contexts of colonialism and slavery. In other words, nineteenth-century artists often refused to create contemporaneous black female subjects, who would have been, by necessity, contextualized by or narrated through nineteenth-century race politics. Hiram Powers's *Greek Slave* (Figures 16 and 17) is exemplary of this second displacement and indicative of the instability of meaning, the ambivalence of racial identifications, and the quagmire of racial politics that these artists navigated.

Powers's *Greek Slave* is a work with which scholars of nineteenth-century American neoclassical sculpture must contend, if only because of its startling international popularity. What William Wetmore Story's *Cleopatra* would become for the 1860s and Gibson's *Tinted Venus* had been to the 1850s, Powers's *Greek Slave* (Figure 16) was to the 1840s. It is important to note that Powers's sculpture was both a popular and a financial success for the artist.[1] The iconic status of Powers's female nude was due in part to the frequency of its citation within the literature of cultural tourism, laudatory poetry, and the popular press. But it was also carefully orchestrated by the painter Miner K. Kellogg, Powers's American agent, who published a collection of favorable reviews in a pamphlet, which, distributed to viewers of the *Greek Slave,* served to prepare them

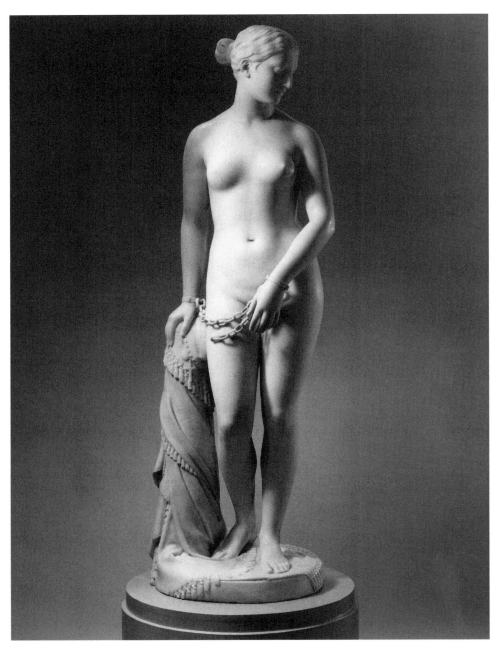

Figure 16. Hiram Powers, *Greek Slave,* 1848, third version. Marble. 165.7 x 53.3 x 46.4 cm. The Collection of The Newark Museum, Newark, New Jersey. Gift of Franklin Murphy Jr., 1926.

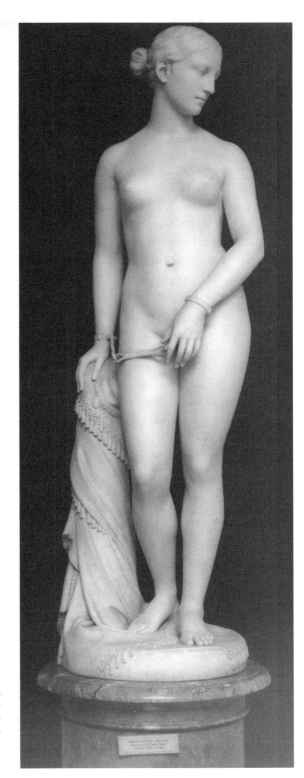

Figure 17. Hiram Powers, *Greek Slave,* 1869,
sixth version. Marble. 167.6 x 50.2 x 46.7 cm.
The Brooklyn Museum, Brooklyn, New York.
Gift of Charles F. Bound (55.14).

for an appreciation of the sculpture's subject and narrative by persuasively acquainting them with the artist's intentions.

Having viewed Gibson's *Venus,* cultural tourist Samuel Young Jr. recorded his opinion: "It is very beautiful and quite equal to Powers' Greek Slave."[2] Writing in 1853, Young aptly recognized the degree to which Powers's sculpture had become the contemporary standard against which all other sculptures were to be measured.[3] In *Graham's Magazine* in 1855, Anna Lewis went even further in her canonization of the sculpture, favorably relating the *Greek Slave* to treasured ancient sculptures such as *Minerva Parthenos* and *Venus de Medici.*[4] The fame of Powers's *Greek Slave* is owed in part to its reception at the Great Exhibition of 1851, in London, where it was awarded a place of honor at the end of a central nave decorated with other plasters and marbles. Also of great significance was the royal sanction of Queen Victoria, who, with "her little train, before the doors were open to the public, sat for more than half an hour in front of it," according to the record of the American tourist Horace Binney Wallace.[5] This sanction undoubtedly helped to secure a place for the *Greek Slave* in the contemporary canon, increasing the sculpture's currency for the Other classes who flocked to see it in public exhibition or purchased more modest ceramic replicas for their own homes. The vast popularization of the *Greek Slave* through affordable small-scale replicas was somewhat snobbishly recalled by Henry James, who commented on them as "even so pensive, in sugar-white alabaster, exposed under little domed glass covers in such American homes as could bring themselves to think such things right."[6]

The exhibition history of some of Powers's versions of his *Greek Slave* serves as a testament to the midcentury democratization of "high" art exhibition practices. As early as 1845, the first version was publicly exhibited by its English owner at Grave's Pall Mall, in London.[7] However, it was Hiram Powers's third version of the sculpture that was seen by vast numbers of people in New York, New England, Philadelphia, Baltimore, Washington, Louisville, and St. Louis between August 1847 and July 1851.[8] This sculpture was rather paradoxically welcomed in the American North as well as in the slaveholding South, also touring in New Orleans (1849), Augusta, Georgia, and both Charleston and Columbia, South Carolina (1850–51).[9] A typical handbill advertised a twenty-five-cent entrance fee and the availability of pamphlets for six and a half cents while briefly summarizing the sculpture's international acclaim and thematic and narrative intent.[10]

The stunning popularity of the *Greek Slave* was also realized in commissioned replicas, which included smaller full-length figures, busts, and even Parian ware and ceramic "souvenirs."[11] Between the summer of 1842 and the fall of 1869, Hiram Powers completed at least six known versions of the sculpture titled *Greek Slave.*[12] While the first, third, and fifth versions were basically unchanged except for alterations to the base, the other three versions were more dramatically altered. The discarded garments in the second version loop once, not twice, around the supporting pillar, and the fourth and unlocated version was reportedly draped or clothed.[13] The most dramatic change occurred in the sixth version (Figure 17), in which Powers altered the original decorative

chains that bound the figure's wrists to a more realistic and historically specific manacle, an alteration with pointed symbolic repercussions for the representation of blackness and slavery, which I will pursue below.

From Venus to Slave: Narrating Nudity

Powers, who had begun his career sculpting wax figures for a representation of Dante's *Inferno* at the Dorfeuille's Western Museum in Cincinnati, loosely modeled the *Greek Slave* on the classical sculpture *Venus of Knidos* (c. 350–300 BCE) but changed Venus into a slave.[14] Antique examples of Venus often had the same compositional arrangements, which provided modesty to the white female body by positioning the hands in front of the chest and the genitalia. Powers would also have had access to the *Capitoline Venus,* at the Musei Capitolini, Rome, the *Venus de Medici,* at the Uffizi, in Florence, and the *Venus Victrix,* also at the Uffizi, among other works. This change from a pagan to a particular kind of Christian subject was instrumental in the sculpture's acclaim, particularly for a puritanical American audience. Powers's racial and sexual choice of subject, as we shall see, was the first step in securing a high moral tone, offering a spiritual intention and historical context defending against claims of sensualism, which undoubtedly accompanied the representation of the female nude. American sculptors were acutely aware of the dangers inherent in the representation of the nude and the need for a raison d'être to mediate nudity. Powers's comments in the wake of his *Fisher Boy* (1844) not only demonstrated his desire to contain the sexuality of *Eve Tempted* (1842) and the *Greek Slave* but clearly defined the threat of a possible transgression.

> It is a difficult thing to find a subject of modern times whose history and peculiarities will justify entire nudity—but where the subject and its history make this necessary, it may be looked upon with less reserve than it could be if the exposure were intentional on the part of the artist. In the case of my Eve clothing would be preposterous, for she was conscious she was naked only *after* she had fallen. History and nature both require nudity. The Slave is compelled to stand naked to be judged of in the slave-market;—this is an historical fact. Few such subjects, however, can be found.[15]

In referencing the idea of *reserve,* Powers described how modes of viewing and inevitably pronouncements of quality were determined by the artist's ability to narrate a safe space of viewing for his or her audience and by aestheticizing and abstracting the human body, permitting the viewer to consume the unclothed subject within nineteenth-century bourgeois limits of politeness.[16] Since nineteenth-century audiences often consumed art in public or semipublic spaces, the need for the artist to provide a safe narrative framework that allowed for a socially appropriate contemplation of the unclothed human form was even more acute. Karen Sánchez-Eppler has argued for the process of reading sentimental fiction to be understood as a "bodily act" wherein the representation of slavery could trigger physical sensations in the reader's body, such

as tears, sobbing, increased heart rate, and so forth. As descriptions of audience responses attest, particularly those of women's reactions to Powers's *Greek Slave*, the act of viewing sculpture was equally understood to be a sensorial experience that could alter the emotional and physical state of the viewer. But whereas reading was largely a private activity, the often public nature of art viewing dictated a more strict moral policing of subjects and limits of representation. The artist's intentions were closely scrutinized by viewers, who were quick to condemn what they saw as unfounded or illegitimate nudity. Powers asserted that since the mastery of the sculptor's art was largely judged on his or her ability to represent the human form, the sculptor searched for subjects that would allow the demonstration of an intimate knowledge of human anatomy without a disruption of the idealized chastity, purity, and innocence of the paradigmatic white female subject that nineteenth-century white bourgeois audiences demanded. To maintain this ideal nudity, a cause was needed that could effectively remove the responsibility of a potentially sexual gaze from the white female subject: *Eve* was nude because shame did not exist before the Fall; the subject of the *Greek Slave* was nude because she had been forcibly stripped; neither then was morally responsible for her unclothed state.

But it was also the racial specificity of Powers's female slave, her signification as a white woman, that simultaneously ensured the sweeping sentimentalism and the paternalistic moral concern with which she was greeted, inasmuch as it disavowed the immediacy and horrors of American and transatlantic slavery and the specific oppression of black female slaves. Within a patriarchal society, the body of a female slave ensured that the sculpture could be received with sympathy rather than with the pity or shame that may have easily been associated with a male slave. While the chains on the female slave could index a female passivity and helplessness associated with nineteenth-century bourgeois femininity, on a male slave they invoked a symbolic castration, the loss of masculinity and maleness through inaction and powerlessness. While popular cultural art forms explicitly visualized the brutalities of slavery, to enter the realm of "high" art, slavery had to be sanitized, so to speak. It had to be aestheticized and the body of the slave contained in ways that facilitated the Victorian ideal of visual consumption. This point was critical to the white female slave's acceptance, since, as the abolitionist author Harriet Beecher Stowe stated, "slavery, in some of its workings, is too dreadful for the purposes of art. A work which should represent it strictly as it is, would be a work which could not be read."[17] It is telling that Stowe used the word *read* and not *written*, a choice indicating the artist's critical role in the aesthetic "cleansing" of slavery and the concern for the reader of such a work.

Yet, Powers inverted not only the race of the slave but also that of the master and in so doing opened his sculpture to the possibility of symbolic recuperation by abolition and slavery advocates alike. In a letter to Edwin W. Stoughton dated 1869, Powers retroactively described the inspiration for what was and would remain his most famous work:

It was several years after being in this city, and while thinking of some new work to be commenced, that I remembered reading an account of the atrocities committed by the Turks on the Greeks during the Greek Revolution. . . . During the struggle the Turks took many prisoners, male and female, and among the latter were beautiful girls, who were sold in the slave markets of Turkey and Egypt. These were Christian women, and it is not difficult to imagine the distress and even despair of the sufferers while exposed to be sold to the highest bidders. But as there should be a moral in every work of art, I have given to the expression of the Greek Slave what trust there could still be in a Divine Providence for a future state of existence, with utter despair for the present mingled with somewhat of scorn for all around her. She is too deeply concerned to be aware of her nakedness. It is not her person but her spirit that stands exposed, and she bears it all as Christians only can.[18]

Powers chose as the pivotal historical moment of his sculpture the Greek War of Independence (1821–30). During this war Americans used religion and race to broadly identify with and support the Greeks, marginalizing the Turks as nonwhite and non-Christian oppressors. Americans analogized themselves, like the modern Greeks, as the rightful descendants of the ancient site of democracy and compared their own revolution to the events of the Greek War.[19]

Yet, Powers's letter exceeds a mere explanation of the context, theme, and subject of his sculpture. It indicates the fabrication of moral tone, which was repeated continually in newspaper reviews, laudatory poems, and descriptions of the sculpture. Symbolically, the morality of the female nude was conspicuously encoded in her marble body in several ways. First, Powers's composition included on the draped pillar to her right a cross and a locket, symbolizing Christianity and love, respectively. Second, the strategic placement of the rather decorative chains in the original conception, ensured that the slave's bonds, along with her left hand, which fell down across and in front of her body, thwarted an unrestricted view of her genitalia. Powers was direct about this compositional choice: "Her hands [will be] bound and in such a position as to conceal a portion of the figure thereby rendering the exposure of the nakedness less exceptionable to our American fastidiousness."[20] The sculptor would again return to this strategic placement to deny an unimpeded view of the white female sex in his later allegorical nude *California* (1858), which held a divining rod. Third, and as Powers had intended, her averted face and rather ambiguous expression were taken as signs of self-absorption, which was repeatedly interpreted as both a spiritual unconsciousness of her tenuous position and a mixture of both resignation and Christian resolve.[21] Further, her head, in almost full profile, ensured that the *Greek Slave* could not be interpreted as inviting a sexual gaze and also linked the sculpture to the paradigmatic visualization of whiteness in western human "sciences," in which the profile pose was incessantly deployed as a means of objectifying bodies and measuring racial difference through physiognomy.[22] Perhaps most important, Powers's letter also explicitly described

a raison d'être for the female subject's nudity, an absolute necessity in the sexually re-gressive Victorian culture of the midcentury. The subject of the *Greek Slave* was nude indeed, but because she had been stripped against her will and was unaware of her own nudity, her morality and Christian virtue were preserved, and any sensualism was safely detached from her person and made the responsibility of her audience, both real and imagined.

Imagining Audiences

Analysis of the reception of the *Greek Slave* must contend with at least two audiences—the "real," dominantly white, bourgeois, Victorian audience, who flocked to see it, and the "imagined" audience of nonwhite, nonwestern men whom Powers's racialized narrative implied. The context of Powers's thematic choice, perhaps more than that of most sculptures, was dependent on the evocation of the latter imaginary audience for its efficacy. The imaginary audience that the nineteenth-century viewer was compelled to contemplate was a disquieting rabble of lascivious Turks, a band of brown-skinned men pushing and crowding toward the market stage, where this chaste, moral, Chris-tian, and let us not forget white, woman was about to be auctioned as a slave to the highest bidder. As one poet saw it, the scene was set, "in base Constantinople's foul Bazaar!"[23] Dependent on the racialization of sexuality, the narrative relied on the pop-ular belief in the overdetermined sexuality of Other races. The threat was not just of male sexuality but of *black* male sexuality. The immediate dichotomy of slave/master and colonized/colonizer, which still persisted within the contemporary practices of transatlantic slavery, was inverted and firmly reentrenched. The white female was the slave on whom the evil brown Turks were about to commit horrendous atrocities that were, as indicated in her helpless unclothed and shackled posture, of a particularly heinous and explicitly sexual nature. Inasmuch as her fate was surely rape, the sculp-ture played on the cult of bourgeois femininity and the idealization of white female beauty as a trophy for heterosexual males.

Joy Kasson has ably noted that the abandoned sexuality and immoral sensuality widely associated with eastern cultures within western Orientalisms were actively deployed within nineteenth-century "high" art and popularized within more illicit and mass-produced cultural examples of pornographic prints and novels.[24] Many examples represented female slaves within the theme of sexual enslavement as it related to Euro-centric ideas of oriental harems, in order to arouse or titillate. Perhaps most famously, French Orientalists such as Jean-Léon Gérôme and Jean-Auguste-Dominique Ingres represented white women, often juxtaposed with the Other bodies of black women, Asians, and interracial women, as sexual trophies for sale in arenas of carnality in paint-ings such as Gérôme's *The Slave Market* (c. 1867) (Figure 18) and *Slave Sale at Rome* (1884) and Ingres's *Bain turc* (1852–63) and *Odalisque with the Slave* (1840).

Gérôme's painting advances the narrative that Powers's sculpture implied, repre-senting the moment of physical inspection of the female slave body by "dark" males.

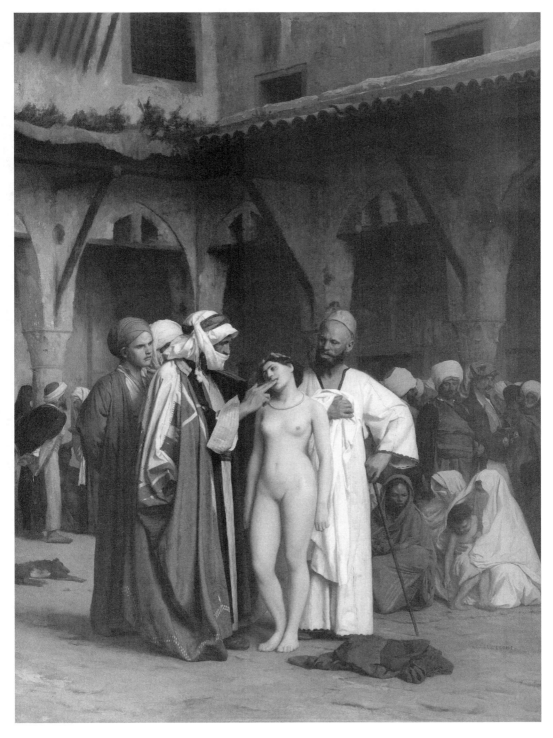

Figure 18. Jean-Léon Gérôme, *The Slave Market,* c. 1867. Oil on canvas. 84.3 x 63 cm. Sterling and Francine Clark Art Institute, Williamstown, Massachusetts.

Three males stand to her left. One male, most likely the potential buyer, boldly inserts his fingers into the standing woman's open mouth. This penetration is sexual, prophesying the later vaginal penetration that is certain to follow and echoing the oral penetration of pornographic prints such as those of Thomas Rowlandson. The standing, frontal, and unclothed state of the female body increases her vulnerability, as does her expanse of white/Asian/interracial flesh against the darker complexions of the male assessors. The crouching women behind this central display, fully covered and veiled, indicate the extent of the public revelation that this woman has endured, as does the pile of discarded clothing at her feet.

The painter Miner K. Kellogg, who had acted as Powers's agent during the American exhibition of the slave, successfully exhibited his own painting entitled *The Circassian* at the Academy of Fine Arts in Florence in 1846 and three paintings entitled *The Greek Girl*.[25] Within the domain of sculpture, the Milanese Raffaele Monti's *A Circassian Slave in the Market* was exhibited, like Powers's *Greek Slave*, at the Great Exhibition of 1851. Meanwhile the Frenchman Jean-Jacques Pradier had exhibited his seated white, nude, and turbaned *Odalisque* (1841) (Figure 19) in Paris about the time Powers was beginning work on his slave.[26] Pradier also sculpted odalisques, Turkish harem slave women, sleeping, dancing, reclining, and crouching. There are striking similarities of pose between Pradier's sculpture (viewed from the back) and Ingres's seated, lute-playing odalisque in his *Bain turc*. Pradier's nude also holds a peacock feather fan like Ingres's *Grande odalisque*. Pradier's visualization of a full-size nude odalisque was potentially transgressive, since the erotic and sexual implications, also seen in contemporaneous orientalizing paintings, located an acquiescing, if not sexually provocative and aggressive, white female subject, who, although mediated by a racial "corruption," posed problems for the heightened physicality and intimate viewing relationships of three-dimensional sculpture. However, nineteenth-century French audiences were far more forgiving of sensualism in art than their American counterparts.

Compared with Powers and Gérôme, Pradier offered yet another moment in the sexual narrative. The woman in this instance was already in the harem, already given over to the (interracial) sexual contact. The moments of auction and inspection were past. Calmly seated with drapery and leg carefully positioned for modesty, her role was ironically not modest. She was a servant whose sole purpose was to serve the sexual needs of her implied, yet absent, "dark" master. Her turned head and ambiguous expression—was it calm, amorous?—can be read as her regard of the approaching male body. Are we witness to the titillating moments before miscegenating sex?

Kasson has noted that contemporaneous popular pornographic engravings, such as Thomas Rowlandson's *The Harem*, assumed a foreign or racially Other male sexual gaze and blatantly illustrated the erotic potential of the themes in sexually explicit ways— hence, the seated male's exposed and prominently erect penis. Rowlandson's white female subjects welcome the dark male gaze. They pose, preen, and turn to expose themselves more fully to the master's gaze in the hopes of being the chosen one(s). The titillation here involves both the impending (interracial) sex and the embodiment

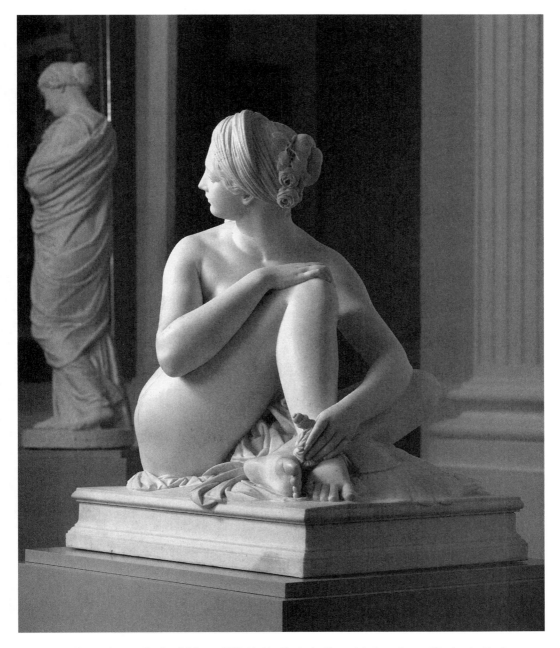

Figure 19. Jean-Jacques Pradier, *Odalisque,* 1841. Marble. Musée des Beaux-Arts, Lyon, France. Réunion des Musées Nationaux/Art Resource, New York.

of white female sexual self-knowledge and action, so repressed in "high" art. Another unnamed Rowlandson print from the same period depicts an orgy, with the sexually aroused turbaned male surrounded by five sexually complicit and aggressive white women, one of them stooping to grip the man's erect penis, seemingly ready to perform fellatio.[27]

The nineteenth-century viewers of the *Greek Slave* did not fail to observe the threat to its female subject along racial lines. Writing in October 1823, Edward Everett of Massachusetts, later a U.S. representative and senator, beseeched his readers "to think of the mothers and daughters sold in the open market, driven with ropes about their necks into Turkish transports, and doomed to the indignities of Syrian or an Algerine slavery."[28] The mothers and daughters for whom Everett pined were the white Greeks, and the slavery that he railed against was that imposed by Syria and Algeria: as if the slave practices of his own American soil were any less indignant to its black mothers and daughters. Powers himself had confirmed that he had imagined his slave to be "among barbarian strangers."[29] By racializing the sexuality of the Turks, some authors stated in more explicit terms their belief in the connection between the white women's inevitable sexual violation and the race–color of their captors: "She knows she is of a trampled race, that the iron grasp of the master is upon her . . . that his heart is hot with lust."[30] And Anna Lewis, a white woman, wrote of the slave being "beneath the libidinous gaze of shameless traffickers in beauty."[31] By choosing to look at instances of slavery in the Greek War of Independence, Powers eclipsed the black female slaves who were, even as he labored in his Florentine studio, being sold naked to and publicly humiliated by white men and women in the slave markets of New Orleans, South Carolina, Virginia, and Alabama in his native America.

Signifying the Slave Body

The *Greek Slave* was most often taken at face value as an artwork within the continuing discourse on the Greek War of Independence. However, because of the unavoidable political currency of transatlantic slavery within the antagonistic national discourse on race in the 1840s, many Americans did not fail to recognize its symbolic relevance to slavery in general and more specifically to the steadfast practices on American soil.[32] Volatile political debates about the conditions for inclusion of new territories in the Union dominated the national imagination throughout the 1840s. In 1846, faced with the expansion of national boundaries triggered by the outcome of the Mexican War, Northern politicians sought to prohibit the extension of slavery into new territories through the proviso added to an appropriation bill by the Democrat David Wilmot of Pennsylvania. The sectarian hostilities were so intense that slaveholding states such as South Carolina threatened secession in 1849. Although the subject of the *Greek Slave* was a white woman, readings of a black female slave were often registered by abolitionists or people sympathetic to the abolitionist cause. The symbolic trigger in the *Greek Slave* that located the possibility of an abolitionist interpretation was the chains.

As Kirk Savage has noted, the popularity and legibility of abolitionist visual imagery, initiated in eighteenth-century Britain and imported to America, was, by the mid-nineteenth century, largely identifiable by strategic deployment of symbols such as the liberty cap and chains.[33]

Chains binding the upraised hands of a kneeling black male slave, represented in profile, became the central symbol in the British abolitionist movement when the image was mass-produced as the sculptural cameo *Am I Not a Man and a Brother?* (c. 1787) (Figure 20), by Josiah Wedgwood.[34] This pose and its symbolism were imported into sculpture-in-the-round in works such as Edmonia Lewis's *Morning of Liberty/Forever Free* (1867), whose kneeling slave woman raises prayerful hands on hearing news of emancipation.[35] So prolific was the symbolic identification of chains with abolitionism in mid-nineteenth-century visual culture that Powers's placement of broken chains under the foot of his allegorical white female sculpture *America* (c. 1848–50) (Figure 21), intended as a national monument for the Capitol building in Washington, provoked its rejection as a potentially inflammatory symbol of partisan abolitionist sentiment.[36]

Powers's experiences throughout the commissioning process of *America* are beneficial to a reading of race in the *Greek Slave,* since the two sculptures intersect in their representation of chains, which provoked abolitionist readings through their inference of slavery and a black slave body. Powers's keen awareness of the inflammatory potential of his symbolic choice was chronicled in his correspondence, which, for almost two decades (1848–65), detailed his aesthetic and political intentions for the sculpture. In a letter from 1848, Powers acknowledged that his allegorical figure was less an accurate allegory of an absolute national democracy than a hopeful vision of a more racially inclusive future. Circuitously citing slavery and the continuing disenfranchisement of blacks in America, Powers wrote of sending his sculpture to "America, where—barring the rice and sugar planters—her doctrine is received as gospel."[37] It was the unfulfilled potential of Powers's national allegory of democracy that trapped him between proslavery interests and some abolitionists whose sentiments were expressed in poems like the one that appeared in *The Liberty Bell* (1852): "Hold back 'America' yet many a year, / Rather than let the pure marble lie!"[38] The lie to which such abolitionists objected was that an allegory of a chain-squashing *America* could ever be used to faithfully embody a slaveholding nation.

In attempts to appease the politicians who controlled the commission, Powers's sculpture, early defined as an American Liberty, underwent extensive symbolic revisions. Largely it seems on the advice of Edward Everett, Powers abandoned the liberty cap, another potentially inflammatory symbol, for his allegorical figure. Significantly, the emblem of William Lloyd Garrison's American Anti-slavery Society represented a helmeted female allegory of Liberty standing on broken whips and chains and bearing a standard topped by a liberty cap.[39] The engraving of *Liberty* in Cesare Ripa's *Iconologia* demonstrates the historicity of many of these features.[40] Another source of the popular examples of the mass deployment of chains in the service of an abolitionist visual discourse was the commemorative medal *England I Revere, God I Adore. Now I Am Free*

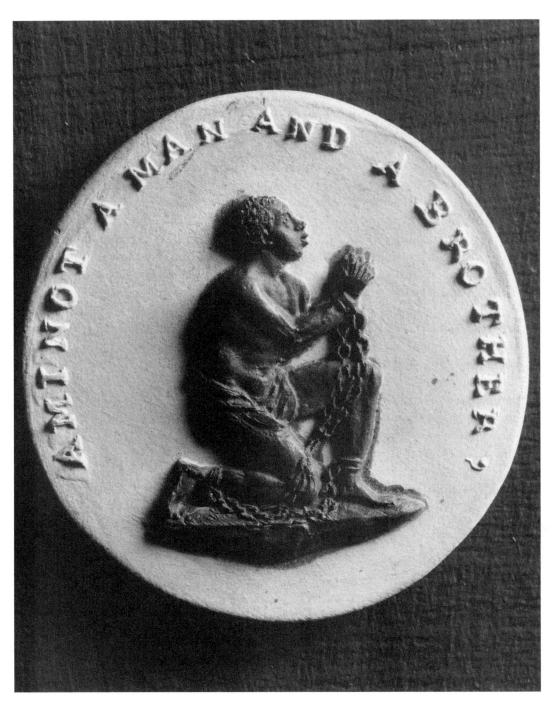

Figure 20. Wedgwood Jasper medallion, *Am I Not a Man and a Brother?* c. 1787. Diameter of 35 mm. Courtesy of the Wedgwood Museum Trust, Staffordshire, England.

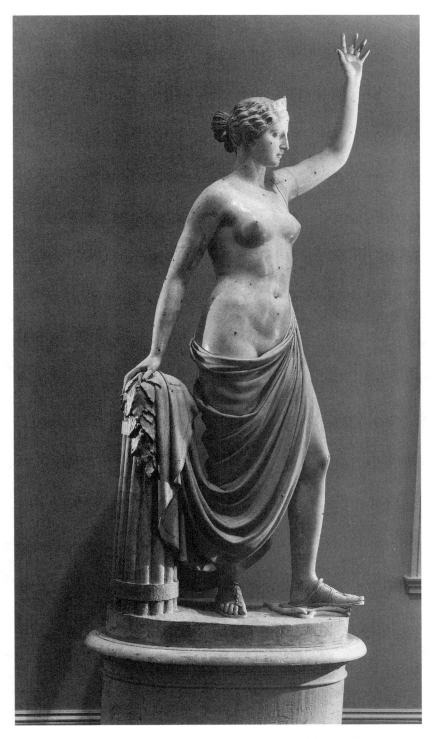

Figure 21. Hiram Powers, *America,* c. 1848–50. Plaster. 226.5 x 89.3 x 42.8 cm. Smithsonian American Art Museum, Washington, D.C. Museum purchase in memory of Ralph Cross Johnson.

(1834). The coin, which shows a joyous and newly liberated black male slave standing on serpentine whips and broken chains, was one of several that commemorated the liberation of the slaves in Britain and its colonies.[41] Smiling, the bare-chested black man waves his hands exuberantly in the air, while the vegetation and the distant windmill remind us of his slave labor—the raw goods he harvested in the tropics and the equipment he tended in extracting their value for the enrichment of European metropolises.

Further evidence of the transgressive abolitionist potential of the representation of chains in Powers's *America* comes from Samuel Jennings's *Liberty Displaying the Arts and Sciences* (1792) (Figure 22). In this painting, commissioned by the Quaker directors of the Library Company of Philadelphia, a benevolent white female Liberty is represented in the act of offering knowledge and education, in the form of books, to a genuflecting group of black slaves, while another group of slaves dance around a liberty pole in the distance. The liberty cap on the pole at her side and the broken shackle under her bare foot function as overt condemnations of the educational disenfranchisement of blacks within the institution of slavery.[42]

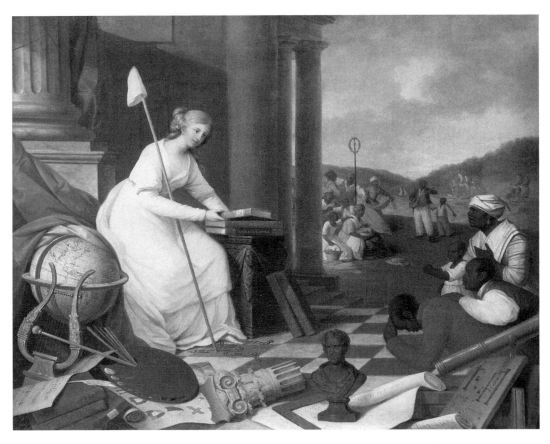

Figure 22. Samuel Jennings, *Liberty Displaying the Arts and Sciences*, 1792. Oil on canvas. 153 x 185.4 cm. The Library Company of Philadelphia, Philadelphia, Pennsylvania.

According to Fryd, the Quakers, involved in explicitly abolitionist activities, had specified to Jennings their desire for the inclusion of the shackles beneath the foot of Liberty. Liberty and the grateful slaves are perched at the edge of a checkered floor strewn with the detritus of the west's most treasured symbols of civilization. Palette and paint brushes, lyre, scrolls, globe, broken classical column, antique bust, and mathematical and scientific tools mix in disarray. The arts and culture, geography and sciences, writing, thought, literacy, measurement appear perhaps as broken and forgotten as the shackles. While books litter the floor like discarded symbols of disposable and corrupt knowledge, we should ponder which titles Liberty has thought it best to protect and bestow on the slaves. Jennings's painting advocated for the liberation of blacks from slavery and their rights to literacy, education, and knowledge, yet simultaneously questioned the western knowledge that had constituted a "civilization" capable of producing slavery.[43]

Powers's explicit abolitionist desires for his *America,* like Jennings's, were manifested in his original intention to include a liberty cap in America's upheld hand.[44] In a letter of 1849, Edward Everett, eventual U.S. secretary of state, dissuaded Powers from using the liberty cap in his *America,* stating an inconsistency in the deployment of the classical symbol of personal emancipation for references of constitutional liberty. Years later in 1866, Powers explained in a letter written to a patron, Mr. Aspinwall, that *America* trampled on "evil signified by chains" and that he "preferred to adopt broken chains (emblem of liberty) to the liberty cap, an ignoble emblem—since it was given to free'd slaves—who wore it by tolerance and not by any acknowledged right."[45] Likely Everett, like Montgomery Meigs (in charge of art for the U.S. Capitol under Jefferson Davis), sought also to appease his Southern slaveowning political colleagues, who would have interpreted the pileus-waving *America* as a condemnation of slavery.[46]

The symbolic function of chains shifted between the broad interpretation of a general symbol of despotism to the very specific interpretation of a reference to the continuing practice of American slavery. *America's* earliest conception had shown her trampling a diadem underfoot, but since this risked offending his European and specifically English patrons, Powers toyed with the idea of replacing the symbol of constitutional monarchy with a scepter before considering manacles and eventually settling on broken chains.[47] This distinction was profound in that it activated a symbolic shift in the body of the enslaved from individual (black) slaves to the less tangible enslavement of the body politic. As Powers would describe in 1853 in a letter justifying his choice, *America's* chains were "large like those used on prison doors" and "not manacles—no allusion to the 'Peculiar Institution,'" as slavery was known.[48]

It is important to note how thoroughly Powers's conceptualization and use of symbolism for his allegory were determined by his keen awareness of the competing visual requirements and symbolic limits of the work and its potential for multiple readings by his international audience and patrons, as well as the political powers that would determine the national commission. Quite simply, the acceptance of Powers's

America hinged on his ability to represent a national allegory of liberty that could disavow the disenfranchised bodies of black slaves. The eventual rejection of Powers's *America* by a Northern president, Pierce, exemplifies the extent to which Northern politicians sought to appease and accommodate the desires of Southern proslavery politicians. Within the program of art for the U.S. Capitol, Secretary of War Jefferson Davis and Montgomery Meigs deliberately rejected abolitionist symbolism but also disavowed the black subject generally as a presence that recalled slavery and, again, potential antislavery sentiment. Because of the sectarian hostilities that divided North from South within American political discourse of the 1840s and '50s, artists had to grapple with the symbolic limits of race within the representation of a national identity. Artists were challenged to produce art objects that could narrate the political rhetoric of a unified national democracy without directly representing or inadvertently evoking the marginalized body of the black slave or the institution of slavery and thereby the untruth of American liberty. The currency and legibility of symbols of slavery, actively deployed by abolitionists, made their representation by slavery advocates open to misinterpretation and confusion. The political censorship of the black subject from the U.S. Capitol admitted the representation of only one black subject. Constantino Brumidi's fresco *Cornwallis Sues for Cessation of Hostilities under the Flag of Truce* (1857), originally displayed on the south wall of the House chamber and from 1961 in the House member's private dining room, included the figure of a lone black male youth deep in the shadowy left corner behind two white soldiers and distanced from the central dramatic action of the three primary white male figures. Jefferson Davis and Montgomery Meigs's approval of the representation of the black youth is directly related to his abject status, which, encoded through composition (as opposed to the symbolic use of objects) registered by his peripheral placement, secured the colonial ideal of a natural opposition between white and black racial identifications.[49]

We can also understand Powers's hesitancy and dilemmas in completing his allegory in light of the evolution of his personal opinions about abolitionism. Whereas correspondence from 1849 documents his resentment of the so-called radical politics of Garrisonian abolitionism as threatening to the Union,[50] by the early 1850s and especially into the middle of the decade Powers's shifting political views were revealed in his hesitancy to complete the symbolization of his *America* and his growing frustration over the repeated delays and the politicization of the commission by Southern interests.[51]

Jean Fagan Yellin has traced a pivotal shift in Powers's political position to the 1854 passage of the Kansas–Nebraska Act, after which, appropriating popular abolitionist iconography in his letters, he increasingly regarded Southern political interests and the desperate preservation and expansion of slavery as the most fateful threat to the Union.[52] To his cousin and trusted friend John P. Richardson he wrote:

> I have become very spunky on the subject of slavery extension, although until the Nebraska bill passed I was dead against the rabid abolitionists. I thought that slavery should be let alone—but now that a step has been taken to extend it over more

territory I think it high time to oppose it tooth and nail every where. There was a prospect while slavery was limited to certain bounds that in time the evil would die out of itself, the white population might smother it, but now the fire has kindled in new places and unless it is met at every point it will extend past all controul [sic]. This Nebraska bill will rouse the people every where, and for one abolitionist before, there will now be ten or twenty. Free soldiers will soon have rule of the country, mark my words.[53]

At this same moment Powers wrote to Richardson seeking to "take advantage" of what he called an "established evil" by purchasing six hundred acres of land in the burgeoning territory.[54] Powers was not shy in declaring the specific events that marked the shift in his politics toward the more "radical" Garrisonian abolitionism. In a letter of 1859 he charged:

> The present state of our country is most alarming. . . . The envy of whole nations—groaning in chains. . . . The Sumner case. The breaking of the Missouri Compromise, the atrocious frontier proceedings in Kansas, the Dred Scott decision, all southern measures of encroachment have brought this about and as if Providence intended an issue of the slavery question.[55]

When President Franklin Pierce delayed the acceptance of the sculpture by proposing a commission on its suitability, Everett wrote to Powers bestowing his opinions on the source of the delays:

> He is extremely guarded as to every thing that concerns the "peculiar institution" [chattel slavery]; and he may be afraid that Southern members of Congress will misinterpret the meaning of the chain under the foot of America and regard her as abolitionist.[56]

For Powers, the endless delays and requests for adjustments were much more than a nuisance. As he described:

> I regret the distraction of my Statue *America*. It was a work on which I had expended all the knowledge of art I possess and although opposed by President Pierce, and Capt. Meigs, and superceeded [sic] by an order—not from Congress—but by an individual (Capt. Meigs)—I still hoped that it would at least be seen by my countrymen at home.[57]

In the end, Powers's *America* was ultimately never purchased for the Capitol but obtained by the federal government only after his death.

Reading American Slavery onto the *Greek Slave*

While Powers had struggled to deny the specific abolitionist symbolism of his *America,* various writers had earlier recognized and honored the abolitionist potential of

the *Greek Slave* in poetry, prose, and journalism. In a tribute to the sculpture, Eliza-beth Barrett Browning's sonnet extended beyond the historical turmoil of Greece and confronted the institution of slavery in general: "The serfdom of this world! appeal, fair stone, / From God's pure heights of beauty against man's wrong!"[58] Another author writing in the *Eastport Sentinel* noted the "painful significance" of Powers's sculpture:

> In no country could the truth and reality of the picture be better felt and understood. It brings home to us the foulest feature of our National Sin; and forces upon us the humiliating consciousness that the slave market at Constantinople is not the only place where beings whose purity is still undefiled, are basely bought and sold for the vilest purposes,—and the still more humiliating fact that while the accursed system from which it springs has well nigh ceased in Mahomedan countries, it still taints a portion of our Christian soil, and is at this very moment clamoring that it may pollute yet more.[59]

Yet, another author writing in the *Washington National Era* marveled at the "hardness of that nature which can weep at sight of an insensate piece of marble." Detailing the hypocrisy and denial that allowed white (female) viewers to expend such emotional and sentimental energy on an inanimate representation of a slave when living, breathing human beings enslaved in their midst garnered no such sympathy, the author continued, "There were fair breasts that heaved with genuine sympathy beneath the magic power of the great artist, that never yet breathed a sigh for the sable sisterhood of the South!"[60] It is perhaps in response to such commentary that the black art historian Freeman Murray interpreted the *Greek Slave* as "American arts' first anti-slavery document in marble."[61]

Blatantly sympathetic references to black female slaves were not standard in the writings of antislavery sympathizers who praised the *Greek Slave*. These obvious gaps in the logic of aesthetic and moral celebration of the representation of a female slave in the midst of American slavery were often capitalized on by proslavery factions. Although the welcome reception for the *Greek Slave* in the American South may seem ironic or implausible, the popularity of the sculpture among slavery advocates was proved in the success of the public tours cited above and in the sculpture's early patronage by a slaveholder from South Carolina,[62] the state that held the dubious honor of having the most slaves in the Union in 1860.[63] Kirk Savage has demonstrated that the pro-slavery argument at midcentury was aimed at infantilizing blacks and defining slavery as a moral Christian institution whose goal was to "civilize" and care for the heathen blacks, who were incapable of self-regulation and self-government.[64] Belying this idea of benevolent slavery and incompetent and intellectually deficient blacks, a woodcut print circulated in the *American Anti-slavery Almanac* (1840), entitled *"Poor things, 'they can't take care of themselves,'"* (c. 1840) (Figure 23), represents a white bourgeois couple out for a stroll, remarking erroneously and condescendingly about the obviously skilled and industrious group of black men competently engaging in labor, including

woodworking, blacksmithing, and gardening. The wealth and leisure of the white couple, signaled by the woman's bourgeois dress, fan, and parasol, are juxtaposed to the larger and centralized black active bodies of the absorbed foursome. The white couple, who have approached from a distance, announce their hasty stereotype, seen in the text bubble, but do not disrupt the work of the busy slaves. For the white slaveholders of the American South, their propensity to reject the *Greek Slave* as abolitionist visual propaganda hinged in part on their desire to make religious and racial distinctions between themselves (the "good" slave drivers) and the imaginary Turkish villains (the "bad" slave drivers).

Articles such as the one published in the 8 September 1847 edition of the *New York Saturday Emporium* criticized abolitionists' practices through their praise of the female slave, acerbically pondering the absence of legal proceedings to free the shackled lady.[65] Similarly, an astute yet cynical journalist writing for the *Yankee Doodle* criticized Northern abolitionists by imagining the impossibility of any similarity between their reactions to a sculpture of a black female slave and to the *Greek Slave:*

> If the object of . . . peculiar admiration had happened to be some poor negress from the rice fields of the South, we should no doubt have heard of great doings among the abolitionists, and read some fearful denunciations in the *Tribune* about the cruelty and hard-heartedness of slave owners.[66]

While I will address below what this journalist stated so glibly—the aesthetic possibilities and limitations of the black female body as slave—the incongruity highlighted above emerged in the actual reaction of white abolitionist viewers to the represented state of the white female's enslavement and the hypothetical reaction to an actual black female subject in the same state. However, equally relevant was the public's interpretation of the slave's reaction to her own enslavement.

The public's interpretation of the subject of the *Greek Slave* as restrained (both literally and symbolically), controlled, and helpless was central to the sculpture's sympathetic reception, as was revealed in the criticism of Powers's earlier *Eve Tempted* (1842), which demonstrated the extent to which the allusion to a knowledgeable and active

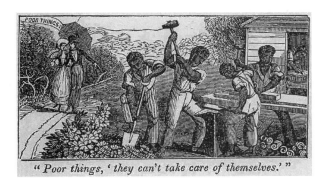

Figure 23. *"Poor things, 'they can't take care of themselves,'"* c. 1840. Woodcut print, circulated in *The American Anti-slavery Almanac,* 1840. Library of Congress, Rare Book and Special Collections Division, rbpe 24800100, Washington, D.C.

" *Poor things, 'they can't take care of themselves.'* "

female sexuality (even within a biblical theme) was transgressive to a mid-nineteenth-century bourgeois audience, at least as far as the white female subject was concerned.[67] The public's desire to read the female subject as spiritual, in a way that released her from or erased her bondage, located the dialectic of body/soul that informed nineteenth-century feminine sentimental fiction.[68] Powers's knowledge of and concern for the cultural limits of nudity for the female subject were displayed in his comments about *Eve* and the *Greek Slave:* "I have endeavored in these two statues to avoid anything that could either by form or import offend the purest mind; and to accomplish my design better, I have left out any expression in either of them of a *consciousness of their nudity.*"[69] The elimination of a conscious nudity was equated with an idealized state of true womanhood, here defined by a feminine passivity activated by divine intervention or male dominance. The public's insistence that the subject of the *Greek Slave,* through her chastity, morality, and Christianity, transcended any suffering was used to distinguish her racially from her contemporary black female counterparts and was itself a disavowal of the legitimate and painful responses of real slaves to the brutalities of slavery.[70]

This repeated disavowal of suffering is also a dominant facet of nineteenth-century slave narratives, which regularly suppressed the emotional, physical, and psychic horrors of slavery by refusing to include the specificities of oppressive slave practices, particularly the sexual ones. When such inclusions were made, we often find an apologetic author or editor, as in the case of Harriet Jacobs's *Incidents in the Life of a Slave Girl, Written by Herself* (1861), edited by Lydia Maria Child. In the same vein, Frederick Douglass apologized for taking the time to remember his mother and grandmother in his autobiography, *Narrative of the Life of Frederick Douglass, an American Slave, Written by Himself* (1845). This literary paradigm effectively policed the voices of slaves and rendered as unspeakable much of the reality of their experiences, in a genre that was largely directed at the conversion of white readers. Whereas resignation for white women was interpreted as a sign of appropriately feminine passivity, a show of resistance implied action and the possibility of anger, which, encoded as masculine, would have effected a displacement from the category of Woman. So overwhelming was the interpretation of the spiritual transcendence of the woman represented in the *Greek Slave* that Henry Tuckerman was compelled to ask, "Do no human pulses quiver in those wrists that bear the gyves / With a noble, sweet endurance, such as moulds heroic lives? / Half unconscious of thy bondage, on the wings of Faith elate / Thou art gifted with a being high above thy seeming fate!"[71]

The few occurrences of direct citation of American slavery or black female slaves proved the exception to the rule. It is significant to acknowledge that when talk of the *Greek Slave*'s relevance to American slavery occurred, it generally actualized around concern for the interracial female slave. An article in the *Christian Inquirer* was explicit:

> Let no one keep down the natural promptings of his indignation by the notion of woolly heads and black skins. Let him rather read the advertisements of these sales. . . . Let him not shut his eyes and his heart to the fact, that many who meet this fate are

the daughters of white men, daughters brought up in luxury, and taught to expect fortune. Let him not ignore the fact that white skins, fair hair, delicate beauty, often enhance the market value of his country women thus exposed for sale.[72]

White skins and fair hair were codes for beauty as much as the word *beauty* itself. By identifying the interracial bodies as the beautiful daughters of white men, this author supported a patriarchal authority informed by white male colonial desire, which, in refusing the possibility of the Other source of the interracial body, black men and white women, deliberately disavowed the possibility of white female desire for the black man. The main alignment of miscegenating sex was that between white men and black women. The institutionalized sexual exploitation of black women within slavery was supported by the inherently coercive relationship between master and slave and the black woman's lack of human status within legal discourse. However, the white man's desire for the black woman could not be named, since it went against the Eurocentric belief in the white body as the paradigm of beauty. Rather, the rape of black women by white men was rationalized as the result of the black woman's excessive sexuality. The suppression of white male desire for black women parodies the practices of anti-slavery fiction, wherein, as Sánchez-Eppler has written, "the story of the white woman's desire for the black man is not told, and his desire for her is constantly reduced to the safer dimensions of a loyal slave's nominally asexual adoration of his good and kind mistress."[73]

Furthermore, it was the racialized class expectations of these interracial females that were used to determine their right to a particular status as freedwomen. The author of the *Christian Inquirer* article referenced luxury and fortune to designate an elite class position from which identifiably black bodies were excluded. It is the whiteness of the slave women's bodies that allowed the author to argue for their class privilege, personhood, and liberty. But in explicitly signifying the bodies of female slaves as white, the author exploded the colonial myth of absolute racial identifications, and the question becomes, When blackness is invisible, through what criteria can a subject be designated a slave?[74] For as Sánchez-Eppler has argued, "If the body is an inescapable sign of identity, it is also an insecure and often illegible sign."[75] For the author of the *Christian Inquirer* article, the possibility of an emotional response to the rejection of slavery was clearly stated along precise racial lines. The bodies of Negro slaves with their "woolly heads and black skins" were seen as a deterrent in the generation of a public outcry that could motivate sentiment or natural indignation. Instead, the white viewing audience of Powers's *Greek Slave* was urged to read the slave body as white or at least interracial. It was through the identification of white Negroes, the "daughters of white men" whose bodies bore the symbolic signs of white female identity, "white skins, fair hair, delicate beauty," that the antislavery message of the *Greek Slave* was most widely deployed.[76] This colonial deference to or preference for an interracial black female type, obviously implicated by western ideals of female beauty, signals an aesthetic and material complex for neoclassicism, which shall be taken up in detail in the following chapter.

The White Captive: Liminality and Nativeness

With his *White Captive* (1857–58) (Figure 24), Erastus Dow Palmer also turned to a completely white "slave." Though this sculpture is an obvious response to Powers's sculpture, Palmer rejected a historical theme, instead resorting to the romanticized legends of Indian captivity narratives, which detailed white female captivity at the hands of Native Americans, a subject popularized in nineteenth-century literature and art. But that is not all that Palmer rejected. His white female "slave" was not the slender, elegant embodiment of the canonical neoclassical adult female with hand poised on draped post, but a fleshy pubescent young woman, or even a girl, strapped to a tree stump. Her face was not the classicizing, expressionless mask of an ideal but the portraitlike specificity of a particular woman. Her hair was not neatly bound at the nape of her neck but cropped and lose about her face. Her hands were not bound frontally and strategically in ornamental chains but drawn behind her and tied with cloth to fully reveal her body and genitalia. Her expression did not solely reflect spiritual resignation or saintly oblivion but registered some anxiety about, even fear and contemplation of, impending horror.

Like Powers, Palmer inverted the racial relationship of master–slave, captor–captive. But instead of the "lustful Turk," the colonial stereotype of the "wild Indian" is what the viewers of Palmer's *White Captive* were meant to imagine. And whereas Powers's imaginary context was the marketplace at Constantinople, Palmer's was the liminal American frontier, an uncertain geographical and psychic space between the "civilized" domesticity of white society and the so-called pagan savagery of Native culture. Whereas Powers's *Greek Slave* could be read literally as the body of the Greek woman or symbolically as the black body of an American slave, Palmer directed his viewer to the body of respectable, white American women. But obvious dialogue with Powers's nude resulted in an ambivalence in meanings: Was Palmer's transformation of Powers's white female subject a way to point out the racial disavowal of the *Greek Slave,* or a sincere attempt to address the plight of white women, or both?

Publicly exhibited in New York in 1859, *The White Captive* was broadly celebrated as a narrative of domestic instability and disruption that hinged on the removal of a white female from her home and her potential sexual violation and cultural corruption at the hands of "uncivilized Indians."[77] The youthfulness of the nude female, who was often described as a "maiden" or a "daughter,"[78] served to reinforce her virginal status, thereby exciting the threat of sexual violation. Not only did Powers's *Greek Slave* look physically more mature, but also the presence of the locket, which was read as a symbol of romantic love, positions her as a woman who has been lost to a lover or betrothed. For Palmer, who had envisioned a narrative in which the young white child of a male pioneer falls into "Indian bondage" after being stolen from her home at night, the racial and sexual dichotomization of the pure, young white girl and the "uncivilized," brute Indians was essential to a sympathetic reading of the sculpture by a dominantly white bourgeois audience.[79] Echoing what had come fifteen years earlier with Powers's work,

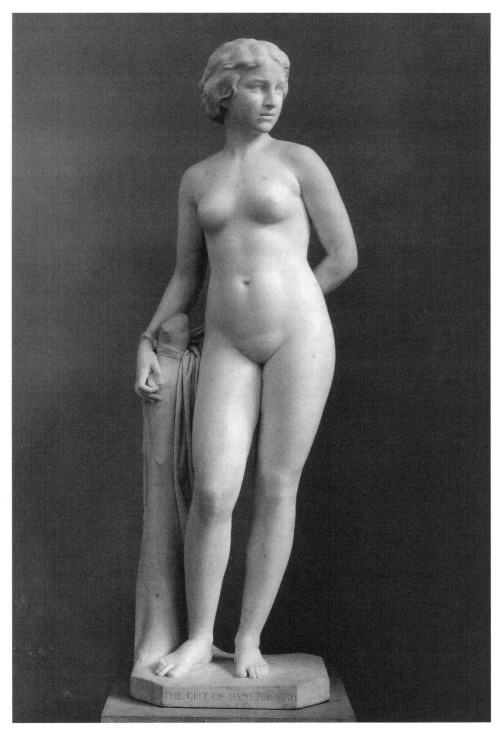

Figure 24. Erastus Dow Palmer, *The White Captive*, 1857–58, this version 1858–59. Marble. 165.1 x 51.4 x 43.2 cm. The Metropolitan Museum of Art, New York. Bequest of Hamilton Fish, 1894 (94.9.3).

the audience's response to *The White Captive* focused on the captive's Christian resolve and knowledgeable resignation as opposed to active resistance or struggle.[80]

The sculpture also relied heavily on the colonial identifications of Natives within western literature and art. Many such artistic works were actually visual representations of popular novels or poems, such as James Fenimore Cooper's *The Last of the Mohicans* (1826) and *The Wept of Wish-ton-Wish* (1829) and Henry Wadsworth Longfellow's *The Song of Hiawatha* (1855),[81] but they were also fueled by the proliferation of Indian captivity narratives.[82] American writers and artists represented the Native subject within colonial narratives to promote Eurocentric ideals such as the advance of "civilization" against a dying race, the threat of the "wild Indian" as sexual and cultural corruption, and the white race as Christianizing saviors of the uncivilized pagan. While Peter Stephenson's sculpture *The Wounded Indian* (1850) and Ferdinand Pettrich's sculpture *The Dying Tecumseh* (1856) occupy this first category, John Vanderlyn's painting *The Death of Jane McCrea* (1804) and Palmer's *White Captive* occupy the second, and Palmer's *Indian Girl, or the Dawn of Christianity* (1853–56) (Figure 25) is exemplary of the third.[83]

Louisa Lander's *Virginia Dare* (1859), based on the first English child born in the Roanoke Colony, Virginia, focused on the visually absent Native body as an agent of the decivilization of the white female subject.[84] The seminude figure, adorned with "Indian" ornament, is neither bound nor shackled. Yet, exiled in a "pagan" world, the previous destruction of her "civilized," white, Christian colony ensures that there is no real threat of her escape.[85] Another example of the white woman's possible conversion to Native culture was the American Joseph Mozier's *The Wept of Wish-ton-Wish* (1859). Based on the 1829 novel by James Fenimore Cooper, the sculpture, like the novel, represented the titillating, if dangerous, possibility of uncontested white female transition into "pagan" culture. The standing figure represented an adult Ruth, the daughter of Puritan settlers who had been captured by Indians as a young girl, now returned to her long-lost home as the wife of a Native chief, Narragansetts, and mother of a mixed-race infant. As opposed to Virginia Dare, who would have had no relatives or home left to return to, Ruth, now Narra-mattah, ultimately rejects her white culture.

Mozier's sculpture, which represented a fully clothed, heavily draped, and contemplative Narra-mattah, foregrounded the threat of the Other's culture through the potential contamination of the white female body, which is ultimately sexual. The ever-present threat of miscegenation was embodied in the presence of the interracial infant. Chauncey B. Ives's sculptural trio *The Willing Captive* (1868) represented more explicitly in its title and its composition the threat of cultural and corporeal hybridity. The standing figure of the young white woman, her body marked with signs of "Indianness," clings to her Native husband and moves away from the beseeching figure of the older kneeling female. Symbolically in between her Native husband and the maternal white woman, representing "primitivism" and "civilization," respectively, she has made her choice to reside in an Other culture. All three of these sculptures depended on narratives that situated the white female body as the liminal body perched between white civilization and Native primitiveness. If Native penetration and corruption of

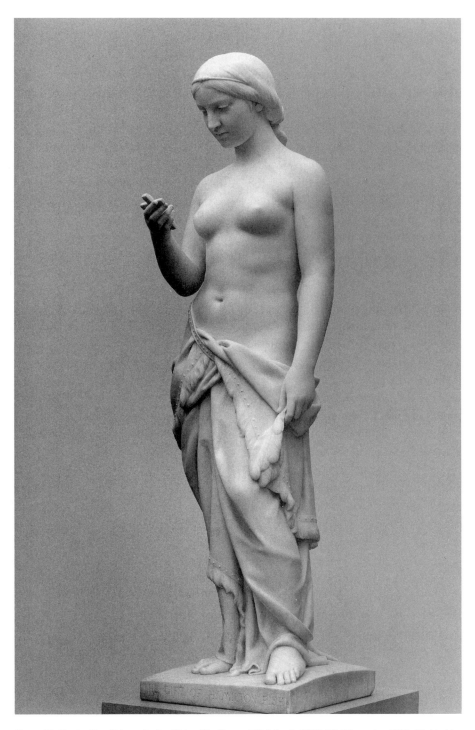

Figure 25. Erastus Dow Palmer, *Indian Girl, or The Dawn of Christianity,* 1853–56, this version 1855–56. Marble. 152.4 x 50.2 x 56.5 cm. The Metropolitan Museum of Art, New York, Bequest of Hamilton Fish, 1894 (94.9.2). Photograph by Jerry Thompson. All rights reserved.

white culture was effected, it was literally and sexually to be performed through the white female body.

Nineteenth-century sculptors were similarly invested in representations of the civilizing of Indians via Christian religious conversion. Again, it was the female body of the Native that was targeted as liminal and open to salvation in such works, not to corruption this time. Prior to the success of Palmer's *White Captive,* his first ideal sculpture, *The Indian Girl, or the Dawn of Christianity,* had represented the religious transformation of a partly clad Indian maiden, her gaze transfixed by the cross in her right hand, while her slackening grip on the feathers, symbolic of Native decadence and pagan culture, went unnoticed in her left. Although not fully exposed like the subject of *The White Captive,* the Native female's loosely draped and improperly secured skirt slip tantalizingly low to reveal her narrow hips and a portion of her buttocks. As opposed to the fully unclothed white female, who has been stripped against her will, the sexualized body of the Indian woman is offered to the viewers as a facet of her primitiveness, her unconsciousness of her exposed body, which suggested, by nineteenth-century bourgeois standards, not only an inappropriate level of comfort with her own body but also a culpability in its visibility.[86] Powers noted the transgressive potential of partial nudity and the comparative chastity of full nudity while referring to the male artist's experience of working with a life model:

> Whatever temptation they have experienced while so engaged, has been while the model was partially draped, either dressing or undressing. And I have heard many say, and I can testify from my own experience, that he who can resist the allurements of a modern *belle,* dressed *à-la mode,* is steel-proof against all the temptations of naked models, statues, and pictures.[87]

While Powers's words reinscribed the patriarchal authority of the male artist and the hegemonic assumption of heterosexuality in defining the source of temptation as the partly clothed body, he located the activation of desire as the *process of revelation or concealment* of the body, a process that indicated action and its means, clothing. But as I have argued throughout, the sexualization of a body can never be separated from the body's racial identifications. The racial implications for the sexualization of the female body were acknowledged by Palmer, who saw his *White Captive* and *The Indian Girl, or the Dawn of Christianity* as a kind of pair demonstrating the bidirectional influences of "Christianity upon the savage, and the savage upon Christianity."[88]

The colonial assumption that European culture and Christianity were intrinsically superior to all other cultures and religions greatly informed the nineteenth-century visual consumption of these sculptures. Hiram Powers's seminude Indian maiden depicted fleeing from the encroachment of white civilization in *The Last of the Tribes* (1867–72) (Figure 26) could not generate the level of horror, sorrow, sympathy, or pity engendered by his *Greek Slave,* Palmer's *White Captive,* or Mozier's *The Wept of Wish-ton-Wish,* precisely because, to a dominantly white audience, white colonization and

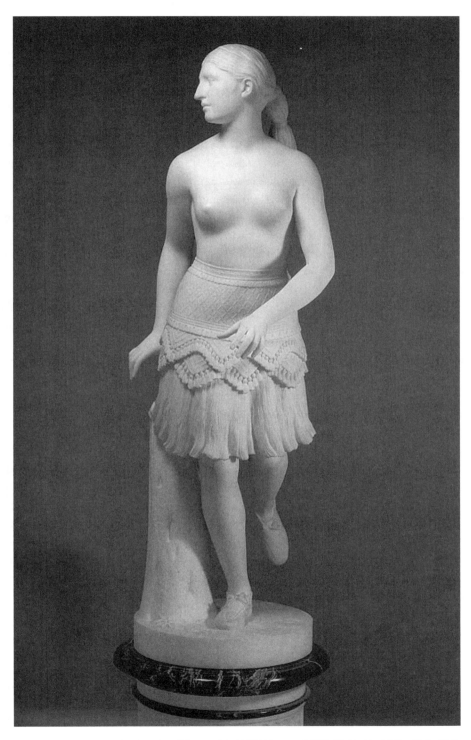

Figure 26. Hiram Powers, *The Last of the Tribes,* modeled 1867–72, carved 1876–77. Marble. 167.9 x 57.7 x 81.3 cm. Smithsonian American Art Museum, Washington, D.C. Museum purchase in memory of Ralph Cross Johnson.

its outcome, the threat of the annihilation of Indigenous cultures, were received not as an immoral or unjust process but as the natural course of evolution. Furthermore, the Native female subject, like the black, was not as sympathetic as the white. Similarly, Joseph Mozier's cross-holding *Pocahontas* (1859), interestingly presenting an exposed breast in contrast to the impossibly draped figure of a white Ruth/Narra-mattah in his *The Wept of Wish-ton-Wish*, whose cultural transition was propelled by love and religion, was indicative of the triumph of white culture more than a statement of grief at the loss of Native ways of life.

The body of the white female as a transitional site was also registered in Palmer's *White Captive*. Whereas Joy Kasson has read the subject of *The White Captive* largely as a statement on social and sexual transitions, changing cultures, and liminality,[89] I would add that Palmer's deliberate deployment of a Native Other in contrast to a paradigmatic white female body, like Powers's earlier deployment of a Turkish/Arab Other, points specifically to the centrality of racial and sexual significations within the contested identifications of mid-nineteenth-century America. But it also exposes the extent to which white racial privilege was guaranteed only by the racial marginalization that produced blacks, Arabs, and Natives as Others and the economic control of land that ensured the eventual geographical displacement of Natives and barred blacks from legitimate and legal landownership, which can activate social independence and full citizenship. If it were true, as one white reviewer claimed in regard to *The White Captive,* that "our women may look upon it, and say, 'She is one of us,'" then by placing the subject of the work on American soil, Palmer made the sexual and cultural threat of the Other body much more personal and immediate.[90]

Although conceived on the eve of the Civil War and given a decidedly American context, Palmer's white "slave" was conceptually further removed from black American slavery than even her predecessor, the subject of the *Greek Slave*. Few reviewers made a connection between the plight of the white girl and the fate of millions of enslaved black girls and women. One who did, writing in the *Century,* suggested bluntly that Palmer consider a black slave for a future sculpture.[91] What was perhaps most fascinating about the response to Palmer's *White Captive* is that, although an immediacy and familiarity were achieved in the shift of geographical context despite the deep racial disavowal of black slaves, several white viewers described their disturbance at the slippage that occurred in their oscillation between the "real" position of the cultured white bourgeois viewer and that of the "imaginary" and implied wild Indians. The contextual proximity of the American subject, combined with the youthfulness of the female body and the unabridged access to her sex, contributed to viewers expressing discomfort at *becoming* like the very "wild Indians" who had captured the maiden. One author stated, "We feel almost as ruthless as her savage captors in continuing to look at her while she suffers so much."[92] And "in gazing upon it," another added, "are we not taking the first returning step toward the barbarism of the savages, whose act of obscene cruelty it is intended to depict?"[93] The line between disinterested viewing and emotional and visceral experience was also that between white and Native.

In both cases these authors posit a racial shift *downward* from their space of "civilized" whiteness to that earlier evolutionary state of "savage" Indianness. However, their disturbed and uncomfortable responses can also be read as the inability of these viewers to displace their own fears/desire legitimately and convincingly onto the bodies of Natives: the process of racial othering was disrupted, the infallibility of the white gaze was thwarted, and the white self was here forced to address the emotions that were traditionally too easily displaced or repressed. The aggressive acts of displacement and disavowal that characterize colonial practices of viewing are evident in what Joy Kasson has termed "the dogged determination of viewers to read a captivity narrative as a story of triumph"[94]—a result of the psychic resistance to the instability and ambivalence of whiteness.

The Meanings of Shackles

Whereas Powers's earlier version of the *Greek Slave,* John Bell's *Octoroon* (Figure 27), and Giacomo Ginotti's *L'emancipazione dalla schiavitù/La schiava* (Figure 28) all deployed largely decorative chains for strategic compositional purposes, Powers's refashioning of the shackles in the sixth version of the *Greek Slave* (1869) signaled a deliberate change in their symbolic significance as they pertained to the "peculiar institution." As I have discussed earlier, on a previous occasion after he had struggled with the symbolism of his *America,* Powers described the chains under the allegory's foot as the generalized symbol of despotism and incarceration, disavowing their potential to signify American slavery and its abolition, by referencing manacles as being more specific to the peculiar institution. It was in the 29 November 1869 letter from Powers to a patron E. W. Stoughton, quoted in part above, that the sculptor elucidated his reconception of the chain in the *Greek Slave,* stating:

> I regard the substitution of the regular manacles for the rather ornamental than real chain in former repetitions of the "Greek Slave" as a decided advantage, since it distinguishes it from all others, and is really more to the purpose. The figure on this account can hardly be called a repetition, since it has a difference.[95]

Powers's statement has multiple meanings and intentions. First, since Powers took pains to advise his buyer that this sixth version was the last repetition over which the buyer would have discretion regarding the sanction of reproductions, the letter, in distinguishing the sixth version from all others, was intended to secure this version's originality and elevate its market value.[96] The redesign of the chain was also pragmatic, since Powers had received criticism about the impracticality of the ornamental-looking original chain.[97] But the symbolic meanings of the "regular manacles," which replaced the "ornamental" chain, are directed by Powers's own phrase "more to the purpose." So what was the purpose of the regular manacles?

The institution of slavery spawned a technology of oppression, replete with innovative material instruments and physical methods of corporeal restraint and torture. By

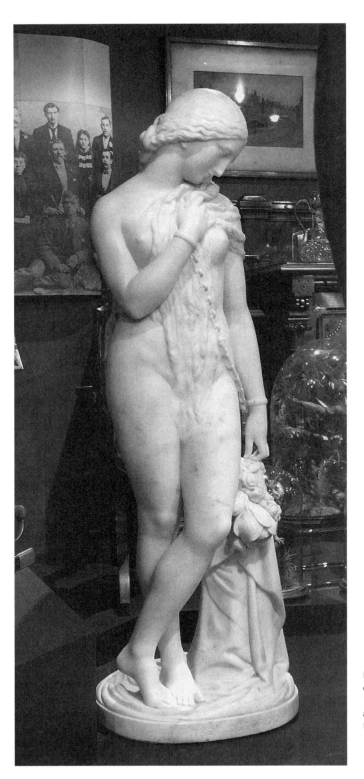

Figure 27. John Bell, *Octoroon*, c. 1868. Marble. Height of 159.6 cm. Blackburn Museum and Art Gallery, Blackburn, United Kingdom.

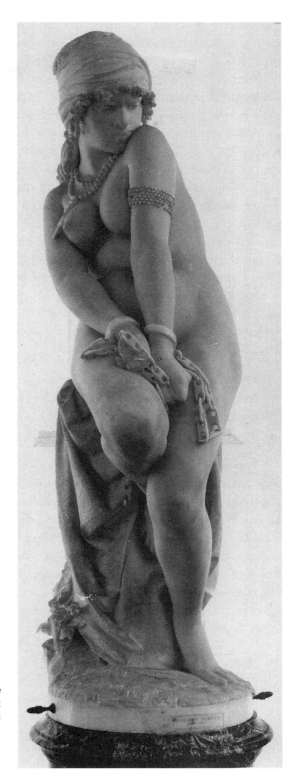

Figure 28. Giacomo Ginotti, *L'emancipazione
dalla schiavitù/La schiava,* 1877. Marble. Height
of 155 cm. Ministero per I Beni e le Attività
culturali, Naples, Italy.

innovative I am citing the importation of tools and instruments from other social spheres and institutions, such as penal systems and the policing of female bodies, into the practice of slavery as well as the development of institutionally specific tools and weapons to be used against slaves. The shackle or manacle was a fundamental tool of slavery, since, used at the first point of colonial contact, its position on the body marked the symbolic transition of the black body from free to enslaved, human to commodity. Although the practical function of the shackle/manacle was to immobilize and restrain the body, its symbolic function was to mark the body as property and commodity, as goods that could be exchanged within economic markets.

Among the numerous horrific instruments of torture, many were designed to be simultaneously spectacular, immobilizing, and painful. Part of slavery's disordering of white patriarchal notions of gender and social definitions of childhood was achieved through the indiscriminate nature of punishment, torture, and execution practices despite the sex or age of a slave. But this disordering occurred not just within the bodies of slaves but within those of their white owners too, the ranks of the gentrified plantocracies. White men and women of the so-called polite bourgeois classes of breeding, civility, and Christianity were equally familiar with the handle of a whip. The former slave Mary Armstrong described the murder of her sister at the hands of her mother's white mistress:

> Old Polly, she was a Polly devil if there ever was one, and she whipped my little sister what was only nine months old, and just a baby, to death. She come and took the diaper offen my little sister and whipped till the blood just ran—just 'cause she cry like all babies do, and kilt my sister.[98]

Punishment was neither organized nor just in the sense of any systematic adherence to particular rules of misconduct and reciprocation. Often the "offense" of the slave was based on the desire for freedom, sustenance, or self-determination and included acts such as running away, self-defense, resisting sexual advances, reading, socializing with slaves from other plantations, or, as Mary Ella Grandberry recalled, "talkin' about de free states."[99] Any social or intellectual pursuits that potentially threatened the preservation of cultivated ignorance among slaves were perceived as offensive to the social and racial order of slavery. For female slaves in particular, any resistance to or defense against sexual assault and rape could be construed as an affront to the "master" and his or her desires. The former slave John Finnely described witnessing such a punishment:

> De worst whippin I seed was give to Clarinda. She hits Massa with de hoe 'cause he try 'fere with her and she try stop him. She am put on de log and give five-hundred lashes. She am over dat log all day and when dey takes her off, she am limp and act deadlike. For a week she am in de bunk.[100]

Whippings were commonly delivered to adult and child slaves, who were often stripped, secured, and displayed in spectacular ways for maximum public visibility. By securing

the slave to a post or a log, as Clarinda suffered, or by staking out on the ground or locking into stocks, the body was immobilized but also unable to react instinctively against, to resist or pull back from, the pain of the repeated physical onslaught. Lucretia Alexander recalled witnessing the use of the stocks when she was a slave:

> The stocks was a big piece of timber with hinges in it. It had a hole in it for your head. They would lift it up an put your head in it. There was holes for your head, hands and feet in it. Then they would shut it up and they would lay the whip on you and you couldn't do nothin' but wiggle and holler.[101]

But as J. G. Stedman documented in *Narrative of a Five Years' Expedition . . .* (1796), the securing of the slave body was also often a precursor to execution. The engraving *The Execution of Breaking on the Rack* (1796) represents a male slave's sentence for killing his white master in self-defense. After chopping off the slave's left hand with a hatchet, the black executioner, according to Stedman, "next took up a heavy iron bar, with which, by repeated blows, he broke his bones to shivers, till the marrow, blood, and splinters flew about the field."[102]

Public flagellation was orchestrated not merely as a deterrent to other slaves but also as a public humiliation or "breaking" for the punished. To receive one hundred lashes was a standard punishment.[103] The receipt of more often marked the master's desire for injury or execution rather than punishment. The historicity of the practice of flagellation for male and female slaves is confirmed by eighteenth-century slave histories such as Stedman's. The engraving *Flagellation of a Female Samboe Slave* (1796) visually describes Stedman's first explicit confrontation with methods of torture in slavery. He recorded:

> The first object which attracted my compassion during a visit to a neighbouring estate, was a beautiful Samboe girl of about eighteen, tied up by both arms to a tree, as naked as she came into the world, and lacerated in such a shocking manner by the whips of two negro-drivers, that she was from neck to ancles literally dyed over with blood. It was after she had received two hundred lashes that I perceived her with her head hanging downwards, a most affecting spectacle.[104]

Often delivered by overseers renowned for their particular desire for violence, vengefulness, and blood-lust, such whippings were generally performed with the specific goal of breaking the skin, scarring the body, and letting blood.[105]

Isolation and deprivation were the other side of the spectacular public forms of punishment, since, in removing the slave body from the field of vision, they worked to provoke anxiety in the slave community through the lack of knowledge and the invisibility of the punishment while immobilizing the punished slave, often inflicting severe restrictions to movement, and denying basic human needs such as light, oxygen, food, and waste management. Martha Colquitt recalled slaves being removed to

the "workshop" for punishment and the mystery in which the tool-filled building was cloaked.[106] M. S. Fayan spoke of a jail on the plantation where slaves were locked after suffering under the whip.[107] Mary Ella Grandberry described an acute form of claustrophobic torture and deprivation used against slaves: "Iffen you had done a bigger 'nough thing you was kept in the 'nigger box' for months at de time, and when you got out you was nothin' but skin and bones and scarcely able to walk."[108]

Since, within slavery, white dominance of black people functioned through the imagined inhumanity and racial inferiority of blacks and the cultivation and maintenance of fear and ignorance within the slave community, the brutality of slave punishment was often spontaneous and unplanned, the abuse meted out with objects within the vicinity of the master or mistress and the slave. The frequency of whites using fire or heat to punish slaves located their desire not only to inflict excruciating pain but also to mark the body of the slave in order to remember the so-called offense and the punishment for it—another form of branding. Delia Garlic spoke of her ordeal at the hands of her master's white daughter: "I nursed for her and one day I was playin' with de baby. It hurt its li'l hand and commenced to cry, and she whirl on me, pick up a hot iron and run it all down my arm and hand. It took off the flesh when she done it."[109] The normalcy of such vile attacks is in part revealed through the presence of the white infant who witnessed this violence. Slavery institutionalized violence and torture as normal daily acts to be witnessed and carried out by all aspects of white society. Similarly, former slave Andrew Goodman recalled witnessing torture performed with a torch on a captured runaway slave who had been lured back to the plantation with promises of leniency: "He tied him and beat him for a terrible long time. Then he took a big, pine torch and let burnin' pitch drop in spots all over him. Old Charlie was sick about four months and then he died."[110]

Within the schemata of possible implements of torture and restraint, the use of chains, shackles, or manacles was very common. Although these tools were sometimes secured around the neck as a collar, they were also often used to secure limbs, wrists, and ankles, fastening them together or locking the body to a fixed point or an extraordinarily heavy "mobile" weight. In all cases, the goal was to prohibit the mobility of the slave or to discourage movement or inflict pain through movement, since movement was made so painful and arduous with the hindering object. The engraving *A Female Negro Slave with a Weight Chained to Her Ancle* (1796) represents Stedman's description of his encounter with a female slave thus encumbered:

> non-performance of a task to which she was apparently unequal, for which she was sentenced to receive two hundred lashes, and to drag, during some months, a chain several yards in length, one end of which was locked round her ancle, and to the other was affixed a weight of at least a hundred pounds.[111]

The securing device represented in Powers's original version of the *Greek Slave* was described as a chain and subsequently, in the revisions of the sixth version, reconceived

as a manacle. Although Clara L. Dentler has argued that Powers's reworking of the shackle was a pragmatic decision he and his carver, Remigio Peschi, made, because the carving of the chain from the marble was too slow, delicate, and painstaking, Powers's own letters revealed a decided desire for a considered shift in symbolic meaning behind his deployment of the manacle.[112] Although in both the original and the sixth versions, both shackles were secured at the same point on the female subject's wrists using the same constraints, the difference between the chain and the manacle occurs in the modeling of the marble between the two wrists. The double strand of ovular links between the wrists in the first version, although restrictive in length, were not wholly a hindrance to the rotation of the hands and wrists. However, a close inspection of the manacle, the many rings replaced by three straight linked bars, suggests prohibited movement not only in the distance between the two limbs but also in the supination of the arms and wrists and hands. While the chain, which Powers himself described as ornamental, was certainly restrictive, its material delicacy (conveyed in the lacelike pattern of the delicate-looking double strand of carved marble) and the lacy shadow pattern that may have resulted from the play of light within the exhibition space opened the chain up as the site of aesthetic contemplation, manual dexterity, and material ingenuity rather than limiting it as a tool of restraint, cruelty, and torture. The comparatively austere and simple form of the manacle placed function above aesthetics and emphasized the slave status of the female subject. As I have discussed above, Powers's desire to use his *Greek Slave* as an explicit reference to America's "peculiar institution" occurred only after the extension of slavery in the 1850s spurred his personal political consciousness toward the so-called radical abolitionism that he had previously condemned. Occurring after emancipation, the shift from a chain to a manacle was performed when the fear of Southern political advocacy of slavery was no longer prohibitive to the deployment of symbols of abolitionist visual discourse, since the victory of the North in the Civil War marked a shift toward the conscious deployment of a national visual rhetoric of universal democracy that located the abolition of slavery as its greatest contemporary triumph. With this profound political and social shift, Powers no longer felt compelled to disguise or sublimate the *Greek Slave*'s connection to American slavery or black slaves. The manacle not only insisted on the immediacy of the slavery referenced by the sculpture, but in rendering the tools of slavery more realistic, it made the evocation of a black female slave body more possible.

The *Greek Slave*'s celebrity and emotional currency were its sublimated eroticism, the unfulfilled promise of titillating interracial sex. In his appropriation of the historical event of the Greek War of Independence, Powers was able to represent a white female slave body through which his viewers could choose to identify or disavow the contemporaneous plight of the black female slave. In the *Greek Slave,* Powers created a racially exclusive and protected space of viewing that, guided by narratives of white spiritual triumph over physical bondage, allowed privileged white audiences to distance themselves from the obvious sexual implications of the shackled nude female body. It was not just the subject and its imaginary and social contexts that were racialized but

the very practice of viewing itself. The insistent commentary of the Unitarian minister Rev. Orville Dewey exemplified this point: "The Greek Slave is clothed all over in sentiment; sheltered, protected by it from every profane eye,"[113] an observation that hinged on his belief that the "right" audience (defined as bourgeois, white, western, and Christian) actually *saw* differently from the way their class, race, and religious Others saw and, therefore, guided by their religion, would see a moral message instead of profane nudity. In the *Greek Slave's* representation of a moment that was dependent on the subject's imagined past and future—a past of war and revolution with Turkey and a future of bondage and sexual slavery within a harem—white viewers could experience the titillation and explicit sexuality of the viewing position of the imaginary "lascivious Turks" without owning that position's immorality. Hence, the function of the Other as the site and experience of the self's displaced fantasies and desires.

5. The Color of Slavery
Degrees of Blackness and the Bodies of Female Slaves

Race and Place: Egypt and Racial Hybridity

The Introduction presented Cleopatra as one of several important guises through which black female subjects assumed a heightened visibility within nineteenth-century neoclassical sculpture. However, the American and European fascination with Cleopatra (and the attendant fascination with ancient Egyptian culture) must be placed within the broader context of the prolific and persistent interest in the social, cultural, and scientific limits of black female bodies generally, an interest that often rose to the level of negrophilia.[1] While Cleopatra has repeatedly been appropriated by generations of white western artists as a sexually, morally, and racially ambivalent site of power, desire, deceit, and conflict, her nineteenth-century recuperation by abolitionists, which I shall discuss in more detail in part III, was a particularly critical event in her reracialization as a black queen, which significantly also reclaimed Egypt as a black African site.

This reclamation is crucial to an understanding of Egypt's significance as a critical site of scientific inquiry within the western quest for racial territorialization—the desire for a comprehensive classificatory geography of the derivation of racial origins. Colonized lands received the same intense scrutiny as colonized bodies, the geography and *nature* of a region serving as evidence of the racial origins and characteristics of a people. Therefore, the colonial fascination with black bodies, particularly racially ambiguous ones, cannot be unplugged from the similar perception of territory, Egypt's geographical, cultural, and racial histories as African nation/civilization. The reason for the prolific western perception of Egypt as a contested site of racial flexibility and Egypt's connections to nineteenth-century ideals of racial hybridity are the focus of this chapter.

It is not incidental that nineteenth-century Egyptomania and the establishment of the science of Egyptology coincide with Europe's violent dismemberment and colonization of Africa, for the "sciences" that professed to reveal and retrieve the ancient secrets of Egypt were based on the material observation of bodies and objects made accessible to Europeans through the violence of colonialism. The establishment, institutionalization, and professionalization of these western scientific discourses were a significant part of the process of colonization, fixing the colonized land and its peoples as "specimens" for observation in the pursuit of knowledge and truth. The colonial matrix was dependent on a universal logic of European superiority, which was never questioned. Nineteenth-century scholars, many wholly ignorant of ancient Egyptian, Ethiopian, or other African histories and civilizations, imagined Egypt as a racial and cultural bridge between the superior bodies of Europeans and the inferior bodies of Africans and, in so doing, produced the binary of whiteness and blackness. It is in this vein that the repatriated Swiss naturalist Louis Agassiz commented on the status of Egypt in Africa:

> This compact continent of Africa exhibits a population which has been in constant intercourse with the white race, which has enjoyed the benefit of the example of the Egyptian civilization, of the Phoenician civilization, of the Roman civilization, of the Arab civilization . . . and nevertheless there has never been a regulated society of the black men developed on that continent.[2]

In a statement that privileges western conceptions of social formation, Agassiz treats Egyptians as nonblack and, astoundingly, as non-African; he effectively disavows Egypt's geographical location, the history of black Egyptian rule, and thousands of years of Egyptian interaction and cultural exchange with Nubian civilizations. The easy dislocation of Egypt from Africa marks its position as a liminal geographical and psychic boundary and between-space of Europe and Africa, self and other, white and black within the nineteenth-century colonial western imagination. With its place at the center of the marginal, Egypt has possessed an interesting and complex flexibility and mobility in the range of possible racial significations of the in-between, which is neither simply black nor white in the depths of its hybridity.

It is significant that the term *Egyptian* located a racial ambivalence within the nineteenth-century discourses of western human sciences. One article summarized it thus:

> Much controversy has taken place among men of science as to the physical character of the ancient Egyptians. It may be thought that of a people so ancient abundant testimony would be found in the works of the Greek Travelers and historians, but the difficulty has been created by the conflicting statements of those writers, rather than by their silence on the subject. Volney maintains that they were negroes, and founds his opinion on passages in the works of Herodotus, Æschylus, and Lucian. Ammianus

Marcellinus says they were, for the most part, of a brownish Color; and in an old Egyptian document in the Berlin Museum, in which the contracting parties are described by their external appearances, one is called black or dark brown . . . and the other yellow or honey-colored. Dr. Prichard infers from these accounts, that the ancient Egyptians were a dark-colored people, and that, at the same time, great varieties of Color existed among them.[3]

There was, quite simply, no unanimous agreement among nineteenth-century human scientists on the race of Egyptians. Within the colonial order of nineteenth-century imperial geographies, Egypt represented the preeminent African civilization or, to the die-hard Eurocentrists, the only African civilization, period. Egypt's proximity to the west gave it a privileged cultural position, just as the Egyptian subjects' racial proximity to European whiteness lent them a privileged racial position that sometimes categorized them as Caucasoid as opposed to Negroid. Cleopatra's Egyptianness held the possibility of a racially hybrid body that was at once a marginal site of whiteness and a superior form of blackness. But the process of representing Cleopatra's racialized body and the representational limits of its blackness within nineteenth-century neoclassicism was a product of what Johannes Fabian has termed *visualism*. "The term is to connote a cultural, ideological bias toward vision as the 'noblest sense' and toward geometry qua graphic–spatial conceptualization as the most 'exact' way of communicating knowledge."[4] Visualism, which pervaded nineteenth-century cultural and human science discourses, holds profound implications for how bodies were viewed, why they were viewed, and how the authority of "scientific" vision led to the "authenticity" of racial signification and identification.

The Science of Mapping Race *on* and *in* the Body

By the late eighteenth and early nineteenth centuries, various branches of western human sciences were deeply invested in the study of the black female body within a medical model of health and pathology. Human science's social investment in the racialization of bodies intensified in the mid- to late nineteenth century, the moment when slavery was becoming increasingly morally and politically untenable in western societies. The scientific scrutiny of bodies that related to a search for a definitive catalog of physical characteristics of race and their social and moral implications offered a viable alternative to slavery as the dominant colonial regime, which had previously controlled black bodies. Significantly, the very process of observing and categorizing race was determined by an a priori ideal of the racialized body, since the "scientific" process of visual scrutiny located a search for the corporeal signs of that which was already deemed to exist: racial difference. Eurocentric findings supporting the white body's unparalleled beauty, supreme intellect, and incomparable moral character were offered by human scientists as indisputable fact, which only supported their inevitable scientific conclusions.

The process of scientific observation was structured around the paradigmatic bour-geois body of the white male, often absent from, yet always inferred within, textual and visual comparison and omnipresent in the authoritative gaze of the scientist. On the occasions when the white male body was represented, it became the apex of a strate-gic hierarchical visual arrangement of racial signification. Black bodies were often jux-taposed with animal bodies (monkey, chimpanzee, orangutan), the visual proximity inferring bestiality, excessive sexuality, and inferior mental capacity. In an engraving from J. C. Nott and George R. Gliddon's *Types of Mankind* (1854), the white male body is not submitted to the violence of visual scrutiny and dismemberment. Rather, white man is not objectified but is replaced by an aesthetic object, the head of the canoni-cal Apollo Belvedere represented in the classical sculptural head of that name, itself a product of white male culture, the narcissistic substitution of the ideal body that refuses visual authority.[5] Understanding the racial specificity of the term *classical* (dis-cussed in the Introduction) allows us to see the *Apollo Belvedere* not only as a nineteenth-century paradigm of male beauty but also as a paradigm of white male beauty. Nott and Gliddon were preceded in their use of classical sculpture by Virey, a student of Buffon, who had used the head of Zeus in a sculpture so named. As Savage has noted, "What is quite literally a comparison of god, man, and animal is nevertheless meant to be read as a comparison of white man, Negro and animal."[6] These authors' sense of justification in substituting a representation of a sculptural object (a representation of a representation) in place of a representation of a human body points up the extent to which nineteenth-century scientists relied on sculptural representations to visually embody and authenticate their colonial ideals of racial difference. While the racial infe-riority of the black body was largely unchallenged, the question that disturbed many human scientists was one of origins: Did humans emerge from one source (mono-genism) or from multiple and separate sources (polygenism)?

Although structured by the idea of absolute objectivity, western human sciences were consistently invested in the political and social status of the black body in ways that informed and intervened within social policy, helping to shape racial discourse on issues such as abolition, slavery, and colonization. Within a colonial order that privi-leged European social formations and the body of the white bourgeois subject, western science's observations of Africa and Africans deployed social, cultural, political, and physical difference as the signs of racial inferiority, pathology, and degeneracy.

Scientific theories of racial difference offered geographical and climatic explana-tions to validate and naturalize the colonial scrutiny and identification of black bodies. While skin color was consistently cited as the most obvious, immediate, and visible racial signifier, anatomical and physiognomical differences, such as nose width and lip thickness, were also referenced with a particular emphasis on the shape and size of sexualized body parts and genitalia.[7] Any arbitrary part of the human body seemed capable of communicating a racial identification. The anatomist Étienne Sérres ex-amined the distance between the navel and the penis, while Samuel George Morton filled skulls with mustard seeds and lead shot to measure cranial capacity. Within this

colonial spectrum of signs of blackness, hair was also an important site of racial iden-
tification, the texture, kinky or straight, scrutinized toward a measure of blackness or
whiteness. As Kobena Mercer has noted, "Within racism's bipolar codification of human
value, black people's hair has been historically devalued as the most visible stigma of
blackness, second only to skin."[8] The potency of hair as a colonial measure of racial
signification has profound implications for the visual representation of black bodies in
western culture. Particularly, within the limited color register of nineteenth-century
neoclassical sculptural practices, the signification of hair texture provided an alterna-
tive, in the signification of the racialized body, to the representation of skin color, which
was so systematically and utterly disavowed by the dominance of white marble within
the movement.[9] However, it was the compilation of these racial significations identi-
fied as "biology" that became a measure of intelligence, character, beauty, sexuality,
society, and civilization.

Othering Bodies: Sexual and Racial Difference

The discursive and material practices of transatlantic slavery were dependent on an
imagined black female body that fused the physical body of a laborer and the sexual
body of a breeder. Arguably the female slave labor that became most essential to the
survival of slavery was breeding.[10] These two critical elements of the female slave were
corporeal (body-centered) and dependent on the notion of the black female body as
a site of physical and sexual excess. The excessive sexuality of black females was sup-
posedly visibly manifested on the body in the biological marks of external physical signs
or anomalies best revealed in the body of the female Hottentot.[11] The body of the
female Hottentot was used to secure the ideal of black sexuality as excessive and patho-
logical through various autopsies that recorded the "Hottentot apron" (defined as a
hypertrophy of the labia and nymphae) and steatopygia (protruding buttocks) as proof
of polygenesis. As Sander Gilman has commented:

> If their sexual parts could be shown to be inherently different, this would be a suffi-
> cient sign that blacks were a separate (and, needless to say, lower) race, as different
> from the European as the proverbial orangutan.[12]

Within the physical and material practices of transatlantic slavery, the black female
body became socially accessible and publicly visible, a visibility that existed in dramatic
contrast to the strict invisibility and deliberate concealment of the leisured white female
bourgeois body, a product of culture whose performance of femininity colluded with
white male bourgeois identity and patriarchal power. The gender difference cultivated
by white bourgeois society is precisely what was dismantled within slavery, since the
practices of labor and punishment and their sexual consequences were applied to both
male and female old and young slaves. The dramatic social distinctions between these
two racialized female bodies resulted in the ambivalence of Hiram Powers's *Greek Slave*

(c. 1843), discussed above. The practice of auction, which Powers's sculpture appropriated, was like the visual practice of the human sciences, invested in the visual objectification of the black female body as commodity. On the auction block, the black body was presented, often unclothed, for an authoritative white bourgeois gaze employing pseudomedical terminology that dismembered bodies into excessive examples of their labor and sexual utility: large breeding hips; strong, powerful arms.

The black female body was not alone in its surveillance under an oppressive racializing gaze. The nineteenth-century collapse of the black female body and the white laboring female body was rooted in their shared public visibility, sexual accessibility, physical mobility, and often a decided lack of bourgeois acculturation. For the black female subject, the necessity or obligation of physical labor was the result of racial identifications inherent in the practice of transatlantic slavery (blacks are slaves), identifications that were retroactively symbolic of an imagined class position (slaves do not have economic potential and thereby lack social status).

What Griselda Pollock has called the bourgeois racialization of the white female laboring body and its association with the black racial type emerged from the visual scrutiny and moral judgment of the body's memory of labor (size, stature, musculature, dirt), a memory that, when applied to what Pollock has termed the "absolute difference of the masculine body," belied the normative ideal of the bourgeois female body within the "regime of sex."[13] As Ann Laura Stoler has argued:

> The discursive and practical field in which nineteenth-century bourgeois sexuality emerged was situated on an imperial landscape where the cultural accoutrements of bourgeois distinction were partially shaped through contrasts forged in the politics and language of race.[14]

In locating the laboring body as the critical site of racial difference, the search for an explanation became biological and genetic; the social, economic, and political factors that had actually produced material and physical hardship and shaped specific cultural and social practices were then retroactively recuperated as by-products of a racial difference.[15]

The "excessive sexuality" of the black female also linked her to another threatening body—the white female prostitute. Throughout nineteenth-century sociological, medical, and scientific discourses, the body of the prostitute was pathologized as a source of disease, mainly syphilis. According to A. J. B. Parent-Duchatelet, the prostitute's racial distinctiveness was located primarily within pathologies of the genitalia, which were not a facet of strict biology but the behavioral excesses of sexual activity. Pauline Tarnowsky's standard study of Russian prostitution offered a much expanded field of indicators, most of them visible physical attributes, as signs of the prostitute's degeneracy. Excessive weight, hair and eye color, skull measurements, ear shape, fertility, and family background were all accepted as scientific indicators of the racial type of the female prostitute.[16] The cataloging of physical characteristics as supposedly racial

attributes marked the desire to produce a legible body, one that could be readily identified through the visual scrutiny of physical signs of difference. This compelling need to define a legible female Other who could be instantly and easily identified was, of course, also a facet of the widespread anxiety over the increasing invisibility of prostitutes within metropolises such as Paris and the rampant misidentification of prostitutes as so-called proper bourgeois white women.

The common link that bound these three female subjects—the black female (slave), the white female laborer, and the white female prostitute—was biological, racial: they were all black, and it was their blackness that posed a problem for white bourgeois society. And yet the disorder of their racialized bodies was necessary for the normative ideals of gender, sex, and class, which secured the authority and dominance of the white male heterosexual subject. They were the abject to *his* self. It is in this vein that Griselda Pollock has cited race as a "critical term" in the interplay of class and gender.[17] While the bodies of black women and white female laborers were effectively marginalized through the visibility of their racial, class, and gender difference, the prostitute posed a more insidious threat to the white bourgeois male through her ability to disguise her racially degenerate and diseased body, to adopt feminine etiquette and dress, and to infiltrate polite, white, bourgeois society as a proper bourgeois lady. Much nineteenth-century French painting indexed the bourgeois male fear of the invisibility of the prostitute. Popular caricatures represented men mistaking young working-class women for prostitutes. Meanwhile paintings such as Edouard Manet's *Olympia* (1863) located the ambivalence of the prostitute's racialized body, throwing the covers off the masquerade of the body as Desire, the male fear of knowledgeable and active female sexuality, and the reality of economic transactions of sex. The "problem" for men was that the body of the upper-class prostitute or courtesan parodied the posture, style, and mannerisms of the white bourgeois female in ways that made them visually indistinguishable.

The danger that these Other bodies posed was primarily sexual, the threat of racial contamination through miscegenating sexual contact or interracial sexual reproduction. Hence, while sexual contact with prostitutes embodied the threat of disease for the white male, miscegenation defined the black body's threat of genetic pollution to the white body politic. But miscegenation also created the racial equivalent of the socially elusive, even invisible prostitute—the possibility of the *white Negro*.

Measuring Race: The White Negro Type

White Negroes came in different shapes and sizes but most of all with different degrees of blackness. *Octoroon,* a term that was part of the nineteenth-century colonial racial terminology invested in an obsessive ideal of quantifiable levels of race (blackness), was used to identify a person who was one-eighth black (a person with one black great-grandparent and seven white ones). The terms *quadroon* and *mulatto* indicated people who were one-quarter and one-half black, respectively. The rejection of a person who

was seven-eighths white and only one-eighth black from the racial identification of whiteness demonstrates the extent to which blackness was viewed as a pathology that could corrupt the imaginary purity and privilege of the white body. However, inasmuch as the body of the octoroon represented a biologically acceptable "black" body, it was also a transgressive site that threatened to upset the supposed visual certainty of race. Karen Sánchez-Eppler has noted:

> The quadroon's one-fourth blackness represents two generations of miscegenating intercourse, the octoroon's three—their numerical names attesting to society's desire to keep track of ever less visible black ancestry even at the cost of counting the generations of institutionalized sexual exploitation.[18]

The female octoroon and her interracial counterparts were popularized as tragic heroines within mid-nineteenth-century American fiction.[19] Much of this literature that recorded the plight of the interracial slaves was abolitionist in sentiment, as was the case in Lydia Maria Child's 1842 publication titled "The Quadroons."[20] The octoroon elicited sympathy, because, for all intents and purposes, she was identifiable as white—or at least not readily visible as black. Traces of her Negro ancestry were often detectable in a "ruddy" complexion (effectively disavowed by the white marble of neoclassical statuary) or her "too wavy or curly" hair. But her otherwise white body allowed her to conform to Eurocentric paradigms of beauty and hence western aesthetic norms.

In his painting *The Quadroon* (1880) (Figure 29), George Fuller's "beautiful" interracial slave is distanced from her darker slave peers not only by her complexion, poise, and attire but also symbolically by her physical distance from their laboring bodies, created by Fuller's use of perspectival distance and her own accentuated inactivity. Her sad, beseeching expression meets the viewers with a direct, if withdrawn, gaze, inviting us to action. There has obviously been a mistake; she does not belong in this field. The orderliness of her clothes and the conspicuous locket around her neck indicate a privileged status, which her light complexion and flowing curls confirm as a product of her proximity to whiteness. The locket may, as in Powers's *Greek Slave,* have been used as a device to shore up her proper maidenly status within patriarchal heterosexual norms. Are we to assume that a picture of her male beloved or betrothed is inside, and might he be white, a further testament to her own whitening and the injustice of her enslavement? A Massachusetts native, Fuller derived his *Quadroon* from a sketch he had completed while witnessing the auction of an interracial female slave in the American South. His indignation, vividly captured in a personal letter, locates the slave's proximity to whiteness as both the source of his outrage and horror and the source of her beauty, the features that simultaneously confirm her vulnerability to white men and her right to their protection under the patriarchal code of gender. Fuller wrote:

> Who is this girl with eyes large and black? The blood of the white and the black race is at enmity in her veins—the former predominated. About 3/4 white says one dealer.

Figure 29. George Fuller, *The Quadroon,* 1880. Oil on canvas. 128.3 x 102.9 cm. The Metropolitan Museum of Art, New York. Gift of George A. Hearn, 1910 (10.64.3).

Three fourths blessed, a fraction accursed. She is under thy feet white man. . . . Is she
not your sister? . . . She impresses me with sadness! The pensive expression of her
finely formed mouth and her drooping eyes seemed to ask for sympathy. . . . Now she
looks up, now her eyes fall before the rude gaze of those who are but calculating her
charms or serviceable qualities. . . . Oh is beauty so cheap![21]

Fuller's plea for the slave is strikingly similar to those offered on behalf of *The White
Captive* and the *Greek Slave;* the major difference is that the sympathy he sought to
engender was on behalf of a black female subject. The interracial female's racial hybrid-
ity made her aesthetically acceptable to whites and worthy of white male protection
and yet also activated the white male colonial desire that facilitated her sexual violation.
Frances Green's black male literary slave hero, Laco Ray, in "The Slave–Wife" (1845)
described the predicament of his interracial slave–wife: "She was beautiful. She was in
her master's power. She was in the power of every white man that chose to possess her,
she was no longer mine. She was not my wife."[22] For Laco Ray, the marital status of the
interracial female slave whom he loves is defined within a phallocentric logic based on
his ability to hold exclusive sexual rights to her body. The black female body, within
colonial and patriarchal terms, was defined as the sexual possession of men. However,
Ray's dilemma, like for all black men (arguably slave or free), was that his legal and
social disenfranchisement triggered a symbolic castration, leaving him unable to offer
his wife, as white men could, the traditional social protections of a patriarchal marriage.

Several nineteenth-century sculptors engaged with the interracial subject of the
octoroon directly as opposed to the circumspect route of cloaking the black subject
in a white aesthetic and thematic acceptability. In 1861 John Rogers Jr., the American
sculptor from Salem, Massachusetts, who is largely credited with the single-handed
democratization and popularization of sculpture through the production of what
David H. Wallace has called his "putty-colored plaster statuettes,"[23] began production
on what he envisioned as a career-defining life-size sculpture titled *The Flight of the
Octoroon* (c. 1861).[24] Rogers's immense aspirations for the work he felt he could stake
his reputation on were explicitly documented in his desire that his sculpture be "what
the Greek Slave was to [Hiram] Powers."[25] By 1861, Rogers would have been well aware
of the iconic status of Hiram Powers's *Greek Slave,* which he saw exhibited at the Boston
Horticultural Hall in 1848.

While the representation of black subjects, such as in *The Slave Auction* (c. 1859–
61) (Figure 30), would become standard for Rogers, the attempt at a life-size marble
sculpture was indeed ambitious.[26] As Rogers himself described in a letter to his mother,
Sarah Ellen Derby Rogers, his choice of this particular interracial, black female type
opened up specific narrative, compositional, thematic, expressive, and aesthetic pos-
sibilities that neither a strictly white nor black female subject could enable.

It represents a mother with her child in her arms who is just checking her flight to
listen for pursuit. It will be very lightly draped which will give me a good opportunity

Figure 30. John Rogers, *The Slave Auction,* c. 1859–61. Plaster. Height of 34.3 cm. Collection of The New-York Historical Society, New York (1928.28).

for modeling form and with the great interest which slavery is exciting and the amount of expression and spirit I can put into the figure I feel every confidence in its success. You know an octoroon can have perfectly classical features and the only distinguishing mark will be a very pretty waviness to the hair.[27]

On the eve of the Civil War, Rogers clearly saw an opportunity to capitalize on the prolific American, and indeed international, interest in the subject of slavery.

Choosing to represent his octoroon slave at the moment of her escape, Rogers exploited the social, economic, and material deprivation of slaves to conceptualize a revealing costume for his female figure. Rogers provided the context for the revelation of the female's body. However, the context, unlike that of Powers's *Greek Slave* or Erastus Dow Palmer's *The White Captive* (1857) (discussed above), was not wholly one of external influences, nor did it have to be, since the octoroon's blackness allowed for a certain measure of sexual culpability and disorder. The letter also noted the artist's connections among the context of the sculpture, the race of the subject, and the expressiveness permitted. It was because of the high emotions around slavery and the octoroon's racial identity, which had entrapped her within that slave system, that Rogers felt he could imbue his subject with "spirit." However, if we recall that the overwhelming outpouring of sympathy for Powers's *Greek Slave* hinged on her Christian resolve, feminine passivity, and noble resignation, the representation of resistance, courage, action, panic, and possibly even anger in Rogers's subject was mediated by her blackness or, in other words, by her difference from the paradigm of proper bourgeois womanhood. The most obvious implication of racial preference and colonial desire in Rogers's statement was his matter-of-fact revelation that the octoroon subject, despite her blackness, allowed him to create a female body that could be read as the beautiful, the only explicit signifier of racial otherness, the abject black female body, being her pretty waviness of hair; after all, octoroons with the pretty classical features, code for white, could be read as beautiful. However, it is within this knowledge of the interracial subject's increasingly invisible blackness that the threat of miscegenation recurs and the colonial logic of racial identification is betrayed, for, as Karen Sánchez-Eppler has argued, "miscegenation and the children it produces stand as a bodily challenge to conventions of reading the body, thus simultaneously insisting that the body is a sign of identity and undermining the assurance with which that sign can be read."[28]

Although by mid-October 1861 Rogers's work was well advanced in the clay, in mid-November he was having serious reservations, and on 10 December 1861 he wrote his sister Ellen that the "poor thing died the other day."[29] Yet, although *The Flight of the Octoroon* was never completed, the fact that Rogers—the undisputed "Laureate of home!"—even attempted such a work should alert us to the widespread and specifically popular cultural potential of the black female subject.[30]

Another example of white artistic engagement with this theme in "high" art is the British sculptor John Bell's *Octoroon* (c. 1868), a full-scale marble figure of a standing female nude. Exhibited at the Royal Academy, London, in 1868, Bell's white Negro

slave portrays the classical white beauty and "pretty waviness to the hair" that John Rogers had intended for his incomplete marble.[31] But her racial difference is also registered in her large bosom, shapely body, and pronounced overerect nipples, a voluptuous and womanly body that makes Powers's female slave seem comparatively girlish and asexual.[32] The strong narrative context of Powers's *Greek Slave* is nowhere present. The identity of the octoroon is unclear, as is that of her enslaver, the circumstances of her enslavement, and even her location. Bell's female slave inhabits a nondescript, possibly natural setting, indicated by the garland of flowers that cap the cloth-covered pedestal to her left. Unlike Powers's depiction of the slave's clothes draping the pillar, it is unclear whether the fabric represented by Bell was meant as clothing or merely a decorative design. While the neatly coiffed *Greek Slave* is in facial profile from the front (of her body, the implied starting point of viewing), her distant gaze only slightly lowered, Bell's *Octoroon,* with lowered head in semiprofile, enables the descent of her masses of too curly, unbound hair in front of her body to partly conceal direct access to her chest and genitalia. This discreet pose points up the extent to which the octoroon's whiteness, to her nineteenth-century audience, mediated her sexualization and activated a degree of white paternalistic concern for her predicament. Her raised right arm, which clutches the mass of phallicized hair, also provided Bell with the opportunity to accentuate the decorative chain that extends down the middle of her chest and belly to her left wrist. The female slave is not in a state of heightened awareness, indicating that she was likely not to be read as being in any immediate danger. Her wistful expression does not register the valorized Christian resignation of the *Greek Slave* (nor did it engender fear, anger, or passion in her contemporary viewers, as Palmer's *White Captive* did) but rather registers a withdrawn introspection and sadness. Void of explanation, the narrative of this sculpture was race itself—the interracial, white Negro state of the female slave, who was to provoke sympathy in the viewer.

The popularity of the tragic octoroon theme was also reflected in popular culture. An illustration from Harriet Beecher Stowe's novel *Uncle Tom's Cabin* (1852) by George Cruikshank, titled *Emmeline about to Be Sold to the Highest Bidder* (c. 1852), depicts the withdrawn and sad figure of the young interracial woman with downcast head whose blackness in an otherwise white body is signified in the curliness of her partly unbound hair. Emmeline stands as property on the block among the group of white men, whose top hats, canes, and suits signify "polite" society just as their very presence at the human auction and desire to commodify a young almost-white female vilify them. The ironic inclusion of the allegorical figures of a blind Justice, Liberty, and Faith in the background drives home this point.[33]

Lefevre James Cranstone's painting *Slave Auction, Virginia* (c. 1863) (Figure 31) offers a similar narrative, although devoid of the same internal judgment. While Cranstone represented several dark-skinned slaves, his female slave on the auction block, like Cruikshank's, is interracial, an identification registered more in her light complexion than in her nondescript hair. Although devoid of metal shackles, the black female subject is still bound. Her position on the stage is ensured by the sole black male subject,

whose grip on the slave's wrist symbolically replaces the absent chains with the gleaming black skin of his hand. It is of great consequence that his grip defies the courtly gesture of hand-to-hand contact here, unacceptable by the intimacy and cordiality it would imply. Just like Laco Ray, this black male, also most likely a slave, had no rights to exhibit such courtly gestures to the lighter/whiter female slave, or to any others for that matter. But the black male's "possession" of the white Negro female is elusive and temporary, a mere stand-in for the real economic and social possession by white males. As colonial logic dictated, the slave was inevitably to become the "property" of the white men gathered for the auction instead.

Yet although the white Negro body of the female slave is elevated, literally and symbolically, as the prize of the auction, it is the darker black females who are directly, physically confronted by the white male bodies of slavers, who approach, scrutinize, assess, and actually physically touch them, some in sexually suggestive ways. To the far right, the two white men look over one standing black female, one of their hands grazes her chest in open sexual possession of what he may soon purchase. The despicable, invasive, and violent nature of their contact is highlighted by the presence of black slave children as witnesses to the graphic sexualization of their mothers.

The representational impossibility of the black female body, specifically its antithetical constitution with the Eurocentric conception of beauty, was such that the figure of the octoroon or interracial black woman became almost synonymous with *the black woman* within American neoclassical sculpture and arguably within other forms

Figure 31. Lefevre James Cranstone, *Slave Auction, Virginia*, c. 1863. Oil on canvas. 33 x 53.3 cm. Virginia Historical Society, Richmond, Virginia.

of western art. Not so with the black male body. John Quincy Adams Ward's *The Freedman* (1863) (Figure 32) clearly articulates a so-called full-blooded Negro physiognomy, registered in the full lips, broad nose, and cranial shape of the seated male figure.[34] The "kinky" hair further secures this reading. Bronze material, as when also used by Cordier and the polychromists, captures the blackness of black skin. The slave's muscled body bears the signs of a life of labor. Unshackled and supposedly liberated (although the cuff on his left wrist with dangling links indicates barely so), his tense body, which shifts his weight forward onto his left leg, allows him to stare up and off into the distance in an introspective contemplation of his freedom. The grip of his right hand on the broken links of chain is strong and sends ripples up his muscled forearm. The unquestionable power of his body is constrained by the seated pose. Unlike Lewis's black male ex-slave in *Morning of Liberty/Forever Free,* the subject of *The Freedman* is not triumphant, nor is he prayerful, like Lewis's kneeling ex-slave woman. His freedom is cause for contemplation, not celebration. It is as if, although the material chains that bound his physical body have been broken, the psychic ones are very much alive and well. To arise from his perch into "full" manhood seems both brave and foolish within this context.

But as the representational correspondences between nineteenth-century abolitionist fiction and sculpture attest, the visualization of the sympathetic black male subject still demanded a fetishization that often suppressed the very signs of blackness. My use of the term *visualization* is key, since, although literary descriptions of black characters are produced textually, ultimately the deployment of text is made in order to guide the viewers' visualization of the character. In "The Slave–Wife," Frances Green's representation of her black male hero, Laco Ray, was informed by nineteenth-century racialized aesthetic paradigms of the male body in sculptural form and "high" art generally. Describing him as a black Hercules, Green nevertheless felt compelled to balance the visibility of Ray's complexion, "He was quite black," by purging his physiognomy of other signs of blackness. She wrote, "But the features had none of the revolting characteristics which are supposed by some to be inseparable from the African visage. On the contrary they were remarkably fine—the nose aquiline—the mouth even handsome—the forehead singularly high and broad."[35] For Green, the deployment of terms such as *even, singularly,* and *remarkably fine* demonstrates a sense of surprise that this obviously black body, at least in terms of skin color, could be other than repulsive in feature. Particularly, the term *even* in her description of Ray's "handsome" mouth locates the Eurocentric assumption that the physiognomical signs of blackness, here thick lips, were inherently unaesthetic and inferior to the thin lips of the ideal Caucasian type. The term *fine* also operates as a physiognomical description of dimensions, which gains meaning only within a dialetical relationship with the supposedly broad and unaesthetic physiognomical traits of the black body.

Green's process, as the process of the nineteenth-century abolitionist deployment of the black body generally, was the visualization of a hybrid body, a fetishized blackness that was both purged of offensive and threatening racial signs and still retained the

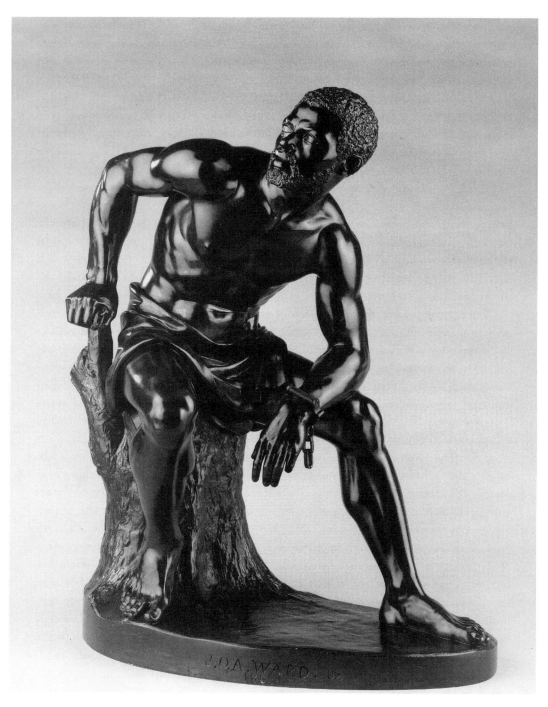

Figure 32. John Quincy Adams Ward, *The Freedman,* 1863. Bronze/metal. Height of 49.8 cm. Cincinnati Art Museum, Cincinnati, Ohio. Gift of Alice Keys Hollister and Mary Eva Keys.

possibility of visually identifiable blackness. John Boyne's watercolor cartoon lampooned the contradiction of the black male body within the colonial practice of western "high" art. In *Meeting of the Connoisseurs* (c. 1807), the black male model, distinguished by an exceptionally muscular physique, is also a custodian (hence the broom he holds), the lightness of the cloth draped around his midriff serving to highlight the blackness of his skin as it simultaneously disavows the presence of his threatening male sex. The enigma of the black "model" is that the Eurocentric presumptions about the unaesthetic nature of his black skin and physiognomy compete with his superlative anatomy. The expressions of the six white male artists who aggressively scrutinize, contemplate, and handle the black model move from consternation to bewilderment, from perplexity to disconcertment. The presence of the broom not only serves to suggest the model's class status and employment—the source of his extraordinary musculature—but also registers the haphazard and unplanned nature of the encounter. This black man was obviously not their first choice of model, but his presence has resulted in this moment of visual and aesthetic scrutiny, racial confrontation, and cultural contemplation. Finally, the impossibility of the black "model's" body is fixed by the visibility of white neoclassical sculptures positioned on the shelf in the distance—in the end shall his representation not become whitened too? As Sánchez-Eppler has argued, "Making a black hero involves not only dyeing the traditional figure of the hero to a darker hue but also separating blackness from the configuration of traits that in the bodily grammar of sentimental fiction signals revulsion."[36]

A striking example of the representational impossibilities and differences between the black male and female bodies was created in Edmonia Lewis's *Morning of Liberty/Forever Free*, a work that represented two recently liberated black slaves. However, the standing male's kinky hair and broad nose are absent from the kneeling woman with classicized facial features and unbound, flowing "white" hair. The problem of signifying race for the black female body was explicitly revealed in Anne Whitney's struggles to race the face of her allegorical *Africa* (c. 1863–64) (Figures 33 and 34). Since as a neoclassicist the piece was intended for white marble, the racial identification concerned Whitney's signification of a black physiognomy and anatomy or the evocation of blackness within the narrative context of the sculpture or both. The sculptor, in an attempt to represent an appropriate level of blackness, is reputed to have reworked the face of her *Africa* several times, receiving criticism from her friend Col. Thomas Wentworth Higginson for her avoidance of an explicitly black type.[37] The before and after photographs of the now destroyed work clearly reveal Whitney's confrontation with the limits of racial representation, specifically in the facial features—lips, nose, and brow—of the two works. The photographic documentation reveals Whitney's retreat from a more obvious black physiognomy. So, Whitney's *Africa* was considered by some to be too white. But such criticism was rare within the colonial discourse of nineteenth-century neoclassical sculpture.

William Wetmore Story's *Libyan Sibyl* (1861) (Figure 35), a companion to his infamous *Cleopatra,* was a sculpture intended as an ideal representation of the black

female abolitionist–orator Sojourner Truth. Story's sculptural choices register two racial disavowals. First at the level of subject, Story's rejection of the option of a portrait of Sojourner Truth begs questions of the possibility of the heroic black female subject's incorporation into neoclassical sculpture. Second, Story's statement that he took as his racial model "Libyan African of course, not Congo," locates his awareness of and investment in preferable types of blackness (the blackness that was most mixed with whiteness) and his rejection of the so-called full-blooded Negro type (here identified explicitly with sub-Saharan Africa).[38]

The difficulties artists faced in racing the black female body relate to two main issues determined by nineteenth-century ideals of sex and gender, beauty and sexuality. The "scientific" rejection of the black body in the nineteenth century encompassed intellectual, moral, social, sexual, and physical implications. The black subject was held to be not just less intelligent than the white but also within a state of moral and physical degeneracy. As such, the black subject was expelled from the category of the beautiful, which was occupied by the paradigmatic white body. As I have already discussed in detail, the human sciences were also invested in the visualization of an overdetermined black sexuality. The pervasive belief in the black's pathological sexuality and the forced sexual availability and social visibility of the black female body within slavery meant that representations of the black female body could easily if not automatically trigger assumptions of social indecency, sexual excess, and moral corruption.

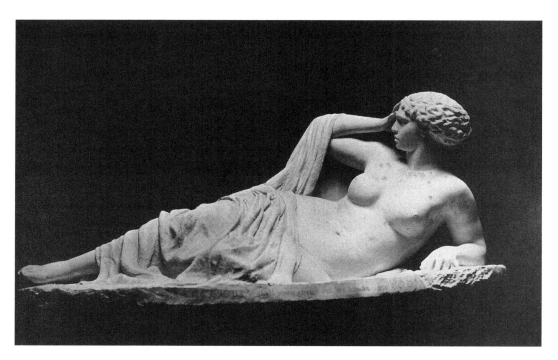

Figure 33. Anne Whitney, *Africa*, c. 1863–64 (initial version). Plaster. Colossal. Destroyed by artist. Photograph from the Anne Whitney Papers, Wellesley College Archives, Wellesley, Massachusetts.

As such when the so-called full-blooded Negro female was *allowed* to be made visible, the context or theme of the sculpture demanded a marginalized or debased female subject that could appease the racist assumptions of dominantly white audiences.

This case is exemplified by the racially and sexually dichotomous duo of Randolph Rogers's *Lincoln and the Emancipated Slave* (c. 1866), in which an elegantly clothed and fully erect Abraham Lincoln grips the wrist of a stooping, half-naked black female slave.[39] Of the many designs for emancipation monuments in midcentury America, Kirk Savage has noted that Rogers's work is the only two-figure sculpture to incorporate a female slave with the body of Lincoln. The texture of the hair emerging from her scarf-wrapped head and her facial features register a black female body, while the broken shackle on her left wrist, exposed breasts, and rough skirt signal the economic disenfranchisement and explicit sexualization of a woman barely emerging from slavery. Kirk Savage has noted that Lincoln's firm grip on the female slave's right wrist avoids courtly interpretations and preserves the racial and sexual dichotomy that would have been called into question had he been depicted in the more courtly and genteel gesture of holding her hand.[40] The reason for this grip, which acts as a distancing mechanism, is different from that noted above between black male and black female slave in Cranstone's *Slave Auction, Virginia*. In both cases intimacy is avoided—in *Slave Auction* because of the elevated status of the white Negro female and the lower status of the darker male, while in *Lincoln and the Emancipated Slave* because Lincoln's white

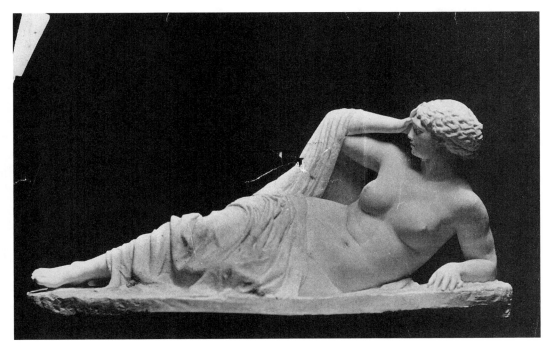

Figure 34. Anne Whitney, *Africa,* c. 1863–64 (after adjustments). Plaster. Colossal. Destroyed by artist. Photograph from the Anne Whitney Papers, Wellesley College Archives, Wellesley, Massachusetts.

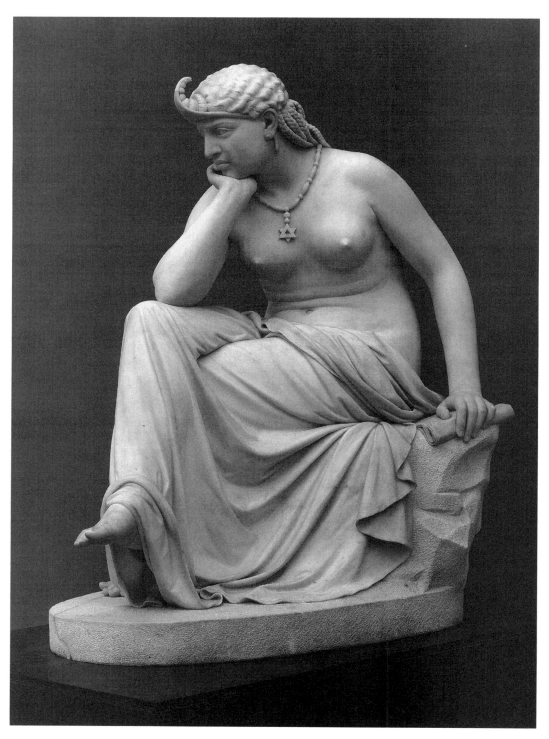

Figure 35. William Wetmore Story, *Libyan Sibyl,* 1861. Marble. 134.62 x 109.47 cm. The Metropolitan Museum of Art, New York. Gift of the Erving Wolf Foundation, 1979 (1979.266).

male body is removed from demonstrations of sexual desire or full racial equality with the black female slave. The gesture refuses the standard gendering (in the form of court-liness and paternalism) of the relationship between white men and women of the same class. This sculpture, proposed as a design for a monument to Lincoln in Philadelphia, could deploy this black female type, since its goal was not to achieve an ideal of female beauty, as Powers's goal was, but to elevate and canonize Lincoln as the white hero who emancipated the helpless and passive black masses, and how better to do that than to represent him, the individual, in the process of saving one of those poor black un-differentiated souls.[41]

The potential class and sexual impropriety of such cross-racial conflict was explic-itly detailed by the English painter Robert William Buss, whose *Art of Love* (1831) repre-sented the shock and visceral disgust of a white man in the moment of his recognition that the white-gloved hand he so tenderly gripped was that of an elaborately dressed and previously veiled black female and not a white lady, which he assumed. Similarly, the patterns of engagement and interaction between white bourgeois male slavers and black female slaves represented by Lefevre James Cranstone in *Slave Auction, Virginia,* sharply divergent from the cross-gender rituals of the white bourgeois, locate an abject black female body as sexual commodity. Within the complex and dense composition, Cranstone used the architectural beam of the auction house to divide the majority of the white male bidders, on the left, from the black female slaves and slave children, mainly on the right. All of the adult slaves ready for auction are females. The sole pres-ence of the black male is used to facilitate the sexual captivity and commodification of the black women: the dark-skinned black man holds the wrist of the interracial female slave on the auction block. It is significant to note that white females are also present, their ghostlike silhouettes and unspecific bodies signified by their bonneted heads, which haunt the opening in front of the door. The painter offered the white women access to the freedom of the world beyond the open door, while opposition-ally the black women's bodies are penned in by the white males that surround them, and their positioning is deep inside the belly of the room. The phallic energy of the slavers, registered in their strained necks, fisted hands, broad stances, and excited move-ment, is simultaneously juxtaposed with the calm, disengaged posture of the clerk, whose crossed arms and relaxed pose against the wall suggest his comfort with and the normality of the practices of human commodification. The other set of potential buyers engage in the sexual contemplation of the black female slaves in a much more direct and physically threatening manner. Within this literal process of the inspection and handling of "property," the white male–initiated contact with the black female bodies mimics Lincoln's masterful and polarizing grip on the kneeling black female slave. But contrarily, their bodies, unlike Lincoln's, do betray interracial desire.

To the far right against the black screen, the white male in profile grips the black female's wrist. While his gruff expression registers aggression, the awkward inclination of her tilted head and her lowered gaze simultaneously register discomfort at being man-handled and her knowledge that her social status and physical context leave her

no recourse. Just to the left of this pairing, two white men crowd a light-skinned slave. The physical proximity of their bodies, the lowered gaze, and sinister smirk of the black-hatted male and the sexually invasive hand gesture, which intrusively grazes the bust of the black female with a knuckled fist, locate a specifically racialized sexual scrutiny and foreshadow the black woman's sexual violation within slavery and her economic potential as a "breeder." The pairing at the far right represents the same instrusive white male presence that is depicted in the standing males in the group of four figures at the center–right, who look down at the seated black women, infiltrating their space. In this group of four, the menacing threat of ownership is intensified by one man's two-handed grip on the back of the bench on which the black women sit, bracketing their bodies. At the center, the man leaning against the dividing architectural pillar gazes in the direction of his hand, which, poised on the shoulder of a seated female slave and precisely between her and the slave child she holds, constitutes a particularly intrusive and symbolically menacing gesture: the threat of the separation of mother and child. Although they are not shackled, the reality of the black women's captivity and immobility is visualized through their position in the foreground of the composition and through the proximity, positioning, and gestures of the larger, standing white male bodies, which, in surrounding their seated bodies, prevent any access to the open light-filled door in the background—and freedom.

Measuring Race: The So-Called *Full-Blooded Negro* Type

Much like Palmer's *White Captive,* another contemporaneous work disrupted the white audience's ability to displace their colonial fear of or desire for Other bodies and reconcile a colonial gaze. Parodying the *Greek Slave,* an illustration titled *The Virginian Slave: Intended as a Companion to Power's "Greek Slave"* (Figure 36), by John Tenniel, was published in the January–June 1851 edition of *Punch, or the London Charivari.*[42] The illustration replaced Powers's white female slave with a woeful black female slave, stripped to the waist, her lower half covered in a tattered-looking skirt, hair bound in scarf, and hands and feet shackled with more than decorative chains. Beside the slave, the phallic pillar, once draped with discarded garments, is now wrapped poignantly in the American flag, which during slavery served as an impotent symbol of democracy, and her pedestal is decorated with a succession of whips and chains above the now ironic slogan "E Pluribus Unum."[43] In a subsequent edition, *Punch* imagined "Sambo's" response to Powers's white female slave:

> But though you am a lubly gal, I say you no correct;
> You not at all de kind ob slave a nigger would expect;
> you never di no workee wid such hands and feet as dose;
> You different from SUSANNAH, dere,—you not like coal-black ROSE.
> Dere's not a mark dat I see ob de cow-hide on your back;
> No slave hab skin so smooth as yourn—dat is, if slavee black.[44]

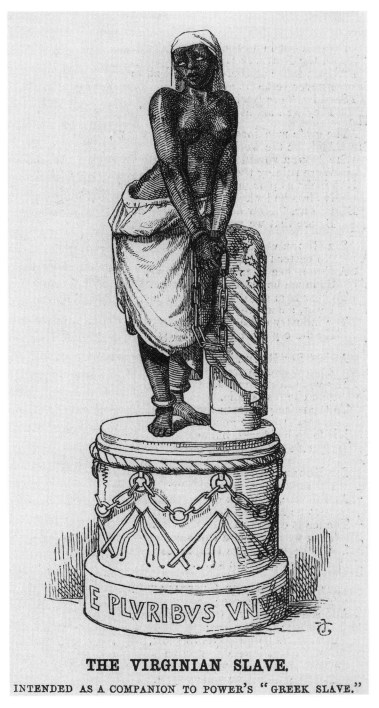

THE VIRGINIAN SLAVE.

INTENDED AS A COMPANION TO POWER'S "GREEK SLAVE."

Figure 36. John Tenniel, *The Virginian Slave: Intended as a Companion to Power's "Greek Slave,"* c. 1851. Engraving published in *Punch, or the London Charivari,* January–June 1851, page 236. The John Rylands University Library of Manchester, Deansgate, Manchester, United Kingdom.

Hence, the poignancy and "humor" of *Punch's* ever so Negro *Virginian Slave* was the painful clarity of her racial difference from the comparatively delicate, leisured, and beautiful body of Powers's white female slave. As the poet recognized, the body of the white female slave did not bear signs of slavery. It was not muscled from physical labor, it had not been branded by an "owner," it did not bear the violent marks of the whip. Rather, as Kirk Savage has noted, this white female slave body still retains her religious, racial, and class identifications and has not undergone the "social death," the (de)/(re)identification of which Orlando Patterson has written.[45]

For the black women who labored endlessly on the cotton, rice, and sugar plantations and in the "big houses" of the American South, who suffered every conceivable form of physical, emotional, and sexual violation, abuse, and injustice, who were cataloged and branded as chattel, and who because of their legal status as property received no protection under the law for themselves or their families, there was no commensurable clamor of woe, outrage, and sorrow, no equivalent heartfelt expressions of remorse, sorrow, or pity. A nude black female subject, no matter how demurely posed or bolstered by Christian symbolism, would not have implied the same level of morality, Christian resolve, or sexual chastity for a nineteenth-century bourgeois white audience and therefore could not have engendered a similar outpouring of poetic despair, sympathy, and outrage as that generated by Powers's *Greek Slave*. Through the intersection of race and sex, the black female body became synonymous with sexual excess, public visibility, and social accessibility. These women were, quite simply, beyond the symbolic order, outside the limits of what was representable within the canons of western "high" art practice. The black female slave of America and the diaspora was the impossible subject, the no-body of neoclassical sculpture, or at least sculpture whose intention was to rally moral indignation or represent beauty.

It was, however, possible to deploy the body of the black female slave to other uses—mainly the abject racial body of social or economic disenfranchisement, noted above, and titillation and sexual spectacle. Giacomo Ginotti's *L'emancipazione dalla schiavitù* (1877) (Figure 28) exemplified this latter potential. The pose, composition, expression, context, and narrative (or lack of narrative structure) of this obviously black female slave stood in stark contrast to the works by Powers, Palmer, Rogers, and Bell. Ginotti clearly identified a so-called full-blooded Negro type by signifying deeply curled hair that escapes from the head scarf, well-defined "thick" lips, and a nose identifiable to nineteenth-century audiences as physiognomically black. The black female body, defined by large globular breasts and full hips and buttocks, anatomically surpasses the voluptuousness and, therefore, the sexual readiness even of Bell's *Octoroon*. The ironically shackled wrists of Ginotti's "emancipated" slave were used as an excuse to represent her sexualized writhing and ministrations, which provoke an eroticized and illicit pose, further accentuating the already large bosom by forcing the breasts together and upward, amplified, not concealed, by the pendant cross that falls across her chest to graze her nipple. The string of jewels wrapped about her upper left arm also works to call attention to the left breast and areola, with which it is juxtaposed.[46] The orgiastic

movements of the black slave's body also locate action, resistance, and passion. However, her actions seem false if one is to read her as struggling against the oddly long stretch of chain links, which do not inhibit the full use of her arms and hands, as would have been intended. Nevertheless, one viewer commented, "The blood rebels in her veins."[47] Such emotions and expressions, which were encoded as masculine within the nineteenth-century bourgeois regimes of sex and gender, were carefully avoided in the representations of white female "slaves." In light of the desire that supposedly chaste marble nudes could engender in nineteenth-century viewers, it is not surprising that Ginotti's black female slave also provoked inappropriate sexual feelings in her viewers, one male wishing that "the marble was a live woman,"[48] presumably so that he could engage in some sort of sexual interaction with her.

Ginotti's slave seems to inhabit some elusive natural setting indicated by the grass at her feet and the flowers at the base. What precisely she was doing "in the forest" is anybody's guess. But again black female subjects did not require elaborate narration to mediate their lack of clothing or sexualized states. The support on which she perches seems to hold her abandoned clothing and bear her body weight through the pressure of her still-shackled foot. This is, to be sure, a thoroughly unclassical pose. Just as elusive is the slave's identity, which is simultaneously represented as African by her racial features and Christian by the pendant cross. The cross was of course, as in Powers's *Greek Slave,* an attempt at eliciting the dominantly white audience's sympathy for the plight of the enslaved Christian female. Undoubtedly titillating and sexually excessive, a black female subject deployed, although transgressively, within the realm of the beautiful, usually strictly reserved for white female subjects, should alert us to the potential significance of the non-American status of the sculptor, an Italian.

Jungle Fever or Who's Afraid of Miscegenation?

The colonial order of bourgeois culture was threatened by the possibility of a body that conformed to the aesthetic scale of whiteness, no longer exhibiting immediate and accessible physical signs of racial difference, but nonetheless contained (in the sense of invisibility and pathology) the biological secret of racial degeneration—blackness. Popular engravings featuring "uppity Negroes" reveal the white fear of miscegenation as the corruption of white moral character through the black body's infiltration of upper-class positions held almost exclusively by whites as a result of racism. Kirk Savage has noted that such proslavery, white-supremacist prints relied on the colonial stereotypes of blackness to scare white viewers through the threat of miscegenation.[49] One such print by Edward W. Clay, *Practical Amalgamation* (1839), features two interracial couples: one, a black man and white woman in a lover's embrace; the other, a gesticulating white man on his knees, kissing the outstretched hand of a mammified black woman. The kneeling white male's grasp on the hand of the seated, bonneted, fan-wielding black woman signifies a courtly gesture, as opposed to the masterful Lincolnesque grip on the black female slave's wrist in Randolph Rogers's *Lincoln and*

the Emancipated Slave. Another popular engraving titled *All the Difference in the World* (1868), published in the 26 September 1868 issue of *Harper's Weekly,* advances a similar "threat" in its representation of a white shoe-shine boy tending to his black male client as another "bourgeois" black male, flanked by two white ladies, passes behind him.[50] In *The Miscegenation Ball* (1864) (Figure 37) interracial couples, predominantly black women and white men, dance and embrace under a banner that proclaims Abraham Lincoln as the orchestrator of the "Universal Freedom," which has resulted in the perversion of white male desire. The uncomfortable integration of class society is conveyed through the similarly bourgeois costumes of both men and women and the improper physical movements and open intimate context. The outcome of this sexually charged atmosphere, which the nineteenth-century white audience would have inferred and for the most part feared, was the little "mulattoes" who would inevitably follow. Ironically, the mulattoes and otherwise interracial children were already predominant in the slaveholding nation, because interracial sexual contact between black women and white men was both frequent and frequently coerced.

Writing in 1863, Louis Agassiz equated miscegenation with the worst forms of social disorder, moral corruption, and physical contamination:

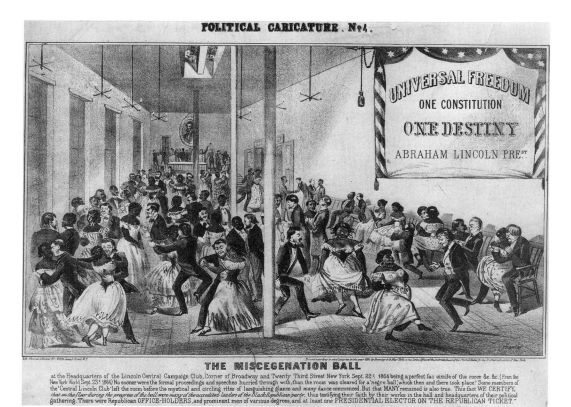

Figure 37. *The Miscegenation Ball,* 1864. Lithograph published by Bromley and Company, New York. Reproduced from the Collections of the Library of Congress, Washington, D.C.

> The production of halfbreeds is as much a sin against nature, as incest in a civilized community is a sin against purity of character. . . . I hold it to be a perversion of every natural sentiment. . . . No efforts should be spared to check that which is abhorrent to our better nature, and to the progress of a higher civilization and purer morality.[51]

But if scientific evidence of the aesthetic superiority of the white body was accurate, how then could one explain the white desire for sexual contact with black bodies? Agassiz's lamentation of miscegenation in the American South demonstrates a prevalent strategy:

> As soon as the sexual desires are awakening in the young men of the South, they find it easy to gratify themselves by the readiness with which they are met by colored (halfbreed) house servants. . . . This blunts his better instincts in that direction and leads him gradually to seek more spicy partners, as I have heard the full blacks called by fast young men.[52]

Again the fictive black female body is cited in terms of its sexual excess (they are spicy partners), which yields an unparalleled accessibility (readiness) to the hapless white male. The biological threat of miscegenation is defined as a by-product of the proximity, visibility, and accessibility of the sexually deviant black female bodies (the halfbreeds were house servants). Agassiz can cope with the threat of miscegenation only by summoning the imagined black female body, which becomes both the source and cause of the forbidden sexual contact. Any white male desire for the black female body is summarily disavowed, since his "better instincts" (a natural desire for superior white females) have been corrupted by his contact with the predatory black female subject. Agassiz's dependence on the idea of the repulsiveness of the black female body is such that he is unable to conceive of the miscegenation that produced the "half-breeds" in the first place. Thus, the original sexual contact between the "pure" white body and the so-called full-blooded Negro body is eclipsed. *Miscegenation* is a colonial term, the existence of which demonstrates white anxiety at the possibility of the very interracial sex it defines.

For the black female, her infiltration of white society was dependent on miscegenation and the production of a visibly white body, since a so-called full-blooded Negro body was readily discernable. The impossibility of the black female body masking itself in white bourgeois culture was the subject of the painting *The Art of Love* (1831), by the English artist Robert William Buss. Buss's painting captures the visceral disgust registered on the face of a white "gentleman" who has mistakenly taken the gloved hand of a black "lady." The black woman's decidedly bourgeois mannerisms and dress are for her but a momentary disguise, which her black face, revealed from beneath the veil, unmasks. The "problem" of the female body is defined as corporeal, her race and the physical signs thereof, since the rest of her body, according to white bourgeois female fashion, is utterly concealed with hat, veil, gloves, and floor-length

skirt. The potential invisibility of the white female prostitute, accessible through the masquerade of class, is here denied the black woman, whose black face disqualifies her from the possibility of the beautiful, even while her body flawlessly parodies acceptable signs of bourgeois class in every other way.

The production of these imagined racial bodies necessitated the primacy of vision as an authoritative "scientific" mechanism of material knowledge, wherein these female bodies were repeatedly submitted to the visual authority of the scientific gaze and represented within a visual field. The visual reproduction of bodies, generally in photographs, drawings, engravings, casts, and sculpture, was characterized by the repetitive representation of dismembered bodies. In photographic compilations in texts such as *Archivio di psichiatria scienze penali ed anthropologia criminale* (1893), bodies (of Russian prostitutes) were divided into a series of overdetermined sexualized parts and fused within mesmerizing patterns of flesh, which were later remembered as a fictive whole body. The practice of visualism can be very seductive. It was not merely science's use of quantity or the sheer redundancy of the body and its parts in representation, but the processes and practices of representation, accepted as objective, that prepared female bodies to receive the authoritative scientific gaze passively. A key attribute is the dominance of the profile pose, which empowered the viewer's gaze and simultaneously transformed the "scientific" subject into an object of viewing.

The centrality of the practice of autopsy to the human sciences reminds us that dismemberment was not merely a visual violence done to a represented body but assumed a physical form and materiality that was directed at the objectified bodies of women after death. As we shall see, the cultural representation of the racial signs of Cleopatra's neoclassical marble body within nineteenth-century texts assumed the same strategies of the visual ordering of the physical signs of the racially deviant female bodies within the human sciences. Both emphasized the excessive nature of specific physical characteristics through their visual separation from the whole body. Both created a fictive whole body from a range of dismembered racialized parts that were reassembled into a disordered, imaginary body. And both assumed intellectual, social, sexual, and moral implications from the assignment of a racial classification.

6. Racing the Body
Reading Blackness in William Wetmore Story's *Cleopatra*

William Wetmore Story in Rome

My exploration of the possibilities and aesthetic limitations of black female subjects within nineteenth-century neoclassicism has led me, full circle, back to the *Cleopatra*s of William Wetmore Story and Mary Edmonia Lewis. Although the sculptors became established in Rome by the latter part of the nineteenth century, both Story and Lewis also maintained strong connections with Boston. William Story first traveled to Rome and Europe in October 1847 at the age of twenty-eight in the wake of a public commission for a sculpture to commemorate his father's life. Prior to this date Story had spent most of his life in Cambridge, near Boston.[1] Nathaniel Hawthorne described Story as a man with a "perplexing variety of talents and accomplishments," which included being a poet, prose writer, lawyer, painter, musician, and sculptor.[2] After several trips back to America, Story eventually abandoned the practice of law to commit himself fully to a career as a sculptor. By 1856 Story and his wife, Emelyn, had acquired spacious apartments on the second floor of the Palazzo Barberini, while Story adopted studio space on Via San Nicolo di Tolentino, later acquiring a more elaborate space at 7 Via San Martino a Macao in 1876.[3] Hawthorne confirmed that the sculptor, at one juncture, had also maintained studio space on the Via Sistina, where the author called on him in February 1858 to find "the statue of 'Cleopatra,' now only fourteen days advanced in the clay."[4] Comparing the sculpture, yet in its embryonic phase, to Story's conception of Goethe's *Margaret,* Hawthorne commented that Cleopatra "is as wide a step from the little maidenly Margaret as any artist could take; it is a grand subject, and he is conceiving it with depth and power, and working it out with adequate skill."[5] In Story's own assessment it was the success of his *Cleopatra* (1862) and her companion, the *Libyan Sibyl* (1862), that preempted his return to the more stable legal profession. Story wrote of the two works:

These I executed in marble, but no one would buy them. . . . But it so happened that the London universal exhibition was to take place and that I was requested to allow these two statues to go into the Roman Court, the Roman Government taking charge of them and paying all expenses. I gave them.[6]

Mary Hamer has done a remarkable job of detailing the political and religious investment of Pope Pius IX's possession of Story's *Cleopatra,* as it paralleled Augustus's similar and much earlier possession of a representation of Cleopatra, which, within the spectacle of his triumph, ensured his political glorification in ancient Rome. Hamer has argued that Pius IX's endorsement of Story's *Cleopatra* was explicitly political. With the dismantling of the secular power of the papacy reducing the papal kingdom to the city of Rome, Pius's possession of *Cleopatra* was a defiant act of remembrance against his political adversaries. Since the disintegration of papal power had been endorsed by Britain, Pius's symbolic recuperation of Cleopatra's marble body, strategically enacted within the London exhibition, was a sign of the continuation of Roman glory even in the face of obvious political defeat.[7] Even within the context of a single historical moment, one marble sculpture of Cleopatra bore multiple and divergent meanings and identifications for her audience. Pius IX was interested in Cleopatra's foreignness only to the extent that she could stand in for his political adversaries and his determined resistance in the face of their demands, a parallel to her historical defeat at the hands of Octavius. But to the educated viewers at the London exhibition, Cleopatra's foreignness declared an explicit racial identity that referenced another conflict across the Atlantic—the endurance of the "peculiar institution" on American soil.

Sculpting Cleopatra

For both Story and Lewis, sculptors creating major works on a large scale, their representations of Cleopatra became the solitary image of a queen. While in painting, western artists from many ages had regularly depicted Cleopatra as one facet of a multifigure composition (with attendants and servants or in the company of Julius Caesar, Antony, or even Octavius), for the sculptor working on a grand scale, a group composition, both costly and complex, was not the traditional or practical choice.[8] Cleopatra fits within the broad category of ideal sculptures, which often took the form of allegorical and historical themes and subjects drawn from literature, the Bible, and ancient Greece and Rome, as well as conceits or fancy pieces and genre sculpture.[9] As a single figure Cleopatra's foreignness could not rest on the proximity of her "exotic" black and brown attendants or solely on the luxury and excess of an exoticized environment. Rather, her body alone carried the major burden of conveying her racial identity. Therefore, physiognomy and anatomy (Cleopatra's face and body) and composition, pose, countenance, and expression (what Cleopatra's body was up to) became critical.

Work on Story's *Cleopatra* began in 1856–57 with a compositional sketch, with the

clay maquette following in the winter of 1858. The first of three different marble versions was completed between 1858 and 1860,[10] the second in 1864, and the third during 1884 and 1885.[11] The alterations to the original were adjustments of the pose (Cleopatra became more relaxed), her drapery (her left breast went from being partly exposed to fully exposed in the second version), and the position of the left hand, which she rests on her knee (the thumb and forefinger touch in the first version and are separated in the second). An artist's engagement in the contemplation and eventual reformulation of a minutia of detail demonstrates the extent to which not only the physicality of the human subject but also the details of its action, pose, and countenance were seen to bear significant symbolic and narrative weight and were actively examined by the audience for their relevance to the subject's identity. In addition to these changes, Story altered the shape of the base from a classical rectangle to a series of "Eastern arches."[12] All of these changes were accompanied by what Ilene Susan Fort and Michael Quick have called "a slightly more African physiognomy, perhaps to suggest an Eastern sensuality."[13] However, Fort and Quick's conflation of African and eastern physical traits recalls the similar confusion that nineteenth-century audiences experienced reading the racial signs of Story's queen. Their shifts between the citation of an Egyptian and a Nubian body shall be discussed in detail below.

Exhibition and Marketing, or How to Sell an Ancient Queen

In the official catalog of the Fine Art Department of the International Exhibition held in London in 1862, Story's *Cleopatra Seated* and *Libyan Sibyl* (or *Sibilla Libica,* as it was named in that catalog) were listed in the foreign division under "Rome, sculpture."[14] Much as with Hiram Powers's *Greek Slave* before it, the notoriety and success of Story's *Cleopatra* were largely derived from its repeated literary representation within the discursive practice of cultural tourism. *Cleopatra,* visible to the cultural tourist of nineteenth-century Rome in Story's studio, was also widely represented and applauded textually within the forms of guidebooks, letters, poetry, prose, art reviews, and travel writing and inserted into the public imagination well before it was in a state of material completion necessary for official exhibition. No doubt the intelligently and aggressively orchestrated publicity that had accompanied Hiram Powers's *Greek Slave* to America was well known to Story and perhaps influential in the way he marketed his *Cleopatra.* The significance of these textual accounts was acknowledged by Story, who reported that visitors to his Roman studio would bring copies of Nathaniel Hawthorne's novel *The Marble Faun, or the Romance of Monte Beni* (1860), from which they would read aloud while viewing the sculpture.[15] Hawthorne, too, was equally cognizant of the power of his novel to affect the course of Story's career when he wrote to a friend stating, "Look well at [Story's] Cleopatra, for you will meet her again in one of my chapters which I wrote with most pleasure. If he does not find himself famous henceforth, the fault will be none of mine. I at least, have done my duty by him."[16]

Cleopatra's Blackness

Nancy Proctor has argued that the *Cleopatra* of Hawthorne's "fictional" Kenyon is the fetishized (phallic) object that stands in for the impossibility of the woman sculptor, who was strikingly absent from Hawthorne's *Marble Faun,* despite his significant professional and social interactions with Harriet Hosmer and Louisa Lander in Rome, which he recorded in considerable detail in his *Passages.* However, I would like to add my concern for Cleopatra's racial signification, the impossibility of the black/Native woman artist, and the presence of the black female body. The fetishized object for Hawthorne is not just gendered; it is also raced. It is a black female body that in the end is unveiled and can be signified only as a frozen, *white,* marble sculptural object and not as an active, producing, "black" female body.[17] We must be attentive not only to the sex–gender assignment of subjects but also to the psychoanalytical negotiation of the racialized body, which, through fetishization, is achieved through not just presence but also absence.

Literary representations like Hawthorne's *Marble Faun* effectively prepared Story's audience for his sculpture, the narrative and the meanings he wished to deploy, meanings that preceded largely from the correct racial identification of Cleopatra's body as black. Traces of these anxieties and intensities are available to us through the nineteenth-century textual accounts of the people who viewed Cleopatra's marble body. That Cleopatra's race and its legibility were of paramount importance to the nineteenth-century artists who represented her and the audiences who viewed her is evident in the historical documents that we have inherited.

An examination of some of the contemporary textual responses to Story's *Cleopatra* will allow for a better understanding of the specific material and aesthetic elements of the sculpture that resulted in the reading of a black body for Cleopatra and the cultural, social, and political implications for such a body. Story's visual deployment of signs of blackness could become effective only if his audience was knowledgeable of the racial signs he deployed, capable of reading and deciphering those signs, and willing to see a black body and the requisite symbolic position afforded an ancient queen. This textual evidence was produced by the elite audiences, the leisured and wealthy classes for whom art was a demonstration of "cultural capital." The texts from this elite group were generated from their experience not just as viewers but also as benefactors, patrons, supporters, and collectors, many of whom had personal relationships with the artists, formed through cultural circles in America or through contacts made within the process of cultural tourism—people who were in the privileged position to influence cultural production. Although the voices are dominantly those of white men, the highly inaccessible and materially impenetrable bourgeois body of the white female viewer is an essential structuring component of the exposed and sexually available black female body represented in the sculpture.

Griselda Pollock has noted, "In bourgeois culture, we find the ironic pairing of the artificially fashioned form of the female nude and over-costumed lady, hatted, gloved,

corsetted and so swathed in metres of heavy cloth that scarcely a trace of the body was visible."[18] In both cases we are confronted by the social and cultural performance of sex, gender, and race. There exists another striking disjuncture, that between the rather exuberant and definitive textual naming of blackness and the restrained and controlled material visibility of blackness within the marble sculpture itself. As I pursue the body of the black Cleopatra, race and sexuality are, as Griselda Pollock has described, "caught up in the troubled field of subjectivity, sexuality and vision in a bourgeois imagination that is white, colonial and masculine by virtue of the way these terms coincide and mutually inflect each other."[19]

Blackness Equals . . . : Reading/Writing Race

As early as February 1858, Nathaniel Hawthorne noted that *Cleopatra* was a sculpture "into which [Story] has put all possible characteristics of her time and *nation* and of her own individuality"[20] (italics mine). In April of that same year he would elaborate that the sculpture of the ancient queen was "a work of genuine thought and energy, representing a terribly dangerous women—quiet enough for the moment, but very likely to spring upon you like a tigress."[21] As this further description of the sculpture attests, Cleopatra's animalization was connected, for Hawthorne, to her *nation* or race—her blackness. It is not insignificant to add that in Hawthorne's first encounter with the work, Story's *Cleopatra* was in the clay, the dark tactile medium's displacement of the dominant white marble surely adding to Hawthorne's reading of a black female body. In his *Marble Faun,* Hawthorne went yet further in narrating a black body for the ancient queen:

> Cleopatra sat attired in a garb proper to her historic and queenly state, a daughter of the Ptolemies. . . . The spectator felt that Cleopatra had sunk down out of the fever and turmoil of her life . . . and was resting throughout every vein and muscle. . . . But still there was a great, smouldering furnace, deep down in the woman's heart. The repose, no doubt, was as complete as if she were never to stir hand and foot again; and yet, such was the creature's latent energy and fierceness, she might spring upon you like a tigress, and stop the very breath that you were now drawing, midway in your throat. The face was a miraculous success. The sculptor had not shunned to give the full Nubian lips, and other characteristics of the Egyptian physiognomy. His courage and integrity had been abundantly rewarded; for Cleopatra's beauty shone out richer, warmer, more triumphantly, beyond comparison, than if, shrinking timidly from the truth, he had chosen the tame Grecian type.[22]

Dangerous beauty this. Hawthorne's description deployed race, as characteristics both of and within the body, with an essentialism that located the human science's visualization of the racialized body. While Cleopatra's lips and face purportedly bore the signs of her Nubianness and Egyptianness, her body, pose, and expression, animalized

through the allegory of a killer wild cat, also betrayed the signs of corporeal excess and dangerous temperament, which easily aligned her with an Other sexuality.

Henry Adams produced another early account of Story's *Cleopatra* in a letter dated 17 May 1860, which he wrote after a visit to Story's studio.

> He is and has been for a long time, busied with a statue of Cleopatra, and it is something so original that I cannot help dilating on it a little. He has gone to the *East for inspiration,* and has broken loose from the whole tribe of senseless, traditional Cleopatras. . . . His Cleopatra is an Egyptian woman, not a Grecian or Italian girl. He has sought for the pure eastern type, believing that that type contains as much that is grand and beautiful and attractive, as the European, which artists have produced and reproduced for centuries. [A] figure *thoroughly Egyptian* in costume as well as *feature.* She is meditating apparently her suicide. To me apart from the *rich sensualism of the face and form,* there is a great charm in the expression that she wears; . . . Mr. Story has tried to breathe the mystery and grandeur of the sad and solemn old Sphynxes and Pyramids into his marble.[23] (italics mine)

Adams succeeded in acknowledging Story's significant racial departure from the standard Grecian/Italian (white) type to the sensual eastern/Egyptian type, through a statement that acknowledged and reentrenched the colonial hierarchies of human aesthetics and sexuality. In an article reprinted from *Dublin University Magazine* in the 28 July 1860 issue of *Dwight's Journal of Music,* an unknown author wrote a highly romantic description of Story's sculpture adhering to the mythical ideal of the sculptor working the marble block to reveal the already extant ideal form that was trapped within:

> Heavy fall the mallet strokes on chisels, searching out the *tawny terrors* of the Egyptian's *panther-beauty* from the marble block:—That is the Cleopatra, whom our author has shown to you. Now push open the little swinging door that guards the inner studio. You shall almost start and draw back your foot before the towering height and *passionate energy* of her who lifts one hand to heaven for help, and in the other grasps a scimitar. She is no Greek: you see it by one glance at the bold arch under which quiver nostrils breathing vengeance. . . . She is no Roman either.[24]

The author's declaration of Cleopatra's non-Greek and non-Roman status resulted in part from her "bold arch" and quivering nostrils—in short from her race, which he registered in her physiognomical characteristics—as well as from her countenance (after all, her nostrils were breathing vengeance). But the author also performed for his readers a brief character analysis, which included a comparison of Cleopatra with the likes of "proper" women such as Clytemnestra, Lucretia, and Judith. The author's choice of these women was not a matter of their sinless natures. Quite the opposite, these women were guilty of grave crimes against themselves and others. However, their Romanness and Greekness mediated the circumstances and conditions under which their actions

were manifested and the ways in which their responses exhibited an appropriate female self-effacement, innocence, penitence, or resignation, much like Powers's *Greek Slave.* In other words, these women, although guilty of doing "bad" things, were nevertheless "good" because they did them as women and not as men. The gender roles were not breached; therefore, their behaviors were not threatening to the patriarchal order. As the author elaborated, "Lucretia looked not up, but down along the sword, shame blending with savage indignation before she buried it hilt-deep in the breast a Tarquin's touch had soiled."[25] The implication here is that Cleopatra would have looked up, and while it is not specifically stated what this looking up would have meant (is it a sign of self-determination, pridefulness, conceit, defiance?), the inference is that it was the appropriate response of neither a woman nor a Roman. Cleopatra's race is the source of her mysterious and terrifying qualities. It is her not-Greekness and not-Romanness—her racial otherness—that leads to the descriptions "panther-beauty" and "passionate energy." Cleopatra's racial otherness was the trigger for both her exoticization and animalization. Her animalization was something that was to be fostered deliberately and elaborately by the sculptor himself, as we shall see shortly.

In another text that predates the official public display of Story's *Cleopatra,* the author, Edward E. Hale, is equally invested in defining Cleopatra through lack, telling his readers what Cleopatra was not. Hale applauded Story's *Cleopatra* as a unique contribution to contemporary art that transcended the mere copying of the antique. To Hale, Story's *Cleopatra* succeeded in capturing the complexities of Cleopatra's character and the moment of her morbid contemplation. But Hale's enthusiasm was also decidedly bound up with his racial reading of the ancient Egyptian queen and its implication for her "nature":

> And do you remember, my friend fond of history,—as you look, do you remember,—that she is an *African woman?* The little jet of Greek blood, which Ptolemy brought into this dynasty three centuries ago, is only the smallest fraction of this *Egyptian's life,*—not the hundredth part of it, nor the two-hundredth part. A line of Egyptian mothers for ten generations have made her wholly Egyptian,—*in this raving hot blood of hers; in this passionate temper; and in the whole quality, even, of her mind.* It was no pretty Greek beauty that worked such havoc with such men as those. You are looking, my dear friend, on an *African* queen,—the first since Sesostris to hold sway over the conquered heroes of Europe; and her sway is broken now, and Europe is thundering at the gates of her citadel. You have the same old story of Africa,—always outwitted by Asia, always outfought by Europe,—as you look on in despair.[26] (italics mine)

Hale's words, which locate Africa at the bottom of a continental hierarchy, assumed the viewers' sympathetic reaction to Cleopatra's predicament and despair and situated a potential abolitionist reading. That Africa was supposedly always outwitted and outfought was a point not for celebration but for sorrow. Hale's declaration of Cleopatra's Africanness was largely a facet of what he understood as her matrilineal heritage,

which has never been conclusively confirmed. Cleopatra's "wholly Egyptian" nature was intrinsically connected to an entire set of racial stereotypes that affected all aspects of her being. It was from these generations of Egyptian mothers that Cleopatra had inherited her raving hot blood and passionate temper. Cleopatra's nature is by implication excessive and feral, and the roots of this nature are understood as racially and maternally bound, for it is something that is in her *blood*. These racial and therefore biological characteristics also, of course, implicated her sexuality and were the means by which she worked havoc on white men such as Antony and Julius Caesar. No Greek/white woman was capable of such sexual prowess, but for an African/black woman, it was understood to be in the blood, like the black female house servants whom Agassiz termed "spicy partners."

Hale read Story's composition as a representation of Cleopatra's final brooding moments before the fatal suicidal act. But he read into the suicide more than the destruction of an individual body—that of a race and continent: "Again: she is not Greek, but an Egyptian; and, if you will consent that Egypt shall typify Africa for you, you may make this a symbol of *Africa's despair*"[27] (italics mine). Written on the eve of the Civil War, "Africa's despair" had an immediate and poignant relevance for blacks, slaves and free, of a racially and politically divided America. The idea of Egypt as representative of Africa and the state of Africans generally was also reiterated by James Jackson Jarves, despite his belief in Cleopatra's Greek lineage.

> We may ethnographically object that Cleopatra, sprung from Hellenic blood, could not be African in type. Still it is a generous idea, growing out of the spirit of the age,— the uplifting of downtrodden races to an equality of chances in life with the most favored,—to bestow upon one of Africa's daughters the possibility of the intellectual powers and physical attractions of a Grecian siren.[28]

By implication white woman's intellect or beauty was considered to be so far beyond the grasp of the black woman that Story's representation becomes a generous intervention, a fabrication founded on the benevolence of white abolitionists. Again, I return to my earlier thoughts about the representational difficulties of marginalized subjects. By the mid-nineteenth century, the representation of the black female body had taken on certain distinct forms that did not encompass a notion of beauty and intellect comparable to those of white female subjects. Cleopatra's representation as a beautiful black woman in possession of intellectual ability was a stunning departure from the traditional parameters within which the black female subject could be represented. But the caveat was that her beauty was, like that of the octoroons of John Bell and John Rogers, mediated by its interracial quality, while the sexualization of the black woman displaced her from any easy alliance with bourgeois norms of proper womanhood, coded as white. The various authors' stubborn determination to deploy many of the racial stereotypes of blackness and the traces of hostility, fear, and titillation that those stereotypes engendered demonstrate the power and permanence of the colonial

order and the extent to which the reading of the black subject occurred within the process of viewing and not necessarily within the process or parameters of representation.

Hale's statement of Cleopatra's blackness has more to do with his assessment of ancient history than with any specific aspect of the marble sculpture that Story had represented. The closest Hale gets to an actual analysis of *Cleopatra*'s marble body is his comment that Story "represents . . . not a girl, but a woman, with a woman's beauty and a woman's form."[29] The distance between Story's modeling of Cleopatra's body and Powers's and Palmer's modeling of the white women in *Greek Slave* and *White Captive,* respectively, should be noted again. Story's black queen has the voluptuous form indicative of sexual knowledge and readiness seen in Ginotti's emancipated black female slave and Bell's *Octoroon.* Are we to understand then that a woman's form and beauty are qualities attributable only to African women? Of course not; rather, the idea of womanliness here is a substitute for the idea of a knowledgeable, active, threatening, and even dangerous female sexuality.

I continue with an examination of the reviews and texts that postdated the exhibition of Story's *Cleopatra* at London. The glowing review published in the 10 May 1862 edition of the *Athenaeum* read thus:

> And among the new men Mr Story, the American, bears away the honours. . . . Queenly Cleopatra rests back upon her chair, in meditative ease, leaning her cheek against one hand, whose elbow the rail of the seat sustains; the other is outstretched upon her knee, nipping its forefinger upon the thumb thoughtfully, as though some firm wilful purpose filled her brain, as it seems to set those *luxurious features* to a smile as if the whole woman "would." Upon her head is the coif, bearing in front the mystic uraeus, or twining basilisk of sovereignty, while from its sides depend the wide Egyptian lappels *[sic],* or wings, that fall upon her shoulders.[30] (italics mine)

It is important to note that Story's deliberations over the specific gesture of Cleopatra's hand were not a futile endeavor. His audience absolutely did notice such details and used them to interpret character, expression, and even, as this reviewer attests, the idea of thought—all attributes that were linked inevitably to racial identity. Any hint of the reviewer's opinions about the race of this Cleopatra was coded within his description of her authentic Egyptian garb and adornment as well as within the cryptic description of her features as luxurious. The notion of the luxurious operates in the same way as the concept of the foreign or exotic, as a label that is projected outward from the speaking, empowered, and idealized white subject at the center. What was luxurious about the thick lips and broad noses of many Africans was the "excess" flesh or dimensions, which were, of course, excessive only when set against the normative lips and noses (understood to be generally thinner) of white Europeans. But race was also disguised within the author's recognition of a type of intensity of expression that is seen as inharmonious with white female subjectivity. The reviewer's racial description went even further in the discussion of Story's *Libyan Sibyl/Sibilla Libica,* describing her body

as being "in the full-blown proportions of ripe womanhood" and her face as having a "Nubian cast."[31] Here again, a womanly body is used as a synonym for a black female sexuality. And although the Sibyl was named as Nubian, we are not privy to which physiognomical traits led to this visual deduction.

On 6 April 1867 the Baltimore merchant Frank Frick visited Story's Roman studio and found copies of his *Cleopatra* and his *Libyan Sibyl,* which he described rather dismissively, along with Story's *Medea* (1868) and *Dalilah* (1866–67), as "all from the same Nubian woman with heavy lips."[32] Again the term *Nubian* is deployed, not *Egyptian* or *African,* signaling the author's desire to distinguish between the interracial identity of the Egyptian type and the so-called full-blooded Negro type. In the same vein, writing in 1870 James Jackson Jarves would call the same mouth "vulgar," and yet while this vulgarity of the mouth seemed a sure way of naming its blackness, Jarves went on to charge that Cleopatra's face "has no ethnographically decisive type."[33] Jarves would surely, at this point, have taken offense at Edward Hale's declaration of Cleopatra's historical Africanness, since he went on to complain that "Story has forgotten that she was wholly Greek in race and culture."[34] But the general consensus was that Story's *Cleopatra* was a black, African queen. In a *New York Times* article of 1882, an anonymous author found Story's *Cleopatra* interesting "because of her quasi-Egyptian attire and the full lips and slightly different modeling of face that denote a mixture of negro blood."[35]

Story's Desires

But what, if anything, did the sculptor Story have to contribute to the literary racial description of his *Cleopatra?* William Wetmore Story's poem of the same name appeared in the 16 September 1865 edition of the *Dwight's Journal of Music* and was later published twice in *Graffiti d'Italia,* first in 1868 and again in 1875. Story's poem can be understood in light of nineteenth-century artists and art viewers' overwhelming investment in the narrative potential of art. As such, poetry and prose were often displayed with the artworks or disseminated through art journals. There is a striking discord between Story's marble sculpture of a restrained and contemplative queen and the poem wherein a restless, emotional, and demanding Cleopatra is haunted by dreams and memories of her beloved Antony. Her tumultuous state exists in stark contrast to the calm of her environment. The afternoon is slumbering, the Nile is slow and smooth, the crocodiles are sleeping, the lotuses are lolling, the twilight breeze is lazy, and "yon little cloud" is as motionless as "a stone above a grave." Yet, in her torment she is unable to be appeased or comforted, although she seeks respite from the deeds of her servant Charmian and the presence of her "creamy white" pet cockatoo, another evocative image that leads us to imagine the dramatic contrast of the white bird with Cleopatra's brown skin. In the end, all of Charmian's actions—she turns over Cleopatra's pillows, opens her lattice so that she may smell the garden, sprinkles her with rose leaves, and fans her with sandalwood scents—and the antics of the bird are for naught, and Cleopatra violently orders them from her chamber:

There—leave me, and take from my chamber
That wretched little gazelle,
With its bright black eyes so meaningless,
And its silly tinkling bell!
Take him,—my nerves he vexes—
The thing without blood or brain,—
Or, by the body of Isis,
I'll snap his neck in twain![36]

Cleopatra's race is confirmed in the latter half of the poem through her animalization, to which Story devoted half of his text. Cleopatra, lamenting over Antony, dreams of a "past-time . . . / Aeons of thought away," when she was a "smooth and velvety tiger, / Ribbed with yellow and black." We are privy to Cleopatra's remembrances of her animal life, which she now yearns for, a time when she had a "fierce and tyrannous freedom" and was governed only by the "law of her moods." Much of Cleopatra's pleasure from her previous incarnation as a tiger was derived from the fear she sparked in other creatures; the elephants "started" and the giraffes "fled wildly." But central, too, was her enjoyment of the physical pleasure of her fierce and ferocious sexual coupling with Antony, her wild, powerful, and grand mate. Story's description of their sexual joining is a sadomasochistic mixture of violence, surrender, pleasure, and pain: "Then like a storm he seized me, / With a wild triumphant cry / . . . For his love like his rage was rude; / And his teeth in the swelling folds of my neck / At times, in our play, drew blood."[37]

The vivid recollections of a past animal life were a clever disguise for the mediation of a feral, even pornographic, sexuality that would by no means have been acceptable for deployment within "high" art genres of a human narrative within the boundaries of nineteenth-century Victorian sensibilities. Cleopatra's celebration of the violence, mystery, and passion of this life and her experience and enjoyment of sexual pleasure—she exclaimed, "That was a life to live for!"—were not synonymous with the ideals of proper white womanhood at the time. But they were certainly synonymous with the ideals of black sexuality as excessive, limitless, uncontainable, and dangerous. The crescendo of violence reaches its sexualized climax at the end of the poem, with Cleopatra and Antony still in tiger form, killing together: "Where the antelopes came to drink; / Like a bolt we sprang upon them, / Ere they had time to shrink. / We drank their blood and crushed them, / And tore them limb from limb." Cleopatra's sentimental yearning for the days of such explicit violence intermingled with obvious sexual energy sits well with the various authors' readings of the expression and countenance of Story's marble queen, which repeatedly emphasized a passionate, brooding sensualism and a barely contained aggression. If you will recall, the anonymous author of the *Dublin University Magazine* article referred to Cleopatra as a panther-beauty.

The contemporaneous readings of Story's *Cleopatra* confirm a fascination with her racial status as well as the shared belief that said status was black. But also revealed is

that the educated, white, art-going public of the nineteenth century was not at all clear in any precise way about what these black characteristics were. In the midst of the age dominated by scientific notions of race, flaring nostrils, full or vulgar lips, luxurious features, panther-beauty, a passionate nature, and a womanly form hardly qualified as definitive descriptions of a distinct biological racial category. Such descriptions were even more illusive than the arbitrary measurements of earlobes and crania offered by western human scientists. What these texts cumulatively demonstrate is the problematic assertion that *white people just knew a black person when they saw one,* an assertion that confirmed the idea that race is something that is always visibly accessible on the body.

Many of these descriptions of Story's *Cleopatra* invoke a collapse between the Egyptian body and the body of the Nubian. Although the nineteenth-century human scientists broadly categorized peoples of African descent as Negroid/Negro, further distinctions were frequently made between the physiognomical and anatomical characteristics of Africans on the basis of their geographical location within northern or southern regions. The deliberate representation and ready acknowledgment of Cleopatra's racially hybrid body are problematic when one recalls that ancient Egyptians and Nubians were culturally, racially, and geographically distinguishable. According to Frank Snowden:

> The dark- and black-skinned Africans mentioned most often in the records of Mediterranean peoples lived in parts of the Nile Valley south of the First Cataract. This region was designated frequently in Egyptian texts and the Old Testament as Kush (Cush) and Aithiopia (Aethiopia) in Greek, Roman, and early Christian authors. The area, also referred to as Nubia, is often divided into Lower Nubia, extending from the First to the Second Cataract; and Upper Nubia, stretching southward from the Second Cataract to the area in the vicinity of Meroe, situated about halfway between the Fifth Cataract and present-day Khartoum.[38]

The ancient civilizations of Nubia and Egypt were intimately entwined for long periods, with the Egyptian occupation of Nubia lasting almost five hundred years and the subsequent conquest of Egypt and its absorption by the Napatan Kingdom of Kush (c. 750–300 B.C.), which established a capital at Meroe, surviving for over one thousand years.[39] By the time of Ptolemaic rule in Egypt, Nubia was a wealthy and distinct kingdom, and although diplomatic and commercial relations between Egypt and Nubia appear to have continued, they were sometimes strained by Egyptian exploitation of Nubian resources.[40] Nubians and Ethiopians would have been a visible part of Alexandrian society, and Nubians appear to have served alongside Egyptians in the Ptolemaic military.[41] So from where did the nineteenth-century notion of the Egypto-Nubian body emerge?

Friendship and Abolitionism: Sumner and Story

Story's political position regarding the question of race and slavery in nineteenth-century America supports the abolitionist reading of his *Cleopatra.* Story's friend and

biographer the novelist Henry James included Story among the Northern sympathiz-
ers during the American Civil War and counted Story's *Cleopatra* and *Libyan Sibyl* as
artistic expressions of this abolitionist sympathy. As Henry James related in a chapter
devoted to these two sculptures, "His own sentiments and convictions relieved them-
selves by a demonstration on which he was distinctly to be congratulated and of which
we shall presently encounter evidence."[42] But Story was also moved to write his feel-
ings about the "case for the North" in letters, which, with the aid of his friends Robert
and Elizabeth Browning, appeared as "the American Question" in the London *Daily
News* on 26, 27, and 28 December 1861.[43]

Although expatriated, Story had maintained contact with his American friends,
Northerners, and some politically active abolitionists who kept him abreast of current
issues regarding slavery, race, and the Civil War, with personal accounts of national
political debates. Story's own abolitionist views were undoubtedly influenced by the
socially and politically conscious poet and literary critic James Russell Lowell,[44] but one
of his most profound abolitionist influences likely derived from his long-standing
friendship with the Massachusetts senator and outspoken abolitionist Charles Sum-
ner.[45] Through correspondence spanning forty years, Story and Sumner continued
their long-distance friendship, which had begun in Boston when Sumner had been
mentored by Story's father, Justice Story, a Supreme Court judge.[46] At the conclusion
of a reunion in Boston in 1851, when Story had returned from Rome, he wrote knowl-
edgeably of Sumner's political commitments and prominence within the abolitionist
movement, his words revealing an intimate friendship:

> I leave no one in this country with more regret than you. You have always been to
> me more brother than a friend. . . . I would that you were to go with us. But you
> have tasks noble to perform. How many look to you to carry out great principles in
> legislation, to speak stirring words into the dull ear of apathy, and to create a soul under
> the ribs of slavery.[47]

It was Sumner's dramatic physical attack at the hands of the Southern legislator
Preston Brooks that would prompt his next meeting with Story, this time in Rome.
In 1856 while writing at his desk on the Senate floor, Sumner was viscously attacked
with a cane, beaten in the head to the point of unconsciousness.[48] Brooks, an advocate
of slavery, offended by one of Sumner's speeches, had pronounced Sumner's words
libelous to South Carolina and his relative, Mr. Butler. This physical attack registered
the extent of the sectarian hostility over the issue of slavery within American political
circles leading up to the Civil War. Suffering from partial paralysis and neurological
pains after the attack, Sumner, under medical instruction, sailed to Europe for recu-
peration and stayed with the Storys in Rome in 1859. Despite Sumner's harrowing expe-
rience, his political resolve appears not to have been swayed. Rather, it appears to have
been strengthened. It is undoubtedly significant that within this critical period before
the Civil War and during the conception of *Cleopatra,* Story had intimate daily contact

with his abolitionist friend, who expressed a determination to resume his political re-
sponsibilities in America.[49]

Sumner, who had been elected to Congress in 1851, actively campaigned against slav-
ery, the racial segregation of education, and the expansion of slavery into new American
territories. Describing his early interest in slavery, Sumner had written of the signifi-
cance of the abolitionist newspaper the *Liberator* and his first political speech chal-
lenging the annexation of Texas as a slaveholding state.[50] As Andrew F. Rolle has noted,
it was "from his letters the Storys obtained their best information about the course of
the Civil War" and, I would add, the national discourse on race and slavery in general.[51]
In several such letters Sumner advised Story, "The rebellion will be crushed, and Slav-
ery too,"[52] calling the rebellion "nothing but *Slavery in arms*."[53] Yet later Sumner would
write, "Have faith this republic is a lifeboat that cannot be sunk. Grant assures the
president that he shall take Richmond."[54]

Sumner, who had been one of few to support Story's career shift from lawyer to
sculptor in the first place, not only championed Story's sculpting career but also encour-
aged him to engage in the representation of subjects that dealt directly with the press-
ing political and social issues that defined America's racial crisis. Sumner wrote to Story:

> You will be happy to know that the fate of Slavery is settled. This will be a free coun-
> try. Be its sculptor. Give us, give mankind, a work which will typify or commemorate
> a redeemed nation. You are the artist for this immortal achievement.[55]

Sumner's endorsement recalls the contested symbolic meanings of Powers's *America* as
a commemoration of a hoped-for American democracy. Concrete examples of the types
of subject that Sumner advocated for Story are documented in the senator's attempts
to win two specific commissions for his friend: a statue of Lincoln to be awarded ten
thousand dollars and the memorial statue proposed for Colonel Robert Gould Shaw.[56]

There is little doubt that Story was aligned with abolitionist causes and that he
intended his *Cleopatra* to be interpreted as a black queen, a type of African allegory, in
order to convey the sense of frustration and despair of an America divided against itself
in war by racial strife and more specifically divided on the issues of the status of the
black subject within its union. To answer the question I posed above in this chapter—
From where did the nineteenth-century notion of the Egypto-Nubian body emerge?—
the Egypto-Nubian body of Story's *Cleopatra* was the ancient version of the nineteenth-
century interracial female or the white Negro type favored by the neoclassical sculptural
movement. As Ginotti's emancipated black female slave blatantly indicates, Story's
potentially Nubian *Cleopatra* was far more racially constrained than some of her black
female counterparts produced in other western contexts or other cultural forms. Yet,
Ginotti was an Italian, and Story an American; Ginotti's sculpture postdated the end
of transatlantic slavery, and Story's work was deployed into the heart of a complex of
racial issues and was intended not, as Ginotti's, explicitly to titillate but also to illicit
abolitionist sympathy from a dominantly white and American viewing audience.

And yet despite the relative absence of overt sexuality in *Cleopatra,* contemporaneous critics saw her repeatedly as possessing the potential for an animalistic sexuality coded as black and dangerous. The site of this sexuality was culled in part from the historical knowledge of Cleopatra's life and loves (white males); interracial desire, with all its dangers and titillation, was thus recalled. As we have seen, the approval of female subjects by nineteenth-century audiences hinged on the "correct" deployment of racialized identities that conformed to colonial stereotypes of racial difference and preserved the sanctity of the white female ideal. Story made *Cleopatra* black enough to evoke danger and provide sexual titillation but white enough to register beauty and inspire abolitionist sympathy. Her Egypto-Nubian body was as much an index of the impossibility of a full-blooded Negro female type in high art as it was an indication of an endemic Euro-American ignorance of the ancient and contemporaneous differences between African and African diasporic subjects.

7. The Black Queen in the White Body
Edmonia Lewis and the Dead Queen

The Fact of Blackness

By the time Edmonia Lewis began work on her sculpture *Death of Cleopatra* (1875) (Figure 38),[1] an indelible shift in the possibility of the queen's racial identification had already taken place. Cleopatra was, by the late nineteenth century, readily identifiable as a black female subject. As I have argued throughout, her blackness had been represented, evoked, and implied within both literature and the visual arts and supported by human science classifications of ancient Egyptians as a racially hybrid category with varying degrees of Negroid ancestry as well as supported by the abolitionist desire to deploy antislavery symbols within visual discourse.[2] As I will discuss in detail below, the significance of race and blackness for the subject of Cleopatra also extends to Lewis's *Hagar* (1875) (Figure 39), of the same period.

In choosing the subject of the tragic Egyptian queen, Lewis would have been vividly aware that her sculpture would inevitably be scrutinized on the basis of race and specifically compared with Story's earlier and much-celebrated work. Lewis would also have been cognizant of a potential comparison with Harriet Hosmer's *Zenobia* (1859), her representation of the ancient queen of Palmyra in chains.[3] Without a doubt, Lewis's residence in the Roman colony and her acquaintance with William Wetmore Story, possibly directly but definitively through mutual friends such as Harriet Hosmer and Lydia Maria Child, provided a knowledge of the acclaim of his *Cleopatra* as well as its overwhelming narration as a black female queen. Lewis would also, through her close association with Anne Whitney, have been aware of Whitney's struggle to race the body of her *Africa* (c. 1863–64) to an "acceptable" level of blackness, an aesthetic and material process that would have had far greater personal implications for Lewis than for her white contemporaries.[4] Evidence of Lewis's consciousness and experimentation

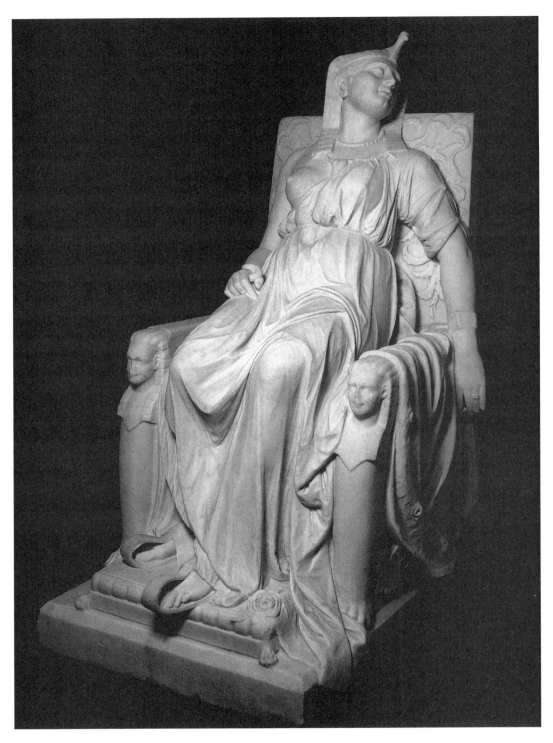

Figure 38. Edmonia Lewis, *Death of Cleopatra*, 1876. Marble. 160 x 79.4 x 116.8 cm. Smithsonian American Art Museum, Washington, D.C. Gift of the Historical Society of Forest Park, Illinois.

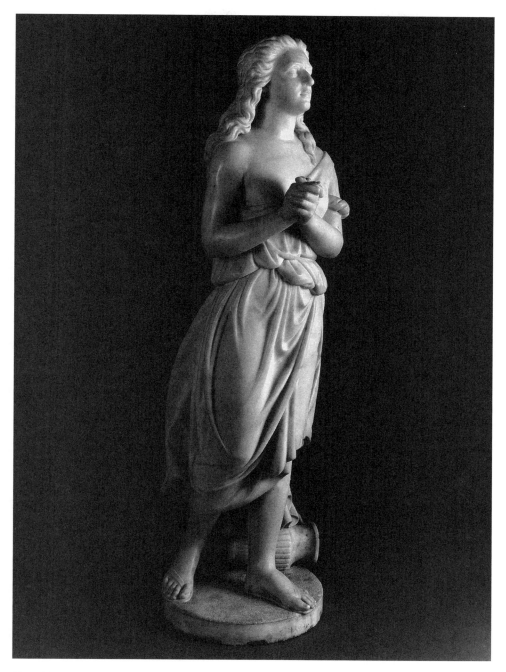

Figure 39. Edmonia Lewis, *Hagar*, 1875. Marble. 133.6 x 38.8 x 43.4 cm. Smithsonian American Art Museum, Washington, D.C. Gift of Delta Sigma Theta Sorority, Inc.

in racing her own black subjects also exists in a description of her *Morning of Liberty/ Forever Free* (1867) and her earlier *Freedwoman* (c. 1866), a description that compared the two female figures.[5] Henry Wreford, who saw the latter work in Lewis's Roman studio in March 1866, described it as representing a kneeling freedwoman with clasped hands and upraised eyes in praise to God for liberty.[6] Further, Wreford noted, "Her boy, ignorant of the cause of her agitation, hangs over her knees and clings to her waist. She wears the turban which was used when at work. Around her wrists are the half-broken manacles, and the chain lies on the ground still attached to a large ball."[7] Lydia Maria Child, who likely saw a photograph of the work, judged it harshly:

> The group of the Freedwoman and her Child strikes me disagreeably. The face is pretty good, but the figure is shockingly disproportioned. The feet are monstrous. I under-stand Mr. Waterston is trying to get it cut in marble, but I think he had better not.[8]

From a photograph submitted by Lewis to the *Freedmen's Record,* an anonymous author, who was obviously knowledgeable of both works, compared them thus:

> Many of our readers will be glad to hear from Edmonia Lewis . . . now a resident in Rome. She sent us a photograph of a new design for a group called "The Morning of Liberty," representing a standing male figure casting off his chains and a young girl kneeling beside him. The design shows decided improvement in modelling the human figure, though the type is less original and characteristic than in "The Freedwoman," which she sketched in the Spring.[9]

This rather cryptic corporeal description begs the question, *Characteristic of what?* The two works' incorporation of a black female subject suggests that the author's inference pertained to the characteristic nature of the race or blackness of the female subject. The implication then is that Lewis's first black female in *Freedwoman* was somehow "more" black than the one in her second attempt.[10] It is significant that Lewis's experimentation with racing her subjects demonstrated a progression away from deliberately and unequivocally black subjects to a more interracial, *white Negro* visualization of the black body. The title of this section, "The Fact of Blackness," is an obvious nod toward Frantz Fanon and a reminder that race, whether of the represented subject or the artist, functions on multiple levels, including the psychic.[11]

Abolitionism's Stake: Egypt as Black Africa

For Lewis, the possibility of a black Cleopatra derived not only from the depictions in Lewis's own artistic endeavors and in those of Story and Whitney but also from Lewis's direct interaction with and knowledge of prominent black and white abolitionists whose beliefs, personal writings, and public declarations supported the idea of a black Cleopatra as a means of pridefully relocating ancient black civilizations as the source

of contemporary black peoples. The prominent Boston abolitionist and advocate of female equality Lydia Maria Child, who had, however tentatively, supported Edmonia Lewis's career since their first meeting in Boston in 1864, described in a personal letter a young black female acquaintance as being "queenly enough for a model of Cleopatra."[12] What's more, Child's racial signification, which included a "dark brown girl" with "nostrils expanded proudly" and a "well-shaped mouth," located a so-called full-blooded Negro type, whom Child further described as handsome.[13] Like Child, Harriet Beecher Stowe also specifically deployed the term *Egyptian* in describing the famous black female abolitionist–orator Sojourner Truth.[14] And last, Lewis's friend and fellow sculptor Anne Whitney described the younger artist herself: "She smiles . . . somewhat in the style of an African princess."[15]

For many educated blacks, Cleopatra's blackness was made possible through a racial pride that linked their African ancestry to ancient Egyptian civilization. As Malini Johar Schueller has argued, "While proslavery anthropologists strove to demonstrate the lowly status of black peoples in Egypt, prominent African-Americans like Frederick Douglass, Henry Highland Garnet, and later Pauline Hopkins, used Egyptology to validate the idea of Africans being the originators of civilization."[16] Lewis's acquaintance with Douglass, the prominent black abolitionist–orator and author, was confirmed in his travel diary, which recorded their encounters in Rome in 1887 when he visited with his second wife, Helen.[17] Douglass sat for a portrait bust during this visit. Besides Douglass, Lewis also knew influential abolitionists such as Rev. Leonard A. Grimes, Rev. J. D. Fulton, R. C. Waterson, William Lloyd Garrison, William Craft, William Wells Brown,[18] Rev. Henry Highland Garnet,[19] and the extraordinary Remond family, which included Charles Lenox Remond, Caroline R. Putnam, and Dr. Sarah Ann Parker Remond.[20] Garnet was a potentially very early and critical influence on Lewis, since it was he who Lewis originally sought out in New York in order to obtain guidance regarding her artistic aspirations, according to an article published in the *New York Times* on 29 December 1878.[21] Garnet used both biblical and ancient scholarly references to support his claim regarding the blackness of Egyptians.[22] His list of illustrious blacks included the Egyptian queen herself: "Numerous other instances might be mentioned that would indicate the ancient fame of our ancestors. . . . I will barely allude to the beautiful Cleopatra, who swayed and captivated the heart of Anthony."[23] Also of potential significance for Lewis was the 1858 publication of David Dorr's *A Colored Man round the World, by a Quadroon,* in which the educated author's proud declaration of blackness was intimately connected with his fundamental belief in the blackness of ancient Egyptians:

> The Author of this book, though a quadroon, is pleased to announce himself the "Colored man around the world." Not because he may look at a colored man's position as an honorable one at this age in the world . . . but because he has the satisfaction of looking with his own eyes and reason at the ruins of the ancestors of which he is the posterity. . . . Well, who were the Egyptians? Ask Homer if their lips were not thick, their hair curly, their feet flat and their skin black.[24]

Hagar

Lydia Maria Child linked the success of what she called Lewis's *Freedmen's Group* to her production of *Hagar*. "The sale of that work and the puffs written to accomplish it, have encouraged Edmonia to make another large statue; the Hagar."[25] Child apparently thought little of the new work, which she saw in a photograph sent by Edmonia "after a long silence."[26] To her friends the Shaws, Child wrote, "I think it is better than the *Freedman and his Wife,* but I do not think it is worth putting into marble. It looks more like a stout German woman, or English woman than a slim Egyptian, emaciated by wandering in the desert."[27] Child's reading of Lewis's Egyptian woman as decidedly white (as German or even English) is an insightful commentary on what she saw as Lewis's failure to represent an Egyptian body for Hagar. For Child, an abolitionist moving within the circles mentioned above, Hagar's body was potentially and strategically black.

Although Child's comments about *Hagar* are acerbic, tainted by her perpetual quest to keep Lewis's ambitions and actions in check, they nevertheless document Lewis's earliest production of ideal marble works in Rome and her ability to garner patronage and favorable criticism. Confidence in Lewis's knowledge of the nineteenth-century's symbolic conflation of Egyptianness with blackness also derived from her own oeuvre. Created in 1875, the same year as her *Death of Cleopatra,* Lewis's *Hagar* locates an Egyptian female slave within a biblical narrative that prophesied the sexual marginalization of black female slaves within transatlantic slavery.[28] Hagar, who appears twice in the Old Testament (Gen. 16:1–16, 21:9–21) and once in the New (Gal. 4:22–31), was an Egyptian bondwoman to Sarah and Abraham.[29] Sarah's inability to conceive prompted her collusion with her husband, Abraham, to continue his line through Hagar. That it was Sarah who decided to propose "breeding" Hagar locates her access to and power over her bondwoman's body and sexuality, a power paralleled in the white plantation mistress's access to and control over her female slaves within nineteenth-century plantocracies. In the Douay version of the Old Testament, commonly used by nineteenth-century Catholics, Edmonia Lewis would have read of how Sarah "took Agar . . . and gave her to her husband to wife" (Gen. 16:3). Sarah's determination that Hagar should be bred locates the extent to which she perceived Hagar's body and indeed Hagar's offspring to be the property of her and her husband. Sarah to Abraham: "Behold, the Lord hath restrained me from bearing; go in unto my handmaid, it may be I may have children of her at least" (Gen. 16:1–2).

As the term *barren* indicates, Sarah's inability to conceive Abraham's children displaced her from the category of "true" womanhood within a patriarchal order in which women's social and familial value was tied to their ability to bear children and to mother.[30] Although the Bible states of Hagar, "She, perceiving that she was with child, despised her mistress" (Gen. 16:4), Sarah's perception that Hagar was mocking her inability to conceive can be at least partly attributed to Sarah's own self-loathing or self-repudiation in the face of what was considered a social, familial, and maternal

failing. Once Hagar was "with child," conflicts occurred between the two women, and Hagar temporarily fled. Sarah's authority over Hagar, activated by Abraham's sanction, "Behold thy handmaid is in thy own hand, use her as it pleaseth thee" (Gen. 16:6–7), became a nineteenth-century abolitionist metaphor for the antebellum relationships between the white plantation mistress and the black female slaves and their similar culpability in the sexual violation of black women.[31] In both cases, the Egyptian/black female slaves had no social or judicial/legal recourse to their own bodies, their sexuality, their "breeding" potential, or their unborn or born children.

Inevitably, Hagar returned to her "owners" and "submitted" to Sarah as she had been cautioned to do by an angel. Yet, when Sarah bore Isaac through divine intervention, Hagar and her son, Ishmael, were cast out, an event triggered by the two brothers' playing together. The brothers' interaction must be read as threatening not only along class and power lines but along religious and racial lines too. Again Sarah activated Hagar's abandonment, threatened by the possibility that Ishmael might be counted an heir to Abraham equal to her own son, Isaac. The dispossession of the Other son is here both racial (Ishmael was part Egyptian and his mother, Hagar, was a bond-woman) and social (his presence threatened the inheritance of his Jewish half-brother, Isaac). Lewis's sympathetic abolitionist representation of Hagar contradicted the New Testament teachings regarding the bondwoman. In Galatians 4:22–31, Paul used the story of Hagar, Sarah, and Abraham to distinguish between the flesh (Hagar) and the spirit (Sarah), deploying a metaphor for an alignment with the Jewish lineage of Abraham and Isaac in order to achieve the inheritance of God. However, this alignment with a Jewish lineage, represented by Sarah and Isaac, was predicated on the denial of the Egyptian lineage of Hagar and Ishmael. Paul wrote, "Cast out the bondwoman and her son; for the bond-woman shall not be heir with the son of the free-woman" (Gal. 4:30).[32]

Within the Hagar–Ishmael theme, some contemporaneous sculptures predating Lewis's works focused on Ishmael's plight. In H. M. Imhof's *Hagar and Ishmael* (1856), the distressed mother holds her right hand to her temple in despair, while in her left the down-turned jug indicates the lack of water. At her feet, the swooning figure of a seated Ishmael extends an empty cup. In Giovanni Strazza's earlier *Ismaele abbandonato nel deserto* (1846), the despairing figure of the mother is totally absented, instead leaving only the slender body of the naked Ishmael, reclining in a sleep–death with an overturned water vessel at his side. Notably, in eliminating Ishmael, Sarah, and Abraham, figures that had been traditionally incorporated in paintings, engravings, and sculptures of this theme, Lewis's sculpture focuses on the figure of Hagar and the suffering of the Egyptian bondwoman.

Lewis cleverly represented Hagar in a pose and context that had the potential for two distinct readings within the biblical narrative. With the overturned and empty water jug at her side, Hagar's prayerful pose (clasped hands and slightly upturned face) may indicate her presence at the fountain where the angel first appeared to her when pregnant. But simultaneously, the overturned jug may also evoke the lack of water in the

wilderness, where she and Ishmael have been cast out; and Ishmael's absence, the result of Hagar's grief-stricken decision to place him under a shrub to die. In choosing to sculpt such a potentially provocative subject, Lewis orchestrated the confluence of a complex of issues that affected black female slaves within nineteenth-century transatlantic slavery in America and the diaspora by representing a much-recognized biblical narrative.

Hagar located not only the sexual violation of black women as "breeders" of new slaves but also the availability and expendability of black women as sexual commodities, the culpability of white women within this sexual exploitation, white anxieties around cross-racial interaction, and the familial dispossession of "black" children by their white parents. The commodification of the body and specifically the denial of one's own relatives in exchange for economic gain were common aspects of the "peculiar institution," which was also represented and condemned in the contemporaneous painting by Thomas Satterwhite Noble, *The Price of Blood* (1868) (Figure 40).

Noble represented a seated, luxuriously clad white planter accepting payment in exchange for the standing, shabbily dressed, barefoot mulatto slave, his son. Noble's

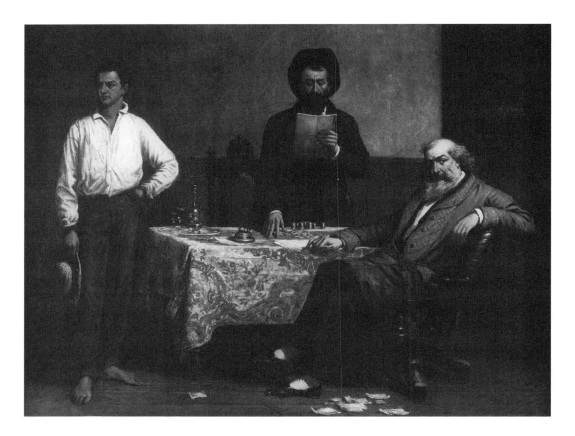

Figure 40. Thomas Satterwhite Noble, *The Price of Blood,* 1868. Oil on canvas. 99.69 x 125.73 cm. Morris Museum of Art, Augusta, Georgia.

condemnation of the callous monetary exchange of human life is sealed in the central placement of the slave trader, who, oblivious to the human drama around him, carefully peruses the contract, with a stack of coins he will soon accept counted out on the table before him. Noble's mindful inclusion of a fragment of a painting of Abraham's sacrifice of Isaac on the wall behind further points up the immorality of the exchange. Besides the evidence from the symbolically laden biblical texts that provided the narrative of Lewis's *Hagar,* the sculptor's physical racialization of the Egyptian was performed largely through the wavy hair of the white Negro type, whom her contemporaries John Bell and John Rogers had imagined for their own interracial subjects.

Sarah Parker Remond

Lewis may have also developed her understanding of Cleopatra and Hagar from her friendship with and knowledge of the lectures and writings of the older black abolitionist–orator Dr. Sarah Ann Parker Remond. Since Remond was approximately twenty years older than Lewis, like Lydia Maria Child and Charlotte Cushman, she would have provided a strong female role model of professionalism, independence, and education for the considerably younger woman. However, we should not underestimate the importance of Remond's blackness, which would have provided a profound racial connection and a shared experience of racial marginalization for the two American women.[33] Remond, who hailed from an activist Salem, Massachusetts, family, advocated abolition and equality for free blacks and women.[34] Although Lewis may have known of Remond from her years in Boston or even Ohio,[35] it is more likely that the two became acquainted in Europe, since Remond, who sailed alone for Europe in 1858, was politically active in Britain throughout the late 1850s and early 1860s before she moved to Florence, Italy, in 1866.[36] While Lewis, like Remond, was likely in attendance at Anne Whitney's Easter Sunday gathering in 1868,[37] Remond's acquaintance with the white art critic James Jackson Jarves provided another potential link to Lewis and other contemporary artists.[38] By 1886, Frederick Douglass placed Lewis among the vibrant multiracial cultural circle who gave the Remond home at Palazzo Maroni the reputation as a cultural center.[39]

Remond's lectures and writing intersect powerfully with Lewis's *Hagar,* since she distinguished the black male and female slave experience and spoke explicitly about the sex and gender specificity of the suffering of black women within American slavery, detailing for her audiences the exposure of women at auction, sexual abuses, the white man's lust for black women, the colonial desire for interracial slaves, and the black female slave's lack of authority over her own children.[40] Remond also discussed the specific case of Margaret Garner, the black female slave who had deliberately killed her child to spare her offspring a life of slavery. Without a doubt the absolute despair and hopelessness of Margaret Garner begged comparison with the biblical Hagar, who was similarly devoid of the social power to protect her child or ensure his social status and legal rights of inheritance.

Departures in Death: Rejecting Victorian Sentimentalism

Another point through which Lewis's *Hagar* and *Death of Cleopatra* converge is their expression or mood. Compared with what her early ideal works depict, which could be described as hope and triumph, Hagar's troubled expression and prayerful pose and Cleopatra's morbid, newly dead body convey defeat or outright despair. The *Death of Cleopatra* constitutes a remarkable departure from the Victorian prescriptions of representing death. The immediacy of Cleopatra's death is significant. Many sentimental neoclassical sculptures, such as Edward Brackett's *Shipwrecked Mother and Child* (1850) and Harriet Hosmer's *Beatrice Cenci* (1857), represent dead subjects, especially females, within compositions that facilitate sorrowful narratives of domestic disruption and maternal loss. However, these bodies often evoke sleep or repose rather than death, and many, particularly within funerary monuments, compositionally display the body in reclining poses, which suggest not just sleep but also the peacefulness of an afterlife and the contrived pose of a body already prepared for burial or rituals of viewing. The presentation and representation of such dead bodies does not disrupt their interpretation as the beautiful, since they refuse the signs of death and the decaying body of the corpse.

For instance, Lorenzo Bartolini's sculpture *Monumento all contessa Zamoyska* (1837) utilizes a chaise longue to precisely pose the seated figure, which represents the deceased countess. The exact placement of the carefully enfolded hands in her lap and the orderliness of the drapery around her head and shoulders suggest an ordered body that has been prepared for public presentation and visual consumption. In contrast, Lewis's compositional choices for the enthroned Cleopatra do not convey the same possibility of repose and certainly were not interpreted by contemporary audiences as peaceful. The thrust of Cleopatra's head up and backward and the carelessly draped left arm, which extends down over the side of the throne, suggest pain and physical abandon, both incongruous with a gentle or temporally removed death, yet evocative of the physical loss of control and torment associated with death by venom or poison.

Lewis's Cleopatra is dead or very close to it; the contortions and lack of signs of ritual preparation disrupt the reading of her body as a safe aesthetic object. Instead of an orderly dead body, Cleopatra's is read as freshly dead, since the abandoned contortions of her body do not indicate a temporal dislocation between the viewer and the deceased. As a short synopsis in the *Woman's Journal* (1878) describes, Lewis represented the moment that Cleopatra "touched the asp to her bosom."[41] Compared with what Bronfen has termed "secured dead bodies,"[42] Lewis's newly dead queen is not comforting; the body's instability in its transition is disquieting and threatening. This is not, as with Countess Zamoyska, a body already prepared for burial, but a body in its death throes—a body *dying*. The immediacy of Cleopatra's death indicates a narrative of witness within which Cleopatra dies under the gaze of the audience.

Lewis's Cleopatra, her "time," precedes the mourning process through which

the body is transformed and commemorated, with scientific processes of preservation moving it from a decaying corpse to temporary representational stability.[43] As such, Lewis has disrupted the entrenched western notion of "beautiful death," wherein the female's belief in her Christian salvation makes her fearless, even happy, in passing, affording closure for her mourners by allowing them to remember (in the sense of putting back together and of recalling) her body harmoniously. The indecorous and destabilized body of Lewis's dying Cleopatra is represented in preritualized death. This representation of dying instead of death refused the nineteenth-century tradition of the fetishization of death, which regulated the difference of the dead body, protecting the imagined integrity of the viewer's body/self through the aestheticization of the corpse.

Lewis's choice of a dead queen sharply diverged from Story's living, contemplative, and brooding subject. This shift was noticed by an anonymous author who characterized it as "a work that in some sense typifies the attitude of both the races she represents."[44] Although, as I shall argue below, Lewis did not represent a physically black queen, she was nevertheless racially aligned with her subject in a way that reductively resulted in overdetermined racial descriptions of her innovative representation of death and expression. This dramatic shift has correspondences with abolitionist fiction's radical proposal of the slave's self-annihilation as a certain and immediate means to abolish slavery. The caveat is, of course, that this unequivocal method of abolition is activated only by the literal termination of much of the race. If Cleopatra stood as a nineteenth-century symbol of black/African subjectivity, then her death through suicide harbors both the possibility of a moral spiritual release from social disenfranchisement and racial oppression and the fatalistic and genocidal demise and destruction of a race. The latter potential encapsulates abolitionists' disillusionment about the failure of the racial promise of an America freed from slavery, that a true equality could be achieved for blacks. If Lewis delivered a "liberated" Cleopatra, it was liberation at an extreme price.

This ideal of the fatalistic yet heroic death/suicide of the slave, adapted from the patriarchal logic of the classical body/soul dichotomy, is an extreme transformation of the corporeality of the flesh—a fetishization that exceeds the mere suppression or purging of race/blackness but is satisfied only with the utter annihilation of the flesh and the impotency of its racial signs and therefore the eradication of its threat. In this way, much as Alexis de Tocqueville argued in his *Democracy in America* (1835), the black subjects are offered freedom contingent on the disavowal of and disintegration of the very blackness that identifies them and calls up the need for liberation in the first place. Death for Cleopatra, the black queen, was a state that offered the respite of a Eurocentrically conceived universal whiteness. In death/freedom Cleopatra achieved spiritual liberation symbolized as whiteness. As Sánchez-Eppler has noted, "The obliteration of the body thus stands as the pain-filled consequence of recognizing the extent to which the body designates identity."[45] However, Cleopatra's death also signaled a defiant recognition of the very forces that sought to eradicate and imprison the black body even after slavery.

Considering Reconstruction

Post–Civil War America from the late 1860s throughout the 1870s, a period often cited as the failure of Reconstruction, was informed by the deep disillusionment of blacks and white abolitionists. Within this context, in which Southern politicians refused to enfranchise blacks with legal equality, desegregated social access, or full citizenship status, Lewis's depiction of Cleopatra's dead body was informed by the despair of a race for whom the abolition of slavery had resulted not in the liberty they had sought but rather in the further entrenchment of a vociferous racism. The "liberation" of blacks from American slavery did not translate into social, legal, or political equality but, instead, the entrenchment of racism, segregation, and racial brutality. Throughout the 1860s and '70s, this mood of despair and futility was undoubtedly a topic of discussion between Lewis and the Remonds. Explicitly, Sarah Remond's disillusionment with the possibility of tangible black equality and freedom had motivated her decision to expatriate to Florence and then Rome.[46] Recognizing the coloniality of nineteenth-century American legal discourse, Sarah understood that the ideology of white supremacy and its fundamental hatred of blacks were so vehement and prolific that the rights of "liberated" blacks would never be respected or legally enforced. Also understanding that the social marginalization of blacks was made possible by denial of access to self-representation and the external imposition of an abject identity, shortly after the end of the Civil War, Sarah wrote sorrowfully of the stories of blacks, "It will never be written. It can never be written."[47]

In distinct contrast to *Hagar* and *Death of Cleopatra,* Lewis's earlier ideal works corresponded in date with the end of the Civil War and the initial and short-lived optimism that was expressed by blacks and the Northern communities that had fought for and supported the Union. Her first ideal work *The Freedwoman on First Hearing of Her Liberty* (1866), now lost, represented a young boy with his prayerful and thankful mother, whose clasped hands, broken shackles, and kneeling pose was undoubtedly informed by the British abolitionist slave cameo.[48] With *The Morning of Liberty/Forever Free* (1867), Lewis replaced the male child with the standing figure of an adult male, whose protective hand on the kneeling female's shoulder indicates the potential for a legitimate familial bond and the black male aspiration to full manhood through the patriarchal ideals of citizen, father, and husband facilitated by the news of their freedom.[49]

Trampling Expectations: Lewis's *Cleopatra*

While Jacqueline Fonvielle-Bontemps has argued that Lewis never sculpted a black figure, and Kirsten Buick has interpreted the male/female unit in *The Morning of Liberty/Forever Free* as the unproblematic white bourgeois gendering of black male–female relations, both scenarios, in implying Lewis's uncomplicated complicity in colonial racial norms and patriarchal sex and gender norms, overlook the importance of the strategic deployment of black female subjects in Lewis's oeuvre.[50] Unlike many of her white

contemporaries who focused on the heroic white figure of Lincoln, Lewis deployed black subjects to commemorate the freedom blacks had gained through the Emancipation Proclamation.[51] Even prior to her sculptures that commemorated the Emancipation Proclamation, Lewis was one of few artists to acknowledge the role of black men in the Civil War with the individualized figure of a heroic black soldier, *Sgt. William H. Carney* (c. 1863–64).[52] The choice of Carney, a soldier in Robert Gould Shaw's 54th regiment, is significant, since it represents a brave black individualized manhood in noble defense of the American nation.[53]

While Lewis apparently avoided sculpting slaves, it is of certain significance that her first ideal sculpture and first large-scale endeavor in Rome was a sculpture celebrating the Emancipation Proclamation, using as its central figure the body of a black female ex-slave.[54] While Lewis's contemporaries fashioned many unclothed, shackled female slaves, which traded on colonial desire and sexual titillation, Lewis's free black mother disrupted black women's status as chattel/commodity, instead locating the black woman's right to choose her sexual partners and marriage partners, assert familial relationships, and care for her own children as opposed to those of whites.[55] Although the kneeling pose, which had been made legible within British abolitionist discourses, has been easily aligned with disenfranchisement within a patriarchal order, Lewis's use of a pose first deployed with the black male body signals the symbolic recuperation of "male" rights by the female subject. Inasmuch as the accompanying phrase "Am I not a Man and a Brother?" insisted on an acknowledgment of the black man's humanity and manhood as the basis of citizenship, the female's kneeling pose, offering the similar question "Am I not a Woman and a Sister?" within the context of the coexisting rhetorics of women's equality and abolitionism, alluded to the woman's desire not just for freedom but also for the very same citizenship rights via a recognition of womanhood.[56]

Lewis's phenomenally successful *Death of Cleopatra* was exhibited at the Philadelphia Centennial Exhibition of 1876 beneath "a canopy of Oriental brightness," perhaps reminiscent of the display of Powers's *Greek Slave* beneath scarlet drapery at the Great Exhibition of 1851 in London, which manifested a rosy flush that raced the marble body with the illusion of white flesh color.[57] In searching for prototypes of the seated queenly figure, Marilyn Richardson has noted Canova's monument to *Napoleon's Mother, Madame Letezia* (1805), his *Grand Duchess Marie Louise as Concordia* (1809–14), and his mourning figure seated beside the effigy of Countess de Haro in the tomb's relief (1806–8).[58] Antique precedents were also available and significant sources, including *Seated Agrippina* and *Cleopatra,* both of which represented contemplative, seated female figures on a large scale.[59] But we should also look to Story for closer precedents with his seated *Sappho* (1863), *Salome* (1871),[60] and, of course, his *Cleopatra* (1862).

Misreading Lewis: Race and the Artist's Body

By the mid-1870s Lewis was extremely successful and celebrated in her career. Anne Whitney's 1869 prediction, "she is very plucky and may grow rich yet," seems to have

come to fruition.[61] Whitney's letters demonstrate particular insight where Lewis's fortunes were concerned. In another letter of December 1870, she speculated that Lewis, newly returned from a visit to America, had garnered commissions or other forms of support.[62] Those predictions were dead accurate, for just over a month later, Whitney wrote home about Lewis's grand success: "You know that the enterprising daughter of Africa's Sunny fountains raffled off her Hagar for $6000. Probably she had that business in her eye . . . when she went to America."[63] A few years later, Lewis's *Cleopatra* was secured for inclusion at the Philadelphia Centennial Exhibition when the centennial commissioner, John W. Forney, visited her Roman studio in the summer of 1874.[64] Although no specific sculptures were mentioned, Forney documented calling "upon Miss Lewis, the young colored sculptress, who had just sold one of her pieces for eight hundred dollars."[65] As was typical of Lewis's white contemporaries, Forney focused on the sculptor's race, foreclosing on the discussion of her art. Furthermore, this documentation of the selling price of her works registers a degree of awe if not incredulity at the level of her success, a response that was often not recorded in cases of white artistic success.

Repeatedly, white authors writing about Lewis marveled at her race, which was variously and erroneously documented. To differing degrees Lewis's productive body was described as a racial oddity or spectacle, positioning her as an object of an incessant visual scrutiny. Perhaps the coarsest example of Lewis's objectification within the colonial regime of race was from an author known only as H. W., whose March 1866 article titled "A Negro Sculptress" proclaimed Lewis as "an interesting novelty" that had "sprung up amongst us"—the us of course being the accepted white expatriates.[66] The term *novelty* indicates the rarity of a culturally active black presence within the Roman colony, as opposed to those who must have been present as slaves and servants. But it also points up the extent to which white expatriates and colonists saw Lewis within the limits of a colonial western imagination.

The confused, hybrid racial identifications and misidentifications that the viewers of Story's *Cleopatra* deployed uncannily mimicked the racial signification of Lewis's own interracial body, mainly by her white contemporaries.[67] Many of the known descriptions of Lewis's physical appearance, personality, and mannerisms come from other people rather than from Lewis herself, because of the lack of any extensive centralized archival holdings or historical bibliographies.[68] While to a large extent we must rely on other people's opinions of Lewis, it is important to note that the context of the descriptions (published articles and public words, private utterances and personal letters) and the identities and motives of the corresponding parties severely altered their content.[69] Like her white female contemporaries, Lewis was often infantilized. Descriptions that detail a persona of naive, unconscious, and childlike manners facilitated the public's curiosity about the "lady artist's" gender-bending dress and habits and justified her and other women's independence and professional dedication through their supposed sexual abstinence.[70]

Different authors emphasized different aspects of Lewis's racial ancestry and made claims for the harmony of both her Native and African heritage or the dominance of

one over the other. Writing in 1878, one author described Lewis as one who "physically and mentally, united many of the traits of two races—the Indian and the negro."[71] But the description of the "habitus quietude and stoicism of the Indian race," as well as the "trace of the sadness of both races in her manner,"[72] should alert us to the extent to which white scrutiny of black and Native bodies was informed by colonial desires that produced convenient stereotypes. While abolitionists would have wished to play up Lewis's blackness for obvious reasons, much of the misidentification appears to have stemmed from legitimate difficulties in visually reading Lewis's body. Although for the most part, Lewis was readily identifiable as interracial, her Native–black mixture was sometimes misidentified as a white–black mixture. Writing in 1866 from Rome, Henry Wreford described Lewis thus, "Her eyes and the upper part of her face are fine; the crisp hair and thick lips, on the other hand, bespeak her negro paternity."[73] The term *fine,* generally deployed to describe white physiognomical traits, here doubles both as an indicator of scale and dimensions and as a Eurocentric judgment on handsomeness. A similar usage was deployed in the abolitionist "The Slave–Wife" (1845), by Frances Green, who in attempting to narrate the heroic black male figure Laco Ray, actively suppressed any potentially disturbing signs of his blackness:

> He was quite black, the skin soft and glossy; but the features had none of the revolting characteristics which are supposed by some to be inseparable from the African visage. On the contrary they were remarkably fine—the nose aquiline—the forehead singularly high and broad.[74]

For Green, Laco Ray was handsome despite his blackness. With Green, as with Wreford, the signification of white traits was dichotomized with the blackness that was visible elsewhere—Laco Ray's skin and Lewis's hair and lips.

The struggle with naming Lewis's racial hybridity continued in Lydia Maria Child's letter to the *Liberator:* "I told her I judged by her complexion that there might be some of what was called white blood in her veins."[75] Lewis's discussion with Child and her response, which defined her father as a "full-blooded Negro" and her mother as a "full-blooded Chippewa," demonstrated her knowledge of the popular nineteenth-century modes of naming degrees of race as amounts of blood and the colonial racial preferences that they implied. Lewis's response to Child, "I have not a single drop of what is called white blood in my veins," is reminiscent of David Dorr's proud and unnecessary assertion of his "colored" status, although, as a quadroon, he could pass for white. Also similar to Dorr's usage was Lewis's use of the descriptive *colored,* which was widely understood as an undeniable signifier of unmediated or dominant blackness.[76]

Lewis's black ancestry again took precedence in a brief article in the January 1879 issue of the *Woman's Journal,* which defined her as "the well-known colored sculptor," as it had earlier in the December 1878 issue, which described her as "the colored sculptress."[77] Similarly, in evoking slavery with "daughter of the race / Whose chains are breaking," the laudatory poem "Edmonia Lewis," by Lewis's early Boston

patron Anna Quincy Waterson, located the artist's black culture and related it to her "gift" of sculpture.[78]

But the nineteenth-century textual record indicates that Lewis's racial self-definition added to the confusion about her racial identification, particularly her own affinities and opinions about it. In a private letter to Maria Weston Chapman, detailing her intention to honor William Lloyd Garrison with the presentation of her *Morning of Liberty/Forever Free,* Lewis apparently distanced herself from her blackness by using the phrase "my father's people" (as opposed to "my people") in reference to her black heritage.[79] However, earlier, in 1866, Henry Wreford cited Lewis's more direct identification with her blackness in her purported statement "so was *my* race treated in market and elsewhere" (italics mine), in reference to her sculpture *The Freedwoman on First Hearing of Her Liberty.*[80]

Lewis was often quoted as offering romanticized descriptions of her early life as a naive Indian, descriptions that reinforced the colonial binary of the "wild Indian" and the "civilized white man."[81] In one example Lewis's narrative parodied the "objective" and "detached" discourses of anthropological observation in her descriptions of her mother as a wandering "wild Indian" and of her upbringing as having a "wild manner."[82] Such texts described the story of Lewis's first encounter with sculpture in Boston as the spiritual epiphany of an unsophisticated Indian in the face of the civilized white man's "stone image."[83] The sculpture that supposedly sparked Lewis's acculturation was Richard Greenough's *Benjamin Franklin* (1855).[84] Another account printed in the *New York Times* offered William Wetmore Story as the artist who had inspired Lewis's desire to sculpt when she reportedly saw an unnamed sculpture in front of a Boston statehouse. The possibility that Lewis had not seen a sculpture until moving to Boston is hard to believe, even allowing for the scarcity of public sculpture in American cities during the mid-nineteenth century. Although there is no indication that Lewis studied sculpture at Oberlin College, she did produce a notable drawing, *The Muse Urania* (1862), which indicates her early talent at representing the human form.[85] While Lewis may have used another two-dimensional image to produce this drawing, it is equally possible that she worked from a plaster or marble cast of the antique sculpture. Likewise, it is possible that Oberlin College, if not the town of Oberlin, gave Lewis access to sculptures, whether originals or casts.

The ludicrousness of such a facile description and its blatant attempt to infantilize and primitivize Lewis becomes obvious when it is juxtaposed with the "first encounter" story of a white male sculptor, Hiram Powers. Speaking of his viewing of a plaster copy of Jean Antoine Houdon's bust *Washington* (1788) in Cincinnati, Powers stated, "I gazed on it a long time, and felt a strong desire to know the process by which it had been made."[86] While for Lewis, race supposedly mediated a naive expression of detached awe, for Powers it was the trigger for intellectual curiosity and a thirst for knowledge about cultural production.

What we have inherited as Lewis's self-definitions (however mediated) fits too comfortably within the colonial stereotype of the Native woman as Pocahontas—the

romanticized, unthreatening image of the naive young Indian girl whose denial of her own culture in favor of Anglo-European "civilization" is triggered by her love of a white man.[87] My doubts about Lewis's supposed enthusiastic and naive deployment of these stereotypical racial self-identifications and my belief in their embellishment or outright fabrication by white writers, supporters, and patrons stem largely from Lewis's seemingly deliberate resistance to the deployment of the Pocahontas-type within her own oeuvre, unlike the tendencies of her white contemporaries such as Powers, Palmer, and Mozier.[88] Although Lewis apparently expressed to Lydia Maria Child the desire to produce a sculpture of Pocahontas, no evidence exists to suggest that the work was ever completed or even begun. Instead, all of Lewis's known "Indian" themes were deployed through her interpretation of Longfellow's *The Song of Hiawatha* (1855), a choice that heightened the legibility and popularity of her works that were indelibly linked to the celebrity of the poem and its author. Other Indian stereotypes that Lewis's works refused were the fashionable narratives of the dying brave, the Christianization and civilization of "wild Indians," and the Native as threat to white civilization through the violation of white women. Lewis's refusal to use these stereotypical Native identifications is very significant, since her Native racial heritage and the desire of her white audience to read her into her artwork would have easily allowed her to deploy such colonial stereotypes as "authentic." Rather, Lewis's experience with white sculptors, supporters, and patrons, her obvious intelligence, determination, savvy, and courage, would indicate that if she indeed participated in the proliferation of a Pocahontas self-image, it was likely a deliberate and astute method of self-marketing that capitalized on the white public's entrenched colonial prejudices and desires.[89]

As a sculptor whose race was widely read as black, Lewis would have been expected by her white audiences and contemporary white sculptors to deploy black subjects, to engage in the abolitionist visual discourse, and specifically to race her Cleopatra black. The burden of Lewis's race for the thematic and subjective choices of her sculpture also extended to her Native heritage. For a dominantly white audience, all too willing to scrutinize Lewis herself as an object of vision, any deployment of Native subjects held the potential for interpretation as unmediated autobiography or, in the case of female subjects, self-portraiture.

Writing of Lewis's request for information about Pocahontas, Child described her active encouragement and delight at the potential of the subject for Lewis: "I complied with her request, and told her I thought it would be a good subject for her, because she had been used to *seeing young Indian girls,* and could work from *memory,* and with her *heart* in it, for her mother's sake . . . I think she would make a statue of an Indian better than anything else."[90] For Child, Lewis's ability to put her heart into a work and to create authentic representations was gauged by her racial proximity to the work's subject, not, as was the common practice with other white artists, by her ability to perform rigorous museological and literary research and to master the materials and aesthetic processes of her chosen media and style. But the problem of such beliefs rested in the assumption that Lewis's memory of her Native and black ancestry

and culture gave her access to homogeneous and unmediated authentic identifications that precluded her from a similar affinity for western contemporary or classical subjects. Therefore, Lewis's assumption of an "authentic" Native and black identity came at the expense of her legitimate position within western culture.

The Black Queen in a White Body

Despite the arguably dominant expectation that Lewis would deliver a black Cleopatra, one of the most thorough contemporaneous descriptions of Lewis's *Death of Cleopatra* refutes this assumption. In a book suggestively titled *Great American Sculptures* (1878), the author William J. Clark had strong praise for Lewis's work on the basis of its "authentic" deployment of race. Comparing Lewis with Margaret Foley he concluded:

> An even more remarkable sculpture from the hand of a female artist . . . which was in the Centennial Exhibition was the Cleopatra of Edmonia Lewis. This was not a beautiful work, but it was a very original and very striking one, and it deserves particular comment, as its ideal was so radically different from those adopted by Story and Gould in their statues of the Egyptian Queen. Story gave his Cleopatra Nubian features, and achieved an artistic if not a historical success by so doing. The Cleopatra of Gould suggests a Greek lineage. Miss Lewis, on the other hand, has followed the coins, medals, and other authentic records in giving her Cleopatra an aquiline nose and a prominent chin of the Roman type, for the Egyptian Queen appears to have had such features rather than such as would positively suggest her Grecian descent. This Cleopatra, therefore, more nearly resembled the real heroine of history than either of the others, which, however, it should be remembered, laid no claim to being other than purely ideal works.[91]

Although Clark's references to Lewis's search for the historical Cleopatra are mainly attributed to her racing of the subject's body, Marilyn Richardson has argued that Lewis's deployment of Cleopatra's costume demonstrated an awareness of ancient descriptions of the queen's adoption of the symbolic costume of Isis for her office, particularly in the detailed floral and organic decoration of the robe's fringe, which is draped over the left side of the throne.[92] In an attempt to achieve historical authenticity, Harriet Hosmer had conducted similarly rigorous visual and textual research for her *Zenobia* in the libraries of Boston.[93] Lewis's search for the historical Cleopatra would have certainly led her to the Vatican collections of Egyptian art, but Marilyn Richardson has also suggested that Lewis traveled to Paris to witness the Egyptologist August Mariette's exhibition of Old Kingdom art and artifacts at the Paris Exposition in 1867.[94]

Quick not to dismiss the works of the male artists Story and Gould, Clark sets up a clear division between what he read as the historically unsubstantiated or ideal works of Story and Gould and the authentic "portraiture" of Lewis. But the difference between historical authenticity and the ideal was defined as racial; Story's choice of a

Nubian or black racial type and Gould's Greek type are seen as inauthentic and historically unsubstantiated choices. Meanwhile, Lewis's suggestion of a "Roman" or "white" type was taken by Clark as the historically authentic racial choice. The relevance of Lewis's choice seems not to have been lost on her black audiences back in America. In one response, a Bishop Turner, who described a life of toil on behalf of his black race, mentioned the work in the context of his comments on the place of the black at the Philadelphia Exposition of 1876:

> At the national exposition in Philadelphia in 1876 I grant that one colored man had a painting in the art gallery, but it was not known that it was the work of a negro until it took a first premium and he came to get it and the surprise created a sensation. But the only position other than that, so far as I could learn, filled by a colored person was attending the toilet rooms and bringing water to scrub some of the floors at night. The statue of Cleopatra, which Miss Edmonia Lewis, the celebrated colored sculptress, had on exhibition there, was brought from Rome, in Italy, and she did not appear in the character of an American colored woman. Therefore, we can claim no credit for the recognition given her.[95]

In the context of the limited opportunities for blacks in nineteenth-century America to demonstrate their intellectual and cultural abilities, Turner seems more than disappointed that Lewis, in his estimation, failed to capitalize on this very public opportunity to signify blackness in a way that defied the endemic marginalization of blacks throughout the rest of the exposition. So how can we interpret Lewis's choice to avoid the overwhelmingly successful and provocative deployment of a black Cleopatra, made famous and acceptable by Story and strongly supported and substantiated by many of her own abolitionist friends and acquaintances?

It is important to note that Clark's reading of Lewis and her *Cleopatra* confirms the innovative nature of her thematic and compositional choices but also positions her squarely within the accepted norm of an intellectually rigorous cultural practice in which artists were expected to do historical research to understand their subjects. Clark's assertion of a desire for authenticity, bolstered by visual research with ancient representations, is compelling but not substantial enough to explain Lewis's choice. After all Story, too, was a member of the Roman colony and would have had the same, if not freer, access to the exact same collections. When we examine Lewis's *Cleopatra* within the context of her other representations of black female subjects, her racing of the Egyptian queen is not so exceptional. Like many of her contemporaries, Lewis seemed to struggle with the Eurocentric aesthetic limits of neoclassicism, which equated the racialized white ideal of the classical with the beautiful. In such a context, the representation of a racially specific black body became problematic, limiting the symbolic, subjective, and narrative possibilities of a sculpture.

As I have already discussed, contemporary descriptions of Lewis's earliest ideal works demonstrate a conscious shift away from deliberately black female subjects to

neoclassicism's prevalent interracial body type. Lewis's white Negro women coincide with the dominant sculptural tendency to restrict the amount of blackness in the female subject and deploy interracial types. Her deployment of race falls within the acceptable limits of the nineteenth-century neoclassical community of which she was a part. However, for Lewis, who had a much more personal stake in abolition than any of her white contemporaries and who had, at the time of her *Cleopatra,* a personal stake in Reconstruction, to avoid a black female Cleopatra at a moment when such a representation would have been expected, welcomed, and praised marks a difficult and deliberate ideological choice—a choice likely consciously informed by her many connections to abolitionists and contemporary racial discourse.

I would argue that Lewis's choice to race her *Cleopatra* "white" is part of what Nancy Proctor has termed the "ingenious negotiation by Lewis of the double-edged 'Pygmalion effect.'"[96] In refusing visible racial signs of blackness for her *Cleopatra,* Lewis thwarted the Pygmalion effect and distanced herself from any attempts by her white audience to *read her into the work.* Quite simply, Lewis did not race her sculpture black because she did not have to do so in order to achieve the results she desired: a work that signaled the prolific black and abolition disillusionment at the failure of Reconstruction. For Lewis's dead *Cleopatra,* symbolic of the continuing oppression of the black race under Reconstruction, whiteness represented the transition to spiritual freedom occasioned by the demise of the black body, the prison of the soul. The associations between Cleopatra and a black Africa were so profound and had been so thoroughly popularized by the 1870s that, as William Clark's analysis attests, any depiction of the ancient Egyptian queen had to contend with the issue of her race and the potential expectation of her blackness. Lewis's white queen gained the aura of historical accuracy through primary research without sacrificing its symbolic links to abolitionism, black Africa, or black diaspora. But what it refused to facilitate was the racial objectification of the artist's body. Lewis could not so readily become the subject of her own representation if her subject was corporeally white. But the racial liminality of the white female body, the geographical location of Egypt, and the entrenched abolitionist discourse of a black Egypt meant that a white woman could possibly become black and that a Cleopatra at this juncture, regardless of her actual corporeal race, could be *read* as a black queen.

Conclusion
Neoclassicism and the Politics of Race

Looking for Lewis

In 2001, just after completing my Ph.D. dissertation, I left Manchester, England, on a plane bound for Italy. My destination was Rome, and my mission would take me to some of the most beautiful and historic cemeteries in the city. I was looking for Edmonia Lewis, or rather her resting place. In reading all of the primary and secondary sources, letters, journals, and newspaper articles I could uncover during the three years that I had worked on my dissertation, I had found that none of the documents had anything definitive to say about where or when she died. Undeterred I went with a hunch, actually several. Although research has revealed that Lewis settled in Rome quite permanently after 1866, she was no stranger to steamship travel. Lewis was a frequent visitor to her home country, returning on many occasions to see family and friends, courier artworks, and attend dedication ceremonies. But even with all of the records of her many Atlantic crossings, there was never any indication of Lewis's desire to return permanently to America or any obvious signs of familial, business, or relationship influences that would have compelled her to do so. From all accounts Lewis was more content in Rome than she had ever been in America. Therefore, I speculated, chances were that she never resettled in America, and thus the best place to look for her was the last place she was known to have resided. My second hunch involved an attempt to determine which cemetery would be most fruitful to focus my investigative energies on. Surely other scholars had searched for Lewis in the Catholic cemeteries of the Eternal City. But what if Lewis's remains had been "misplaced" in the city's now famous Protestant Cemetery?

On examining the cemetery records, I quickly found that Mary Edmonia Lewis had not been buried there, although another Mary Lewis, also an American, had been

buried and exhumed in the early twentieth century. Being persistent, I returned again in the summer of 2004. This time I targeted all possible cemeteries in Rome by going after archived death records. At the Anagraphe di Roma I hit on a hopeful possibility. An American woman by the name of Mary Lewis had died on 21 January 1927 and had been buried in the Catholic Cimitero Verano.[1] Unfortunately, her middle name, Louise, indicated that the woman was not Edmonia. Later in my trip I encountered yet another Mary Lewis, another American who had died in Rome on 11 May 1931 at the age of eighty-eight and who had also been buried at Verano. This Lewis was particularly intriguing, since her dates of birth and death seemed to match Edmonia's. However, this Lewis was a "Mrs." who had only acquired the name Lewis from her husband, William, and whose name at birth had been Mitchell.[2]

In Florence for a conference, I decided on one final effort at the English Cemetery. I was welcomed by two wonderful women who took up my quest as if it were there own, Sister Julia Bolton Holloway and Assunta d'Aloi. They quickly determined that Lewis had not been buried in their cemetery or in any of the Catholic cemeteries in Florence, which they contacted on my behalf. However, although Mary Edmonia Lewis remained elusive, I was privileged to see the graves of Hiram Powers and Elizabeth Barrett Browning.[3]

Lewis was, except for Lavinia "Vinnie" Ream Hoxie, the youngest female sculptor of her era and network who established herself in the Roman art colony in the nineteenth century. Harriet Hosmer was over a decade older (b. 1830), Anne Whitney over two (b. 1821), and Emma Stebbins even older (b. 1815). Three of Lewis's white female contemporaries died shortly after the glorious triumph of her *Death of Cleopatra* (1875): Margaret Foley in 1877, Florence Freeman in 1876, and Emma Stebbins in 1882. Charlotte Cushman also died in 1876, the year of the Philadelphia Exposition. Only six of the female sculptors lived to see the twentieth century (Sarah Clampitt Fisher Ames, Harriet Hosmer, Lavinia Ream Hoxie, Louisa Lander, Blanche Nevin, and Anne Whitney) and even fewer of them, four to be exact (Hoxie, Lander, Nevin, and Whitney), are known to have lived beyond our last definitive traces of Edmonia Lewis.

The dates of the elusive sculptor Mary Edmonia Lewis are often cautiously cited as (1843–45 to after 1911). This undetermined range of years has been adopted because of the lack of definitive evidence of her birth and because, as of yet, the date, place, and circumstances of her death also remain unknown. What *is* certain is that the young, adventurous, and decidedly brave woman who first set sail for Europe in 1865 was certainly not the same mature, famed, accomplished, internationally renowned sculptor who likely perished there decades later. That woman, who was scarcely past twenty when she set out and was later described by Henry Wreford as an "interesting novelty" because of the nexus of her race and cultural aspirations, "*naive* in manner . . . and all-unconscious of difficulty," had become a savvy, well-traveled, educated, innovative, and accomplished artist of international repute.[4] In 1878, her *Death of Cleopatra* was still creating a stir back in America when it was displayed at the Chicago Exposition.[5] In an article of December 1878, she was credited with having sculpted the bust

of General Ulysses S. Grant, "who sat for it in Rome last winter," a far cry from her haphazard and spontaneous pursuit of Longfellow through the streets of Rome more than a decade before.[6] At around the same time she returned to America, where she was warmly received at a reception given by "the colored citizens of New York, in Shiloh Presbyterian Church," at which she unveiled a life-size bust of John Brown, which she presented to Rev. Henry Highland Garnet.[7] Lewis was back again in September 1898 "with several pieces of her art work," having arrived onboard the steamer *Umbria* direct from London.[8]

As the twentieth century dawned, public word of Lewis's comings and goings became more and more infrequent. In his *History of American Sculpture* (1924), Lorado Taft remembered Lewis's early bust *Colonel Robert Gould Shaw* and her fame-winning *Cleopatra* but claimed that nothing since had been heard of the sculptor.[9] Part of her disappearance from the pages of the journals and newspapers of the day was due quite simply to neoclassicism's fall from artistic favor. Modernism's ascent was triggered by technological inventions such as photography and the X-ray, geopolitical events such as colonization and the influx of African, Native North American, and other indigenous arts into western European centers, industrialization, and the growth of modern cities. These new aesthetic, media, and sociopolitical preoccupations conflicted with some of the basic tenets of neoclassicism. The noble, always-white classicizing forms of the once dominant artists such as Hosmer, Lewis, Powers, and Story began to seem dated, rigid, and staunchly old-fashioned next to the work of younger aesthetically experimental sculptors. While neoclassicism was fundamentally an art form that, in many ways, looked back—with reverence and respect to antiquity—modern sculpture arguably looked consistently and aggressively forward.

Very few, if any, of the once-famed neoclassical sculptors made successful transitions into modernism. Many arguably had no desire to. The turn of the century marked a moment when many of neoclassicism's brightest stars, advanced in age and beyond active production, had already passed or were more concerned with a comfortable retirement than a relocation to Paris, the new heart of western cultural production.

In 1909 when the *Rosary Magazine* reported that Lewis was "advanced in years" but was "still with us," she would have likely been between sixty-four and sixty-six years of age.[10] Unlike the amount that is known about Emma Stebbins, Harriet Hosmer, or Louisa Lander, nothing is known of Lewis's personal life, sexual or romantic. This has led some scholars to assume that Lewis, like other of her fellow female sculptors, was a lesbian. Although it is tempting to assume so, we know that Lander and Hoxie demonstrated heterosexual preferences, even though others, such as Hosmer and Stebbins, had relationships with women. However, any speculation about Lewis's sexual preference, as yet, has no substantiation within the literature. Although she is mentioned as having female companions at certain moments in her life, she is more often than not described as living an independent life in Rome, far away from family and keeping her own apartments.

Discovering Lewis's sexuality may prove significant in several ways. As with other

artists of the period, their sexuality and their romantic commitments shed light on their personal habits, cultural motivations and access, financial situations, mobility, and identity within the Roman expatriate community. For example, "family men" such as Hiram Powers had always to balance his cultural desires with financial ones, since he had a large family to support. Meanwhile, female contemporaries leading a "chaste existence" or those within a lesbian relationship had far more freedom to pursue their artistic endeavors, unimpeded by society's ideals of what a proper *heterosexual* woman should desire, which was decidedly *not* a career as a professional and internationally renowned artist (rather, mainly a husband and lots of babies). Furthermore, the process of successfully tracing a female artist throughout her lifetime and accessing literature on her is often a matter of knowing her married name as opposed to her birth one.

Since Lewis was, to my knowledge, never romantically connected (at least publicly) with anyone, man or woman, throughout her career, we may speculate that she never married. Therefore, we are still searching for someone buried as Mary Edmonia *Lewis* as opposed to some other family name. If Lewis was not married, she likely never had children, given the restrictions of late nineteenth- and early twentieth-century bourgeois society. Without immediate family in close proximity, Lewis probably maintained some sort of social and support network that she had developed from her earliest days in Rome. However, the composition of such a network must have shifted dramatically, given the death of so many of the original expatriates (who were, again, significantly older than Lewis) and also given that many of the colony's members simply returned to America with the decline of neoclassicism and Rome as its cosmopolitan center. Given the racial climate of the times, this return to America was, of course, far easier and far more desirable for Lewis's white peers than for herself or her black ones.

Finding Lewis's grave would represent a significant cultural, scholarly, and human achievement. For art historians it would mean a real hope for calculating the size and contents of her oeuvre, locating lost works, and deciphering later patronage and support networks. We cannot properly begin to find Lewis's lost works if we do not know how long she produced, how many sculptures we are looking for, or where to begin our search. The dates of Lewis's life would also help us to understand the vastly different historical, social, and cultural moments that she inhabited. It is interesting to think about her experiences of the advent of not only modernity but also modern art in Europe. Did she overlap at all or interact with or was she even known to the later influx of African-American cultural producers who flocked to Paris in the early twentieth century? Had she heard of or even seen Josephine Baker dance, experienced jazz music, or read any of the expatriate writers' works? And if so, what did she, a seasoned traveler who had now spent more of her life in Italy than in America, think of all of it? Was she still making art in 1909, and if so, what shifts, if any, had been made in her style, subject matter, and media? Did she engage with modernism, or was her career, in her sixties, already over? Quite simply, Lewis may have a lot to teach us about the experiences of people of color in turn-of-the-century Europe. Lewis in death, as in life, has much to teach us about the material, social, and psychic realities for race in

the nineteenth and twentieth centuries. When we do find her resting place, it is my sincere hope that we approach it with the reverence and respect of which she is deserving.

Neoclassicism, Race, and Blackness

In an article published in 1865, Lydia Maria Child deftly summarized some of the most pressing concerns of her time:

> At the present epoch, Africa is everywhere uppermost in the thoughts and feelings of mankind. It is difficult even for the most indifferent to avoid being interested about this tropical race, in one way or an other, for or against. . . . So pervasive is the atmosphere, that artists are breathing it also. . . . The Star of Africa has risen above the horizon, but what will be its splendor when it culminates no prophet can foresee.[11]

Child's insights were compelling. She described a national landscape in which politicians, preachers, writers, and artists alike were preoccupied not only by the geopolitical shifts and occurrences of the continent but also by the fate of its millions of still enslaved and diasporized peoples. Within this climate, the black body became a viable and decidedly necessary subject of representation for the artists of the day. Neoclassical sculptors, many of them abolitionists or sympathizers, used their sculptures to deploy representations that championed the causes of antislavery.

I have argued throughout that the representation of black female subjects bore significant differences from their black male counterparts, differences that necessitate careful scrutiny along the lines of sex, gender, sexuality, class, and other forms of intersecting markers of identity. Although black female and male subjects both appeared regularly in nineteenth-century western art as slaves and freed peoples, there are distinctions in theme, subject, and body that did not manifest equally across both groups. For the black female subject, Cleopatra, freedwomen, and slaves proliferated, each often harnessed for explicitly abolitionist ends. And yet, neoclassicism's very materiality reveals the psychic and social limits of cross-racial contact, intimacy, and equality.

The always already white marble of neoclassicism persistently refused the representation of the black body at the level of skin/color. This disavowal of the very mark that the nineteenth century claimed to be the most visible sign of racial difference and inferiority indexed white anxiety about proximity to the racial Other. The supposedly colorless neoclassical marble produced the normative racial body as the white body, which was symbolically associated with purity, morality, and truth and, although ever present, needed never to be named. The conscious suppression of and antagonism toward the competing contemporaneous practice of polychromy point to a chromophobia that was as much an anxiety about color generally as it was a way to disavow white as a color.

The issue of color intersects with neoclassical works in another profound sense. The works discussed throughout also reveal the extent to which black female subjects

were consistently whitened by artists. This dominance of the *white Negro* type is not paralleled in the contemporaneous representations of black male subjects, which exhibit a far greater racial flexibility in their signification and a tendency toward the so-called full-blooded Negro type. We must understand the desire for a whiter black female subject as connected to the ideal of the female body as the beautiful in western art more generally. If the white female body was a site of (hetero)sexual pleasure for the assumed male viewer, the black provided the opportunity for an even greater sexual license, since the black female was prolifically assumed to be always already sexually deviant. Several works discussed throughout have provided evidence of the ways in which the white Negro female body was used simultaneously as a site of excess sexuality and a means to illicit sympathy for white viewers for a beautiful, and usually imperiled, female subject.

The sculptors and their works discussed here provide an interesting and complex mix. The artists themselves, expatriates, far from home, created a successful international haven in Rome. Their daily interactions, disputes, friendships, and affairs provide critical insights into the most pressing political and cultural issues of the day. Although their aesthetic and medium betrayed deep historical attachments, far from being removed from their time and place, these sculptors were profoundly invested in producing works that commented explicitly on the events of their day. At the top of the list was Africa, its colonization, and the enslavement and continuing dispersal and oppression of its peoples. For this reason alone, they are all worthy of renewed art historical scrutiny and attention. But any such inquiries must be attentive to the vast differences in identity and subjectivity of the artists, which in every way mediated their vision, mobility, access, production, and experience. Race was consciously at the center of who these artists were, what they were able to accomplish, and what they chose to sculpt. Our task today as art historians and scholars is to shed light on the implications of the centrality of race, as well as the implications of other critical factors, and not to erase retroactively and obfuscate what was an overarching and prolific concern of their time and art.

Acknowledgments

This book, a labor of love, has been in the works since 1998, when I started my Ph.D. in Manchester, England. It would not have been possible without the generous support I received from Fonds de recherche sur la société et la culture (Etablissement de nouveaux professeurs-chercheurs) and the Social Sciences and Humanities Research Council of Canada (Standard Research Grants Program). Many kind, knowledgeable, hard-working, and generous people have assisted me in the process of completing this project. I would like to thank Marcia Pointon (my formidable supervisor), David Lomas (my saving grace and other supervisor), and Griselda Pollock for their critical early support and feedback when the seeds of this research were being planted. My library and archival research often led me to institutions in the United States and Europe. In Chicago I was aided by Debbie Vaughan of the Chicago Historical Society and John Aubrey at the Newberry Library. I would also like to thank Robert Ellis of the National Archives in the United States.

I extend my most heartfelt thanks to Nicola Pedde, former senior researcher, Information Resource Center, U.S. Embassy Rome, Office of Public Affairs, Rome, Italy. He went out of his way to provide insightful information into the workings of Italian archives and death records, and he went above and beyond what could ever have been expected; in the course of many e-mail messages and phone conversations, he knowledgeably cleared a path for me to conduct research in Rome in July 2004. Thanks also to the following people who helped me in Rome: Giuseppe Fresegna and Alberto Paesani, Cimitero Verano; Giulio Palanga, National Library in Rome; and Maria Grazia Taurchini, Anagraphe. In Florence I was welcomed at Cimitero delle Inglesi by two wonderful women who embraced me and my project with great enthusiasm and warmth; I owe a debt of gratitude to Sister Julia Bolton Holloway and

Assunta d'Aloi for all of their help in searching grave records and for allowing me access to the library. Countless people and institutions provided help and support in the United Kingdom; in particular, I was aided by the able staff at the John Rylands University Library, Deangate, Manchester.

Editors at other presses were instrumental in helping me shape this project into what it has become today. I would like to thank Alison Welsby and Lynne Pearce. I would also like to acknowledge Judith Wilson for her thorough, challenging, and detailed feedback, which inspired me to do better work. Several of my students performed valuable research and administrative support for this project; my thanks to Ruth Burns, Samantha Burton, Clara Lapiner, Jolene Pozniak, Justina Spencer, and Anuradha Gobin for their hard work.

I could never leave out my most supportive, intelligent, kind, and encouraging editor, Andrea Kleinhuber. You taught me so much and showed great patience and dedication as you led me through the world of scholarly publishing. Thanks also to Richard Morrison, Adam Brunner, Laura Westlund, the amazing Robin Whitaker, and everyone at the University of Minnesota Press for supporting and working on this project.

To the cast of characters from the nineteenth century, especially Edmonia Lewis, whose paths I have traced here, thanks for leaving such interesting, provocative, and compelling traces of yourselves and your work. And last but never least, I give recognition to my parents, Barbara Nelson and Maxwell Nelson, for always supporting and encouraging me in all of my endeavors.

Notes

Abbreviations

AWP–WCA	Anne Whitney Papers, Wellesley College Archives
BC	Berg Collection (Henry W. and Albert A.), The New York Public Library
BMAG	Blackburn Museum and Art Gallery, Blackburn, England
BPL	Boston Public Library, Anti-slavery Collection, Rare Books and Manuscripts Department
CCP–LOC	Charlotte Cushman Papers, Library of Congress
ETCA	Evans–Tibbs Collection Archives, Washington, D.C.
FDD–LOC	Frederick Douglass Diary, Library of Congress
HKBP	Henry Kirke Brown Papers, Archives of American Art, Smithsonian Institution
HL	Huntington Library, San Marino, California
HL–HUL	Houghton Library, Harvard University Library
HPP–AAA	Hiram Powers Papers, Archives of American Art, Smithsonian Institution
HPS–NYPL	Hiram Powers Scrapbook, New York Public Library
LOC	Library of Congress
ML	Meigs Letterbook (Montgomery C. Meigs), Manuscript Division, Library of Congress, Washington, D.C.
NARA	National Archives and Records Administration, National Archives, United States
RSP–MHS	Robie–Sewall Papers, Massachusetts Historical Society, Boston
SFC–NYPL	Shaw Family Correspondence, Manuscripts and Archive Division, The New York Public Library, Astor, Lenox and Tilden Foundations

Introduction

1. Throughout this volume, I use *sex* to designate the biological categories of male and female. *Gender* refers to masculinity, femininity, and all points in between. *Sexuality* refers to sexual orientation or preference.

2. On the "author-function," see Michel Foucault, "What Is an Author?" *Art in Theory: 1900–1990* (Oxford: Blackwell Publishers, 1992), 927.

3. Stuart Hall, "Introduction: Who Needs 'Identity'?" *Questions of Cultural Identity* (London: Sage Publications, 1996), 3.

4. Judith Butler, *Bodies That Matter: On the Discursive Limits of "Sex"* (New York: Routledge, 1993), 65.

5. Griselda Pollock, *Differencing the Canon: Feminist Desire and the Writing of Art's Histories* (London: Routledge, 1999), 18.

6. Butler, *Bodies That Matter,* 65.

7. Distinguished International Researchers in Conversation, seminar series, University of Manchester, 16 October 2001. This lecture was one of a series of conversations between visiting scholars and University of Manchester faculty organized for the 2000–2001 academic year.

8. Pollock, *Differencing the Canon,* 13.

9. Ibid., 34.

10. Ibid., xiv, 12.

11. Paul Gilroy, *The Black Atlantic: Modernity and Double Consciousness* (London: Verso, 1993), 9.

12. Pollock, *Differencing the Canon,* xvi.

13. Gilroy, *The Black Atlantic,* 15.

14. Aimé Césaire, *Discourse on Colonialism,* trans. Joan Pinkham (1955; rpt., New York: Monthly Review Press, 1972), 20.

15. Butler, *Bodies That Matter,* 1.

16. Ibid.

17. Alexis de Tocqueville, *Democracy in America* (1835); cited in Alexander O. Boulton, "The American Paradox: Jeffersonian Equality and Racial Science," *American Quarterly* 47 (September 1995): 488; and Kirk Savage, *Standing Soldiers, Kneeling Slaves: Race, War, and Monument in Nineteenth-Century America* (Princeton, N.J.: Princeton University Press, 1997), 219.

18. Savage, *Standing Soldiers, Kneeling Slaves,* 15.

19. Butler, *Bodies That Matter,* 97.

20. Ibid., 109.

21. Ibid., 112.

22. See, for example: Michael D. Harris, *Colored Pictures: Race and Visual Representation* (Chapel Hill: University of North Carolina Press, 2003); Albert Boime, *The Art of Exclusion: Representing Blacks in the Nineteenth Century* (Washington, D.C.: Smithsonian Institution Press, 1990); Thelma Golden, *Black Male: Representations of Masculinity in Contemporary American Art* (New York: Whitney Museum of American Art, 1994); Hugh Honour, *The Image of the Black in Western Art,* 4 vols. (Cambridge, Mass.: Harvard University Press, 1989); Alaine Locke, *The Negro in Art: A Pictorial Record of the Negro Artists and of the Negro Theme in Art* (New York: Hacker Art Books, 1979); Guy McElroy, *Facing History: The Black Image in American Art 1710–1948* (Washington, D.C.: Bedford Arts Publishers in Association with the Corcoran Gallery of Art, 1990); Ellwood C. Parry, *The Image of the Indian and the Black Man in American Art* (New York: G. Braziller, 1974); Jan Nederveen Pieterse, *White on Black: Images of Africa and Blacks in Western Popular Culture* (New Haven, Conn.: Yale University Press, 1992); Paul Gilroy, *Picturing Blackness in British Art 1700s–1900s* (Tate Gallery, London, 28 November 1995–10 March 1996).

23. I have borrowed the term *intervention* from Griselda Pollock, who advocates "feminist interventions" in art history. See Griselda Pollock and Rozsika Parker, *Old Mistresses:*

Women, Art and Ideology (London: Pandora Books, 1981); and Pollock, *Differencing the Canon.*

24. Butler, *Bodies That Matter,* 65.

25. Jean Walton, "Re-placing Race in (White) Psychoanalytic Discourse: Founding Narratives of Feminism," in *Female Subjects in Black and White: Race Psychoanalysis, Feminism,* ed. Elizabeth Abel, Barbara Christian, and Helene Moglen (Berkeley: University of California Press, 1997), 245–46.

26. Pollock, *Differencing the Canon,* xv.

27. Michel Foucault, "The Eye of Power," *Power/Knowledge: Selected Interviews and Other Writings 1972–1977,* ed. Colin Gordon, trans. Colin Gordon, Leo Marshall, John Mepham, and Kate Soper (New York: Pantheon Books, 1980), 155.

28. Pollock, *Differencing the Canon,* 18.

29. Butler, *Bodies That Matter,* 83.

30. Ibid., 62.

31. Walton, "Re-placing Race in (White) Psychoanalytic Discourse," 223.

32. Butler, *Bodies That Matter,* 75.

33. Parveen Adams, *The Emptiness of the Image: Psychoanalysis and Sexual Differences* (London: Routledge, 1996), 50.

34. Charles Bernheimer, "'Castration' as Fetish," *Paragraph* 14, no. 1 (1991): 3.

35. Butler, *Bodies That Matter,* 77.

36. Ibid., 82.

37. Adams, *The Emptiness of the Image,* 32.

38. David Batchelor, *Chromophobia* (London: Reaktion Books, 2000), 22.

39. Savage, *Standing Soldiers, Kneeling Slaves,* 8.

40. Savage has noted the relationship between sculpture and the "theoretical foundations of racism." Ibid., 8.

41. Ibid., 12. Savage has noted that human scientists such as Blumenbach, Camper, and Cuvier among others used classical sculpture as the paradigm of the white body with which they compared the differences of black bodies. See ibid., 9.

42. Ibid., 16.

43. David Chaney, *The Cultural Turn: Scene-Setting Essays on Contemporary Cultural History* (London: Routledge, 1994), 148.

44. B. Werlen, *Society, Action and Space* (London: Routledge, 1993), 3.

45. Jacques Derrida, "'The Exorbitant: Question of Method' and 'The Engraving and the Ambiguities of Formalism,' from *Of Grammatology,*" *Art in Theory: 1900–1990* (Oxford: Blackwell Publishers, 1992), 918.

46. Foucault, "What Is an Author?" 926. Foucault discusses the study of discourse via modes of existence as an alternative to the focus on expressive value or formal transformations, which in art history might be broadly correlated to connoisseurship and formalism.

47. Michel Foucault, *Discipline and Punish: The Birth of a Prison,* trans. Alan Sheridan (New York: Vintage Books, 1977), 27, 28.

48. Césaire, *Discourse on Colonialism,* 21.

49. Butler, *Bodies That Matter,* 12.

50. Ibid., 94–95.

51. Homi K. Bhabha, "The Other Question: Difference, Discrimination and the Discourse of Colonialism," in *Out There: Marginalization and Contemporary Culture,* ed. Russell Ferguson, Martha Gever, Trinh T. Minh-ha, and Cornel West (New York: The New Museum of Contemporary Art and the Massachusetts Institute of Technology, 1990), 71.

52. Harris, *Colored Pictures,* 2.

1. Dismembering the Flock

1. William H. Gerdts, "Celebrities of the Grand Tour: The American Sculptors in Florence and Rome," in *The Lure of Italy: American Artists and the Italian Experience 1760–1914,* ed. Theodore E. Stebbins Jr. (New York: Museum of Fine Arts Boston in Association with Harry N. Abrams, Inc., Publishers, 1992), 68. Sculptors had preferences for certain types of marble. Powers, based in Florence, indicated his desire for Serravezza (this is the spelling he used) over Carrara marble, the latter of which he described as "too coarse in grain and too translucent to give sufficient contrast of light and shade." He also described a shortage of Serravezza marble, perhaps due to his reliance on specific quarries, and a shortage of workmen as his "only difficulty." Powers noted that almost all of his works were sculpted from Serravezza marble, and he begged patience of his patron with regard to an unfinished commission for which he still required marble. Letter, Hiram Powers to Mr. Aspinwall, 7 April 1866, HPP–AAA.

2. Joy Kasson, *Marble Queens and Captives: Women in Nineteenth-Century American Sculpture* (New Haven, Conn.: Yale University Press, 1990), 11. For example, Thomas Crawford and Horatio Greenough trained with Thorwaldsen, Randolph Rogers with Bartolini, and Harriet Hosmer with John Gibson.

3. William H. Gerdts, *American Neo-classic Sculpture: The Marble Resurrection* (New York: Viking Press, 1973), 17; Gerdts, "Celebrities of the Grand Tour," 66.

4. Erastus Dow Palmer was one American artist whose success was unusual in that he did not train abroad.

5. Romare Bearden and Harry Henderson, *A History of African American Artists from 1792 to the Present* (New York: Pantheon Books, 1993), 63.

6. Eugene L. Didier, "American Authors and Artists in Rome," *Lippincott's Magazine of Literature, Science, and Education* 34 (November 1884): 492.

7. Nathaniel Hawthorne, *Passages from the French and Italian Note-Books of Nathaniel Hawthorne,* 2 vols. (London: Strahan and Co., Publishers, 1871), 1:76.

8. T. Q. (aka Samuel Young), *A Wall-Street Bear in Europe, with His Familiar Foreign Journal of a Tour through Portions of England, Scotland, France and Italy* (New York: Samuel Young Jr., 1855), 95.

9. Hawthorne, *Passages from the French and Italian Note-Books,* 1:92.

10. H. W. [Henry Wreford], "Lady-Artists in Rome," *Art-Journal* 5 (1866): 177.

11. Harriet Hosmer, *Harriet Hosmer: Letters and Memories,* ed. Cornelia Carr (New York: Moffat, Yard and Co., 1912), 18–19.

12. Nancy E. Proctor, "American Women Sculptors in Rome in the Mid-Nineteenth Century: Feminist and Psychoanalytic Readings of a Displaced Canon," Ph.D. dissertation, Leeds University, 1998, 81.

13. Hosmer, *Letters and Memories,* 27.

14. William Wells Brown, "The American Fugitive in Europe: Sketches of Places and People Abroad," *The Travels of William Wells Brown* (New York: Markus Wiener, 1991), 98; cited in Malini Johar Schueller, "Introduction," in David F. Dorr, *A Colored Man round the World, by a Quadroon,* ed. Schueller (Cleveland, 1858), xxiv–xxv. Although Lewis visited America several times after the establishment of her Roman studio, it appears that she never again assumed a residence in her native country. Lewis's return to America was prompted mainly by events that coincided with the exhibition or dedication of her sculpture. For instance on 18 October 1869, Lewis attended the dedication of her *Morning of Liberty/Forever Free* (1867) at Tremont Temple, in Boston, at which the sculpture was formally presented to the Reverend Leonard A. Grimes, an abolitionist minister. In the 1870s Lewis was in Chicago, where she publicly exhibited an early version of her *Hagar* (c. 1868). Several texts

also place her in Philadelphia, where she managed the display of her works, including *The Death of Cleopatra* (1875) at the 1876 exposition. She again returned in 1879, when she was given a reception by the "colored citizens of New York" at Shiloh Presbyterian Church, at which she presented the life-size bust *John Brown* (c. 1864–65) to the Reverend Henry Highland Garnet, who was described as a "veteran colored abolitionist." This was likely an emotional and triumphant return for Lewis, since Garnet was described in an 1878 *New York Times* article (cited below) as one of her earliest sources of support and encouragement. Kirsten Buick, "The Ideal Works of Edmonia Lewis," *American Art* 9 (Summer 1995): 7; Marilyn Richardson, "Edmonia Lewis' 'The Death of Cleopatra': Myth and Identity," *International Review of African-American Art* 2, no. 2 (1995): 36, 40, 50; "Miss Edmonia Lewis," *Woman's Journal,* 4 January 1879, 1; "Seeking Equality Abroad," *New York Times,* 29 December 1878, 5.

15. Letter, Lydia Maria Child to Mrs. Fields, 25 November 1865, Wayland, HL.

16. H. W., "Lady-Artists in Rome," 177.

17. Lynda Roscoe Hartigan, "Edmonia Lewis," *Sharing Traditions: Five Black Artists in Nineteenth-Century America* (Washington, D.C.: Smithsonian Institution Press, 1985), 89. Hartigan lists Lewis's date of departure as 19 August 1865, which seems impossible given Lewis's signed passport application, which is dated 21 August 1865 and was completed within the jurisdiction of Suffolk, S.S. Boston.

18. Passport application, M. Edmonia Lewis, NARA.

19. Ibid.

20. Laura Curtis Ballard, "Edmonia Lewis," *New National Era* 2, no. 17 (4 May 1871): n.p. "Ballard" is a misprint. The author's last name was Bullard, and she was the owner of Lewis's *Marriage of Hiawatha* and mentioned seeing several Longfellow-inspired works during her studio visit with Lewis.

21. Henry James, *William Wetmore Story,* 2 vols. (London: Thames and Hudson; and Boston: Houghton and Mifflin, 1903), 2:127. Quoted from letter from Story to Charles Eliot Norton, from Rome, 1863 or 1864. Although Story appears to have been initially hostile to some of the female sculptors, he and his wife, Emelyn, were later to become good friends with the sculptor Harriet Hosmer. Hosmer, *Letters and Memories,* 275–76, 334–36.

22. In September 1852, the twenty-two-year-old Harriet Hosmer sailed for England accompanied by her father and Charlotte Cushman, who had encouraged her to pursue a career in sculpture. They arrived in Rome in November 1852. Hosmer, who lived with Cushman for five years, would later recognize Cushman as one of her "staunchest, truest friends" for her support, which was instrumental in Hosmer's progress as a sculptor and establishment within the Roman community. Cushman was recognized as an accomplished host, and her Saturday receptions became a mainstay of social life for the expatriate Roman community, assembling various branches of the cultural and social community. See Hosmer, *Letters and Memories,* 144, 224, 306.

23. James, *William Wetmore Story,* 1:257. James wrote several novels and novellas directly or symbolically derived from his experiences within the Roman colony and Italy, including *Roderick Hudson* (1876); *Daisy Miller* (1879); *The Portrait of a Lady* (1881); *The Aspern Papers* (1888); *The Wings of a Dove* (1902); and *The Golden Bowl* (1904).

24. Proctor, "American Women Sculptors," 6.

25. H. W., "Lady-Artists in Rome," 177. Wreford lists also included artists who were not sculptors.

26. James, *William Wetmore Story,* 1:257.

27. Charlotte Cushman and the sculptor Emma Stebbins were partners, and Harriet

Hosmer's letters reveal more than one intimate relationship with women throughout her lifetime.

28. Nathaniel Hawthorne, *Collected Novels: Fanshawe, The Scarlett Letter, The House of Seven Gables, The Blithedale Romance, The Marble Faun* (New York: Literary Classics of the United States, 1983), 953–54.

29. Ibid., 954.

30. Pollock, *Differencing the Canon,* 5. See Parker and Pollock, *Old Mistresses.*

31. Letter, Lydia Maria Child to H. Sewall, 24 June 1868, Wayland, RSP–MHS. Signs of Child's regret at what she saw as her need to rein in Lewis's inappropriate behavior are seen in this letter, in which she likens having to write a "sincere" letter to Lewis to having a tooth pulled.

32. Pollock, *Differencing the Canon,* 13, 8.

33. Proctor has aptly noted that the so-called members of the "flock" were active in Rome over the span of many years, from 1848 until after 1887. Proctor, "American Women Sculptors," 6.

34. Ibid., 22.

35. Hawthorne, *Collected Novels,* 953.

36. Curtis Ballard, "Edmonia Lewis."

37. Proctor, "American Women Sculptors," 6.

38. Griselda Pollock, "'With My Own Eyes': Fetishism, the Labouring Body and the Colour of Sex," *Art History* 17, no. 3 (September 1994): 354–55. Pollock discusses the problem that the visibility of laboring bodies of white women posed to a "regime of sex" that depended on the naturalization of the gender-, sex-, and class-specific body of the bourgeois.

39. Geoffrey Blodgett, "John Mercer Langston and the Case of Edmonia Lewis: Oberlin, 1862," *Journal of Negro History* (July 1968): 201–18; also discussed in Hartigan, "Edmonia Lewis," 87, and in Bearden and Henderson, *A History of African American Artists,* 57–59.

40. The desire to win praise for the merit of her work and not for her race persisted with Lewis. Many years later while preparing works for the Philadelphia Centennial Exhibition of 1876, she shared her wish (although seemingly unfulfilled) to submit her works anonymously so that they might be judged "without favor or prejudice." See "Concerning Women," *Woman's Journal* 4, no. 33, Saturday, 16 August 1873, 257.

41. Lydia Maria Child, "Letter from L. Maria Child," *Liberator,* 19 February 1864, n.p.

42. Letter, Lydia Maria Child to Francis George and Sarah Blake (Sturgis) Shaw, 13 November 1870, HL–HUL. Child placed quotes around these words in her letter.

43. Letter, Anne Whitney to Sarah Whitney, 7–18 February 1869, AWP–WCA. The name of the person who Lewis purportedly involved is illegible in the letter.

44. Letter, Lydia Maria Child to Sarah Shaw, 8 April 1866, SFC–NYPL.

45. Ibid.

46. Ibid.

47. Letter, Anne Whitney to Sarah Whitney, 7–20 January 1870, AWP–WCA.

48. Letter, Lydia Maria Child to Sarah Shaw, 8 April 1866, SFC–NYPL.

49. L. M. C., "A Chat with the Editor of the Standard," *Liberator,* 20 January 1865, 12.

50. Hartigan, "Edmonia Lewis," 88; Juanita Marie Holland, "Mary Edmonia Lewis's *Minnehaha:* Gender, Race, and the 'Indian Maid,'" *Bulletin of the Detroit Institute of Arts* 69, nos. 1–2 (1995): 27. While some sources named William Lloyd Garrison as the go-between, others named Garrison and Lydia Maria Child. However, from Child's own account, when she met Lewis for the first time in 1864, she was already working with Brackett, having completed her first bust, *Voltaire.* See Child, "Letter," *Liberator,* n.p. Child certainly became a patron after this initial meeting. Her own letters document the

payment of twenty dollars for "pieces of sculpture," the purchase of "various photographs of sculpture" for Lewis, and the gift of a "handsome silk gown." The location of *Voltaire* is not known. See the letter from Lydia Maria Child to Harriet Sewall, 24 June 1868, RSP–MHS.

51. "Edmonia Lewis, the Colored Sculptor at Chicago," *New York Times,* 11 September 1870, 5.

52. Letter, Lydia Maria Child to Francis George and Sarah Blake (Sturgis) Shaw, 13 November 1870, HL–HUL. Anne Whitney also mentioned that Lewis had made a life-size statue "last year" called *Hagar.* See letter from Anne Whitney to Sarah Whitney, 7–18 February 1869, AWP–WCA.

53. Letter, Lydia Maria Child to H. Sewall, 24 June 1868, Wayland, RSP–MHS.

54. C., "Sculpture," *Art Review* 1, no. 6 (August 1871): 23.

55. Letter, Edmonia Lewis to Mrs. Chapman, 3 May 1868, Rome, Italy, BPL. Lewis referred to this work as a group because it had multiple figures, in this case two.

56. Hugh Honour, *The Image of the Black in Western Art,* vol. 4: *From the American Revolution to World War I* (Cambridge, Mass.: Harvard University Press, 1989), part 2, "Black Models and the White Myths," 55–59.

57. Letter, Lydia Maria Child to H. Sewall, 24 June 1868, Wayland, RSP–MHS.

58. Letter, Anne Whitney to Sarah Whitney, 7–18 February 1869, AWP–WCA. Lewis's relationship with her brother seems to have been affected over time and by distance. In another letter, Whitney related Lewis's "disgust with Sunrise," who had "taken a squew to himself" (perhaps gotten too big for his britches). See letter from Anne Whitney to Sarah Whitney, 12 December 1870, AWP–WCA. Lewis's existing family ties are not totally clear. In another letter, Whitney described Sunrise as Lewis's "only near relative" and the "only person in the world who ever cared for her success." She also conveyed Lewis's suspense, sadness, and fear for her brother, who had been out of contact for more than six months. According to Whitney, Lewis later learned that he had been "somewhere out west" and was disabled by a "shot in the hand." See letters from Anne Whitney to Sarah Whitney, 19 March 1870 and 14 January 1871, AWP–WCA. But later, Whitney related a visit from Lewis, during which she regaled Whitney with stories of a recent trip, it appears to America, where she ran into her aunt (her mother's sister) in the street and spent a fortnight with her "in her hut." See letter from Anne Whitney to Sarah Whitney, 12 December 1870, AWP–WCA.

59. Letter, Lydia Maria Child to H. Sewall, 10 July 1868, Wayland, RSP–MHS.

60. "Concerning Women," *Woman's Journal* 4, no. 40, Saturday, 4 October 1873, 313. The author of this article reported that Lewis had sold her "Hiawatha and his Bride" to Mrs. C. L. Low of San Francisco for $550.

61. Letter, Anne Whitney to Sarah Whitney, 7–18 February 1869, AWP–WCA. Whitney also mentioned that Mr. P. got his facts from a Mr. Wood, an English artist who had been helping Edmonia financially. Unfortunately, the names in this sentence are illegible.

62. Letter, Lydia Maria Child to Sarah Shaw, 8 April 1866, SFC–NYPL.

63. Letter, Edmonia Lewis to Mrs. Chapman, 3 May 1868, Rome, Italy, BPL. In the letter (transcribed faithfully here), Lewis went so far as to ask Mrs. Chapman to visit Mr. Sewall to determine the circumstances of her group *Forever Free.* Her concerns seemed connected to a situation that Lydia Maria Child described in one of her letters: that Lewis had put herself in debt by doing the work in marble and had shipped it, without a commission, back to supporters in America, expecting them to foot the bill. Mr. Sewall in the end was the person who rescued the sculpture by paying the freight charges.

64. L. M. C., "A Chat with the Editor of the Standard," 12. Buick also concurs with this conclusion. See Kirsten Pai Buick, "The Sentimental Education of Mary Edmonia

Lewis: Identity, Culture, and Ideal Works," Ph.D. dissertation, University of Michigan, Ann Arbor (UMI, 1999), 55.

65. Letter, Lydia Maria Child to Harriet Sewall, 24 June 1868, RSP–MHS.

66. George William Curtis, "Editor's Easy Chair," *Harper's New Monthly Magazine* 22, January 1861, 270; cited in Kasson, *Marble Queens and Captives*, 83.

67. Robert L. Gale, *Thomas Crawford, American Sculptor* (Pittsburgh: University of Pittsburgh Press, 1964), 121; cited in Charlotte Streifer Rubinstein, *American Women Sculptors: A History of Working in Three Dimensions* (Boston: G. K. Hall, 1990), 36.

68. See James Jackson Jarves, "What American Women Are Doing in Sculpture," *Art Review* 1, no. 4 (March 1871): 3. Jarves remarked disparagingly about "the fascinating young miss" or "woman of maturer charms" who dared think herself worthy of sculpting a "public man."

69. Elizabeth Rogers Payne, "Anne Whitney: Art and Social Justice," *Massachusetts Review* 12 (Spring 1971): 245–57. Whitney had a special motivation to secure the commission for the Sumner memorial, since her brother Alleck, who had died of tuberculosis in 1842, had studied law with Charles Sumner at Harvard. For Anne, Sumner's career and convictions appeared to be the very achievements of which her brother's untimely death had robbed him. Thomas Crawford was eventually awarded the commission, and although Whitney received the significant sum of five hundred dollars, it was a token prize that was awarded to all three finalists. Harriet Hosmer's government commission for a memorial sculpture of Thomas Hart Benton, the abolitionist senator from her home state of Missouri, prompted her recognition of the gendering of artistic creativity as well as the phallic symbolism of the embodiment of leadership and heroism. When confirming her acceptance, Hosmer described the commission as an opportunity to prove her worth not as an artist but as a female artist, commissioned to create what she termed a *manly* work. Hosmer acknowledged the terms of public, large-scale sculpture as a masculinized cultural domain, in which women were marginalized and forced to assume gendered representational practices to compete. Kasson, *Marble Queens and Captives*, 161.

70. In fact, Lewis does not appear to have had any substantial formal training in sculpting or anatomy. The full extent of her instruction appears to have been whatever assistance and guidance she gained from her contact with Edward Brackett while in Boston.

71. Letter, Lydia Maria Child to Francis George and Sarah Blake (Sturgis) Shaw, 13 November 1870, HL–HUL.

72. Ibid.

73. Letter, Lydia Maria Child to Francis George and Sarah Blake (Sturgis) Shaw, 13 November 1870, HL–HUL. Child does not indicate the date of her last communication with Lewis or the amount of time that had lapsed in leading her to speculate about Lewis's state of mind.

74. Cornelia Crow, taking her husband's name in marriage, later became Cornelia Carr and compiled and edited Hosmer's papers. See: Hosmer, *Letters and Memories*, 8–9; Rubinstein, *American Women Sculptors*, 47; and Payne, "Anne Whitney," 247–48.

75. James, *William Wetmore Story*, 2:149.

76. Pierre Bourdieu, *Distinction: A Social Critique of the Judgement of Taste*, trans. Richard Nice (London: Routledge and Kegan Paul, 1984), 53–54.

77. Letter, Lydia Maria Child to Francis George and Sarah Blake (Sturgis) Shaw, 13 November 1870, HL–HUL.

78. Savage, *Standing Soldiers, Kneeling Slaves*, 63.

79. Buick, "The Sentimental Education of Mary Edmonia Lewis," 59. See also "A Colored Sculptor," *New York Tribune*, 8 August 1865.

80. In a letter to the American painter Elihu Vedder, the American landscape painter Sandford Robinson Gifford related having received a caller named Eugene Warburg, whom he described as a Negro sculptor from New Orleans. The sculptor, who was out of money and on his way to Florence, apparently produced letters of introduction from notable people, and Gifford and his friends in Venice responded by raising money for him to resume his travels. Letter, Sanford R. Gifford to Elihu Vedder, 1 February 1856, private collection; cited in Theodore Stebbins Jr., "Introduction," in *The Lure of Italy*, ed. Stebbins Jr., 24. See also Regina Soria, *Dictionary of Nineteenth-Century American Artists in Italy 1760–1914* (East Brunswick, N.J.: Associated University Press, 1982), 317. N.b., Soria spells the sculptor's name with an *o*, Warbourg.

81. Although Canada's claim to Duncanson has been refuted by Joseph Ketner, at least until recently, you could still find Duncanson's painting in the Canadian Art installation of the National Gallery of Canada, Ottawa. See Joseph Ketner, *The Emergence of the African-American Artist: Robert S. Duncanson* (Columbia: University of Missouri Press, 1993).

82. K. Quinn, "Robert Scott Duncanson," *The Lure of Italy*, ed. Stebbins Jr. , 186; Bearden and Henderson, *A History of African American Artists*, 64. From her life in Boston, Lewis likely also knew the African-American painter Edward Mitchell Bannister, who had also maintained studio space in the Studio Building during the 1860s. Hartigan, "Edmonia Lewis," 88.

83. Memoirs of William Hayes Ackland, Ackland Art Museum, University of North Carolina, Chapel Hill; cited in Richardson, "Edmonia Lewis' 'The Death of Cleopatra,'" 40. Ackland likely misrecorded the date as 1886 instead of 1876. The word *cook* was at some point crossed out and replaced by *house maid*.

84. Lewis met Whitney in Boston around 1864 before both women relocated to the Roman colony. Anne Whitney, a native of Watertown, Massachusetts, was also a poet whose collected *Poems* was published in 1859. Whitney lived in Rome from 1867 until 1871. Among her philanthropic activities, Anne and her sister Sarah contributed to the Whitney School, a school for freedmen in the South, and the Perkins Institute for the Blind. Payne, "Anne Whitney," 248, 259.

85. Letter, Anne Whitney to Adele Manning, 9 August 1864, AWP–WCA.

86. Letter, Lydia Maria Child to Mrs. Field, 25 November 1865, HL.

87. Letter, Lydia Maria Child to Sarah Shaw, 8 April 1866, SFC–NYPL.

88. Letter, Lydia Maria Child to Sarah Blake (Sturgis) Shaw, 3 November 1864; and letter, Lydia Maria Child to Francis George and Sarah Blake (Sturgis) Shaw, 13 November 1870, HL–HUL. Lewis's portrait bust *Colonel Robert Gould Shaw* dates from 1864. Her success with the mass production of small-scale plasters recalls John Rogers democratization of sculpture and exploitation of the bourgeois and aspiring-to-bourgeois market around the same period.

89. Letter, Lydia Maria Child to Francis George and Sarah Blake (Sturgis) Shaw, 13 November 1870, HL–HUL.

90. Letter, Lydia Maria Child to Sarah Shaw, 8 April 1866, SFC–NYPL.

91. Curtis Ballard, "Edmonia Lewis." Lewis displayed her bust of Shaw at the Sailors' Fair in Boston. Despite the revelations detailed in the personal correspondence, a write-up in the *Liberator* claimed that the bust was well-liked by the Shaw family, who had it photographed by Mr. Marshall. It also states that the family allowed Lewis to sell copies "for her own benefit." It is unclear whether this refers to copies of the photograph or the bust. See "Bust of Col. Shaw," *Liberator*, 9 December 1864, 199.

92. "Medallion of John Brown," *Liberator*, 29 January 1864, 19. The small ad alerted

friends and the public that they could see the medallion in Lewis's studio at 89 Studio Building, Tremont Street. It erroneously also listed her first name as Edmania.

93. Hartigan, "Edmonia Lewis," 89. Although Lewis apparently went on to do several other portraits of the abolitionist hero John Brown, one of which she presented to the Reverend Henry Highland Garnet of Shiloh Presbyterian Church in New York, she never met him but worked from photographs to represent his likeness. "Seeking Equality," 5; "Miss Edmonia Lewis," 1.

94. Letter, Lydia Maria Child to Sarah Shaw, 8 April 1866, SFC–NYPL.

95. Letter, Lydia Maria Child to Francis George and Sarah Blake (Sturgis) Shaw, 13 November 1870, HL–HUL.

96. Letter, Lydia Maria Child to Sarah Shaw, 8 April 1866, SFC–NYPL.

97. Letter, Lydia Maria Child to Sarah Shaw, 8 April 1866, SFC–NYPL; and H. W., "Lady-Artists in Rome," 177. Henry Wreford described seeing a bust of Shaw, which had been ordered by the martyred soldier's family, in Lewis's newly established Roman studio in March 1866.

98. Curtis Ballard, "Edmonia Lewis."

99. L. C. M., "A Chat with the Editor of the Standard," 12.

100. Letter, Lydia Maria Child to H. Sewall, 24 June 1868, Wayland, RSP–MHS.

101. Ibid.

102. Letter, Lydia Maria Child to H. Sewall, 24 June 1868, Wayland; and letter, Lydia Maria Child to H. Sewall, 10 July 1868, RSP–MHS.

103. Letter, Lydia Maria Child to Francis George and Sarah Blake (Sturgis) Shaw, 13 November 1870, HL–HUL.

104. Letter, Lydia Maria Child to H. Sewall, 24 June 1868, RSP–MHS; letter, Lydia Maria Child to H. Sewall, 10 July 1868, RSP–MHS.

105. Jarves, "What American Women Are Doing in Sculpture," 3.

106. Henry James, *Italian Hours* (Boston: Houghton Mifflin, 1909), 181–82.

107. James, *William Wetmore Story,* 1:258.

108. Sibyl Ventress Brownlee, "Out of the Abundance of the Heart: Sarah Ann Parker Remond's Quest for Freedom," Ph.D. dissertation, University of Massachusetts, Amherst, 1997, 91, 121, 136; Miriam L. Ursey, "Charles Lenox Remond, Garrison's Ebony Echo: World Anti-slavery Convention, 1840," *Essex Institute Historical Collections* (April 1970): 115–16; Nancy Prince, *A Narrative of the Life and Travels of Mrs. Nancy Prince, Written by Herself,* 2nd ed. (1853), in *Collected Black Women's Narratives,* ed. Henry Louis Gates Jr. (New York: Oxford/Schomburg Library, 1988); Cheryl Fish, "Voices of Restless (Dis)Continuity: The Significance of Travel for Free Black Women in the Antebellum Americas," *Women's Studies* 26 (1997): 479, 483.

109. Fish, "Voices of Restless (Dis)Continuity," 485.

110. Sources suggest two separate locations for Lewis's studio. After having a new studio built to her specifications, Harriet Hosmer reportedly assisted in having Lewis take over her old studio near the Spanish Steps at Via Fontanella, which had once been occupied by Antonio Canova. This location is substantiated by Anne Whitney, who wrote of the inside wall of Lewis's studio having a marble tablet stating that Canova had once occupied it. See letter from Anne Whitney to Sarah Whitney, 2 May 1867, AWP–WCA; Bearden and Henderson, *A History of African American Artists,* 64; and J. Falino, "Harriet Hosmer," in *The Lure of Italy,* ed. Stebbins Jr., 226. Another account suggests that Lewis occupied studio space on the Via San Nicolo di Tolentino near the Piazza Barberini. J. Falino, "Edmonia Lewis," in *The Lure of Italy,* ed. Stebbins Jr., 241. However, it is possible that Lewis occupied spaces at both sites at different times in her career.

111. Letter, Lydia Maria Child to H. Sewall, 10 July 1868, Wayland, RSP–MHS.

112. T. Q., *A Wall-Street Bear*, 98.

113. Theodore Tilton, *Independent*, 5 April 1866; cited in Bearden and Henderson, *A History of African American Artists*, 63.

114. H. W., "Lady-Artists in Rome," 177.

115. Letter, Lydia Maria Child to Mrs. Fields, 25 November 1865, HL.

116. Letter, Lydia Maria Child to Mr. (James) Thomas Fields, 13 October 1865, HL.

117. Letter, Lydia Maria Child to Mrs. Fields, 25 November 1865, HL.

118. Buick, "The Sentimental Education of Mary Edmonia Lewis," 62–63. Mr. Hart is also mentioned as someone who was very kind to Lewis during her stay in Florence. Lewis supposedly stayed six months, which does not compute with her departure date of August 1865. Since we know that Child was writing of Lewis being in Florence in November 1865 and Lewis apparently arrived in Rome in the winter of 1865–66, a six-month stay in Florence seems a bit long, given that Lewis likely stopped in England and other locations after her initial voyage and before arriving in Florence. See *How Edmonia Lewis Became an Artist*, pamphlet, n.d., Washington, D.C., ETCA, Edmonia Lewis vertical file.

119. Letter, Anne Whitney to Sarah Whitney, 2 May 1867, AWP–WCA. Whitney recalls having been invited for tea one Tuesday by Lewis.

120. John Rogers Jr. to Henry Rogers, Rome, 13 February 1859, Rogers Collection, courtesy of the New York Historical Society, New York; cited in Kasson, *Marble Queens and Captives*, 12.

121. Hawthorne had previously written glowingly about the bust and Lander herself. Letter, Nathaniel Hawthorne to William D. Ticknor, Boston, 14 April 1858, in Nathaniel Hawthorne, *The Letters, 1857–1864*, vol. 18 of *The Centenary Edition of the Works of Nathaniel Hawthorne*, 23 vols., ed. Thomas Woodson, James A. Rubino, L. Neal Smith, and Norman Holmes Pearson (Columbus: Ohio State University Press, 1987), 140–41.

122. Letter, Nathaniel Hawthorne to James T. Fields, Rome, 11 February 1860, ibid., 230.

123. Letter, Nathaniel Hawthorne to Louisa Lander and Elizabeth Lander, Rome, 13 November 1858, ibid., 158.

124. See Proctor, "American Women Sculptors," 107; Hawthorne, *Passages from the French and Italian Note-Books*, 1:91; Nathaniel Hawthorne, *The French and Italian Note-books*, vol. 14 of *The Centenary Edition of the Works of Nathaniel Hawthorne*, ed. Thomas Woodson (Columbus: Ohio State University Press, 1980), 78; Hawthorne, *The Letters, 1857–1864*, 158, 230; Wayne Craven, *Sculpture in America* (New York: Thomas Y. Crowell Company, 1986), 332.

125. Karen Sánchez-Eppler, "Bodily Bonds: The Intersecting Rhetorics of Feminism and Abolition," *Representations* 24 (Fall 1988): 30.

126. Thomas Ball, *My Three Score Years and Ten* (Boston: Roberts Brothers, 1891), 253; cited in Savage, *Standing*, 81.

127. Savage, *Standing*, 32, 36; Vivien Green Fryd, *Art and Empire: The Politics of Ethnicity in the United States Capitol, 1815–1860* (New Haven, Conn.: Yale University Press, 1992), 177.

128. Letter, Henry Kirke Brown to his wife, 30 April 1867, BPL; cited in Savage, *Standing*, 81.

129. Hawthorne, *Passages from the French and Italian Note-Books*, 1:86. Nathaniel Hawthorne was witness to this material process when he visited Story's studio in February 1858, where he found the sculptor at work on the clay maquette of *Cleopatra*, the completed sculpture of Goethe's *Margaret*, the portrait sculpture of Story's father, and in the outer room an artisan busy transferring Story's *Hero* from plaster to marble.

130. Hawthorne, *Passages from the French and Italian Note-Books*, 1:157. Hawthorne's observation was made during his visit to the studio of the deceased sculptor Thomas Crawford in March 1858.

131. See, for example: Hawthorne, *Passages from the French and Italian Note-Books*, 1:156–57; Henry James and William Story, in James, *William Wetmore Story and His Friends*, 1:254, 255, 256–57; Elizabeth Barrett Browning, *Letters of Elizabeth Barrett Browning*, ed. Frederic G. Kenyon (New York: Macmillan, 1897), 2:166; Fanny Kemble in Hosmer, *Letters and Memories*, 28; and Lydia Maria Child, *Lydia Maria Child Selected Letters, 1817–1880*, ed. Milton Meltzer and Patricia G. Holland (Amherst: University of Massachusetts Press, 1982), 265.

132. Proctor, "American Women Sculptors," 98.

133. Hawthorne, *Passages from the French and Italian Note-Books*, 1:190.

134. James, *Letters*, 1:339.

135. In a letter to Hiram Powers, Hosmer identified her anonymous attacker as the American sculptor Joseph Mozier. See Rubinstein, *American Women Sculptors*, 41. Anne Whitney similarly identified the villain and related how Hosmer had told her "the whole history of . . . the slander of Mosier [sic] and some other men (artists) who sided with him . . . saying that she did not do her own work." Letter, Anne Whitney to Sarah Whitney, 7–18 February 1869, AWP–WCA.

136. Letter, Anne Whitney to Sarah Whitney, 7–18 February 1869, AWP–WCA.

137. Curtis Ballard, "Edmonia Lewis." It appears that although Lewis took to doing many tasks customarily left to hired artisans, she nevertheless did at times employ studio workers. One account suggested that Lewis was employing nine male helpers in her busy studio in 1872. See *Cincinnati Enquirer*, 28 September 1872, n.p.

138. Toni Morrison, "The Site of Memory," in *Out There: Marginalization and Contemporary Culture*, ed. Russell Ferguson, Martha Gever, Trinh T. Minh-ha, and Cornel West (New York: New Museum of Contemporary Art, 1990), 299. See also, for example: Olaudah Equiano, *The Interesting Narrative of the Life of Olaudah Equiano, or Gustavus Vassa, the African, Written by Himself* (1769); Frederick Douglass, *Narrative of the Life of Frederick Douglass, an American Slave, Written by Himself* (1845); Henry Bibb, *The Life and Adventures of Henry Bibb, an American Slave, Written by Himself* (1849); and Harriet Jacobs, *Incidents in the Life of a Slave Girl, Written by Herself* (1861). An intriguing exception to this literary rule was the self-published travel narrative by Dorr, *A Colored Man*. Dorr's extraordinary book, which locates the heterogeneity of nineteenth-century black authors, is free of the standard white abolitionist endorsement that was deemed essential to the authenticity of the slave narratives.

139. Letters, Charlotte Cushman to Emma Crow, 9 March and 4 February 1864, CP–LOC; cited in Sara Foose Parrott, "Networking in Italy: Charlotte Cushman and 'The White Marmorean Flock,'" *Women's Studies* 14, no. 4 (1988): 336.

140. Rubinstein, *American Women Sculptors*, 53; letter, Anne Whitney to her family, 9 February 1868, AWP–WCA.

141. Hartigan, "Edmonia Lewis," 90–91.

142. Ibid., 89, 98. For example, an attempt to document Lewis's oeuvre by Gylbert Coker (Hunter College) and Diane Lachatanere (Schomburg Center for Research in Black Culture, New York) has resulted in a list of only 46 compositions. In comparison the online Smithsonian Institution Research Information System, which does not profess to be complete, lists some 373 works by Hiram Powers and only 14, with a potential additional 2 not fully attributed, for Edmonia Lewis (http://americanart.si.edu/search/search_data.cfm, accessed 28 July 2005). In comparison, the Smithsonian has in its own collection

166 works by Powers and only 8 by Lewis (http://americanart.si.edu/search/search_art works.cfm, accessed 28 July 2005). This discrepancy not only suggests the institutional- ization of sex, gender, and race bias in the historical documentation and collection of art but also points up how the patriarchal logic of nineteenth-century culture severely lim- ited women's ability to participate equitably as cultural producers. http://160.111.100.112/ webpac-bin/wgbroker?new

143. Letter, Lydia Maria Child to Harriet Sewall, 24 June 1868, RSP–MHS.

144. Ibid.

145. Letter, Lydia Maria Child to Francis George and Sarah Blake (Sturgis) Shaw, 13 November 1870, HL–HUL.

146. Ibid.

147. Letter, Lydia Maria Child to Sarah Shaw, 8 April 1866, SFC–NYPL. Child also related being reluctant to send some request to Mrs. Minturn from Lewis but felt she could not back out of the situation.

148. Letter, Lydia Maria Child to Francis George and Sarah Blake (Sturgis) Shaw, 13 November 1870, HL–HUL.

149. Letter, Lydia Maria Child to Harriet Sewall, 10 July 1868, Wayland, RSP–MHS.

150. Letter, Lydia Maria Child to Francis George and Sarah Blake (Sturgis) Shaw, 13 November 1870, HL–HUL.

151. Hartigan, "Edmonia Lewis," 90. Another example of Lewis's astute management of her career was her use of photographs of works in progress to promote her Roman stu- dio and her professional identity as a sculptor. Lewis sent a photograph of her second ideal work *Morning of Liberty/Forever Free* to the *Freedmen's Record,* betting that an abolitionist paper would promote the cultural endeavors of a young black artist. *Freedmen's Record,* 3 January 1867, 3; cited in Buick, "The Ideal Works of Edmonia Lewis," 10; and in James A. Porter, "Versatile Interests of the Early Negro Artist," *Art in America* 24 (January 1936): 22.

152. Letter, Anne Whitney to Sarah Whitney, 7–18 February 1869, AWP–WCA.

153. Letter, Lydia Maria Child to Sarah Shaw, 8 April 1866, SFC–NYPL.

154. Albert TenEyck Gardner, *Yankee Stonecutters: The First American School of Sculp- ture, 1800–1850* (New York: published for the Metropolitan Museum of Art by Columbia University Press, 1945), 49–50.

2. "Taste" and the Practices of Cultural Tourism

1. See, for example: Rembrandt Peale, *Notes on Italy Written during a Tour in the Years 1829 and 1830* (Philadelphia: Carey and Lea, 1831); Henry Tuckerman, *The Italian Sketch Book* (Boston: Light and Stearns, 1837); Count Hawks Le Grice, *Walks through the Studii of the Sculptors of Rome* (Rome: Puccinelli, 1844); George Stillman Hillard, *Six Months in Italy,* vols. 1 and 2 (Boston: Ticknor, Reed, and Fields, 1853); Hawthorne, *Passages from the French and Italian Note-Books; Baedeker's Italy, Handbook for the Travelers, First Part: Northern Italy* (Leipzig: Karl Baedeker, 1889); and S. Russell Forbes, *Rambles in Rome: An Archaeological and Historical Guide to the Museums, Galleries, Villas, Churches, and Antiq- uities of Rome and the Campagna,* 9th ed. (London: Thomas Nelson and Sons, 1903).

2. Francis Haskell and Nicholas Penny, *Taste and the Antique: The Lure of Classical Sculpture 1500–1900* (New Haven, Conn.: Yale University Press, 1981), xiii.

3. For a significant and interesting discussion of the generational biological and physiological repercussions of the sustained slave transportation practices of transatlantic slavery, see Thomas W. Wilson and Clarence E. Grim, "The Possible Relationship between the Transatlantic Slave Trade and Hypertension in Blacks Today," in *The Atlantic Slave Trade:*

Effects on Economies, Societies, and Peoples in Africa, the Americas and Europe, ed. Joseph E. Inikori and Stanley L. Engerman (Durham, N.C.: Duke University Press, 1992).

4. Schueller, "Introduction," in Dorr, *Colored Man,* xxvi, xxiv. For more on the colonial incongruity between blackness and bourgeois paradigms of travel, see James Clifford, "Traveling Cultures," in *Cultural Studies,* ed. Lawrence Grossberg, Cary Nelson, and Paula Treichler (New York: Routledge, 1992), 106.

5. Schueller, "Introduction," in Dorr, *Colored Man,* xxviii. See also Fish, "Voices of Restless (Dis)Continuity," 480, 487.

6. Schueller, "Introduction, in Dorr, *Colored Man,* xix.

7. Ibid., xv. As I will discuss further in chapter 4, *quadroon* was a colonial term used to define a person who was one-quarter black. David Dorr was born a slave in 1827 or 1828 in New Orleans. His "owner" was a white lawyer named Cornelius Fellowes, who "treated him as a son" yet later reneged on a promise of manumission. The information for Dorr's book was gained during the three years when he traveled with Fellowes in Europe and the Near East (1851–54). Dorr's self-identification as a quadroon, coupled with the term *colored* in the title, was of exceptional significance not only because of his ability to "pass" for white but also because his early life in New Orleans had afforded him a "privileged" black status between the whites and Negroes, a status known as "colored." See Schueller, "Introduction," in Dorr, *Colored Man,* xi, xvii.

8. Ibid., xxx. See also xxxii, xxxiii.

9. Ibid., xxi, xxxi. See also xii, xxxv.

10. Many fewer slaves were imported to Europe than to North America or the Caribbean. This decreased population resulted in an increased exoticism as the black subject became a novelty or curiosity to the dominant white population. Also the uses of the slave body in Europe were different from its uses across the Atlantic. The demands for agricultural labor in the warmer or tropical climates of the American South and the Caribbean were mostly absent in Europe. Instead, slaves there were regularly used for domestic or industrial service and subsequently were less socially visible.

11. Fish, "Voices of Restless (Dis)Continuity," 477.

12. H. W. Bellows, *Seven Sittings with Powers the Sculptor* (1869); cited in Gardner, *Yankee Stonecutters,* 45.

13. Bayard Taylor, *Views A-Foot; Or Europe Seen with Knapsack and Staff* (Philadelphia: David McKay, 1890), 72; cited in Schueller, "Introduction," in Dorr, *Colored Man,* xxiii.

14. Prior to the publication of the Murray guides, the Italian-language guidebooks by Mariano Vasi, which had been translated into English early in the nineteenth century and revised by Antonio Nibby after 1818, retained their popularity with travelers who were ardently interested in archaeology and architecture. In the 1850s George Hillard's *Six Months in Italy* (1853) became almost indispensable. In the 1860s the German publisher Karl Baedeker began publishing English-language guides, which were popular throughout the late nineteenth and early twentieth centuries. Stebbins Jr., "Introduction," *The Lure of Italy,* ed. Stebbins Jr., 22, 441, 445; Gardner, *Yankee Stonecutters,* 46.

15. Hawthorne, *Passages from the French and Italian Note-Books,* 1:77, 147, 201.

16. Mary-Suzanne Schriber, "Julia Ward Howe and the Travel Book," *New England Quarterly* 62 (1989): 267, 269; cited in Schueller, "Introduction," in Dorr, *Colored Man,* xxi.

17. Gardner, *Yankee Stonecutters,* 44.

18. Pierre Bourdieu, *Distinction: A Social Critique of the Judgement of Taste,* trans. Richard Nice (London: Routledge and Kegan Paul, 1984), 1, 56, 77.

19. Hawthorne, *Passages from the French and Italian Note-Books,* 1:85.

20. Bourdieu, *Distinction,* 2.

21. Hawthorne, *Passages from the French and Italian Note-Books,* 1:67. Hawthorne and his family arrived in Rome in January 1858, occupying rooms on the Via Porta Pinciana.

22. In our contemporary experience of cultural tourism and technological change, a similar phenomenon is witnessed in the process of museum visitors who photograph or videotape themselves with famous works of art as a testament to the visual proximity and the material experience of the "I was there" moment. The audience for such photographic and videotaped representations is certainly smaller and more intimate than the audience of nineteenth-century accounts, or perhaps even nonexistent, because the process of the firsthand dramatization is seemingly more important than the possible visual consumption of the representation.

23. Henry James, *Henry James Letters,* ed. Leon Edel (Cambridge, Mass.: Belknap Press of Harvard University Press, 1974), vol. 1 (1843–75), 162.

24. Hawthorne, *Passages from the French and Italian Note-Books,* 1:123.

25. Ibid., 1:224.

26. Ibid., 1:201.

27. Bourdieu, *Distinction,* 71–72.

28. Gerdts, *American Neo-classic Sculpture,* 7.

29. Edward C. Cheney, *Freedmen's Record* (Boston) 2, no. 4 (April 1866): 69. Lewis proposed to dedicate the marble to Mrs. H. E. Stevenson and Mrs. E. D. Cheney (perhaps related to the author) for their work in the education of blacks.

30. The significance of the artist's studio as a showroom was revealed in Eugene L. Didier's discussion of the "lofty apartments" of Story's Roman studio, which were used to display many of the works in his considerable oeuvre. Recognizing Story as a "leading figure" in the American colony, Didier reported that his impressive studio, situated in a new part of the city on the Via della Mercede in a building called Maeaeo, occupied a "suite of seven rooms on the first floor." See Didier, "American Authors and Artists in Rome," 494.

31. Kasson, *Marble Queens and Captives,* 9.

32. Hawthorne, *Passages from the French and Italian Note-Books,* 1:91. Hawthorne's description refers to the portrait bust completed by Louisa Lander before she fell into social disfavor in the colony.

33. Hawthorne, *Collected Novels,* 951; cited in Gardner, *Yankee Stonecutters,* 13.

34. T. Q., *A Wall-Street Bear,* 98.

35. Bourdieu, *Distinction,* 71, 76–77. Power over time is manifested in the accumulation of historical objects, which infers a level of requisite knowledge for appropriate appreciation, and in the processes of material inheritance by which cultural wealth and knowledge are gifted to future generations.

3. "So Pure and Celestial a Light"

1. Mary Hamer, "Black *and* White? Viewing Cleopatra in 1862," in *The Victorians and Race,* ed. Shearer West (Aldershot, England: Scolar Press, 1996), 53.

2. Pollock, "Fetishism, the Labouring Body and the Colour of Sex," 346.

3. Letter, Lydia Maria Child to Harriet Sewall, Wayland, 10 July 1868, RSP–MHS.

4. Hawthorne, *Passages from the French and Italian Note-Books,* 1:157.

5. Hawthorne, *The Marble Faun,* in *Collected Novels,* 965–66; cited in Gardner, *Yankee Stonecutters,* 48.

6. Adams, *The Emptiness of the Image,* 32.

7. Wolfgang Drost, "Colour, Sculpture, Mimesis: A Nineteenth-Century Debate,"

in *The Colour of Sculpture: 1840–1910,* ed. Andreas Blühm (Amsterdam: Van Gogh Museum, 1996), 62.

8. I have found no references to imply or confirm that artists used wash, pigment, or chemicals to bleach the marble a more "pure" white color.

9. Batchelor, *Chromophobia,* 17

10. Anne Brewster, "American Artists in Rome," *Lippincott's Magazine of Literature, Science, and Education* 3 (February 1869): 197.

11. The American sculptor Joseph Mozier was also known to dabble in polychromy. In at least one version of his *Wept of Wish-ton-Wish* (1859) he adopted the controversial practice, presumably to emphasize the blond hair and blue eyes of the female subject described in James Fenimore Cooper's book of the same name, published in 1829. Kasson, *Marble Queens and Captives,* 97.

12. "Notabilia of the International Exhibition," *Art Journal* (July 1862): 161.

13. T. Q., *A Wall-Street Bear,* 57, 98.

14. Hawthorne, *Collected Novels,* 955.

15. Drost, "Colour, Sculpture, Mimesis," 63–64.

16. Batchelor, *Chromophobia,* 17.

17. Cole quoted in L. L. Noble, *The Course of Empire* (1853); cited in Gardner, *Yankee Stonecutters,* 15.

18. Jarves distinguished between "high" art and "common" art, the former being products of genius, which included works of the spirit that appealed to the soul, and the latter, "faithful representations of natural objects," which were a product of "industry and clever imitation." James Jackson Jarves, *Art-Hints, Architecture, Sculpture and Painting* (London: Sampson Low, Son, and Co., 1855), 66, 155–56.

19. Batchelor, *Chromophobia,* 22–23.

20. Curatorial File, Charles-Henri-Joseph Cordier, Musée d'Orsay, Paris.

21. See Charmaine Nelson, "Vénus Africaine: Race, Beauty and African-ness," in *Black Victorians: Black People in British Art, 1800–1900,* ed. Jan Marsh (London: Ashgate, 2005), 46–56.

22. For example, some titles of Cordier's sculptures include *Vénus africaine* or *Négresse des Côtes d'Afrique* (1851), bronze, 82 cm in height; *Nègre du Darfour* or *Nègre de Tombouctou* (1853), bronze, 83 cm in height; *Noir du Soudan* (1856), bronze; *Homme arabe de Biskra* (1856), bronze, 56 cm in height; *Femme mauresque noire* (1856), bronze, 74 cm in height; *Mulatresse,* marble, 71 cm in height. All of these sculptures are in the collection of the Musée de l'homme, Paris.

23. Hawthorne, *Passages from the French and Italian Note-Books,* 1:188. Hawthorne was referring to his opinions of the American sculptor Joseph Mozier, whose most famous works were *Pocohantas* (1859) and *The Wept of Wish-ton-Wish* (1859).

24. Hawthorne, *Passages from the French and Italian Note-Books,* 1:371.

25. T. Q., *A Wall-Street Bear,* 58.

26. Paul Mantz, "Exposition de Londres," *Gazette des beaux-arts,* October 1862, 374; cited in Drost, "Colour, Sculpture, Mimesis," 66.

27. Drost, "Colour, Sculpture, Mimesis," 64.

28. Jarves, *Art-Hints, Architecture, Sculpture and Painting,* 165.

29. Edward E. Hale, *Ninety Days' Worth of Europe* (Boston: Walker, Wise, and Company, 1861), 149.

30. Ibid., 150.

31. T. Q., *A Wall-Street Bear,* 82.

32. Grace Greenwood, *Haps and Mishaps of a Tour in Europe* (London: Richard Bentley, New Burlington Street, 1854), 250–51.

33. S. Eliot, "Thomas Crawford," *American Quarterly Church Review and Ecclesiastical Register* 11 (April 1858); cited in Gardner, *Yankee Stonecutters,* 47.

34. William H. Gerdts, "Marble and Nudity," *Art in America* 49, no. 3 (May–June 1971): 60.

35. Clara Cushman, *Neal's Saturday Gazette;* cited in Kasson, *Marble Queens and Captives,* 59, and mentioned in Horace Binney Wallace, Esquire, *Art and Scenery in Europe with Other Papers: Being Chiefly Fragments from the Portfolio of the Late Horace Binney Wallace, Esquire of Philadelphia* (Philadelphia: Parry and McMillan, 1857), 202.

36. Gerdts, "Marble and Nudity," 61–62.

37. Ibid., 62.

38. Jarves, *Art-Hints, Architecture, Sculpture and Painting,* 152.

39. T. Q., *A Wall-Street Bear,* 79.

40. Hawthorne, *Passages from the French and Italian Note-Books,* 1:217.

41. Hawthorne, *Collected Novels,* 955.

42. Gerdts, *American Neo-classic Sculpture,* 20.

43. Jarves, *Art-Hints, Architecture, Sculpture and Painting,* 160.

44. Kasson, *Marble Queens and Captives,* 206–7.

4. White Slaves and Black Masters

1. Letter, Hiram Powers to John P. Richardson, 10 July 1854, HPP–AAA. In a letter to his cousin, Powers indicated that he had sold a copy of the *Greek Slave* for four thousand dollars. He also mentions having works in studio valued at seven thousand dollars, independent of his *America,* which he estimated at ten thousand.

2. T. Q., *A Wall-Street Bear,* 98.

3. The status of Power's *Greek Slave* even allowed for favorable comparisons with the antique. Earlier in his journal, Young recorded his comparison between Powers and the antique "masterpiece" *Venus de Medici.* T. Q., *A Wall-Street Bear,* 57, 98.

4. Anna Lewis, "Art and Artists of America: Hiram Powers," *Graham's Magazine* 48, November 1855, 398; Samuel A. Roberson and William H. Gerdts, "'So Undressed, yet So Refined': The Greek Slave," *Museum: New Series* 17, nos. 1–2 (Winter-Spring 1965): 27.

5. Wallace, *Art and Scenery in Europe with Other Papers,* 203.

6. James, *William Wetmore Story,* 1:114–15.

7. Linda Hyman, "The Greek Slave by Hiram Powers: High Art as Popular Culture," *Art Journal* 35, no. 3 (Spring 1976): 216.

8. This exhibition program also served to cement Powers's financial fortune, for a total of $23,500 was raised. The painter Miner K. Kellogg, who had acted as Powers's agent, was paid the fee of $5,675, and the rest, after costs, went to the sculptor. Roberson and Gerdts, "Greek Slave," 16, 20; Hyman, "The Greek Slave by Hiram Powers," 217.

9. Savage, *Standing Soldiers, Kneeling Slaves,* 222.

10. Roberson and Gerdts, "Greek Slave," 16.

11. According to Gerdts, Powers produced at least seventy-seven busts, not including ceramic copies. Gerdts, "Marble and Nudity," 62.

12. Regarding the first version, see C. E. Lester, *The Artist, the Merchant and the Statesman of the Medici, and of Our Own Times,* 2 vols. (New York: Paine and Burgess, 1845), 1:84–85. Regarding all versions, see Roberson and Gerdts, "Greek Slave," 3–23.

13. This fourth version was originally intended for Lord Ward (later the Earl of Dudley) but is now lost. This draped version may be partly represented in a portrait of Powers completed by Alonzo Chappel. Roberson and Gerdts, "Greek Slave," 2, 23.

14. Powers's training in wax, a material known for its ability to represent the textural and plastic qualities of skin, may explain his facility in manipulating marble and his reputation for achieving lifelike effects of flesh in stone. Powers was renowned among his fellow artists for his mechanical inventions, which simplified physical labor, accelerated complex material practices, and refined the finish of the marble, particularly in achieving the effect of skin. Powers discussed creating an apparatus that allowed him to move his advanced model of *Eve* to his new studio and creating files that allowed him to achieve a superior finish to the marble, which represented the textural effects of human skin. Lester, *The Artist, the Merchant and the Statesman*, 1:56–57.

After contemplating passage to Europe on a government-sponsored public vessel, Powers returned to Cincinnati, where he attempted to secure finances for Europe by soliciting portrait commissions for which he would be paid half the fee in advance. Although this plan failed, Powers was eventually fully sponsored to Italy in 1835 by the wealthy patron Nicholas Longworth and settled in Florence by 1837. Lester, *The Artist, the Merchant and the Statesman*, 1:60–62; Hyman, "The Greek Slave by Hiram Powers," 216.

15. Lester, *The Artist, the Merchant and the Statesman*, 1:85.

16. Sánchez-Eppler, "Bodily Bonds," 36.

17. Harriet Beecher Stowe, *Uncle Tom's Cabin* (1852; rpt., New York: Library of America, 1982), 10; cited in Sánchez-Eppler, "Bodily Bonds," 35.

18. Letter, Hiram Powers to Edwin W. Stoughton, 29 November 1869, HPP–AAA and HPS–NYPL; cited in Roberson and Gerdts, "Greek Slave," 4.

19. Vivien Green's article provides an extensive list of the American literature that was deployed in support of the Greeks during the war. Vivien M. Green, "Hiram Powers's *Greek Slave:* Emblem of Freedom," *American Art Journal* 14, no. 4 (Autumn 1982): 34–35.

20. Letter, Hiram Powers to Col. John Preston, 7 January 1841; cited in Kasson, *Marble Queens and Captives,* 50.

21. Letter, Hiram Powers to Col. John Preston, 7 January 1841; cited ibid., 50.

22. Savage, *Standing Soldiers, Kneeling Slaves,* 30.

23. W. H. Coyle, "Powers' Greek Slave," *Detroit Advertiser;* cited in Roberson and Gerdts, "Greek Slave," 18; and in Kasson, *Marble Queens and Captives,* 65.

24. Kasson, *Marble Queens and Captives,* 52–56.

25. A copy of Miner's *Circassian* was purchased by the collector James Robb, who also acquired a copy of Powers's *Greek Slave.* James L. Yarnall and William H. Gerdts, *National Museum of American Arts Index,* vol. 3 (Boston: G. K. Hall, 1992–94); cited in Kasson, *Marble Queens and Captives,* 57, 254. Miner K. Kellogg, *The Greek Girl,* oil, 61.0 × 50.8 cm, Maryland Historical Society, Baltimore.

26. Kasson, *Marble Queens and Captives,* 53–54; and Donald A. Rosenthal, *Orientalism: The Near East in French Painting 1800–1880* (Rochester, N.Y.: Memorial Gallery of the University of Rochester), 107–8.

27. This print is in the collection of the British Museum, London.

28. Edward Everett, "Affairs of Greece," *North American Review* 17 (October 1823): 417.

29. Lester, *The Artist, the Merchant and the Statesman,* 1:88.

30. *New York Express,* n.d., HPS.

31. Lewis, "Art and Artists of America," 398; cited in Hyman, "The Greek Slave by Hiram Powers," 221.

32. Fryd, *Art and Empire,* 188.

33. Savage, *Standing Soldiers, Kneeling Slaves,* 23.

34. While this relief-sculpture cameo was used in Britain, American abolitionists

reproduced the same image, which could be used in public spheres (pamphlets, posters, etc.) and domestic (household materials such as books, broadsides, and pincushions). Savage, *Standing Soldiers, Kneeling Slaves,* 23.

35. Ibid., 63.

36. Savage has noted that the symbolic use of chains was so overwhelmingly associated with abolitionism that slavery advocates suppressed the use of chains in their own propaganda. Ibid., 23, 26. See also Jean Fagan Yellin, "Caps and Chains: Hiram Powers' Statue of Liberty," *American Quarterly* 38 (Winter 1986): 798–826; and Vivien Green Fryd, "Hiram Powers's *America:* 'Triumphant as Liberty and in Unity,'" *American Art Journal* 18, no. 2 (1986): 54–75. On the rejection of Powers's *America,* see Fryd, *Art and Empire,* 206–7.

37. Letter, Hiram Powers to Dr. Playfair, 9 December 1848; cited in Yellin, "Caps and Chains," 801.

38. "'To Powers, the Sculptor,' Friends of Freedom," *The Liberty Bell* (Boston, 1852), 250–51; cited in Yellin, "Caps and Chains," 815.

39. The liberty cap, or *pileus libertatis,* was another symbol deployed in abolitionist visual discourse. The American Anti-slavery Society's emblem is reproduced in Yellin "Caps and Chains," 811.

40. Cesare Ripa, *Baroque and Rococo Pictorial Imagery,* ed. Edward A. Maser (New York: Dover Publications, 1971).

41. The emancipation of slaves in Great Britain and its colonies was approved by Parliament in 1833, given royal assent in 1834, and made effective beginning in 1838.

42. Fryd, *Art and Empire,* 186.

43. The transgressive potential of the allegory of Liberty and specifically the symbolic importance of the Liberty cap within the context of American slavery were registered in the representation of Thomas Crawford's *Justice and Liberty,* intended for placement above the doorway of the east facade of the U.S. Capitol. After Jefferson Davis, secretary of war and a slaveholder who advocated the extension of slavery into America's new territories, rejected the pileus of Crawford's Liberty as a potentially volatile symbol of antislavery sentiment, Crawford eventually changed his subject to *Justice and History* (1855–63) to appease Davis and other Southern politicians by avoiding overt associations with the disenfranchised status of black slaves. Similarly, under the authority of Davis and Montgomery Meigs, Philadelphia architect Thomas U. Walter's design for a statue of Liberty for the dome of the U.S. Capitol (again, designed with pole and pileus) was eventually replaced by a representation of Freedom by Crawford, originally intended as an allegorical hybrid of Peace and Victory. In a letter of 1856, Davis had specifically rejected the inclusion of the pileus on Freedom's head, since he believed "her conflict [was] over, her cause triumphant." For Davis and other slavery advocates, the enslavement of black people was not an injustice for which the symbolism of Liberty should be deployed. Rather, within the colonial logic of nineteenth-century American political discourse, blacks were neither human nor citizens and thereby unworthy of the liberty and freedoms accorded white male citizens. Although the sculpture was stripped of Liberty's symbols, Crawford referred to it as "armed Liberty," a hybrid of Liberty, Minerva, and America, and replaced her pileus with a rather elaborate and exoticized helmet encircled by stars and topped by feathers (a reference to Native culture). Inevitably, Davis was unable to subvert the original abolitionist potential of the sculpture, since *Freedom,* ceremonially installed in 1863 after Crawford's death, coincided with the Emancipation Proclamation and the Battle of Gettysburg. Letter, Jefferson Davis to Montgomery Meigs, 15 January 1856, ML; cited in Fryd, *Art and Empire,* 179–80, 183–86, 188, 193, 195.

44. Fryd, *Art and Empire,* 186, 188.

45. Letter, Hiram Powers to Mr. Aspinwall, 7 April 1866, HPP–AAA. In this letter Powers describes Everett as his noble, late friend who had done his best to secure a place at the Capitol for the sculpture.

46. Letter, Edward Everett to Hiram Powers, 22 January 1849, HPP–AAA.

47. Yellin, "Caps and Chains," 804, 809, 813. This shift from manacles to chains predates the reverse shift that occurred in Powers's *Greek Slave,* which I will discuss below. Powers stayed with the idea of a scepter as the symbol of despotism throughout 1852–53 when the sculpture was almost blocked out. It was not until 1855 that Powers wrote Everett to confirm the completion of the sculpture and the choice of chains underfoot. Letter, Hiram Powers to Edward Everett, 5 June 1855, HPP–AAA.

48. Letter, Hiram Powers to Nicholas Longworth, 10 June 1853; cited in Yellin, "Caps and Chains," 814. Significantly, Powers never openly professed the abolitionist potential of his symbolism until after emancipation, when he recognized the simultaneous interpretations of the chains as the despotism of British rule and chattel slavery. See the letter from Hiram Powers to Brooks, 8 March 1865; cited in Yellin, "Caps and Chains," 824.

49. Fryd, *Art and Empire,* 206–7.

50. Letter, Hiram Powers to Maxwell, 10 November 1849; letter, Hiram Powers to Calvert, 22 June 1851; both cited in part in Yellin, "Caps and Chains," 809, 813.

51. Yellin has noted that although Powers had forwarded daguerreotypes of his sculpture in 1850–51, he revealed in a letter to Everett that he had not placed any emblem under her foot. Powers had finished the sculpture by 1850, but the nonspecific wording of the legislation that had approved twenty-five thousand dollars for the purchase of "some work of art" allowed President Franklin Pierce to delay the official purchase of the sculpture. Letter, Hiram Powers to Edward Everett, 1 January 1851; letter, Hiram Powers to Atlee, 10 February 1856; both cited in Yellin, "Caps and Chains," 813, 815.

52. Letter, Hiram Powers to Brooks, 20 July 1854; cited in Yellin, "Caps and Chains," 815–16. Part of Powers's "popular" deployment of iconography was his descriptions of gesticulating black slaves and explicit details of the methods and tools of punishment used in American slavery. The overt nature of Powers's allegories recalled the representations of the popular press that operated within different aesthetic and representational limits from the "high" art practices of neoclassical sculpture.

53. Letter, Hiram Powers to John P. Richardson, 10 July 1854, HPP–AAA.

54. Ibid. Interestingly, Powers distinguished between taking advantage of an established evil and fully participating in it by stating of his purchase, "but not for evil." He indicated that he felt land to be a stable investment and that he could spend as much as $1,000 and expected the land to be about $1.50 per acre.

55. Letter, Hiram Powers to Brooks, 31 December 1859; cited in Yellin, "Caps and Chains," 819.

56. Letter, Edward Everett to Hiram Powers, 30 July 1855; cited ibid., 826.

57. Letter, Hiram Powers to Mr. Aspinwall, 7 April 1866, HPP–AAA.

58. Elizabeth Barrett Browning, *76 Poetic Works* (London: Henry Frowde, 1906), 337; cited in Roberson and Gerdts, "Greek Slave," 15.

59. *Eastport Sentinel,* 23 August 1848, HPS; cited in Green, "Hiram Powers's *Greek Slave,*" 38.

60. *Washington National Era,* September 1847, HPS–NYPL; cited in Hyman "The Greek Slave by Hiram Powers," 222.

61. Freeman Henry Morris Murray, *Emancipation and the Freed in American Sculpture* (Washington, D.C.: self-published, 1913), 1–3; cited in Roberson and Gerdts, "Greek Slave," 8–9.

62. It would appear that this statement could potentially refer to two families. Both the Hamptons and the Prestons, especially John Preston, were major patrons of Hiram Powers, who had resided in South Carolina. The Prestons owned *Eve Tempted,* the *Greek Slave, Ginevra,* and *Proserpine* and also commissioned several portrait busts, a marble mantel, and a fountain for their Blanding Street residence. David Moltke-Hanson, *Art in the Lives of South Carolinians: Nineteenth-Century Chapters* (Charleston, S.C.: Carolina Art Association, 1979), RSa7, Rsb5–7.

63. South Carolina was the center of proslavery activism in the mid-nineteenth century, and its population recorded a majority of 57 percent slaves in 1860. Savage, *Standing Soldiers, Kneeling Slaves,* 42.

64. In particular, the 1837–38 speeches of South Carolina senator John C. Calhoun were instrumental in forwarding this "positive good" thesis. Ibid., 27.

65. *New York Saturday Emporium,* 8 September 1847, HPS–NYPL; cited in Hyman, "The Greek Slave by Hiram Powers," 222.

66. *Yankee Doodle,* 28 August 1847, HPS–NYPL; cited in Hyman, "The Greek Slave by Hiram Powers," 222.

67. I have already noted Hawthorne's infamous reaction to *Eve,* which culminated in a complete rejection of nudity in sculpture representing "modern" subjects. See Hawthorne, *Passages from the French and Italian Note-Books,* 1:217. Similarly, Horatio Greenough's earlier *Chanting Cherubs* (1831) had been the site of much abuse because of the nudity of the two babes, which were often shielded by aprons during public exhibition in America. Greenough's bare-chested, partly draped *George Washington* (1832–41) also received much racialized criticism, which located the public's discomfort with white male nudity, however heroic, when it was not temporally distanced through a classical subject. See Savage, *Standing Soldiers, Kneeling Slaves,* 58. For a concise history of American audiences' confrontations with and criticisms of the nude in art, see Kasson, *Marble Queens and Captives,* 49–50, and Gerdts, "Marble and Nudity."

68. Sánchez-Eppler, "Bodily Bonds," 49. The dichotomization of the body and the soul offered a symbolic or spiritual escape from bondage, since the soul could not be owned or purchased, and ultimately, through death, the soul was liberated from the physical enslavement of the body. Christian morality offered the promise of ultimate liberation through death. As with the popularity of the theme of suicide for Cleopatra, the female subject's "liberation" and the preservation of her chastity or dignity come at a very high price.

69. Lester, *The Artist, the Merchant and the Statesman,* 87–88.

70. Morrison, "The Site of Memory," 299–305.

71. Henry Tuckerman, "The Greek Slave," *New York Tribune,* 9 September 1847; cited in Roberson and Gerdts, "Greek Slave," 19; and in Kasson, *Marble Queens and Captives,* 62.

72. *Christian Inquirer* 1, 9 October 1847, 207, HPS–NYPL; cited in Green, "Hiram Powers's *Greek Slave,*" 38; and cited in part in Savage, *Standing Soldiers, Kneeling Slaves,* 28.

73. Sánchez-Eppler, "Bodily Bonds," 43.

74. Ibid., 28. Lydia Maria Child explored this question in her *Anti-slavery Catechism* (1836), which examined the conflation of the female slave body with the body of the wife. In the text, Child tells the story of a white male physician who is startled by the revelation that his young Southern bride is black when her father–master calls to claim his daughter–property. The female becomes the object of a financial transaction when her husband is forced to pay for her freedom. Child addressed both abolitionist and feminist concerns by conflating the body of the wife and the slave. She also confronted the colonial logic of racial specificity and visibility by offering a white slave whose own husband,

a physician with intimate knowledge of her body and human anatomy generally, had been unable to discern her black ancestry.

75. Sánchez-Eppler, "Bodily Bonds," 29.

76. Customarily within the practices of transatlantic slavery, any child born to a black female slave was deemed to be a slave also. Significantly then, the *Christian Inquirer's* emphasis on the paternal lineage of the female slaves, "daughters of white men," served to locate the status of interracial children within colonial legal discourses. The existence of white fathers of black slaves named the entrenched practices of sexual violation that saw black women raped by white men for the purpose of the economic expansion of property: the conception of new slave bodies/commodities. But the author's refusal to name the other sexual possibility of interracial children—white mothers and black fathers—also spoke volumes about the absolute denial of the possibility of sexual attraction and contact between these two subjects, a denial supported by the stereotypes of the chaste and virginal white female and the animalized, lascivious, black male rapist. This stereotype, which was used to justify the practice of lynching, mirrors the racial stereotypes deployed against Turkish men to narrate Powers's *Greek Slave.*

77. Regarding the exhibition, see Kasson, *Marble Queens and Captives,* 74. For this interpretation of the sculpture, see Kathryn Zabelle Derounian-Stodola, ed., *Women's Indian Captivity Narratives* (New York: Penguin Books, 1998), xvi. Although historical records suggest that the rape of white female captives was rare because of the specificities of Native cultural practices (such as incest taboos against adopted tribes people and warrior abstinence), white authors of Indian captivity narratives and white artists repeatedly fostered the idea of white woman's sexual violation as the paramount threat of contact between races.

78. Kasson, *Marble Queens and Captives,* 79.

79. Letter, Erastus Dow Palmer to John Durand, 11 January 1858; cited in J. Carson Webster, *Erastus D. Palmer* (Newark: University of Delaware Press, 1983), 278; and in Kasson, *Marble Queens and Captives,* 74.

80. Henry Tuckerman, "Palmer's Statue, the White Captive," *New York Post,* November 1859; cited in Webster, *Erastus D. Palmer,* 29; and in Kasson, *Marble Queens and Captives,* 80.

81. Longfellow's *The Song of Hiawatha* sold thirty thousand copies within the first few months of publication and remained popular with readers years after in other editions. This popularity is confirmed in Lewis's sculptures, which date from over ten years after the original publication. Edmonia Lewis became a major interpreter of Longfellow's poem, completing group sculptures entitled *Old Indian Arrow Maker and His Daughter* (1866), *The Wooing of Hiawatha* (1866), and *The Marriage of Hiawatha* (1871). She also completed ideal busts titled *Hiawatha* (1868) and *Minnehaha* (1868) as well as the portrait bust *Henry Wadsworth Longfellow* (1871). Holland, "Mary Edmonia Lewis's *Minnehaha,*" 32, 35.

82. Derounian-Stodola, ed., *Women's Indian Captivity Narratives,* xi–xiv. This genre, particular to North America, broadly referring to non-Natives captured by Natives, was dominated by white women in the roles of "captive," storyteller, author, and reader. Within this genre there is wide variation, from authentic texts based on real experiences to full-blown fictional narratives. But in all cases such writings were subject to racialized narrative strategies. No such equivalent genre developed to document the experiences of whites as captors or enslavers of Natives, particularly prior to the prolific and lucrative enslavement of blacks.

83. For an excellent summary of the Native subject within nineteenth-century neoclassical sculpture, see William H. Gerdts, "The Marble Savage," *Art in America* (July–August 1974): 64–70.

84. As Joy Kasson has pointed out, because there is no historical evidence to suggest that anyone in the colony survived, an adult Virginia Dare is mainly the stuff of legends. Kasson, *Marble Queens and Captives,* 85.

85. Interestingly, the significance of Lander's choice to represent Virginia Dare as isolated in the sculpture was likely her own isolation from the Roman colony from which she was in exile during the time of production, an exile based on allegations of sexual impropriety, as was detailed in chapter 1.

86. Representations of fully unclothed bodies are not always as titillating or pornographic as representations of partly clothed bodies, quite the opposite. A case in point is the practice of the strip tease with the calculated reveal of the body through the removal of clothing. The feminist revisiting of the art historical categories of the nude and the naked point up some of the representational strategies that unbind any attempts at a simplistic oppositional relationship between the two terms. Idealized or classicized bodies, which are allegorically removed from the temporal space of the viewer and have historically been read as less sexually transgressive, have been termed nudes, while the portrait-like specificity of a face, the lack of allegory, and the deployment of temporally specific clothing often disrupt the idealization of the nude body and point out the biologically and socially transgressive body, the naked. See Marcia Pointon, "Guess Who's Coming to Lunch," *Naked Authority: The Body in Western Painting 1830–1908* (Cambridge: Cambridge University Press, 1990); Lynda Nead, *The Female Nude: Art, Obscenity and Sexuality* (London: Routledge, 1991); and Charmaine Nelson, "'Colored Nude': Fetishization, Disguise, Dichotomy," MA thesis, Concordia University, Montreal, 1995.

87. Lester, *The Artist, the Merchant and the Statesman,* 1:86.

88. Letter, E. D. Palmer to John Durand, 11 January 1858; cited in Webster, *Erastus D. Palmer,* 278; and in Kasson, *Marble Queens and Captives,* 91.

89. Kasson, *Marble Queens and Captives,* 78.

90. This quote was taken from a review that appeared in the *Atlantic Monthly* and was later reproduced as a pamphlet that was distributed to viewers of the *White Captive* in New York. *Palmer's Statue: The White Captive, on Exhibition at Schaus' Gallery, 629 Broadway* (n.d., n.p.); cited in Kasson, *Marble Queens and Captives,* 78–79.

91. *Century,* 19 November 1859, 382; cited in Webster, *Erastus D. Palmer,* 66; and in Kasson, *Marble Queens and Captives,* 83.

92. *Musical World,* 19 November 1859, 4; cited in Webster, *Erastus D. Palmer,* 66; and in Kasson, *Marble Queens and Captives,* 84.

93. *New York Times,* 30 December 1859, 2; cited in Kasson, *Marble Queens and Captives,* 84.

94. Kasson, *Marble Queens and Captives,* 88.

95. Letter, Hiram Powers to Edwin W. Stoughton, 29 November 1869, HPP–AAA; cited in Roberson and Gerdts, "Greek Slave," 25.

96. Letter, Hiram Powers to Edwin W. Stoughton, 29 November 1869, HPP–AAA; cited in Roberson and Gerdts, "Greek Slave," 23.

97. Green, "Hiram Powers's *Greek Slave,*" 32. Vivien M. Green has noted that such criticism was expressed in the *Western Christian Advocate,* 29 November 1848.

98. Norman R. Yetman, ed., *Life under the "Peculiar Institution": Selections from the Slave Narrative Collection* (Huntington, N.Y.: Robert E. Krieger Publishing Company, 1976), 18–19.

99. Ibid., 145.

100. Ibid., 124.

101. Ibid., 12.

102. J. G. Stedman, *Narrative of a Five Years' Expedition, against the Revolted Negroes of Surinam in, Guiana, on the Wild Coast of South America; from the year 1772, to 1777: Elucidating the History of that Country, and the Description of its productions, viz. Quadrupedes, Birds, Fishes, Reptiles, Trees, Shrubs, Fruits and Roots; with an Account of the Indians of Guiana, and Negroes of Guinea,* 2 vols. (London: J. Johnson, St. Pauls Church Yard and J. Edwards, Pall Mall, 1796), 2:306–7. Stedman informs us that the slave was not dead after the horrific beating, and his request for tobacco was greeted with kicks and spitting from spectators.

103. The "whip" could take the form of a specially designed piece of leather, a piece of wood, a strap, or some other material able to break the skin and harm the body. Yetman, *Life under the "Peculiar Institution,"* 59.

104. Stedman, *Narrative of a Five Years' Expedition,* 1:325–26.

105. Yetman, *Life under the "Peculiar Institution,"* 11.

106. Ibid., 62.

107. Ibid., 122.

108. Ibid., 145.

109. Ibid., 133.

110. Ibid., 142.

111. Stedman, *Narrative of a Five Years' Expedition,* 1:15.

112. Letter, Miss Clara L. Dentler to Mr. Graham Hood, associate curator, Yale University, 1 August 1967, 2, Curatorial Files, Hiram Powers, Yale University Art Gallery. Dentler stated that part of the material difficulty with the chains was that the miscarving of any one link resulted in the ruin of the entire chain.

113. Reverend Orville Dewey, "Powers' Statues," *Union Magazine of Literature and Art* (n.d.): 160–61; cited in Kasson, *Marble Queens and Captives,* 58.

5. The Color of Slavery

1. For more on the concept of negrophilia, see Petrine Archer-Straw, *Negrophilia: Avant-Garde Paris and Black Culture in the 1920's* (New York: Thames and Hudson, 2000).

2. Louis Agassiz, "The Diversity of Origin of the Human Races," *Christian Examiner* 49 (1850), 110–45, quotation on 143–44; cited in Stephen Jay Gould, *The Mismeasure of Man* (New York: W. W. Norton, 1996), 79.

3. "Egyptian Antiquities," *Illustrated Magazine of Art* 4, no. 24 (1854): 355.

4. Johannes Fabian, *Time and the Other: How Anthropology Makes Its Object* (New York: Columbia University Press, 1983), 106.

5. The engraving with *Apollo* is reproduced in J. C. Nott and George Gliddon, *Types of Mankind* (Philadelphia: Lippincott, 1854), 458; also reproduced in Gould, *Mismeasure of Man,* 65, and Savage, *Standing Soldiers, Kneeling Slaves,* 10. The head of Zeus is reproduced in the sculpture of that name in Honour, *Image of the Black in Western Art,* vol. 4, pt. 2, 15.

6. Savage, *Standing Soldiers, Kneeling Slaves,* 9.

7. See Gould, *Mismeasure of Man,* 72.

8. Kobena Mercer, "Black Hair/Style Politics," in *Out There,* ed. Ferguson, Gever, Minh-ha, and West, 249.

9. See chapter 3, "'So Pure and Celestial a Light': Sculpture, Marble, and Whiteness as a Privileged Racial Signifier."

10. Deborah Gray White traces this shift to 1807, when the American Congress outlawed the overseas slave trade. See Deborah Gray White, *Ar'n't I a Woman? Female Slaves in the Plantation South* (New York: W. W. Norton, 1999), 68.

11. The twenty-five-year-old "Hottentot" Saartje (Saat-Jee, Sarah) Baartman was publicly exhibited as the "Hottentot Venus" in Europe over the course of five years from 1810 to 1815. Her body was desirable because of her racial difference, which was registered primarily in her sexual organs and buttocks. As such she came to stand for the visual performance of black sexuality. In 1829 another "Hottentot Venus" appeared, this time as the spectacle at the ball of the Duchess du Barry in Paris. See T. Denean Sharpley-Whiting, *Black Venus: Sexualized Savages, Primal Fears, and Primitive Narratives in French* (Durham, N.C.: Duke University Press, 1999), and the forthcoming anthology Deborah Willis and Carla Williams, eds., *They Called Her Hottentot: The Art, Science, and Fiction of Sarah Baartman* (Philadelphia: Temple University Press Academic, forthcoming).

12. Sander L. Gilman, *Difference and Pathology: Stereotypes of Sexuality, Race, and Madness* (Ithaca, N.Y.: Cornell University Press, 1985), 89.

13. Pollock, "Fetishism, the Labouring Body and the Colour of Sex," 356.

14. Ann Laura Stoler, *Race and the Education of Desire: Foucault's "History of Sexuality" and the Colonial Order of Things* (Durham, N.C.: Duke University Press, 1995), 5.

15. Pollock, "Fetishism, the Labouring Body and the Colour of Sex," 356. Griselda Pollock has demonstrated that the bourgeois racialization of the laboring bodies of female miners was dependent on a fictive deviant body whose overcharged parts carried signs of dirt and physical labor (blackened faces, grimy arms, calloused hands) and were inappropriately exposed to public scrutiny (bare calves, feet). The deviance of the laboring body was witnessed in its difference from normative ideals of gender and sex, which were best represented in the ideal feminine body of the idle, elaborately dressed, physically inaccessible, and highly immobile bourgeois lady. "Rigidly encased in a costume which physically inhibits her movements and renders her the mannequin of a femininity she is required to perform in person and in daily ritual, the lady is excluded from labour and money, from mobility in the public realm, from locations of power" (358).

16. Gilman, *Difference and Pathology,* 95.

17. Pollock, "Fetishism, the Labouring Body and the Colour of Sex," 346.

18. Sánchez-Eppler, "Bodily Bonds," 40.

19. Vivien M. Green provides a concise list of some of the literary works that adopted the female octoroon as heroine. Green, "Hiram Powers's *Greek Slave*," 36.

20. Lydia Maria Child, "The Quadroons," *Fact and Fiction: A Collection of Stories* (New York: C. S. Francis and Co., and Boston: J. H. Francis, 1846), 61–76.

21. Letter fragment (salutation missing), George Fuller to ?, 26 January 1850, Papers of George Fuller, The Memorial Libraries, Deerfield, Massachusetts; cited in Sarah Burns, "Images of Slavery: George Fuller's Depictions of the Antebellum South," *American Art Journal* 15 (Summer 1983): 36. Fuller made three trips to the American South in the 1850s, documenting his journeys through letters and a sketchbook. Significantly Fuller was friends with the sculptors John Quincy Adams Ward and Henry Kirke Brown, who was also his mentor. Both sculptors and their own engagement with black subjects are discussed in detail below.

22. Frances Green, "The Slave–Wife," *Liberty Chimes* (Providence, R.I., 1845), 94; cited in Sánchez-Eppler, "Bodily Bonds," 45.

23. Wallace has noted that the average price of one of Rogers's sculptures was fourteen dollars. Unlike many of his contemporaries, who were eagerly flocking to Rome and Florence to pursue full-scale marbles, Rogers received his sculptural education in Paris. He was the cousin of the American female sculptor Louisa Lander of Salem, discussed in detail in chapter 1. Edmonia Lewis's experimentation with popular cultural sculptural objects parallel Rogers's own. While in Boston in 1863–64, Lewis sculpted medallions and

busts of John Brown, William Lloyd Garrison, Charles Sumner, and Wendell Phillips; all named for their subjects, these works held an undoubted appeal for the large antislavery community. David H. Wallace, *John Rogers: The People's Sculptor* (Middleton, Conn.: Wesleyan University Press, 1967), xiii, 65; Lynda Roscoe Hartigan, "Edmonia Lewis," *Sharing Traditions: Five Black Artists in Nineteenth-Century America* (Washington, D.C.: Smithsonian Institution Press, 1985), 88. The location of a *John Brown* medallion or the *Wendell Phillips* sculpture is not known.

24. Wallace, *John Rogers*, 200. Wallace has suggested that, besides the obvious affinity of nineteenth-century American sculpture for themes that deployed black female subjects and the popularity of "tragic octoroon" narratives, Rogers drew inspiration specifically from Harriet Beecher Stowe's *Uncle Tom's Cabin* and Don Boucicault's popular play *The Octoroon*, which was contemporaneously showing in New York, where Rogers had his studio.

25. Ibid., 61, 200.

26. Among Rogers's abolitionist-minded works or works that represent black subjects are his *Slave Auction,* which depicts a black male slave and a black female slave clutching a baby to her cheek as another toddler hides in her skirts, in front of a podium at which a white male auctioneer prepares to "sell them apart"; *The Camp Fire: Making Friends with the Cook* (c. 1862), a Civil War narrative that depicts a black male cook serving a seated white male soldier; *The Wounded Scout/A Friend in the Swamp* (c. 1864), which depicts an escaped slave aiding a wounded soldier and was praised by President Abraham Lincoln and the abolitionists Rev. Henry Ward Beecher and Lydia Maria Childs; *Taking the Oath* (c. 1865), Rogers's most admired work, based on a story related to him by his wife's uncle, figuring a young black boy waiting for provisions for his mistress while a Southern lady with her child in her skirts reluctantly takes an oath of allegiance from a Union officer in order to draw rations; *Uncle Ned's School* (c. 1866), a commentary on the freed black's desire to educate himself, representing an older black male being tutored from a book by a young black female while a young black boy attempts to distract him; *The Fugitives' Story* (c. 1869), a tremendously popular work that represents a trio of prominent white male abolition leaders (poet John Greenleaf Whittier, editor William Lloyd Garrison, and the preacher Rev. Henry Ward Beecher) receiving a fugitive black female slave and her infant; and the *Freedman's Memorial* (c. 1873), an unselected design for a Washington, D.C., memorial competition, which may be the same as or a variant of the earlier design for a Philadelphia monument that incorporated Lincoln and a "crouching negro." See Wallace, *John Rogers,* 80, 96, 145, 182–83, 202, 211, 215, 216, 221–22, 234; and specifically regarding the *Freedman's Memorial,* see Savage, *Standing Soldiers, Kneeling Slaves,* 72.

27. Wallace, *John Rogers,* 200.

28. Sánchez-Eppler, "Bodily Bonds," 41.

29. Letter, John Rogers to (sister) Ellen Derby, 10 December 1861; cited in Wallace, *John Rogers,* 201. Besides an increased demand on his time sparked by orders for his *Picket Guard* (c. 1861–62), Rogers's reservations about *The Flight of the Octoroon* seem to be specifically about its scale and complexity. In the letter cited above he described being in a state of "nervous impatience" over his *Air Castles* (c. 1861), another incomplete large-scale piece, because of the length of time involved in the conception and completion of the sculpture. In the end he destroyed the maquette of his octoroon and declared his unsuitability to work in large scale.

30. W. R. Croffut, *The American Queen,* 18 January 1882; cited in Wallace, *John Rogers,* xiv. While it is obvious that Rogers intended to complete a large-scale version of the work, his reputation as a sculptor of the people—a man whose art was seen, as Croffut applauded, "Where other art seldom met / In the silent rustic places" of the middle-class homes of

"the grateful millions"—should make us aware that it is not presumptuous to assume that Rogers may have eventually also produced smaller, cheaper, more accessible plaster versions of the work.

31. Bell's *Octoroon* was also exhibited in Blackburn, England, in the Art and Industry Exhibition (1874) at the newly opened library and museum, where subsequently, at the urgings of a resident named Mr. Jessie Slater, it was acquired from the artist by public subscription for the reduced sum of 150 pounds as a result of defects in the marble. Curatorial Files, Blackburn Museum and Art Galleries, Blackburn, John Bell, *Octoroon*.

32. Such signs of "womanhood" were also read, within the context of slavery, as signs of female procreative capacity (breeding hips, lactating breasts) and female sexual readiness, discerned in the bodies of black female slaves scrutinized by the white audiences of potential enslavers, who desired physical evidence of the slave's potential to breed and therefore to expand the master's economic holdings.

33. From left to right, Justice, who is blindfolded, is also identifiable by her scales; Liberty, by the liberty cap she bares aloft on a pole; and Faith, by the Christian symbol of a cross. Although Justice has historically been represented with a blindfold to indicate fairness in the unimportance of the visual connection with the ones she serves, during the nineteenth century, the blindfold came to symbolize the malfunction, misapplication, and abuse of justice. The very presence of Liberty is also an ironic gesture, since the classical iconography of the liberty cap, or pileus, indicated the freedom of the slave. Manumission for the Romans was symbolized by the cap's concealment of the physical sign of the slave, the shaved head.

34. A plaster of the small-scale figure was included in the spring 1863 exhibition of the National Academy of Design and was later cast in bronze.

35. Green, "The Slave–Wife," 38.

36. Sánchez-Eppler, "Bodily Bonds," 38.

37. Payne, "Anne Whitney," 247; cited in Savage, *Standing Soldiers, Kneeling Slaves,* 59, 228. Whitney's *Africa* was exhibited at the National Academy of Design, in New York, and the Sailor's Fair in November 1864. Higginson, who had commanded the first black regiment during the Civil War, had written to Whitney after viewing the sculpture to encourage her to represent explicitly Negroid features for *Africa*.

38. Jan M. Seidler, "A Critical Reappraisal of the Career of William Wetmore Story (1818–1895), American Sculptor and Man of Letters," Ph.D. dissertation, Boston University, 1985, 502–22; cited in Savage, *Standing Soldiers, Kneeling Slaves,* 59.

39. Savage, *Standing Soldiers, Kneeling Slaves,* 76.

40. Ibid., 76.

41. Kirk Savage has clearly demonstrated the racial limitations of the visualization of emancipation in American commemorative sculpture, which became synonymous with the representation of Abraham Lincoln as a white male savior who had liberated the passive black slaves. Ibid., 65–84.

42. *The Virginian Slave: Intended as a Companion to Power's "Greek Slave," Punch, or the London Charivari* 20 (January–June 1851): 236.

43. The Latin expression *e pluribus unum,* meaning "from many, one," today appears on the Great Seal of the United States and on all coins. The expression was officially adopted on 20 June 1782 by a committee chosen on 4 July 1776 to prepare a device for the nation's seal. *Grolier Multimedia Encyclopedia* (Danbury, Conn.: Grolier Interactive, 1998).

44. As a colonial stereotype, the "Sambo" was used in the North American context to emasculate black men by deploying a representation of a "yes, ma'am" subject, a buffoonish character who willingly did the biddings of his white masters and did not contest his

inferior racial position. Stereotypical equivalents of the Sambo have been deployed in other geographical and national contexts. See Jan Pieterse, *White on Black: Images of Africa and Blacks in Western Popular Culture* (New Haven, Conn.: Yale University Press, 1992); and "Sambo to the 'Greek Slave,'" *Punch, or the London Charivari* 21 (July–December 1851): 105.

45. The *Greek Slave*'s retention of her identification resulted not only from the signification of her body but also from Powers's use of external symbols such as the cross and locket, mentioned above. Savage, *Standing Soldiers, Kneeling Slaves,* 30; Orlando Patterson, *Slavery and Social Death: A Comparative Study* (Cambridge, Mass.: Harvard University Press, 1982), 35–76.

46. Although I have argued that the material practices and aesthetic preferences of nineteenth-century neoclassicism erased the efficacy of skin color as a racial signifier on the material level, within the realm of imagination and fantasy, the viewers were able and were expected to facilitate and overcome this chromatic lack with their own knowledge of the subject and its narrative. Hence, Ginotti's obviously black female slave, though deployed in white marble, allows for the evocation of the black skin that could not be represented, the black skin that one viewer undoubtedly imagined when he wished this slave woman alive. This blackness that the audience was able to imagine takes on deeper aesthetic meanings when one can also imagine the dramatic juxtapositioning of the brown skin of the slave's breast to the likely white pearls of her upper left arm and colored beads of her necklace.

47. Costantino Abbatecola, *Guida e critica della grande esposizione nazionale di Belle Arti di Napoli del 1877* (Naples, 1877), 104; cited in Honour, *Image of the Black in Western Art,* vol. 4, pt. 2, 171.

48. Ibid., 171.

49. Savage, *Standing Soldiers, Kneeling Slaves,* 26–27.

50. McElroy, *Facing History,* xviii, xxv. I qualify *bourgeois* with quotation marks to indicate the artist's deliberate slippage of the black bodies, which only play at being bourgeois but, in the overdramatization and stiffness of their postures and gestures, indicate an essential discomfort with their newfound class positions. To my mind, this, and not the class position of the author David Dorr (discussed above), is a case for what Malini Johar Schueller has proposed as *whiteface,* the deliberate black parodying of whiteness and the inversion of the blackface visible in the popular minstrel shows of the nineteenth century. But unlike blackface, the outcome of whiteface does not reverse the butt of the joke; rather, the joke is still on the blacks. See Schueller, "Introduction," in Dorr, *A Colored Man,* xxi, xxxi.

51. Letter, Louis Agassiz to S. G. Howe, 9 August 1863; cited in Gould, *Mismeasure of Man,* 80.

52. Ibid., 81.

6. Racing the Body

1. James, *William Wetmore Story,* 1:19. Story's father was the Honorable Justice Story of the national Supreme Court, and his mother (as she has been defined by her male relatives' achievements) was the daughter of Judge Wetmore and the granddaughter of General Waldo, an English officer employed in the American colonies.

2. Hawthorne, *Passages from the French and Italian Note-Books,* 1:84. Hawthorne's comments were recorded in his journal after a visit to Story's studio in February 1858.

3. J. Falino, "William Wetmore Story," in *The Lure of Italy: American Artists and the Italian Experience, 1760–1914,* ed. Theodore Stebbins Jr. (Boston: Museum of Fine Arts, Boston, in association with Harry N. Abrams, Inc., Publishers, New York, 1992), 183.

4. Hawthorne, *Passages from the French and Italian Note-Books,* 1:84–85.

5. Ibid., 1:85.

6. James, *William Wetmore Story,* 1:32–33. Soon after, Story received an offer of three thousand pounds for the pair. The offer was reportedly made by Mr. Morrison, a wealthy Englishman. See Ilene Susan Fort and Michael Quick, *American Art: A Catalogue of the Los Angeles County Museum of Art Collection* (Los Angeles: Los Angeles County Museum of Art, 1991), 383.

7. Mary Hamer, *Signs of Cleopatra: History, Politics, Representation* (New York: Routledge, 1993), 64.

8. Two-figured compositions were rare within American neoclassical sculpture. One should not confuse two-figured sculpture with related but separate companion figures. See Gerdts, *American Neo-classic Sculpture,* 20, figs. 13, 14, 16, 35, 158, 159, 165.

9. In contrast to portrait commissions, which were often instigated by living subjects and intended as representations of intellect, wealth, culture, and affluence, ideal works generally allowed artists a greater deal of creativity and flexibility in the representation of their subject of choice, since they were frequently conceived outside the structure of a commission.

10. Fort and Quick, *American Art,* 383. An example of the first version is in the collection of the Los Angeles County Museum of Art (Los Angeles). Sometime during 1863 and 1864 four examples of the second version were produced in life size, one of which is in the collection of the Metropolitan Museum of Art (New York City).

11. William H. Gerdts, "Egyptian Motifs in Nineteenth-Century American Painting and Sculpture," *Antiques,* October 1966, 498.

12. Fort and Quick, *American Art,* 385.

13. Ibid., 385.

14. *International Exhibition 1862: Official Catalogue of the Fine Art Department* (London: Truscott, Son, and Simmons, 1862), 266. Story's *Cleopatra Seated* and *Sibilla Libica* were listed as items 2691 and 2692, respectively.

15. Letter, William Wetmore Story to Enrico Nencioni, n.d. (c. 1880), BC; cited in Kasson, *Marble Queens and Captives,* 215. *The Marble Faun,* Hawthorne's last complete novel, was derived largely from notes he and his wife, Sophia Amelia Hawthorne, had compiled during a seventeen-month visit to Florence and Rome in 1858–59. In the novel, Hawthorne's fictional sculptor Kenyon, based on William Wetmore Story, is responsible for the sculpture that is described at length and based on Hawthorne's visual assessment of Story's *Cleopatra.*

16. Hawthorne, *Letters, 1857–1864,* 230.

17. It is interesting to note that although Hawthorne's *Marble Faun* predated Lewis's arrival in Rome, his disavowal and objectification of the black female body are the signification of an absence that, in its refusal, registers the possibility of that which it cannot signify—a productive black female body. Any identificatory signification is invested in its own consolidation through the signification of an abject Other as the boundary of its "self."

18. Pollock, "Fetishism, the Labouring Body and the Colour of Sex," 357.

19. Ibid., 346.

20. Hawthorne, *Passages from the French and Italian Note-Books,* 1:85.

21. Ibid., 1:217.

22. Hawthorne, *The Marble Faun,* in *Collected Novels,* 957–58.

23. Henry Adams, *The Letters of Henry Adams: 1858–1868,* ed. J. C. Levenson, Ernest Samuels, Charles Vandersee, and Viola Hopkins Winner (Cambridge, Mass.: Belknap Press of Harvard University Press, 1982), 1:147.

24. "William W. Story and His Cleopatra," *Dwight's Journal of Music* 17, no. 18 (28 July 1860): n.p.

25. Ibid.

26. Hale, *Ninety Days' Worth of Europe,* 145–46.

27. Ibid., 147.

28. James Jackson Jarves, *The Art-Idea,* ed. Benjamin Rowland Jr. (1864; rpt., Cambridge, Mass.: Belknap Press of Harvard University Press, 1960), 224.

29. Hale, *Ninety Days' Worth of Europe,* 147.

30. "International Exhibition," *Athenaeum: Journal of English and Foreign Literature, Science, and the Fine Arts* 1802 (10 May 1862): 631.

31. Ibid., 631.

32. Lilian M. C. Randall, "An American Abroad: Visits to Sculptors' Studios in the 1860's," *Journal of the Walters Art Gallery* 33–34 (1970–71): 48.

33. James Jackson Jarves, *Art Thoughts: The Experiences and Observations of an American Amateur in Europe* (New York: Hurd and Houghton/Cambridge, Mass.: Riverside Press, 1870), 312.

34. Ibid., 312. Jarves's comments constituted a dramatic revisioning of his initial sympathetic commentary about Cleopatra's blackness in 1864. In the sixteen years that separated the two distinct opinions, America had experienced its Civil War, the Emancipation Proclamation, and Reconstruction. Jarves's reversal about Cleopatra's race may indicate a general anxiety about the racial strife in America and the dramatic shift in the status of the black body in American society.

35. "Art Notes," *New York Times,* 13 June 1882, C2, 2.

36. William W. Story, "Cleopatra," *Dwight's Journal of Music* 25, no. 13 (16 September 1865): n.p.

37. Story, "Cleopatra," n.p.

38. Frank M. Snowden Jr., *Before Color Prejudice: The Ancient View of Blacks* (Cambridge, Mass.: Harvard University Press, 1983), 1.

39. Ibid., 24.

40. Ibid., 29. Under Ptolemy Philadelphus (283–246 B.C.) a portion of Nubia was seized and exploited for its elephant population.

41. Ibid., 89–90.

42. James, *William Wetmore Story,* 2:75–76.

43. Ibid., 102–3.

44. *1998 Grolier Multimedia Encyclopedia* (Danbury, Conn.: Grolier Interactive Inc., 1998). Story and Lowell studied law together at Harvard, and both eventually left law to pursue more cultural interests. Lowell's marriage to the poet and abolitionist Maria White also likely informed his own abolitionist activity.

45. Charles Sumner began his political career as a member of the radical wing of the Whig Party known variously as the Anti-slavery Whigs, the Young Whigs, and the Conscience Whigs. In 1845, this contingent organized public meetings throughout Massachusetts to protest the admission of Texas to the Union as a slave state. Sumner became well connected within the Boston, national, and British abolitionist movements. His friends and acquaintances included antislavery, Native rights, and women's rights reformer, writer, and editor Lydia Maria Child; radical abolitionist, women's rights advocate, and labor reformer Wendell Phillips; and the founder of the influential abolitionist newspaper the *Liberator* and the American Anti-slavery Society, William Lloyd Garrison.

46. Andrew F. Rolle, "A Friendship across the Atlantic: Charles Sumner and William Story," *American Quarterly* 11 (Spring 1959): 40–41. Both Story and Sumner had studied

law at Harvard, and later Story had joined the Boston law firm of George S. Hillard and Charles Sumner, where he practiced for two years.

47. Edward L. Pierce, *Memoir and Letters of Charles Sumner, 1845–1860* (Boston: Roberts Brothers, 1893), 3:64–65; Rolle, "A Friendship across the Atlantic," 44.

48. Pierce, *Memoir and Letters of Charles Sumner,* 470.

49. Rolle, "A Friendship across the Atlantic," 46. Sumner's determination to resume his political seat led to his premature return to the Senate and a relapse in April 1858. During his initial voyage to France in 1857, prescribed by physicians, Sumner had not been able to complete the journey to Italy because of a physical relapse. It was only during the second European journey that Sumner and Story were reunited.

50. Pierce, *Memoir and Letters of Charles Sumner,* 69, 101. Sumner cited William Lloyd Garrison's the *Liberator* as the first newspaper to which he ever recalled subscribing. Sumner's speech, delivered at Faneuil Hall in 1845, was part of a program that aimed at gaining public support for the political denunciation of efforts to annex Texas and extend slavery into its territories.

51. Rolle, "A Friendship across the Atlantic," 53.

52. Letter, Charles Sumner to Story, 1 May 1863, Washington, D.C.; cited in James, *William Wetmore Story,* 2:157.

53. Letter, Charles Sumner to Story, 1 January 1864, Washington, D.C.; cited ibid., 159.

54. Letter, Charles Sumner to Story, 9 August 1864, Boston; cited ibid., 160.

55. Rolle, "A Friendship across the Atlantic," 53.

56. Story was to win neither commission. In the first case, Vinnie Ream, a white female sculptor associated with the Flock and based in Rome, was awarded the commission; and in the latter case, Augustus Saint-Gaudens won it.

7. The Black Queen in the White Body

1. The caption for Figure 38 shows 1876 as the year of this scupture's creation, because that is the year specified in the Smithsonian's credit information. Research, however, shows that Lewis sculpted *Death of Cleopatra* in 1875.

2. Nineteenth-century literary and theatrical sources of Cleopatra's blackness include: Henry William Herbert's "Anthony and Cleopatra," *Graham's Magazine* 41 (August 1852): 133–39; Victorien Sardou's play "Cléopâtre," *Théâtre complèt* (Paris: Éditions Albin Michel, 1935), 219; Delphine de Giradin's play, greatly successful in Paris in 1847; and William Wetmore Story's companion poem to *Cleopatra,* called "Marcus Antonius" (place of publication unknown), cited in Richardson, "Edmonia Lewis' 'The Death of Cleopatra,'" 43.

3. The similarities of the historical circumstances of Zenobia and Cleopatra invited comparison, because both were powerful "foreign" queens who challenged Roman authority and were eventually overthrown by Roman rulers. Zenobia ruled Palmyra, in Syria, for six years after the death of her husband in A.D. 267, but her power was eventually usurped by the emperor Aurelian. After being paraded in a triumph, Zenobia was spared and allowed to live out her life in a Roman villa. Kasson, *Marble Queens and Captives,* 152.

4. Payne, "Anne Whitney," 247. Whereas Whitney's whiteness would have guarded against the audience's desire to read her into the subject of a black woman, Lewis's obvious and much-quoted interracial identification would have presented an opportunity for her audience to read the deployment of black female subjects as autobiography.

5. The location of *Freedwoman* is unknown.

6. H. W., "Lady Artists in Rome," 177.

7. H. W. [Henry Wreford], "A Negro Sculptress," *Athenaeum* (3 March 1866): 302.

8. Letter, Lydia Maria Child to Sarah Shaw, 8 April 1866, SFC–NYPL.

9. "Edmonia Lewis," *Freedmen's Record,* January 1867, 3; cited in Buick, "The Ideal Works of Edmonia Lewis," 10, and in James A. Porter, "Versatile Interests of the Early Negro Artist," *Art in America* 24 (January 1936): 22, 27.

10. Evidence that Lewis experimented with the race of her Native subjects also exists. Kirsten Buick has noted that Lewis's representation of Longfellow's literary subject Minnehaha exhibited a similar racial shift evident in a profile examination of the Native female subject in *Minnehaha* (1868) and *Old Indian Arrowmaker and His Daughter* (1872). Like Lewis's free black women, this Native female's physiognomy became less obviously Native from her first to her later representation as the modeling of the nose was adapted, removing the "bump" to exhibit the "fine" outline so prized by white viewers as a sign of ideal beauty. Buick, "The Ideal Works of Edmonia Lewis," 11.

11. Frantz Fanon, *Back Skin, White Masks,* trans. Charles Lam Markmann (New York: Grove Press, 1967).

12. In a letter, Child related meeting Lewis, age twenty, at a Boston reception that appeared, from Child's description, to be a function for abolition advocates. Child, "Letter," *Liberator,* n.p. Child's description of Lewis can be found in her letter to William P. Cutler, 10 July 1862; cited in Child, *Selected Letters,* 414. Meltzer and Holland suggest that the young black woman was likely Charlotte Forten (1837–1914) of Salem, Massachusetts, whose grandfather James Forten had become a principal backer of the antislavery newspaper the *Liberator* after creating a successful sail-making business in Philadelphia.

13. Letter, Lydia Maria Child to William P. Cutler, 10 July 1862; cited in Child, *Selected Letters,* 414.

14. Harriet Beecher Stowe, "Sojourner Truth, the Libyan Sibyl," *Atlantic Monthly* 11, April 1863, 473–81.

15. Letter, Anne Whitney to Sarah Whitney, 28 October 1869, AWP–WCA.

16. Schueller, "Introduction," in Dorr, *A Colored Man,* xxx. The creation of a genealogy of black civilization was an urgent matter for abolitionists and black activists, who understood that the Eurocentric denial of black civilization or the insistence on blacks as "primitive" was a fundamental part of the colonial logic that represented slavery as the benevolent civilizing mission.

17. Frederick Douglass Diary, entry 26 January 1887, FDD–LOC; cited in Richardson, "Edmonia Lewis' 'The Death of Cleopatra,'" 51. The prominent abolitionist–orator had once been a fugitive slave. Early enlisted as an agent and lecturer of William Lloyd Garrison's American Anti-slavery Society, Douglass later split from Garrisonian abolitionism over fundamental differences about the constitutionality of slavery. Douglass's founding of his own abolitionist newspaper, called the *North Star* and later known as *Frederick Douglass' Paper,* was done without Garrison's support. Douglass fought for the rights of black men to enlist in the Union army and was instrumental in the recruitment of soldiers for the 54th and 55th Massachusetts colored regiments. Near the end of his life, Douglass held the position of U.S. minister to Haiti from 1889 to 1891.

18. Buick, "The Ideal Works of Edmonia Lewis," 7. These abolitionists were participants in the dedication of Lewis's *The Morning of Liberty/Forever Free,* which was presented to Rev. Leonard A. Grimes during a ceremony at the Tremont Temple, Boston, in October 1869.

19. Lewis presented her sculpture *John Brown* to the Reverend Garnet in a ceremony at Shiloh Presbyterian Church in New York. "Miss Edmonia Lewis," 1.

20. The Remonds were a black activist family from Salem, Massachusetts. John and

Nancy Remond successfully established themselves in the catering and provisioner business and had many children, including Charles, Caroline, and Sarah. While John became a member of Garrison's Anti-slavery Society, Nancy was a part of the Salem Female Anti-slavery Society, organized by black women. Their political activities included abolition, black voting rights, desegregating education and public transportation, repealing antimiscegenation laws, self-help, the black church, contesting the American Colonization Program's "back to Africa" movement, and establishing black newspapers. The Remonds were exceptional organizers, but to achieve their goals they also resorted to civil disobedience to effect change and draw attention to their causes. Charles Lenox Remond became a prominent abolitionist in his own right. He was the first person of color to address the Massachusetts State Legislature, speaking in support of the desegregation of railroads. In 1837–38, Charles Lenox Remond became the first black lecturer and agent of Garrison's American Anti-slavery Society, traveling the Northeast tirelessly on circuits of lectures. Later his sister Sarah, also an agent and lecturer, traveled with him. Like Douglass, Charles was also an important recruiter of black men to the 54th and 55th Massachusetts Volunteer Infantries of the Union army. Charles and his wife, Amy Matilda Williams Casey, were significant figures within the nineteenth-century abolitionist community, entertaining William Lloyd Garrison, Wendell Phillips, William C. Nell, William Wells Brown, Abigail and Stephen Foster, and other prominent abolitionists in their home. Sibyl Ventress Brownlee, "Out of the Abundance of the Heart: Sarah Ann Parker Remond's Quest for Freedom," Ph.D. dissertation, University of Massachusetts, Amherst, 1997, 47–54, 56, 58, 62, 64, 69, 70, 71. For more on the Remond family, see Brownlee, "Out of the Abundance of the Heart," passim; James O. Horton and Lois E. Horton, *Black Bostonians: Family Life and Community Struggle in the Antebellum North* (New York: Holmes and Meier Publishers, 1979); Shirley J. Yee, *Black Women Abolitionists: A Study in Activism, 1828–1860* (Knoxville: University of Tennessee, 1992); and Dorothy Sterling, *We Are Your Sisters: Black Women in the Nineteenth Century* (New York: W. W. Norton, 1984).

21. "Seeking Equality Abroad," 5. This article names Garnet and William Lloyd Garrison among Lewis's earliest supporters.

22. Henry Highland Garnet, *The Past and the Present Condition, and the Destiny, of the Colored Race: A Discourse Delivered at the Fifteenth Anniversary of the Female Benevolent Society of Troy, N.Y. Feb. 14, 1848* (Miami: Mnemosyne Publishing, 1969), 7. Specifically, Garnet cited the ancient scholar Herodotus as confirming the race of Egyptians through both complexion (blackness) and other physiognomical traits (woolly hair).

23. Ibid., 11.

24. Dorr, *Colored Man*, 11. It is significant to note that Dorr's process of naming blackness, which, in including the citation of visual signifiers of the black body (thick lips, curly hair, black skin), was, according to his own admission, the identification of racial signs that he himself did not necessarily possess. This referencing of the black body then for Dorr, a man who could "pass" for white, was a political act of defiance that laid a prideful claim to a marginalized racial position with which he admittedly was not readily visibly identifiable. Dorr's claim to blackness points up the vast variability of the black body and foregrounds the difficulties in policing racial identifications through vision.

25. Letter, Lydia Maria Child to Francis George and Sarah Black Shaw, 11 February 1869, HL–HUL.

26. Ibid.

27. Ibid.

28. Lewis had previously completed another sculpture titled *Hagar* (c. 1868), which was exhibited in Chicago but is now lost. It is unclear if Lewis's second *Hagar* was of a

different design. See Buick, "The Ideal Works of Edmonia Lewis," 11; and Hartigan, "Edmonia Lewis," 93.

29. These and the following biblical citations relate to the Holy Bible, 3 vols. (Doway, anno 1609; rpt., 1750). The Doway, or Douay, version of the Bible was revised by Bishop Challoner between 1749 and 1752, and three volumes were published in 1749, 1750, and 1752. In my own discussion, I have used the name spellings that are the current convention.

30. Besides the biblical texts, Lewis may have been aware of the story by Nathaniel Parker Willis titled "Hagar in the Wilderness," in which he represented Hagar and Ishmael as the hapless victims of Sarah's malicious jealousy and Abraham as the impotent facilitator of their doom. See Nathaniel Parker, "Hagar in the Wilderness," *Cosmopolitan Art Journal* III, no. 3 (1859): 107–8.

31. The issue of white female culpability in the sexual violation of black female slaves was cited within nineteenth-century abolitionist literature. One such text, "Amy," the sentimental fiction of Caroline Healey, published in *Liberty Bell* (1849), describes two sisters enmeshed within the interlocking regimes of sex and race within the antebellum South. When the white Edith's black half-sister, Amy, becomes the target of a white man's (Charles Hartley's) colonial desire, it is Edith, like the biblical Sarah, who ultimately holds the power to prostitute her sister or preserve Amy's chastity. Hartley's verbal expression of his lust for Amy is thus targeted at Edith and received as a sexual assault against her white bourgeois femaleness, as much an assault as the actual physical and sexual harm he will inevitably force on Amy. As Sánchez-Eppler has argued, Amy's interracial body signifies both past miscegenating sex and the promise of future cross-racial sexual exploitation, since her blackness is synonymous with sexual availability and excess. Ultimately, Amy's sexual violation is as much a function of Edith's concession to Hartley's pressure (her pandering to the limits of white feminine delicacy and politeness and the social improprieties of discussing sex and sexual desire) as it is a facet of Hartley's patriarchal and colonial privilege (his white male access to female bodies). Edith then participates in the colonial structure that disenfranchised Amy, a black slave and her own sister, through a feigned ignorance of the conditions of slavery and its sexual implications for black women. For Edith, the cost of preserving her idealized white femininity is Amy's sexual chastity, a price that produces the very racialized sexuality that Hartley desired in the first place. The black female slave body becomes the sexual surrogate for that of the white female, both directly, as in the case of Sarah, Hagar, and Abraham, and indirectly, as in the case of Edith, Amy, and Charles. Caroline Wells Healey Dall, "Amy," *Liberty Bell* 10 (1849): 6, 8, 11, 12; cited in Sánchez-Eppler, "Bodily Bonds," 41–42.

32. *The Vulgate New Testament: With the Douay Version of 1582* (London: Samuel Bagster and Sons, 1872).

33. Like many other blacks and people of color in the nineteenth century, Lewis and Remond also shared at least one explicit encounter with racial violence resulting in bodily harm. Lewis, as discussed above, was the target of a white racist mob in Oberlin, and Remond was attacked and pushed down a flight of stairs at a theater by two white men after she and her companions (her sister Caroline and William C. Nell) refused to be seated in the black gallery. Although it would be hard to state definitively if Lewis and Remond discussed these particular incidents, the commonality of their social identifications as Americans, women, and blacks would have provided them with a safe and empathetic context within which to share such painful experiences. Brownlee, "Out of the Abundance of the Heart," 79.

34. Ibid., 1.

35. Ibid., 111. Since Charles and Sarah Remond lectured in Ohio in 1857, it is possible that Lewis had heard of the Remonds from her time as a student at Oberlin College, in

Ohio. Although the dates place Remond in Britain before Lewis had relocated from Oberlin to Boston, the *Liberator*'s thorough documentation of Remond's abolitionist activities as a Garrisonian provides yet another potential link between the two women, Lydia Maria Child. Child, who was active within Garrison's abolitionist paper, became acquainted with Lewis in Boston in 1864 and would have been knowledgeable of the Remonds, also Garrisonians, through her work with William Lloyd Garrison and her powerful New England abolitionist connections.

36. Sarah Remond's lectures drew large crowds in Britain, where she spoke to racially mixed audiences of men and women. Since, as most passengers from America, Edmonia Lewis likely docked initially in England after her transatlantic voyage in 1865, it is possible that she heard of Remond's lectures, which included venues in Dublin, Manchester, Bury (Lancashire), Warrington, Edinburgh, Ulverston, and Chesterfield. While in England, Sarah cofounded the London Ladies' Emancipation Society in 1863 with Elizabeth Reid, Clementia Taylor, Mary Estlin, and Harriet Martineau. She also researched the Morant Bay riots at Jamaica, in the West Indies, and the violent response of Governor Eyre and was active in Italian reunification. As was likely the case with Lewis, Sarah Remond never made her home in America again after moving to Italy. In the wake of the Dred Scott verdict, Remond had been denied a visa to the Continent by an American legation in Liverpool. Ultimately, she was forced to get a passport from the British foreign secretary. This blatant denial of her American citizenship and authority over her own person inevitably impacted Remond's decision to expatriate. It was in England and Italy, not America, that she was able to secure the education necessary to become a physician. Remond declared her occupation as physician in the Ninth Census of Italy, in 1870.

37. Letter, Anne Whitney to Sarah Whitney, 17 April 1868, AWP–WCA.

38. Brownlee, "Out of the Abundance of the Heart," 47, 155. Brownlee places Remond among the international socialites, fashionable elite, and notable intellectuals who frequented the parties at the Storys' apartments in the Palazzo Barberini. The significant connection between the Storys and the Remonds occurred a generation prior, when John and Nancy Remond, Sarah's parents, catered affairs for the Honorable Judge Joseph Story, William's father. However, Brownlee does not indicate any sources that connect Sarah socially to William Story.

39. The apartments at Palazzo Maroni were occupied by Caroline Putnam and Martiche Juan Remond, Sarah Remond's sisters, and her nephew Edmund Quincy (Caroline's son). Sarah Remond had relocated from Florence to Rome after the failure of her marriage to Lazarro Pintor, of Sardinia. It is interesting to note that Douglass was welcomed as a guest in the Remonds' Roman home, since throughout the 1860s Douglass had aggressively disparaged Charles Lenox Remond and other Garrisonians. The philosophical split between abolitionists occurred over differences about the constitutionality of slavery. While William Lloyd Garrison and his supporters, like the Remonds, believed slavery to be a constitutional problem existing in the dehumanization of blacks in the three-fifths clause, Douglass and his supporters felt that the Constitution was never intended to support slavery. Born in 1824, Sarah Remond continued to live in Rome until her death on 13 December 1894, when she was buried in the Protestant Cemetery at Rome.

40. Brownlee, "Out of the Abundance of the Heart," 129, 130, 131.

41. "Concerning Women," *Woman's Journal* 9, no. 41, 12 October 1878, 321. It is interesting to note that while reports of the activities of the other women in this article began with their names cited with the title of Mrs. or Miss, Lewis did not receive either formality. We must consider the possibility that her race informed the decision, conscious or not, to leave out any title.

42. Elisabeth Bronfen, *Over Her Dead Body: Death, Femininity and the Aesthetic* (Manchester: Manchester University Press, 1992), 11.

43. Bronfen, *Over Her Dead Body,* 76.

44. "Seeking Equality Abroad," 5.

45. Sánchez-Eppler, "Bodily Bonds," 51.

46. According to Brownlee, Sarah Remond never returned to America after her initial lecturing circuits through Britain.

47. Sarah Remond, *Anti-slavery Standard,* 3 November 1866; cited in Brownlee, "Out of the Abundance of the Heart," 183. It is significant that Remond's disillusionment came swiftly after the victory of the North in the Civil War. That her writing expressed such open futility and despair so soon after the "liberation" of blacks from slavery indicates the rapidity and effectiveness of Southern political resistance to any tangible social, political, and legal equality for blacks.

48. Lynda Hartigan has described this work as Lewis's first sculpture executed in Rome. Although it was likely not the first of all Lewis's Roman works, it was perhaps the first large-scale ideal work. See Hartigan, "Edmonia Lewis," 92.

49. Ibid., 93. It would appear that the title of this work was originally *The Morning of Liberty,* yet the work has come to be more widely known as *Forever Free* because of the inscription of these words on its base.

50. Jacqueline Fonvielle-Bontemps, *Forever Free: Art by African American Women, 1862–1980* (Normal, Ill.: Center for the Visual Arts Gallery, Illinois State University, 1980), 16; Buick, "The Ideal Works of Edmonia Lewis," 6. Fonvielle-Bontemps's assertion replicated the colonial deployment of so-called pure racial categories, blatantly missing the complexity of hybrid racial identifications and particularly the dominance of the interracial black female subjects in nineteenth-century sculpture.

51. While the figure of Lincoln was often paired with a black, usually male, slave body, the sculptural groups generally relied on an abject black body to glorify the image of Lincoln as liberator.

52. Lydia Maria Child, "Edmonia Lewis," *Broken Fetter,* 3 March 1865, 26. I have estimated the dates of this sculpture according to the information about Lewis's time in Boston. Lewis's black soldier, now lost, was even more radical than the figure of the newly free black male slave in John Quincy Adams Ward's *Freedman* (1863). Although the male former slave in Ward's work sat in contemplation of his new social status and potential for citizenship and manhood, Lewis's body of a black soldier, in actively proclaiming the role of black men in securing their own freedom, was a rather defiant representation of a black male as a black *man*. The distinction between being male and being a man is not trivial, since racist stereotypes sought to infantilize black men and deny them the rights and privileges of citizenship largely on the basis of the assumption that they could not achieve the dignity, responsibility, control, and intelligence necessary to be defined as men. The fact that Lewis chose to sculpt a black soldier, someone in the direct service of the state, drives this distinction home. If this is the same work that Hartigan describes, Lewis's sculpture represents a wounded soldier in defense of the American (Union) flag, making the black man's claim to citizenship even more poignant. In this way Lewis's sculpture signaled the later Du Boisian problem of the twoness of black American identity, the state of being either black or American.

53. Lewis's work is also a drastic departure from Augustus St. Gaudens's Robert Gould Shaw Memorial, in Boston, which individualizes Robert Gould Shaw on horseback and yet represents a more anonymous mass of marching black soldiers. Buick, following Woods, argues that Carney had been wounded in battle but never allowed the flag to touch the

ground. See: Buick, "The Sentimental Education of Mary Edmonia Lewis," 50; and Naurice Frank Woods Jr., "Insuperable Obstacles: The Impact of Racism on the Creative and Personal Development of Four Nineteenth-Century African American Artists," Ph.D. dissertation, Union Institute, Montpelier, Vt., 1993, 202.

54. In all of my research I have not encountered any indication of a slave subject within Lewis's oeuvre. Even documentation of her early work in Boston failed to turn up examples of slave subjects. Although Lewis's move to Rome was at the end of the Civil War, in 1865, signaling the liberation of blacks, many of her white contemporaries continued to represent blacks as slaves even after American emancipation. The omission is particularly telling considering that Lewis's black heritage provided an obvious ability to capitalize on black subjects. In light of my discussion of Lewis's racing of black female freedwomen, it is interesting to speculate on how, if in any way, Lewis's representation of a female slave may have shifted her deployment of race. If Lewis was indeed influenced by the colonial associations of freedom and whiteness and the abolitionist strategy of slave self-annihilation as a method of achieving a symbolic "whiteness," then one must wonder if Lewis's slaves would have exhibited more explicitly "black" physiognomical characteristics than her free black subjects did.

55. Lewis also seemed to avoid the eroticized nudity of female subjects, which added to the vulnerability, sensualism, and spectacular sexual nature of such sculptures.

56. Lewis's investment in women's equality is not just speculation but evident in her life choices, independence, self-sufficiency, and her commitment to her career within a field historically dominated by white men, which was also reflected in the lives of her contemporary female sculptor friends, not to mention in the powerful influences of formidable professional women such as Sarah Remond, Lydia Maria Child, and Charlotte Cushman. The possibility of reading an alignment of citizenship/personhood and freedom into the abolitionist symbol of the kneeling female slave is also demonstrated in the deployment of this symbol by William Lloyd Garrison to recruit white females to the "ladies department" of his abolitionist newspaper the *Liberator*. The conventionally gendered activities and objects of white bourgeois domesticity became, through abolitionist discourse, political sites for the repetitive deployment of this visual antislavery symbolism. It was the "freedom" of the white females that allowed them to work toward the liberation of their "sisters in bondage." Yet at the same time, white women struggled to increase their freedoms and to gain full citizenship rights by symbolically aligning their disenfranchisement within patriarchy with the racial marginalization of black women. In this way white women could speak their personal grievances *through* the bodies of the female slaves. Sánchez-Eppler has noted that nineteenth-century white feminists compensated for their inability to articulate publicly the subject of white women's sexual rights to their bodies within marriage by speaking instead on the inability of black women to control their bodies within slavery. Sánchez-Eppler, "Bodily Bonds," 32–34.

57. Clara Cushman, *Neal's Saturday Gazette*; cited in Kasson, *Marble Queens and Captives,* 59; and in Wallace, *Art and Scenery in Europe with Other Papers,* 202. Lewis's sculpture was also later exhibited in the Chicago Exposition of 1878.

58. Richardson, "Edmonia Lewis' 'The Death of Cleopatra,'" 46–47.

59. *Seated Agrippina,* marble, 1.21 m in height, Musei Capitolini, Rome. According to Haskell and Penny, this sculpture was also known as *Agrippina Capitolina* and *Poppea Sabina.* Haskell and Penny, *Taste and the Antique,* 133. *Cleopatra,* marble, 1.62 m in height × 1.95 m in length, Musei Vaticani (Galleria delle Statue), Rome. According to Haskell and Penny, this sculpture was also known as *Ariadne, Dido,* and *Nymph.* Ibid., 184.

60. William Wetmore Story, *Salome,* marble, 144.8 cm in height, Metropolitan Museum of Art, New York City.

61. Letter, Anne Whitney to Sarah Whitney, 7–18 February 1869, AWP–WCA.

62. Letter, Anne Whitney to Sarah Whitney, 12 December 1870, AWP–WCA.

63. Letter, Anne Whitney to Sarah Whitney, 14 January 1871, AWP–WCA.

64. Lewis also exhibited her *Asleep* (1874), *The Marriage of Hiawatha* (1871), *The Old Indian Arrow Maker and His Daughter* (1872), and the terracotta busts *John Brown* (1876), *Charles Sumner* (1876), and *Henry Wadsworth Longfellow* (1871). *Official Catalogue of the International Exhibition,* 2nd rev. ed. (Philadelphia, 1876), 59; cited in Richardson, "Edmonia Lewis' 'The Death of Cleopatra,'" 51. *Asleep* (1874), marble, San Jose Public Library, San Jose, California.

65. John W. Forney, *A Centennial Commissioner in Europe 1874–76* (Philadelphia: J. B. Lippincott, 1876), 117.

66. Again, H. W. stood for Henry Wreford. H. W., "Negro Sculptress," 302.

67. Although Lewis's family history is mostly undetermined and illusory, some sketchy data have been documented. It has been suggested that Lewis was born in Ohio or near Albany between 1843 and 1845, a suggestion strengthened by Lydia Maria Child's observation that Lewis was "about twenty years of age" when Child met her in 1864. Lewis herself stated her place of birth as Greenhigh, Ohio, supposedly in conversation with Henry Wreford. Lewis's father, Samuel, was a black gentleman's servant, probably from Haiti. Lewis's mother was Chippewa (Ojibway/Ojibwa), from a Mississauga tribe within the colonial boundaries of Canada. Apparently, Lewis's early childhood was spent with her mother's tribe, and it has been suggested that she lived in upstate New York and New Jersey. Orphaned before the age of five, Lewis was provided for by her brother, Samuel. Although some sources suggest that Samuel was related to Lewis only through their black father, her reference to him as Sunrise, a Native name, indicates their shared Native heritage, whether or not it was through the same mother. Samuel/Sunrise eventually funded her early schooling near Albany and her college education at Oberlin during 1859–63 through his prospecting in California. See: Child, "Letter," *Liberator;* and H. W., "Negro Sculptress," 302.

68. One of the institutional barriers to researching white women or traditionally racially marginalized subjects is that primary records are often scarce or nonexistent as a result of historical sexual and racial bias and neglect embedded in archival and library practices. While I have located no centralized archive of Lewis's papers or a historical bibliography, her contemporaries, white males and females, were much better documented in their own time and are, therefore, much easier to research today. For example, the nineteenth-century author Henry James wrote William Wetmore Story's biography, Hosmer's friend Cornelia Carr penned hers, Hiram Powers has extensive papers in various locations, and Anne Whitney's papers are housed at Wellesley College Archives.

69. Holland, "Mary Edmonia Lewis's *Minnehaha,*" 29.

70. H. W., "Negro Sculptress," 302. Although within the colony, female sculptors such as Hosmer and Stebbins had open romantic relationships with other women, published reports about their art and lives deleted their lesbianism and inferred a pseudospiritual chastity based on an uncorrupted dedication to their art. For Hosmer, who was all of five feet two, her size also contributed to the public desire to imagine her as an elflike creature or a young boy. Hawthorne initially perceived Hosmer in masculine dress, describing her as a "handsome boy," a description that also reveals a desire to desexualize these women artists, since a young boy's sexuality, unlike an adult male's, is containable and immature and not at all threatening in the way that a grown-up male sexuality would have evoked the specter of a phallicized female. The persistent deployment of the representation of the unwomanly or prepubescent body of the female sculptor was also a disordering strategy

that disavowed the desires of the women of the Flock. The difference and differencing of the "lady artists" served to distinguish them from "normal" women and to explain their rejection of traditional patriarchal codes of femininity, femaleness, and cross-sexual relationships. See Kasson, *Marble Queens and Captives,* 144.

71. "Seeking Equality Abroad," 5.

72. Ibid., 5.

73. H. W., "Negro Sculptress," 302.

74. Green, "The Slave–Wife"; cited in Sánchez-Eppler, "Bodily Bonds," 38.

75. Child, "Letter," *Liberator.*

76. Ibid.

77. "Concerning Women," *Woman's Journal* 10, no. 1, 4 January 1879, 1; "Concerning Women," *Woman's Journal* 9, no. 51, 21 December 1878, 401.

78. A. Q. W., "Edmonia Lewis," *National Anti-slavery Standard* 25, no. 33 (24 December 1864). Waterson's poem commemorated Lewis's successful modeling of the portrait bust of Col. Robert Gould Shaw. The Watersons helped to raise funds for Lewis's initial purchase of marble in Rome. Lewis sculpted a portrait bust of her patron, *Anna Quincy Waterson* (1866), which was one of her earliest works completed in Rome. See Hartigan, "Edmonia Lewis," 95.

79. Letter, Edmonia Lewis to Maria Weston Chapman, 5 February 1867, BPL; cited in Richardson, "Edmonia Lewis' 'The Death of Cleopatra,'" 50.

80. H. W., "Negro Sculptress," 302.

81. Lewis supposedly described her mother as a "wild Indian" and used the same term to describe her early life with her mother's relatives. *How Edmonia Lewis Became an Artist,* pamphlet, n.d., Washington, D.C., ETCA, Edmonia Lewis vertical file; H. W., "Negro Sculptress," 302; H. W., "Lady-Artists in Rome," 177–78.

82. H. W., "Negro Sculptress," 302. This type of detachment also mimics the narrative strategies deployed within abolitionist slave writing wherein black authors were encouraged to achieve an "objective" distance from the experiences they narrated. This practice was particularly abusive and silencing when applied to the narration of sexual violence and abuse, as it privileged the feelings and emotions—the insistence on delicacy and politeness—of a dominantly white bourgeois audience above the anguish of the abused black slave. While this however mediated "quote" reveals the potential extent to which Lewis's self-identifications were influenced, like those of all marginal subjects, by the dominant ideology, we must also consider that Lewis may have deliberately deployed stereotypical self-identifications in order to become more desirable and exotic in the eyes of her white public. Equally, Wreford may have embellished the text to suit his own authorial ambitions.

83. "Edmonia Lewis," *Revolution,* 20 April 1871; "Seeking Equality Abroad," 5.

84. Richard Greenough, *Benjamin Franklin,* modeled 1855, dedicated 17 September 1856, bronze, 2.54 × 0.66 × 0.66 m, Old City Hall, School Street, front courtyard, City of Boston, Environment Department, Art Commission, Boston City Hall, Boston, Massachusetts.

85. Edmonia Lewis, *The Muse Urania,* pencil on paper, 36.8 × 30.5 cm, Oberlin College Archives, Oberlin, Ohio.

86. Lester, *The Artist, the Merchant and the Statesman,* 1:46.

87. The colonial opposite of the Pocahontas image was that of the squaw, which was relatable to drunkenness, "primitiveness," and vice. Lewis's conversion to Catholicism in 1868 also fit nicely with the white public's desire to stereotype her as Pocahontas. Holland, "Mary Edmonia Lewis's *Minnehaha*," 31; Hartigan, "Edmonia Lewis," 94.

88. Letter, Lydia Maria Child to H. Sewall, 10 July 1868, Wayland, 10 July 1868, RSP–MHS.

89. In this vein, Lewis's deliberate self-misidentifications predate Josephine Baker's similar strategies of appropriation of colonial stereotypes of excessive black sexuality to parody her white audience's fears/desires of the black female body.

90. Letter, Lydia Maria Child to Harriet Sewall, 10 July 1868, RSP–MHS.

91. William J. Clark Jr., *Great American Sculptures* (Philadelphia: Gebbie and Barrie, Publishers, 1878), 141.

92. Richardson, "Edmonia Lewis' 'The Death of Cleopatra,'" 43–44. In particular, Richardson has argued that Lewis's sculpture registers an awareness of the descriptions of Cleopatra's royal garb in Plutarch's *Lives of Illustrious Men,* which would have been available to her in Wrangham's 1819 edition (among others) as well as the North African Lucius Apuleius, *The Golden Ass of Apuleius,* trans. William Adlington (London: John Lehmann, 1946).

93. Lydia Maria Child, "Harriet E. Hosmer: A Biographical Sketch," *Ladies' Repository* 21, January 1861, 6; cited in part in Kasson, *Marble Queens and Captives,* 152.

94. Richardson, "Edmonia Lewis' 'The Death of Cleopatra,'" 47, 52. Despite the alluring and logical nature of such a visit for Lewis, I am cautious about the absolute factuality of Lewis's journey, since Richardson does not provide a primary source document for her assertion. However, Anne Whitney mentioned Lewis visiting Paris sometime in the summer of 1869, returning in August at the height of a devastating cholera epidemic in Rome, which Lewis claimed to have survived with a Bible and brandy. Whitney also reported that six people in the house next to Lewis's and one in Lewis's own had died during the epidemic. See the letter from Anne Whitney to Sarah Whitney, 28 October 1869, AWP–WCA.

95. Bishop Turner, "To Colored People," *Constitution: Atlanta GA* (newspaper), Sunday, 13 January 1895, 3.

96. Proctor, "American Women Sculptors," 126.

Conclusion

1. S. 1. P. 1. (1927) (bound directory of deaths and cemetery listings), parte I, anno 1927, Provincia di Roma, Circondario di Roma, Comune di Roma, ufficio di Stato Civile, Registro degli, Atti di Morte, delegazione/di, entry no. 436.

2. Anagraphe, Centrale, Via Petroselli, 55 (Minicipality of Rome, Historical Archive, 2nd floor, Stato Civile).

3. See John Robert Glorney Bolton and Julia Bolton Holloway, eds., *Elizabeth Barrett Browning: Aurora Leigh and Other Poems* (London: Penguin, 1995).

4. H. W., "Negro Sculptress," 302.

5. "Concerning Women," *Woman's Journal* 9, no. 41, Saturday, 12 October 1878, 321. This source lists Lewis's sculpture as "Cleopatra Dying."

6. "Concerning Women," *Woman's Journal* 9, no. 51, Saturday, 21 December 1878, 401.

7. "Concerning Women," *Woman's Journal* 10, no. 1, Saturday, 4 January 1879, 1.

8. "Edmonia Lewis," *Atlantic Constitution,* Sunday, 30 October 1898, 16.

9. Lorado Taft, *History of American Sculpture,* rev. ed. (New York: Macmillan, 1924), 212.

10. "The Catholic Who's Who," *Rosary Magazine,* February 1909, 322.

11. L. M. C., "A Chat with the Editor of the Standard," *Liberator,* 20 January 1865, 12.

Index

abolitionism, xii, xvi, xx, 7, 27, 35, 36, 87, 91, 92, 93, 95, 105, 111, 127, 149, 150, 162, 165, 167, 170, 178, 183; abolitionist community, 42, 43; *Anti-slavery Almanac,* 94, 95; *Anti-slavery Bugle,* 48; *Anti-slavery Standard,* 48; British, 87; *Description of a Slave Ship* (Phillips), 47; *Liberator,* 156, 173; *The Liberty Bell,* 87; *Lincoln Memorial,* 36, 37; philanthropy, 19, 43; *"Poor Things, 'they can't take care of themselves,'"* 95; Quakers, 91; World Anti-Slavery Conference, 32. *See also* Lincoln, Abraham

abolitionists, 30, 130, 154, 156, 163, 175, 177, 183. *See also individual abolitionists*

Africa, xi, xii, xviii, xxix, 113, 114, 115, 116, 130, 145, 149, 150, 151, 152, 154, 169, 172, 173, 178, 181, 183, 184; African queen, xiv; Africanness, xi

Agassiz, Louis, 138, 139, 150

America (Powers), xiv, 87, 89, 90, 91, 92, 93, 105, 156

Ames, Sarah Clampitt Fisher, 10, 180

antislavery. *See* abolitionism; abolitionists

art education, xxii, 19, 23; and anatomy and medicine, 23, 24; private tutoring, 24

art history, xvi, xvii, 44, 182

artists: female, 10; "lady-artists" 6, 172

author-function, xv

authorship, 45, 46, 48, 52, 54

Baker, Josephine, 182

Ball, Thomas: and *Lincoln Memorial,* 36, 37

beauty, xxxi, 117, 120, 122, 124, 133, 136, 140, 150, 177, 184; male, 116; and whiteness, xxxi, 70, 82, 125

becoming and identity, xi, xii, xiii, xxvii, xxviii, 104. *See also* body

Bell, John, 125, 136, 150, 167; *Octoroon,* 105, 106, 124, 125, 136, 150, 151

Bhabha, Homi K., xxxiv

blackness, xi, xii, xiv, xviii, xix, xx, xxi, xxv, xxviii, 13, 43, 46, 62, 75, 79, 114, 117, 124, 139, 150, 152, 159, 173, 175; Black Atlantic, xviii; black body/subject, xiv, xv, xviii, xix, xx, xxii, 48, 63, 68, 69, 98, 116, 127, 130, 147, 151, 183; black diaspora, xviii, 178, 183; black female body/subject, xiv, xv, xviii, xix, xx, xxii, xxiii, xxviii, xxix, xxxi, 75, 113, 115, 117, 118, 119, 122, 124, 130, 133, 137, 139, 143, 146, 183, black feminism, xvii, xxii, 15; black male body/subject, xxii, 82, 125, 183, 184; black–Native, xxii, 14, 15, 17, 26, 31, 44, 173; black producers, xxv; black sexuality, 82, 130, 153, 157; black skin; 96, 126, 127, 129, 163, 183; and class, 20, 42;

Charmaine A. Nelson is associate professor of art history at McGill University.